To: Emma

I hope you enjoy looking at the photos. I'm glad I met you Em :D

Demi Santos

americans

[1940-2006]

americans

[1940-2006]

> Amerika: Die soziale
Landschaft 1940 bis 2006.
Meisterwerke amerikanischer
Fotografie

> America: The social landscape
from 1940 until 2006.
Masterpieces of American
photography

Kurator | Curated by
Peter Weiermair

Herausgeber | Edited by
**Kunsthalle Wien
Peter Weiermair
Gerald Matt**

DAMIANI

KUNSTHALLE wien

Register | Index

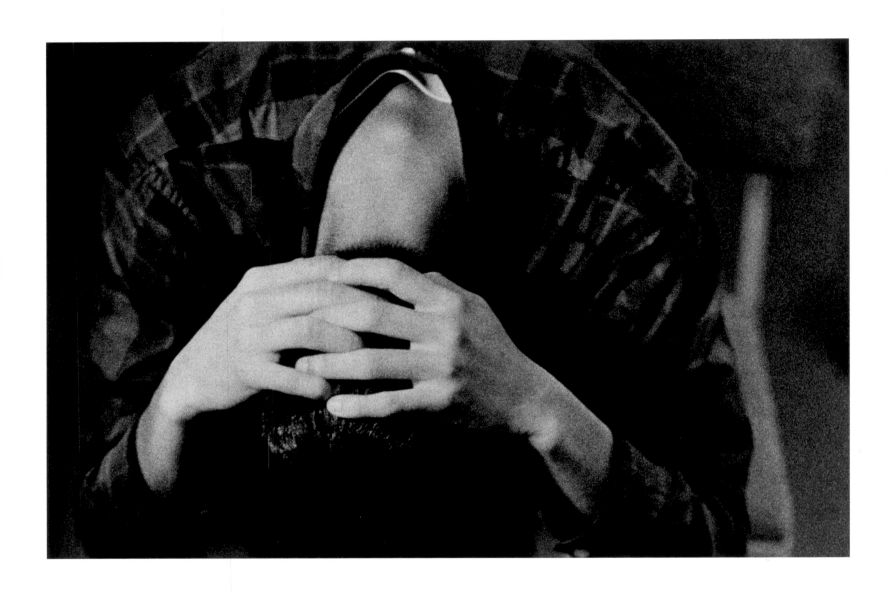

[Tulsa, 1983]

Gerald Matt | Guantanamo, Patriot Act, Krieg gegen den Terror, Abu Ghureib: Neue verbale Leuchttürme,
Direktor die seit dem 11. September 2001 in der politischen Diskurslandschaft erschienen sind.
Begriffe als Symptome für ein Verrutschen geopolitischer, moralischer und ideologischer
Gewissheiten. Ist etwas faul im Lande Amerika? Oder haben die Europäer wieder mal
nichts verstanden? Seit fünf Jahren herrscht jedenfalls gegenseitiges Misstrauen. Für viele
europäische Intellektuelle ist Bush der Antichrist in der Maske eines fundamentalisti-
schen religiösen Predigers. In den USA wiederum werden die Bewohner von der anderen
Seite des Atlantik in bestimmten Milieus gerne als „whimps" oder als „Euroweenies"
bezeichnet, die lieber guten Wein trinken, als in die Verteidigung ihrer Länder zu investie-
ren. Doch auch in Amerika selbst geht ein tiefer Riss durch die Gesellschaft. Der
Literaturwissenschaftler Harold Bloom hat jüngst Präsident Bush mit Kapitän Ahab vergl-
ichen, der im Irak seinen „weißen Wal" gefunden habe und damit das Land in die
Selbstzerstörung führe.

In diesem aufgeheizten Klima versucht die Ausstellung der Kunsthalle Wien eine
Bestandsaufnahme: Gibt es noch jenes ´andere Amerika` im Sinne des Poeten Walt
Whitman, das mit den Energien der Selbstfindung und der Selbsterhaltung kodifiziert ist?
Das „Land of Hopes and Dreams", wie es der Popsänger Bruce Springsteen in einem
Songtitel beschrieben hat? Oder ist die Nation eine „gemeinschaftlich erlebte
Zwangslage", wie der Kulturtheoretiker Greil Marcus einmal geschrieben hat. „Ein
Versprechen und ein Fluch, dem niemand entkommen kann?"

Da die Kunst kein geeignetes Mittel ist, um die Schlagzeilen der vergangenen Woche zu
bebildern, setzt das Projekt der Kunsthalle bei einem umfassenderen Begriff der USA an. Es
geht um ein Amerika, das den „pursuit of happiness" in Aussicht stellt, und sich gleichzei-
tig als Universum der Brüche und Risse präsentiert. In der Ausstellung *Americans*, benannt
nach dem berühmten Fotobuch von Robert Frank, wird durch den prismatisch gefilterten
Blick von 13 Fotografen das Leben in existentiellen Randlagen über einen Zeitraum von
einem halben Jahrhundert dokumentiert und ästhetisch gestaltet. *Americans* zeigt
Künstler verschiedener Generationen, die die Aufbrüche, Krisen und Veränderungen der
amerikanischen Gesellschaft unter dem Druck der politischen Verhältnisse und gegenkul-
tureller Projekte am Beispiel von Individuen, urbanen Milieus aber auch Veränderungen
von Landschaften und Stadträumen zum Ausdruck bringen.

Die Fotografien sind frei von der Ideologie einer „Family of Man"; ihr diagnostischer Blick
legt vielmehr die Wunden einer Gesellschaft offen, die zwischen religiösem
Fundamentalismus und bohemehaftem Exzess, zwischen Rassismus und liberalem Über-
schwang, zwischen Weltregierungsanspruch und kleinräumigen alternativen
Lebensentwürfen an ihren eigenen Widersprüchen zu zerbrechen droht. Es gibt in
Americans sowohl junge Künstler, die ihre Motive im Land des zweiten Irakkrieges und der
Post-Katrina-Epoche suchen, als auch große Klassiker wie Diane Arbus, Lee Friedlander,
Bruce Davidson und Robert Frank. Im Zusammenspiel zeitlich versetzter Positionen ist es

möglich, den Blick in die historische Tiefe zu lenken und Urteile über die gegenwärtigen USA am visuellen Repertoire des 20. Jahrhunderts zu messen.

In den Arbeiten fast aller beteiligter Künstler spielt neben der dokumentarischen Unbestechlichkeit auch der Sinn für das Zeremonielle, das Performative, die Theatralität des Alltags eine Rolle. „Während wir bedauern, dass die Gegenwart nicht so ist wie die Vergangenheit," hat Diane Arbus einmal gesagt, „und bezweifeln, ob sie wohl je Zukunft werden wird, harren ihre zahllosen unergründlichen Gewohnheiten ihrer Bedeutung. [...] Das sind unsere Symptome und Denkmäler. Ich möchte sie bloß retten, denn das Feierliche und Merkwürdige und Alltägliche wird einmal zur Legende werden."

Americans spannt einen Bogen von Helen Levitts Straßenfotografie aus New York in den vierziger Jahren zu Robert Franks „On the road"-Blitzlichtern der Beat Generation. Von den Außenseitern und Marginalisierten, die Diane Arbus abgebildet hat zu Richard Avedons Porträts von Leuten aus den unteren Gesellschaftsschichten von Texas.

Fotografie wird in der Ausstellung aber auch zum Tagebuch, zur Dokumentation privater Obsessionen und erotischer Exaltationen: Larry Clark rückt die Sexualität von Minderjährigen wie auch das Leben von Drogenabhängigen ins Bewusstsein. Mit derselben, oft brutalen Offenheit untersucht Peter Hujar die Lebenswelt von Transvestiten und Transsexuellen. Ryan McGinley und Ed Templeton wiederum vermitteln in ihren stark autobiografisch gefärbten Arbeiten ein distanziertes Bild des heutigen hedonistischen Jugendkults, geprägt von erotischer Promiskuität und begriffslosem, ideologiefreiem Vergnügungstaumel.

Diese Fotoarbeiten wollen kein Urteil fällen, sondern stellen die Urteilskraft des Betrachters auf die Probe. Anders als in der „Concerned Photography" des 20. Jahrhunderts, wo Bilder um Verständnis warben, aber auch das Selbstverständnis nicht-konformistischen Verhaltens einforderten, geht es den jüngsten Beiträgen um Statements ohne moralischen Unterton, um einen kalten, distanzierten Blick auf das, was der Fall ist.

So siedelt sich *Americans* zwischen den Polen einer partizipatorischen Fotografie, die ihren Objekten wenn schon nicht zu ihrem Recht, so doch zu ihrem Ausdruck verhelfen kann, und einer von Désinvolture geprägten Dokumentationsästhetik an. „In Amerika", schreibt Susan Sontag, „ist der Fotograf nicht nur die Person, die die Vergangenheit festhält, sondern jene, die sie erfindet."

An dieser Stelle möchte ich Peter Weiermair danken, der das von uns gemeinsam entwickelte Konzept als Kurator in eine spannende Ausstellung umsetzte. Gedankt sei auch dem Team der Kunsthalle, das fachkundig und kompetent das Projekt realisierte: Sigrid Mittersteiner (Assistenz), Mario Kojetinsky (Produktion), Johannes Diboky (Technik), Claudia Bauer (Presse) und Claudia Ehgartner (Vermittlung).

Gerald Matt | Guantanamo, Patriot Act, war against terror, Abu Ghureib: new verbal lighthouses that
Director have appeared in the political discourse landscape since 11 September 2001. Expressions as
symptoms of shifted geopolitical, moral and ideological certainties. Is something rotten in
the state of America? Or have Europeans again understood nothing? In any case, for five
years there has been mutual mistrust. For many European intellectuals Bush is the
antichrist in the mask of a fundamentalist religious preacher. In the US, on the other hand,
inhabitants of the other side of the Atlantic are described in some circles as "wimps" or as
"Euroweenies", who prefer to drink good wine rather than investing in the defence of their
countries. But also in America itself, there is a deep rift running through society. The liter-
ary scholar Harold Bloom recently compared President Bush to Captain Ahab, who had
found his "white whale" in Iraq and was thereby leading his country to self-destruction.

In this heated climate, the exhibition in the Kunsthalle Wien is attempting a stocktaking:
is there still that "other America", in the sense of the poet Walt Whitman, which is codified
with the energies of self-discovery and self-preservation? The "Land of Hopes and Dreams"
the pop singer Bruce Springsteen once described in a song title? Or is the nation a "commu-
nally experienced predicament", as the cultural theoretician Greil Marcus once described
it? "A promise and a curse that nobody can escape"?

As art is not a suitable medium to illustrate last week's headlines, the Kunsthalle project
starts with a comprehensive concept of the US. It concerns an America that holds out the
prospect of the "pursuit of happiness" and simultaneously presents itself as a universe of
breaks and rifts. In the exhibition *Americans*, named after the famous photo book by
Robert Frank, life on the existential margins over a period of half a century is documented
and aesthetically shaped through the prismatically filtered view of 13 photographers.
Americans shows artists of various generations who express the departures, crises and
changes in American society under the pressure of political circumstances and counter-
cultural projects through the example of individuals and urban milieus but also through
changes in landscapes and urban areas.

The photographs are free of the ideology of a "family of man"; their diagnostic view rather
reveals the wounds of a society that is in danger of breaking on its own contradictions,
between religious fundamentalism and bohemian excess, between racism and liberal exu-
berance, between the claim to world leadership and small-scale alternative life-styles. In
Americans as well as young artists seeking their motifs in the land of the second Iraq war
and the post-Katrina epoch, there are also great classics such as Diane Arbus, Lee
Friedlander, Bruce Davidson and Robert Frank. In the interplay of chronologically shifted
positions, it is possible to look into the historical depths and to measure judgements of the
present-day USA against the visual repertoire of the 20th century.

Alongside documentary integrity, a sense of the ceremonial, the performative, the theatri-
cality of everyday life also plays a role in the work of almost all the participating artists.
"While we regret that the present is not like the past," Diane Arbus once said, "and despair

of its ever becoming the future, its innumerable, inscrutable habits lie in wait for their meaning... These are our symptoms and our monuments. I want simply to save them, for what is ceremonious and curious and commonplace will be legendary."

Americans spans a range from Helen Levitt's street photography from New York in the forties to Robert Frank's "On the Road" snapshots of the beat generation. From the outsiders and the marginalised that Diane Arbus photographed to Richard Avedon's portraits of people from the lower social strata of Texas.

Photography in the exhibition also becomes a diary, a documentation of private obsessions and erotic exaltations: Larry Clark forces the sexuality of minors and the life of drug addicts into our consciousness. With the same, often brutal openness, Peter Hujar explores the world of transvestites and transsexuals. In their heavily autobiographically coloured works, Ryan McGinley and Ed Templeton on the other hand provide a distanced picture of the present-day hedonistic cult of youth, marked by erotic promiscuity and conceptless, ideology-free pleasure-seeking.

These works of photography do not seek to pass judgement, but put the judgemental power of the observer to the test. Different from the "concerned photography" of the 20th century, where pictures campaigned for understanding but also required the self-image of non-conformist behaviour, the latest contributions concern statements without a moral undertone, a cold, distanced look at how things are.

Thus *Americans* lies between the poles of participatory photography, which can help its objects if not to their rights at least to their expression, and a documentation aesthetic characterised by désinvolture. "In America," writes Susan Sontag, "the photographer is not simply the person who records the past, but the one who invents it."

Here I would like to thank Peter Weiermair, who as curator has turned a concept we developed together into an exciting exhibition. Thanks also go to the Kunsthalle team, who have realised the project with skill and expertise: Sigrid Mittersteiner (curatorial assistant), Mario Kojetinsky (production manager), Johannes Diboky (construction manager), Claudia Bauer (public relations) and Claudia Ehgartner (education department).

What function does social documentary perform right now, in the entertainment and digital communications environments that have evolved frantically within the last fifteen years? An answer gradually suggests itself. The edgy witness of documentary slows down perceptions that have become too feverish and distracted, and its insight uncover the psychic travails, not just the physical hardships, that human beings suffer. With an eloquence found nowhere else in its medium, social documentary offers a weighted counterexample to all those exciting or indifferent but lightsome visual inputs that just whiz by. It asks that its subjects not be forgotten, and it develops the pictorial means to support and make vivid their memory. For in the end, the documentary mode is not to be relegated to history, it makes history.

Max Kotzloff

Peter Weiermair | Die Ausstellung *Americans* entlehnt ihren Titel dem berühmten Buch eines jungen
Kurator der Ausstellung Schweizer Fotografen, der in ihm seine Eindrücke von Amerika aufzeichnete und Bilder
abseits vomn Klischee machte. Er war eine überzeugende, subjektive Stimme, die vorur-
teilsfrei für sich Amerika entdeckte. In ihm fand die für die amerikanische Fotografie typi-
sche Straßenfotografie einen bedeutenden neuen Vertreter. Mit Robert Frank und Helen
Levitt, einer von Cartier Bresson beeinflussten Fotografin, für die ebenfalls die Straße der
Ort der Beobachtung sozialen Verhaltens war, setzt die Ausstellung ein, die in dreizehn
Bildstrecken abläuft.

Ein Arbeitstitel zu Beginn der Arbeit an dieser Ausstellung hieß „Meisterwerke der ameri-
kanischen Fotografie" und wir haben ihn beibehalten, obzwar die Ausstellung nicht eine
Sammlung von Einzelbildern ist, sondern eine chronologisch strukturierte Abfolge von
Bildsequenzen, welche jeweils eines oder wenige soziale Themen zum Inhalt haben.
Bewusst habe ich nicht Anthologien der jeweiligen Künstler konstruiert, die Bilder aus
ihren langen Karrieren zusammengeführt.

Es ist eine Ausstellung über Amerika, seine gesellschaftlichen Probleme, seine
Außenseiter, seine Konflikte und Prozesse in einem halben Jahrhundert von der Mitte des
20. Jahrhunderts bis heute.

Die Absicht war es nicht, eine Geschichte der sozialdokumentarischen Fotografie zu schreiben, welche in Amerika von Lewis Hine über die Protagonisten der Farm-Security-Administration–Programme, etwa Walker Evans und andere, bis heute eine große Tradition besitzt.

Was auffällt ist vielmehr die Tatsache, dass die in dieser Ausstellung vertretenen Künstler von verschiedenen stilistischen Richtungen kommen, dass eine Figur wie Diane Arbus für eine ganze Reihe von jüngeren Künstlern ein wesentliches Vorbild war (Peter Hujar, Rosalind Solomon); zum anderen ragt Gordon Parks als ein Vertreter der „concerned photography" von früher herein.

Richard Avedon, der große Mode- und Gesellschaftsfotograf, verlässt in *In the American West* Mode und Society, nimmt jedoch seine Studiostrategien mit nach Texas. Larry Clark und Ed Templeton schaffen Tagebücher, in denen sie selbst Teil der „sozialen Szene" werden, so wie auch Lee Friedlanders Bilder von der Einsamkeit der Großstadt seinen Schatten enthalten. Dokumentation und Fiktion mischen sich bei Ryan McGinley. Es gibt also keinen gemeinsamen stilistischen Nenner, allein das sich über die Jahrzehnte verändernde Thema der sozialen Szene eint die Bildautoren. Welch Unterschied, wenn Bruce Davidson das schwarze Ghetto schildert oder Gordon Parks, dessen berühmte Putzfrau den Titel ziert, sich als Schwarzer mit Harlem auseinandersetzt.

Die Ausstellungsarbeit hat ihren Anfang genommen, als das Musée des beaux-arts du Canada in Ottawa einen größeren Komplex von Bildern Diane Arbus' als Leihgabe in Aussicht stellte. Dieser große Werkabschnitt wurde dann verdichtet, um nicht der zwar einflussreichen und wichtigen Fotografin zu einem Übergewicht in der Ausstellung zu verhelfen.

Urs Stahel vom Fotomuseum Winterthur lieh uns Arbeiten von Robert Frank und ich danke ihm wie auch Udo Kittelmann vom Museum Moderner Kunst in Frankfurt, welches uns aus der Bildfolge *Tulsa* von Larry Clark aussuchen ließ, jenem aufsehenerregenden Buch über die Situation von Jugendlichen und Drogenkonsum in einer kalifornischen Kleinstadt.

Besonders glücklich bin ich, dass wir einen Ausschnitt von *In the American West* von Richard Avedon zeigen können. Die Richard Avedon Foundation (Norma Stevens und ihr Mitarbeiter James Martin) haben dies möglich gemacht.

Howard Greenberg war auch diesmal wie so oft zuvor hilfreich und ermöglichte das Studium seines Archivs. Larry Miller machte Helen Levitt zugänglich und wies mich auf Burk Uzzle hin, mit Janet Burden suchte ich Lee Friedlander aus. Rosalind Solomon war für mich die große Entdeckung. Ich bin froh, dass sie wie auch andere Fotografen das erste Mal in Wien zu sehen sein werden. Dies gilt auch für Ed Templeton, der in der Kunsthalle Wien eine Installation realisieren wird.

So sehr wichtige Bilder, Meisterwerke und Ikonen der amerikanischen Fotografie des 20. Jahrhunderts in die Ausstellung integriert wurden, so habe ich wie immer auch seltene Arbeiten mit aufgenommen. Dies gilt etwa für Peter Hujar, dessen Nachtlandschaften New Yorks weniger bekannt sind.

Der Katalog wurde von dem Verlag Damiani in Bologna mit großer Sorgfalt hergestellt. Bei kürzester Vorbereitungszeit ist es Andrea Albertini und seinen Mitarbeitern gelungen, ein hervorragendes Katalogbuch zu gestalten und zu drucken. Wie in vielen meiner Publikationen lasse ich auch hier die Künstler zu Wort kommen und in kurzen Äußerungen sich zu ihrem Anliegen und Metier mitteilen. Elisabetta Zoni danke ich in diesem Zusammenhang für manche Anregungen. Für alle Recherchen und eine intensive und aufwändige Arbeit an Katalog und Ausstellung möchte ich jedoch nicht versäumen, meiner Mitarbeiterin Sigrid Mittersteiner von der Kunsthalle Wien besonders herzlich zu danken.

> On the Exhibition and Catalogue

What function does social documentary perform right now, in the entertainment and digital communications environments that have evolved frantically within the last fifteen years? An answer gradually suggests itself. The edgy witness of documentary slows down perceptions that have become too feverish and distracted, and its insight uncover the psychic travails, not just the physical hardships, that human beings suffer. With an eloquence found no where else in its medium, social documentary offers a weighted counterexample to all those exciting or indifferent but lightsome visual inputs that just whiz by. It asks that its subjects not be forgotten, and it develops the pictorial means to support and make vivid their memory. For in the end, the documentary mode is not to be relegated to history, it makes history.

Max Kotzloff

| Peter Weiermair
Curator of the exhibition

The exhibition *Americans* takes its title from the famous book by a young Swiss photographer who recorded his impressions of America in it and made images that were beyond cliché. He was a convincing, subjective voice who discovered America for himself without prejudice. He became an important representative of the street photography typical of American photography. The exhibition, which runs in thirteen image sections, begins with Robert Frank and Helen Levitt, a photographer, influenced by Cartier Bresson, for whom the street was likewise the place for the observation of social behaviour. A working title at the beginning of the work on this exhibition was "Masterworks of American photography", and we have kept it although the exhibition is not a collection of individual pictures but a chronologically structured succession of image sequences each containing one or several social themes. I consciously avoided constructing anthologies of each artist that bring together pictures from their long careers.

It is an exhibition about America, its social problems, its outsiders, its conflicts and processes in half a century from the mid 20th century until today.

The intention was not to write a history of social documentary photography, which in America has a great tradition up until today, from Lewis Hine through the protagonists of the Farm Security Administration Programme, for example Walter Evans and others.

What is noticeable is rather the fact that the artists represented in this exhibition come from various styles, that a figure like Diane Arbus was an essential model for a whole range of young artists (Peter Hujar, Rosalind Solomon), and on the other hand that the influence of Gordon Parks projects forwards from earlier times as a representative of "concerned photography".

In *In the American West*, Richard Avedon, the great fashion and society photographer leaves fashion and society but takes his studio strategy with him to Texas. Larry Clark and Ed Templeton create diaries in which they themselves become part of the "social scene", in the same way as Lee Friedlander's pictures of the loneliness of the big city contain his shadow. With Ryan McGinley, documentary and fiction merge. There is thus no common stylistic denominator; only the theme of the social scene, changing over the decades, unites the authors of the pictures. What a difference, if Bruce Davidson portrays the black ghetto or Gordon Parks, whose famous cleaning lady graces the cover, analyses Harlem as an African-American.

The exhibition work started when the Musée des beaux-arts du Canada in Ottawa agreed to lend a major complex of Diane Arbus's pictures. This great section of work was then condensed in order to ensure that the indeed influential and important photographer was not over-weighted in the exhibition. Urs Stahel from the Winterthur Photographic Museum loaned us works by Robert Frank, and I would like to thank him as well as Udo Kittelmann from the Museum of Modern Art in Frankfurt, who allowed us to choose from the *Tulsa* picture sequence by Larry Clark, the sensational book about the situation of youth and drug use in a small Californian town.

I am particularly pleased that we can show a section of *In the American West* by Richard Avedon. The Richard Avedon Foundation (Norma Stevens and her colleague James Martin) have made this possible.

As so often before, Howard Greenberg was helpful this time too, and made it possible to study his archive. Larry Miller made Helen Levitt accessible and pointed me in the direction of Burk Uzzle. Together with Janet Burden I selected Lee Friedlander. Rosalind Solomon was the great discovery for me. I am happy that she, like other photographers will be shown for the first time in Vienna. This is also true of Ed Templeton, who will set up an installation in the Kunsthalle Wien.

However much important pictures, masterworks and icons of 20th century American photography are integrated into the exhibition, I have also as always included rare works. This is true for example of Peter Hujar, whose night landscapes of New York are less well known.

The catalogue was produced with great care by the Damiani publishing house in Bologna. With the shortest preparation time, Andrea Albertini and his colleagues have succeeded in

producing and printing an outstanding catalogue. As in many of my publications, here I also let the artists have their say and in brief statements convey something of their concerns and their metier. I would like to thank Elisabetta Zoni for some suggestions in this context. For all the researches and intensive and extensive work on the catalogue and the exhibition, however, I would not like to omit to give heartfelt thanks to Sigrid Mittersteiner, my colleague at the Kunsthalle Wien.

> americans

> **Helen Levitt**

All I can say about the work I try to do, is that the aesthetic is in reality itself.

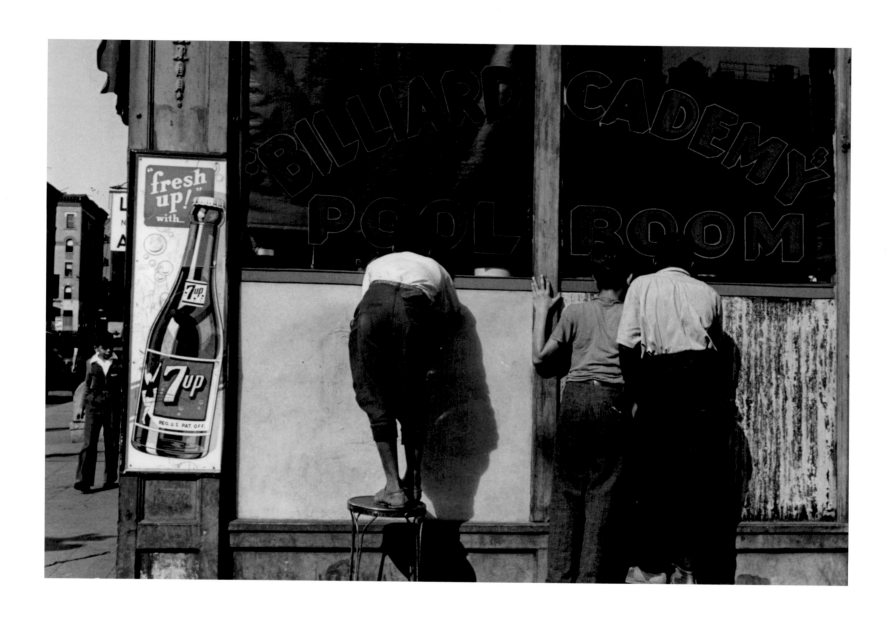

[New York, c. 1940]

21

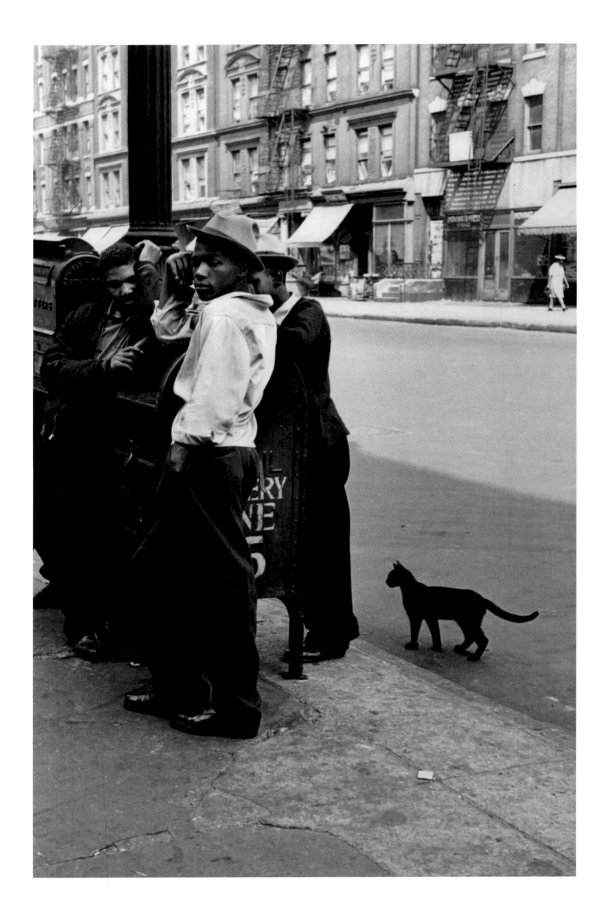

[New York, c. 1940]

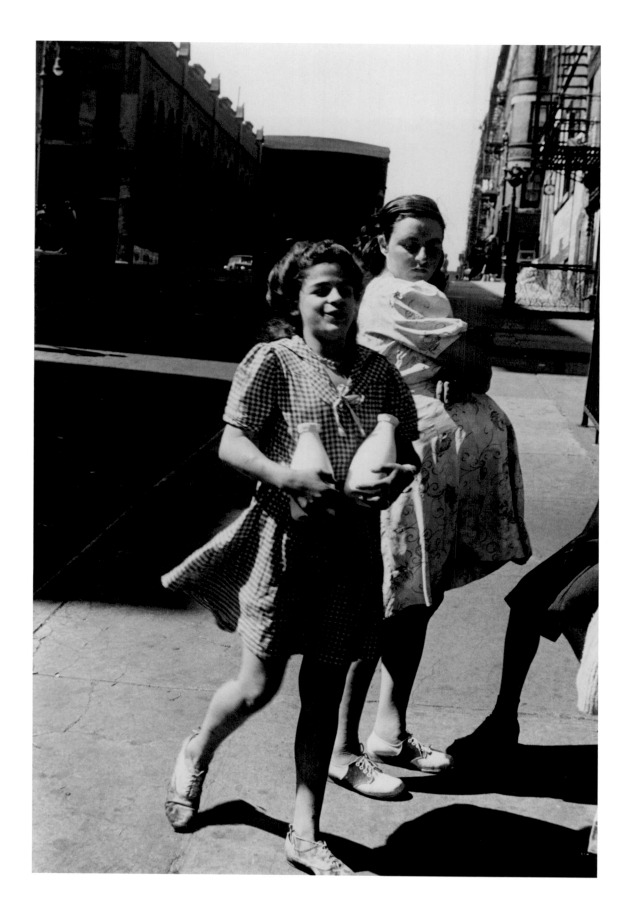

[New York, c. 1940]

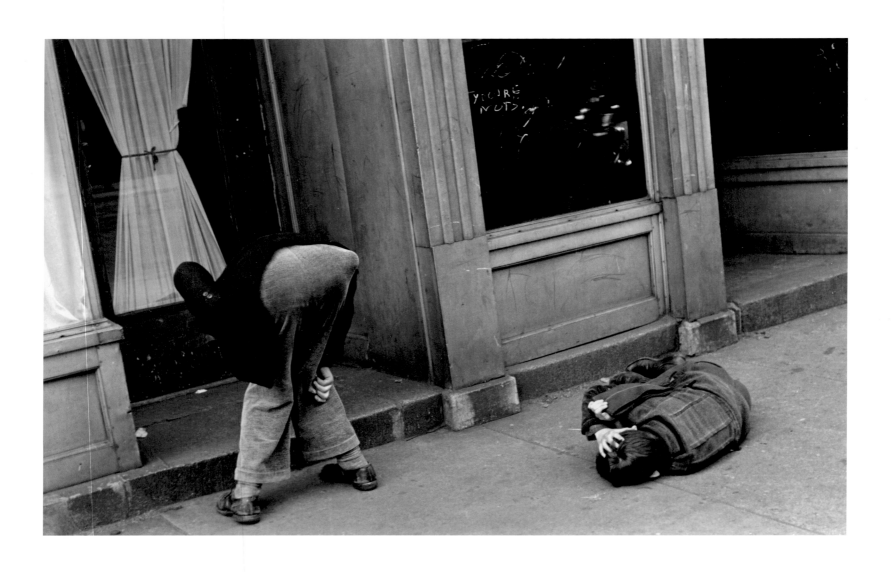

[New York, c. 1940]

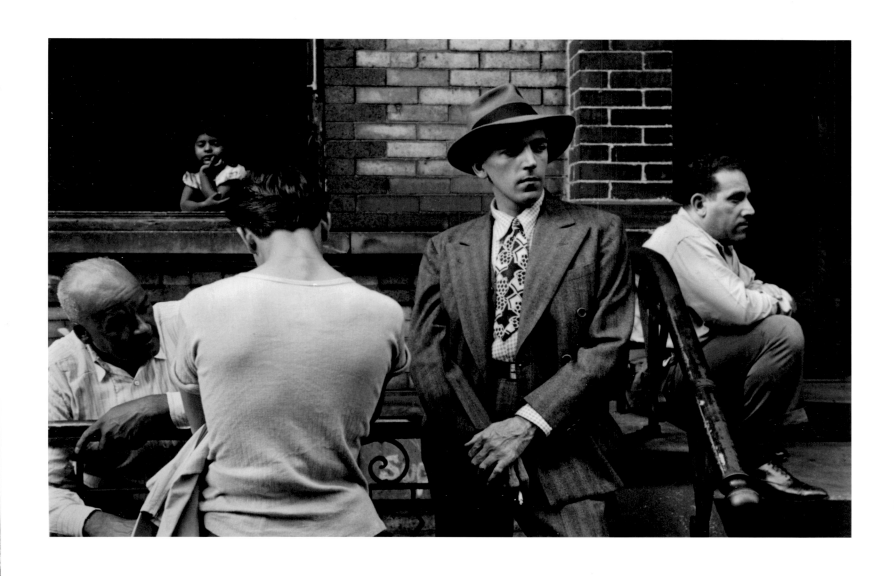

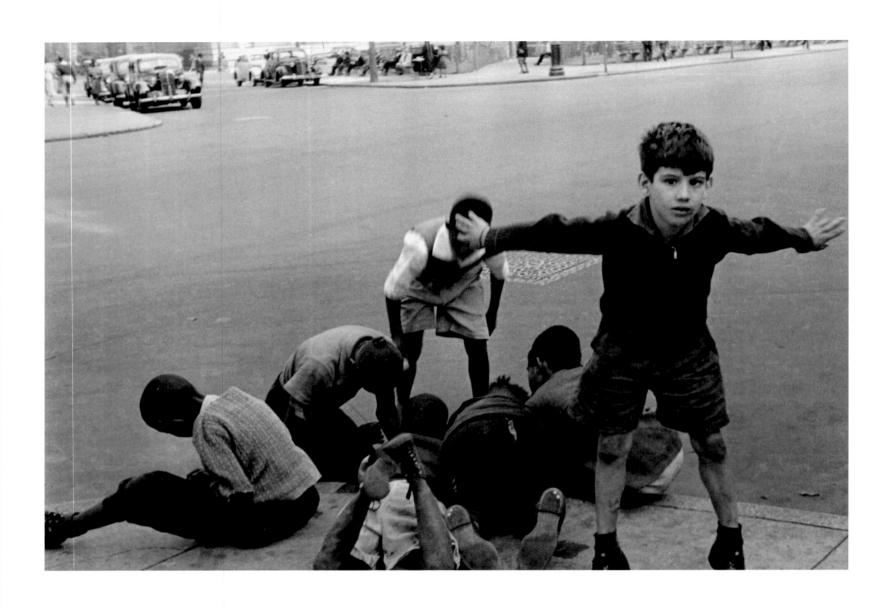

[New York, c. 1940]

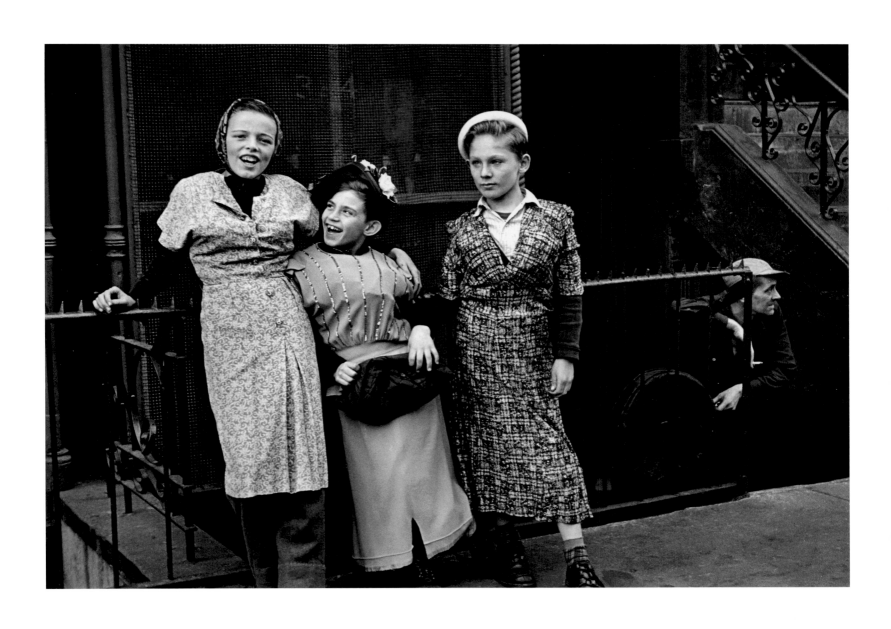

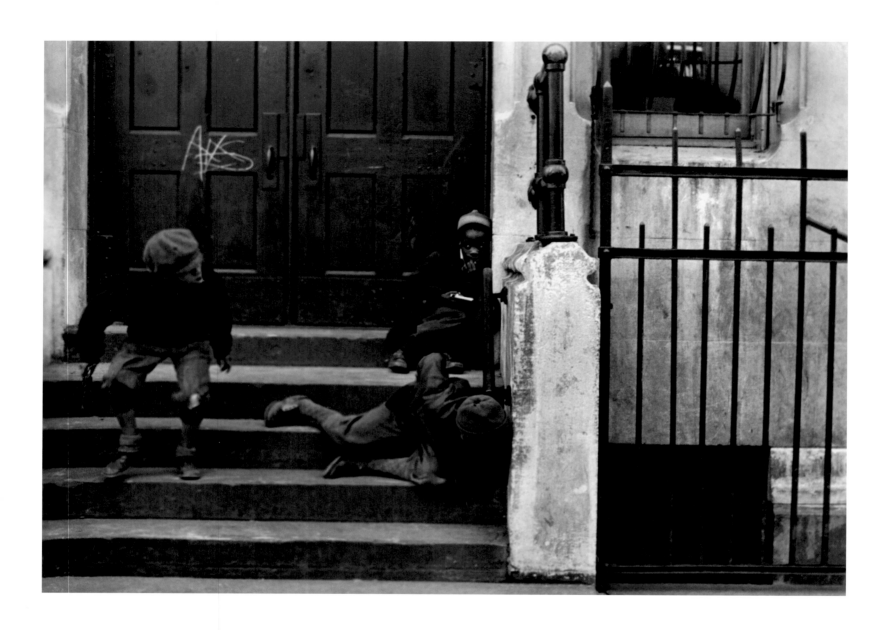

[New York, c. 1940]

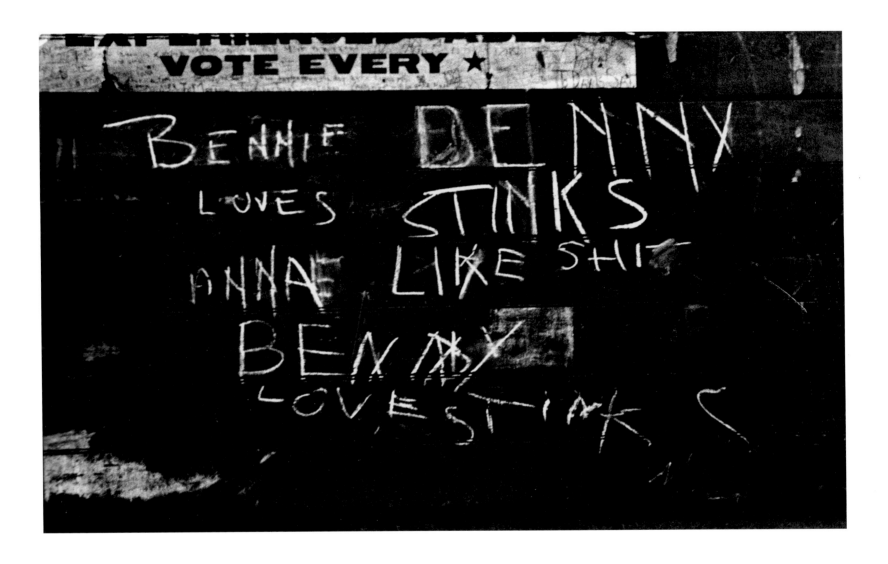

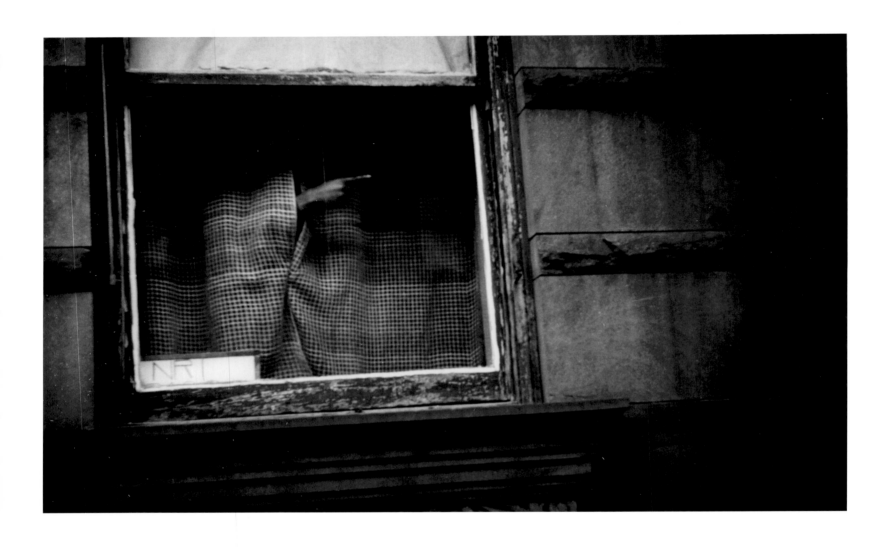

[New York, c. 1940]

> Robert Frank

Black and white are the colors of photography.
To me they symbolize the alternatives of hope and
despair to which mankind is forever subjected.

It is always the instantaneous reaction to oneself
that produces a photograph.

There is one thing the photograph must contain,
the humanity of the moment. This kind of
photography is realism. But realism is not enough
- there has to be vision, and the two together can
make a good photograph.

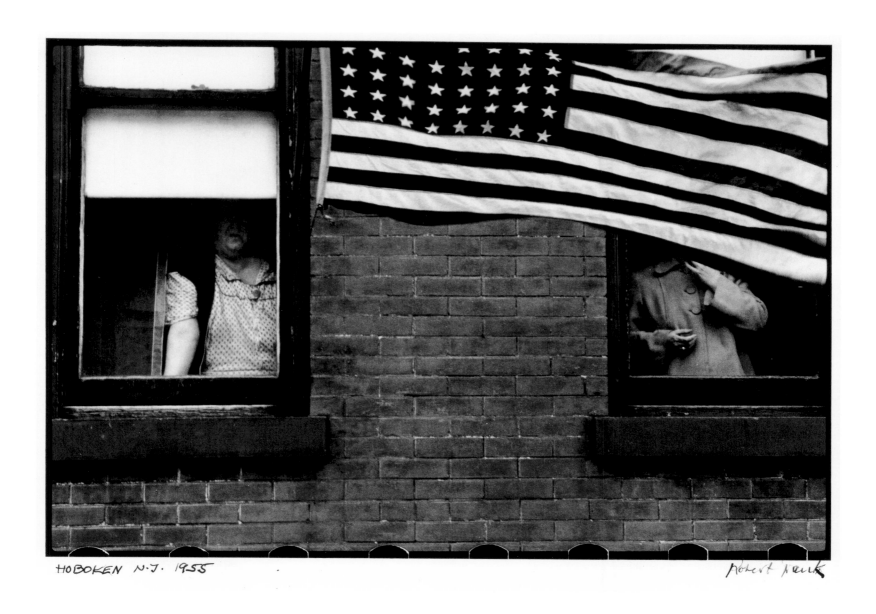

HOBOKEN N.J. 1955

Robert Frank

[Parade in Hoboken, 1955]

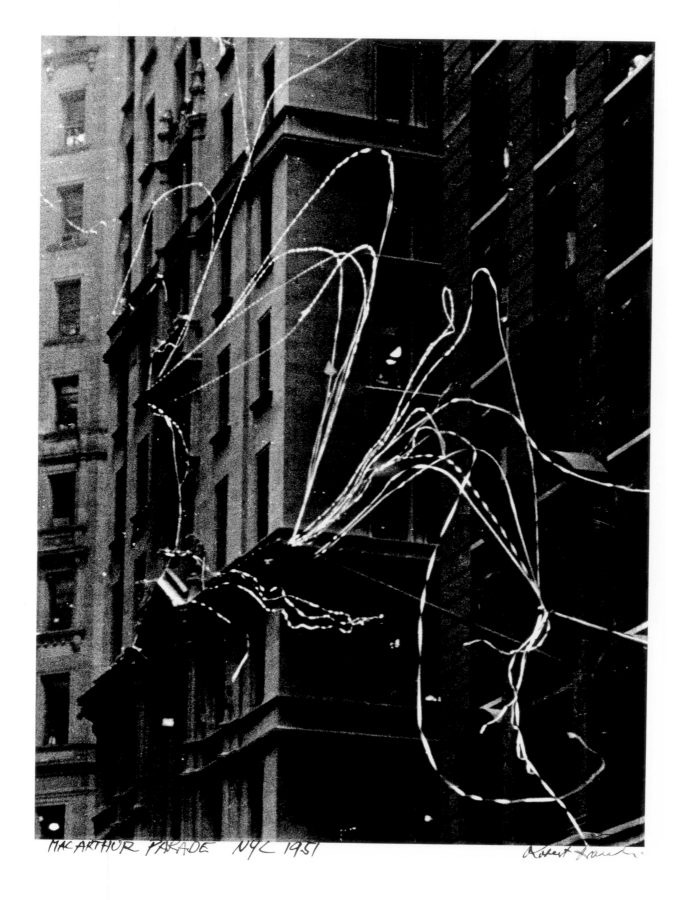

MAC ARTHUR PARADE NYC 1951 Robert Frank

[Ticker Tape, New York, 1951]

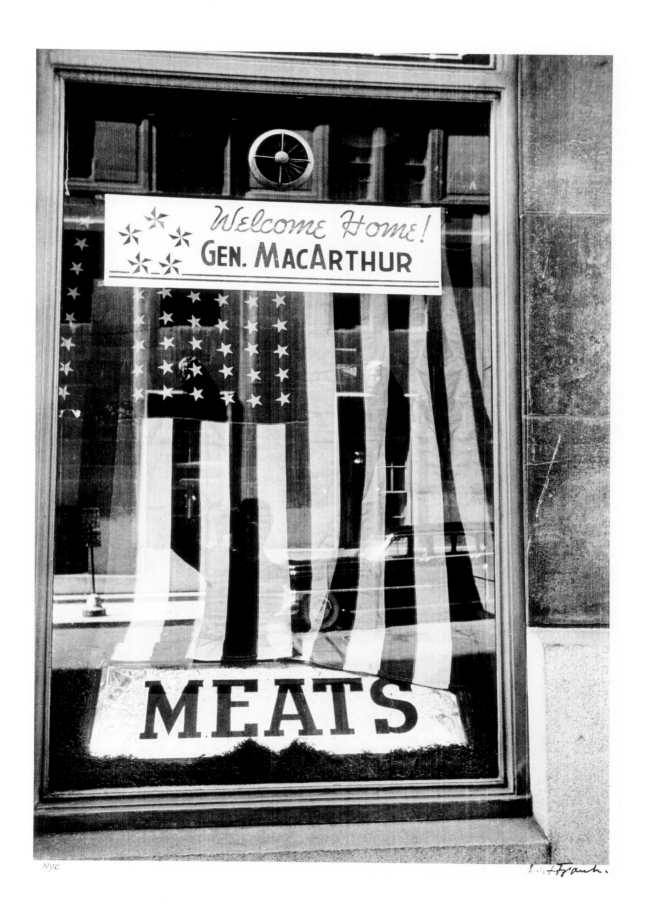

NYC

[Wallstreet (Welcome Home Gen. Mac Arthur), 1951]

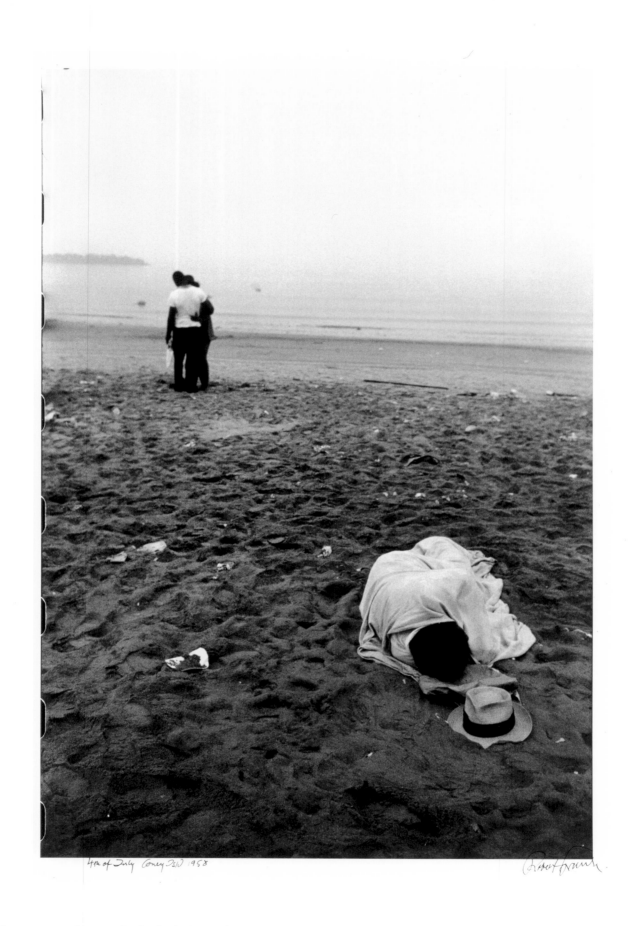

4th of July Coney Isld 1958

Robert Frank

[Coney Island, 4th of July, 1958]

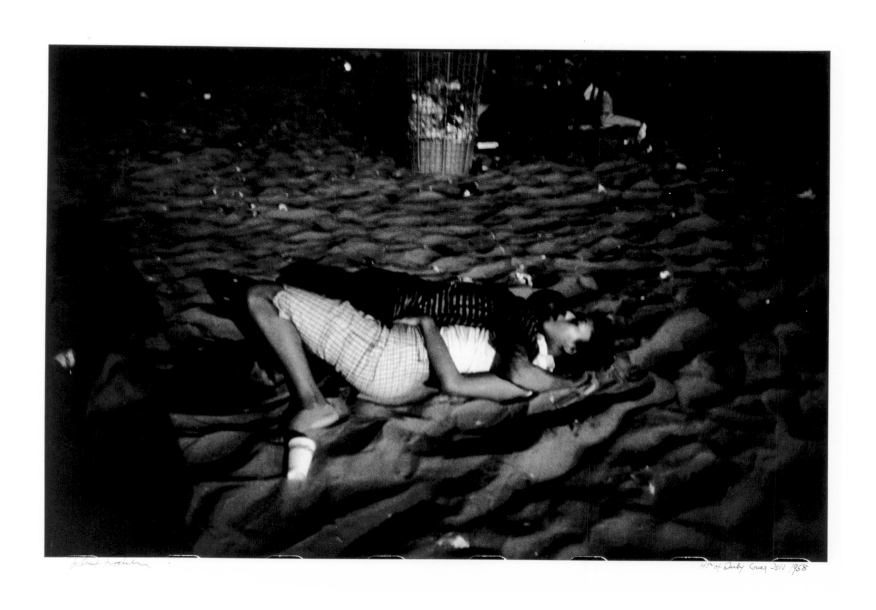

[Coney Island, 4th of July, 1958]

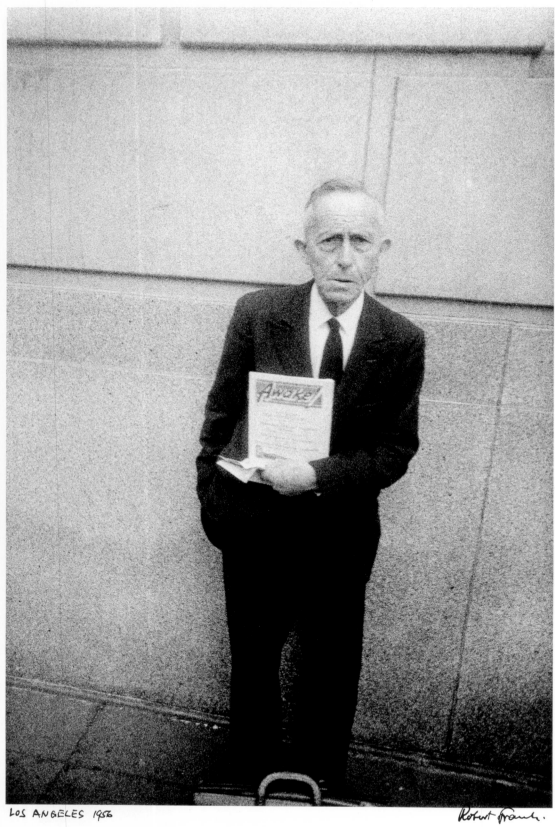

LOS ANGELES 1956

Robert Frank

[Jehova's Witness, Los Angeles, 1956]

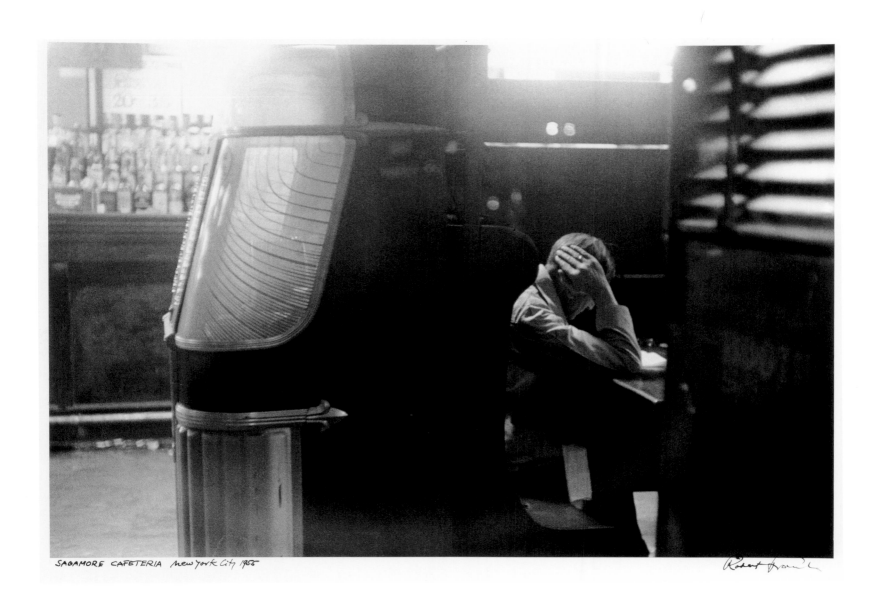

SAGAMORE CAFETERIA new york City 1955

Robert Frank

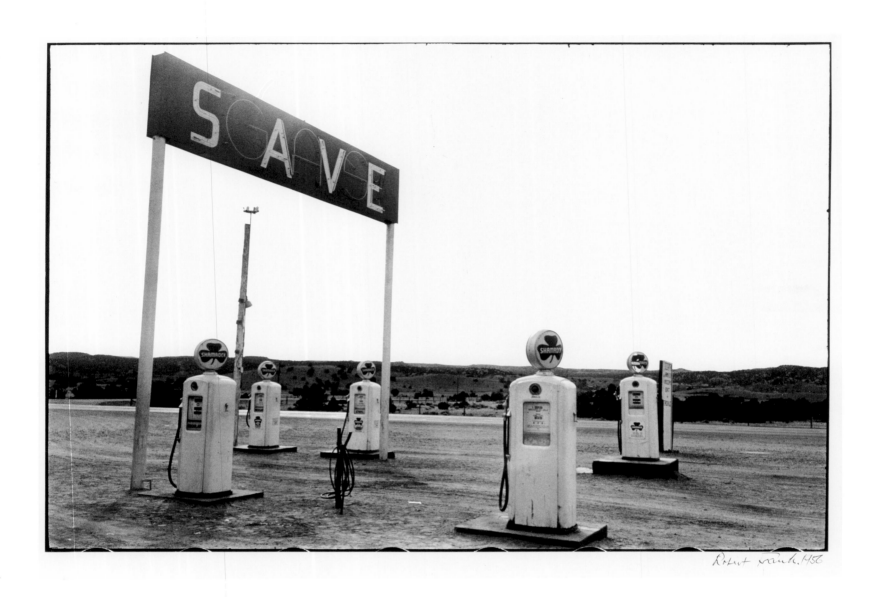

[Santa Fe, New Mexico, 1955]

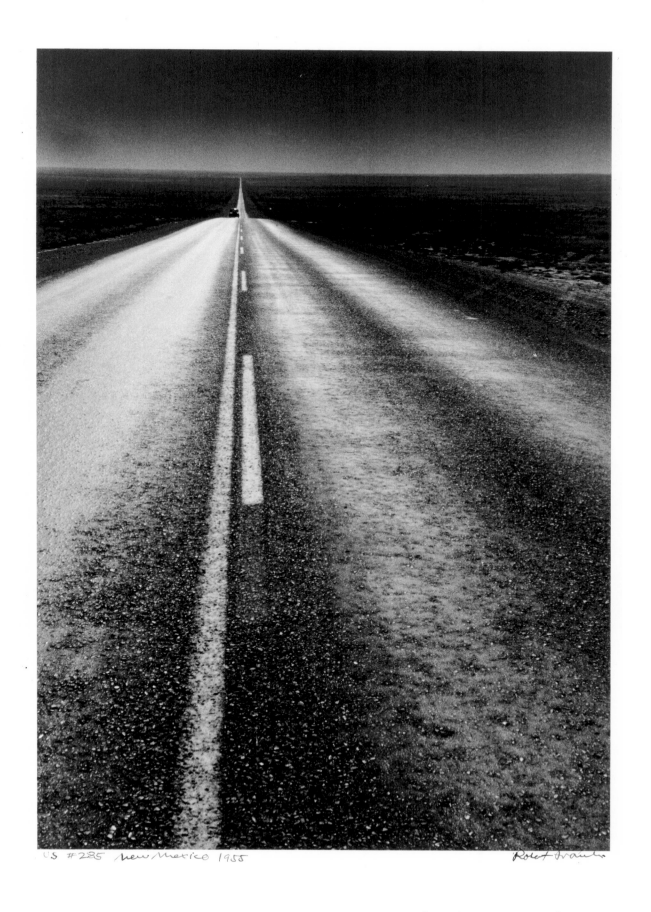

US #285 New Mexico 1955

Robert Frank

[US #285 New Mexico, 1955]

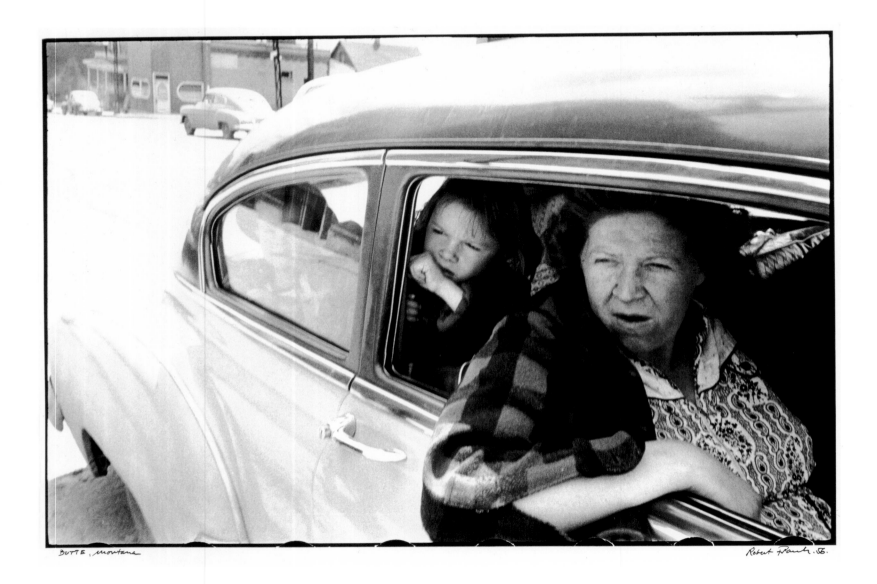

BUTTE, Montana

Robert Frank. 56.

[Butte Montana, 1956]

> Lee Friedlander

I always wanted to be a photographer.
I was fascinated with the materials.
But I never dreamed I would be having
this much fun. I imagined something
much less elusive, much more mundane.

[Nashville, Tennessee, 1963]

[**New York City, 1963**]

[Baltimore, Maryland, 1962]

[New York State, 1965]

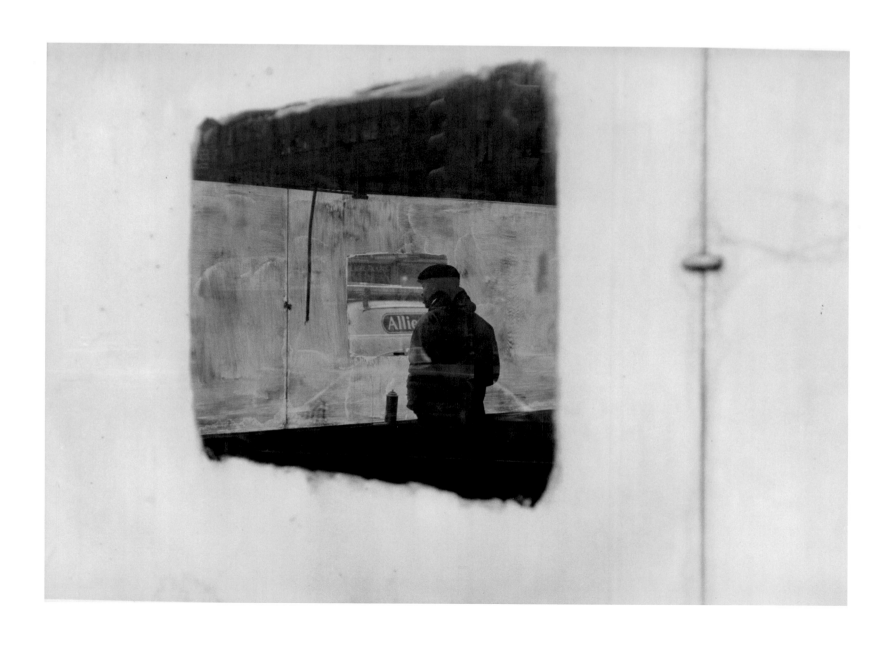

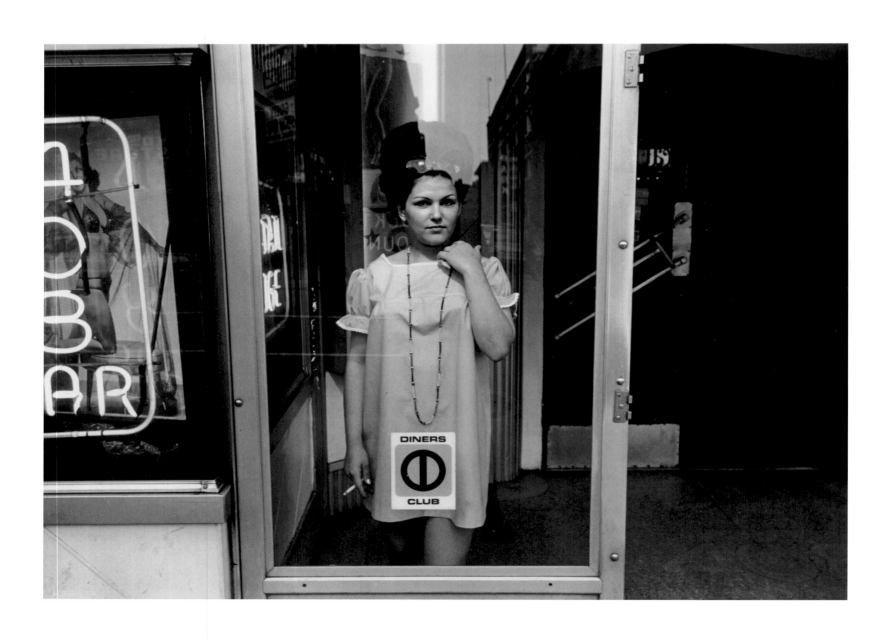

[Baltimore, Maryland, 1968]

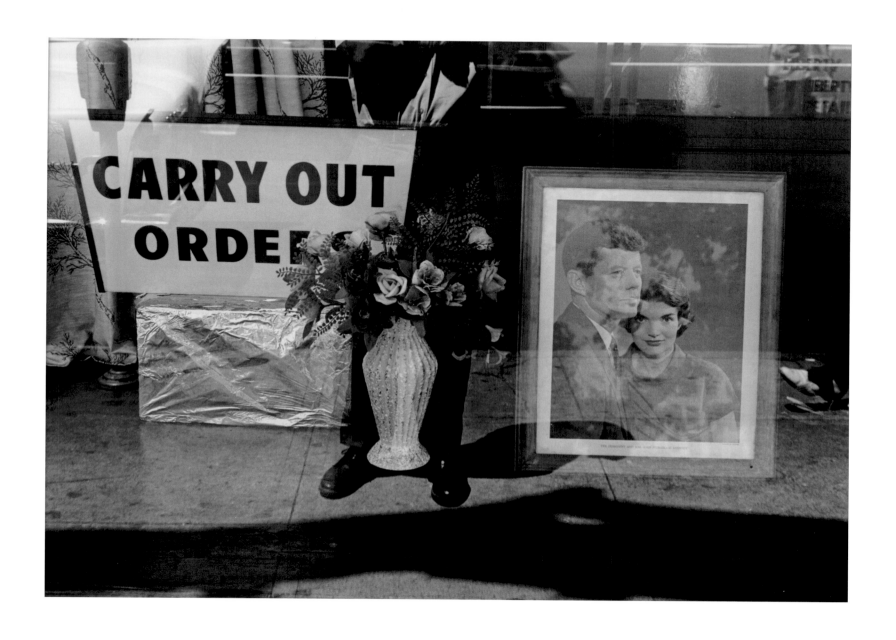

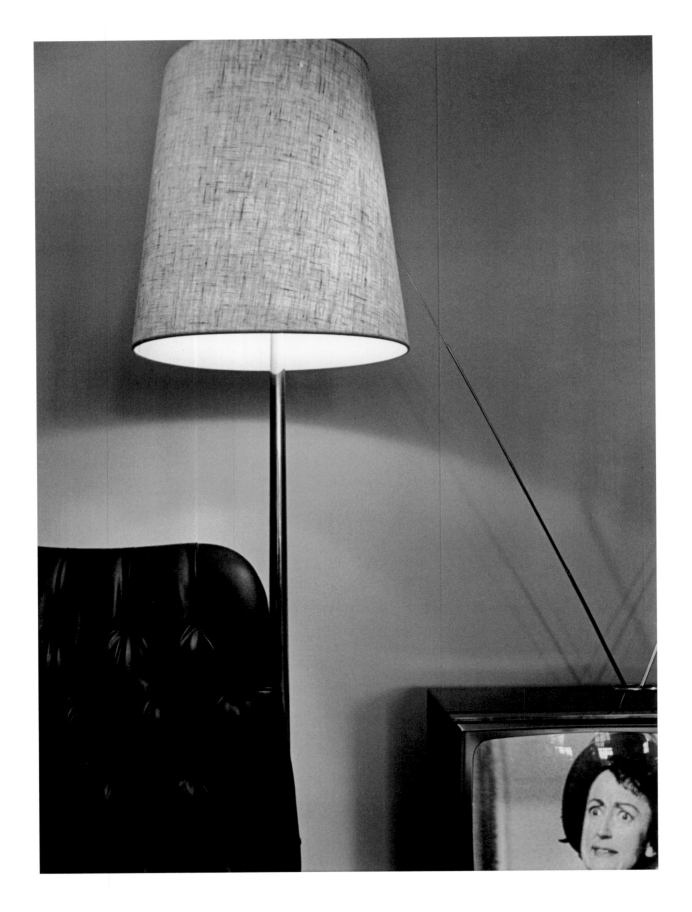

52 | Lee Friedlander [New Jersey, 1969]

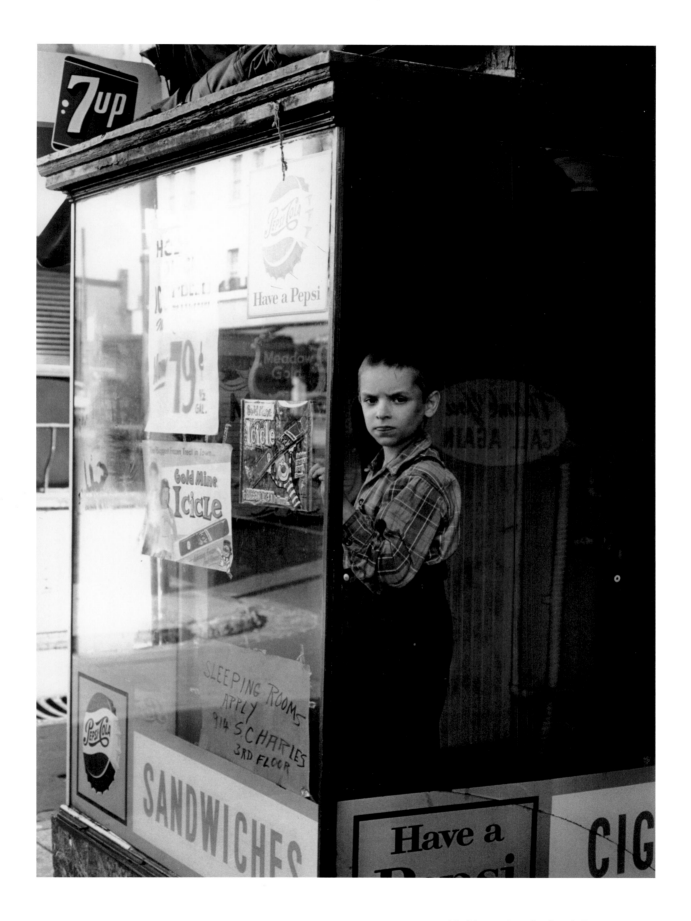

[Baltimore, Maryland, 1962]

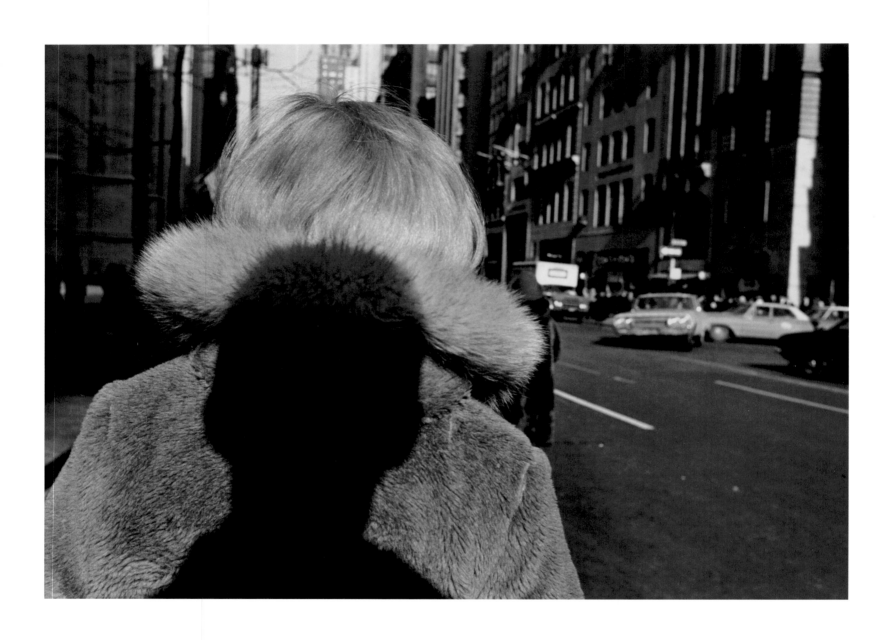

[**New York City, 1966**]

> Bruce Davidson

"What you call a ghetto, I call my home." This was said to me when I first came to East Harlem, and during the two years that I photographed the people of East 100th Street, it stayed with me. Home became an old man who grows grass between broken slabs of concrete in a tenement backyard, children behind windows covered by chicken wire, walls with pictures of Christ, Kennedy, and the American flag, and a retired maid in uniform scrubbing her own linoleum floor. Home is formal family photographs, a boy with an African-head medallion on a rooftop who wouldn't let me photograph his pigeons because he wanted them to be free, a party given by seven brothers for their mother arriving from Puerto Rico who they hadn't seen in eighteen years, a young articulate poet and revolutionary who feared that his photograph would end up in an FBI file, four bullet scars on the abdomen of a reform school graduate, and a conga drummer who has two jobs and goes to night school to study aeronautical engineering. It is an aspiring fashion designer, commuter traffic on the East River Drive, a Springfield rifle under a neatly made up cot, a blinded Marine veteran of Vietnam learning to use his cane, junkies in basements and abandoned buildings, a musician who when his violin was stolen could not afford to buy another and joined the Air Force, the child in her white Sunday dress who gave me the name "picture man," the taxi driver who had his small son pay me a quarter for the photograph I'd given them, the theater and dance group Soul and Latin going to Central Park with their name on T-shirts, the pregnant girl on a rock surrounded by rubble in a lot waiting patiently for me to compose, and the man in the bar who looked at my white skin and said I'd raped the world. I entered a life style, and, like the people on the block, I love and hate it and I keep going back.

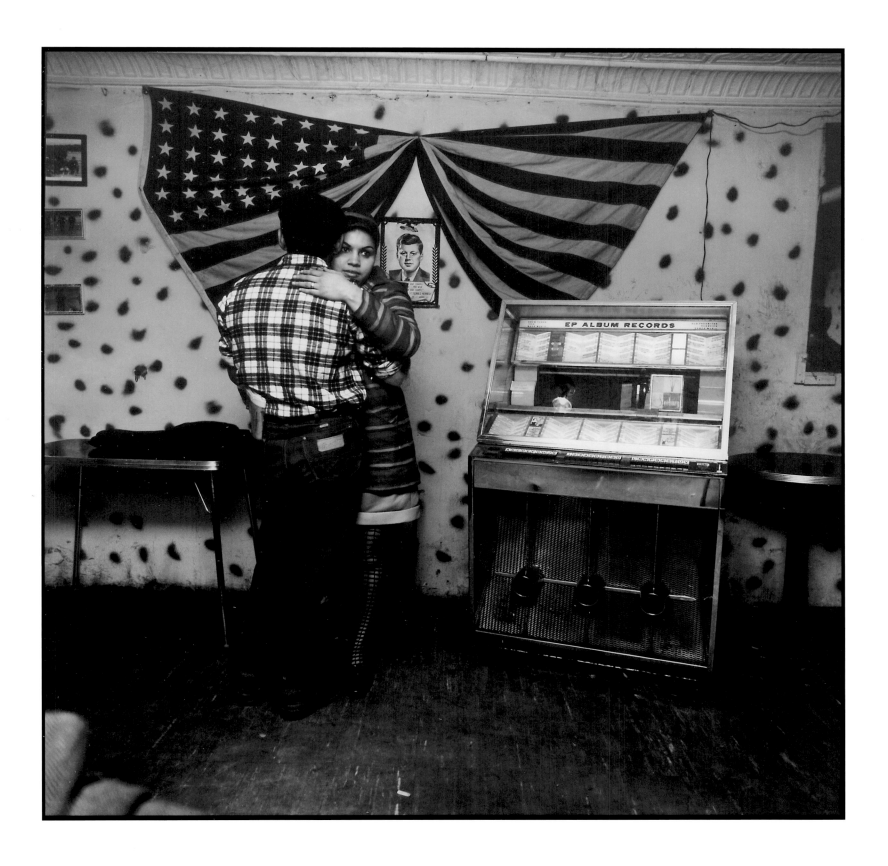

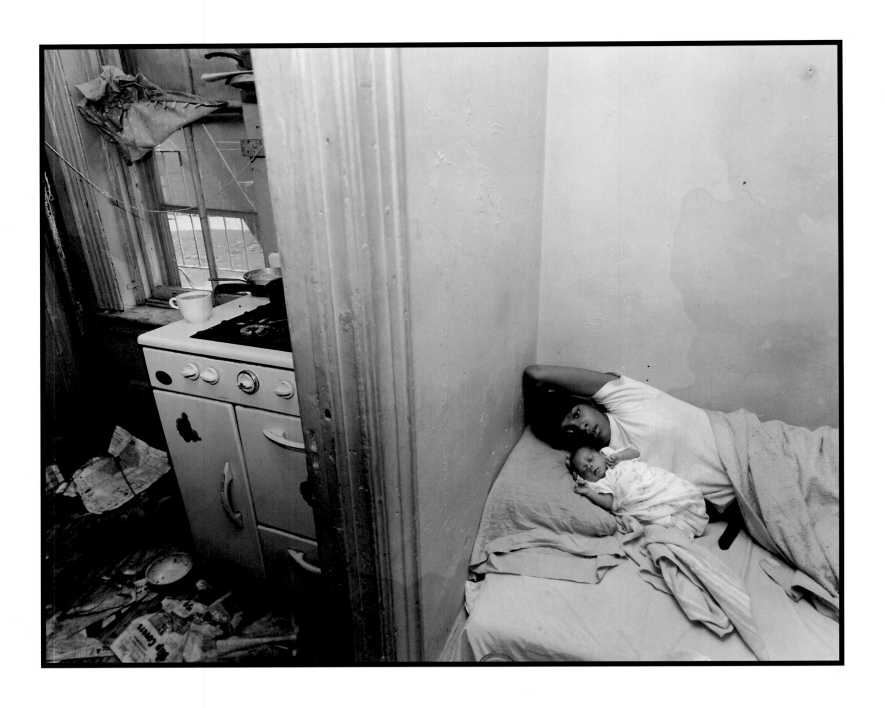

[USA. New York City. East 100th Street, 1966]

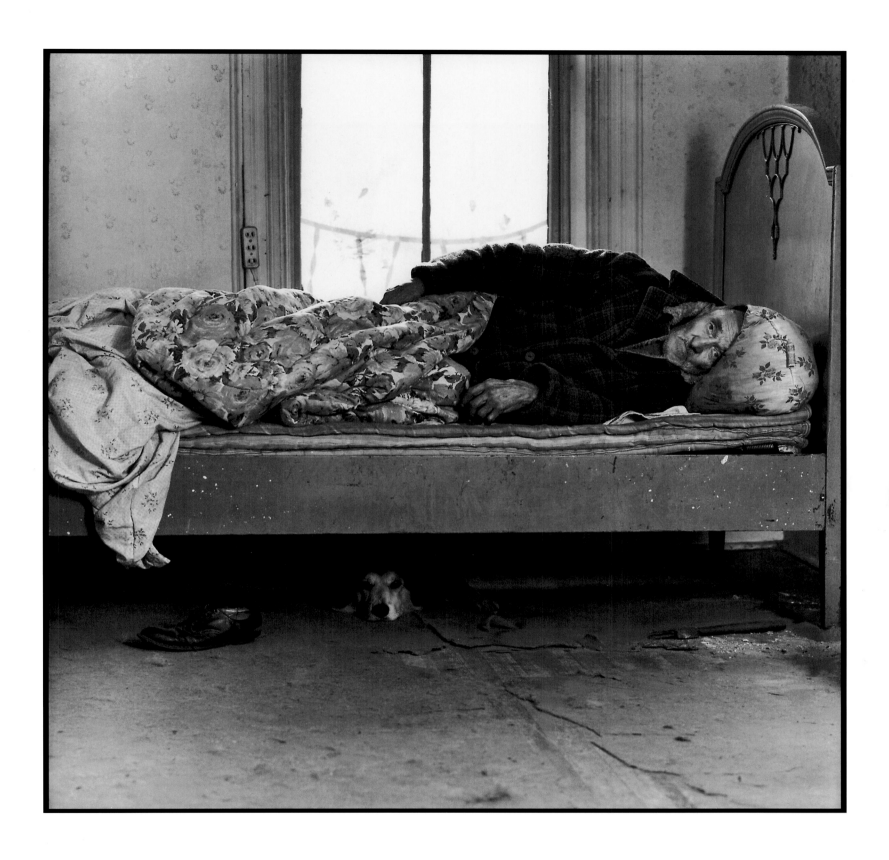

[USA. New York City. East 100th Street, 1968]

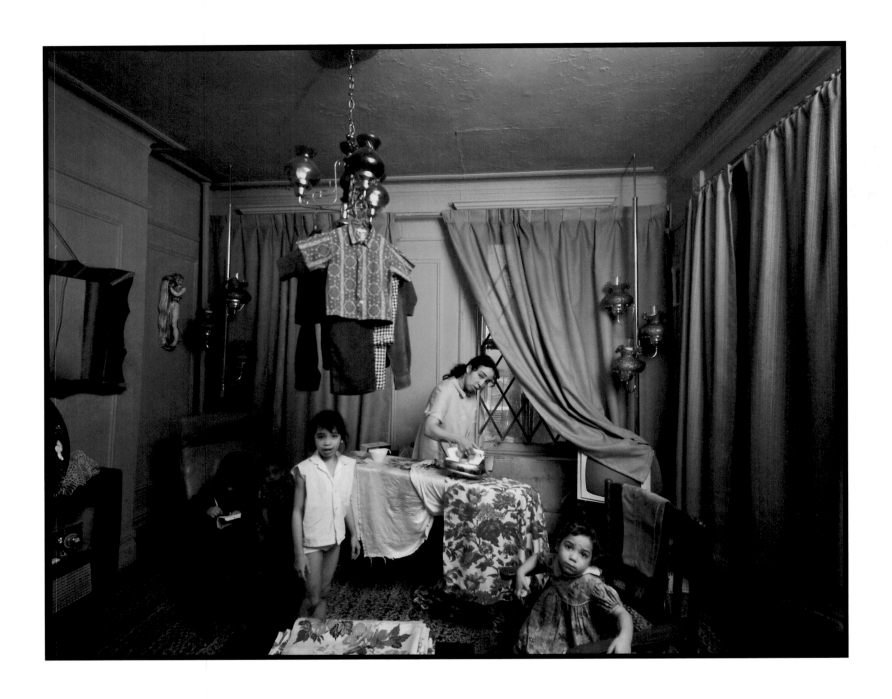

[USA. New York City. East 100th Street, 1966]

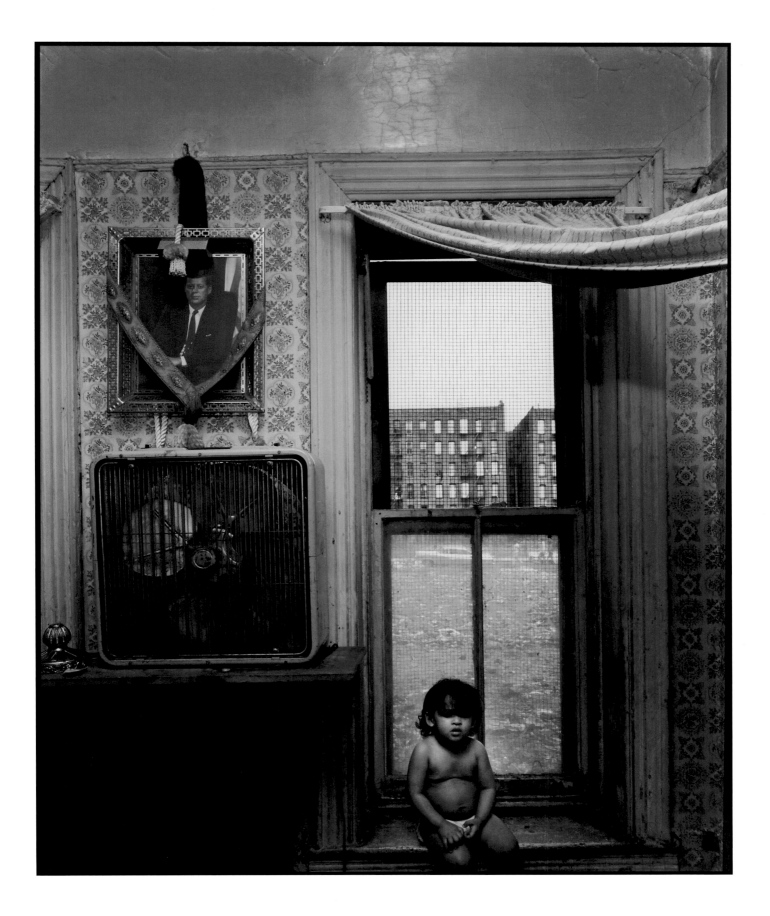

[USA. New York City. East 100th Street, 1966]

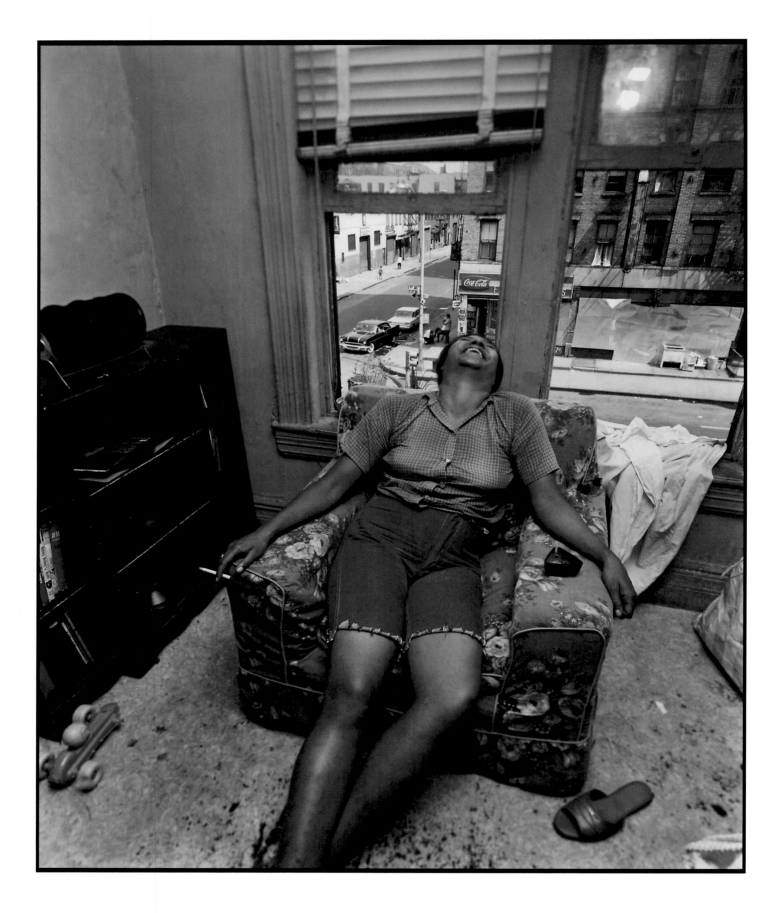

[USA. New York City. East 100th Street, 1966]

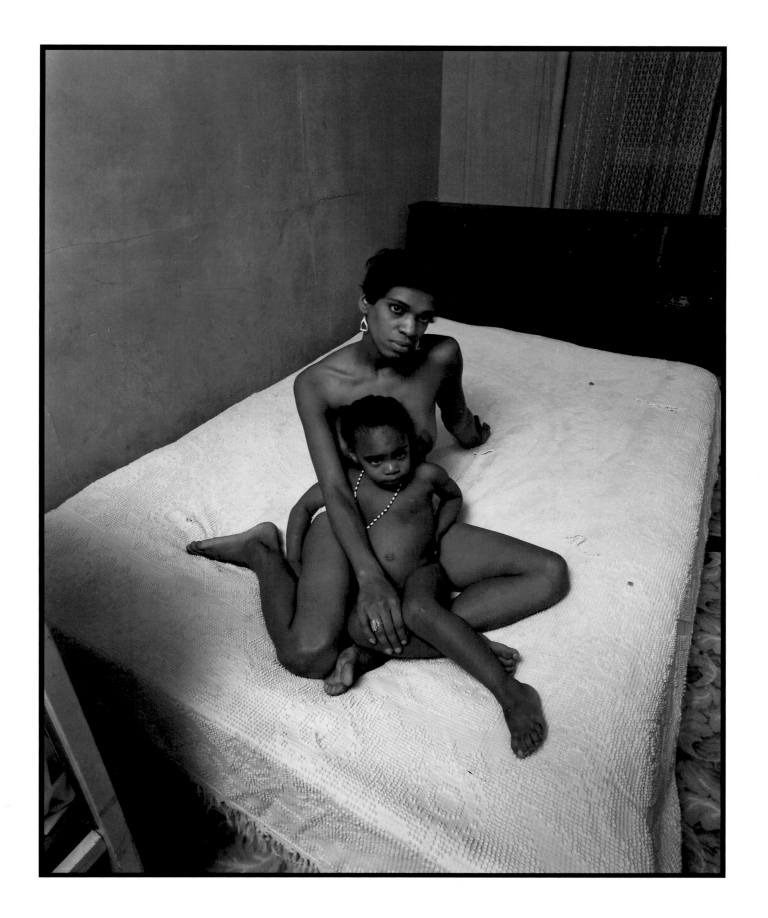

[USA. New York City. East 100th Street, 1966]

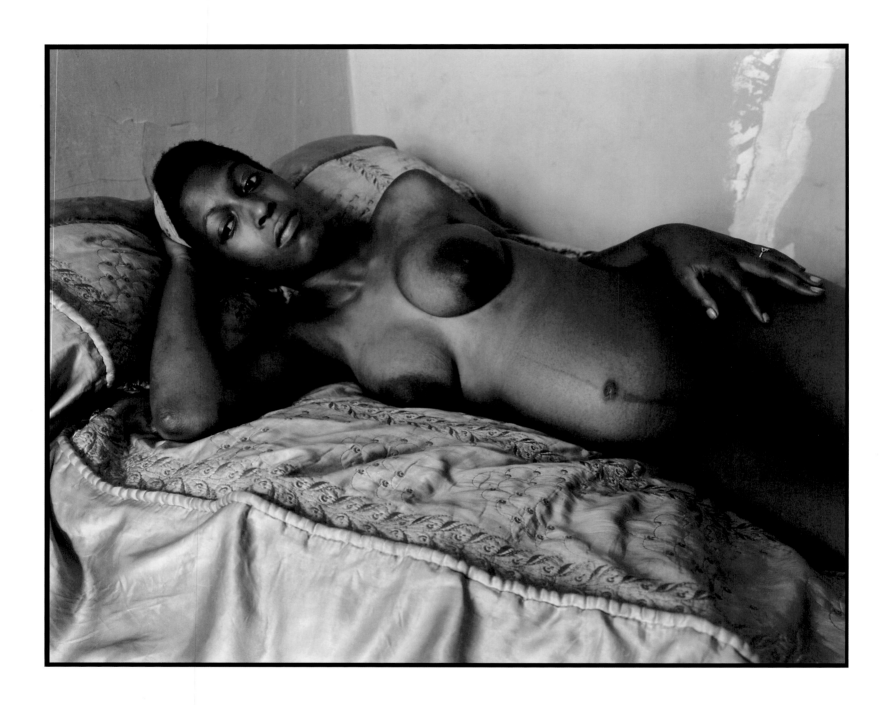

[USA. New York City. East 100th Street, 1966]

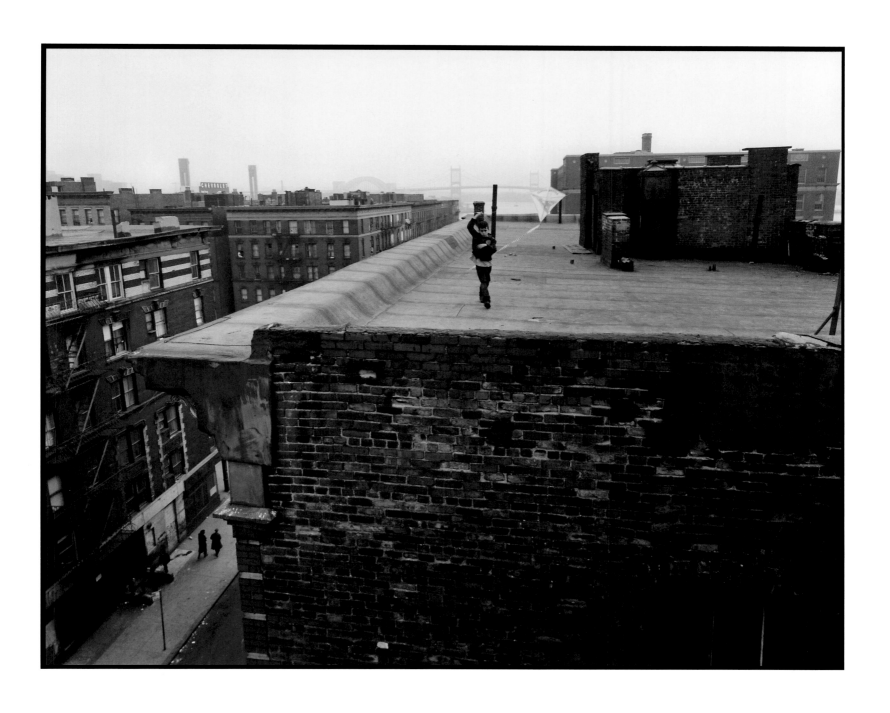

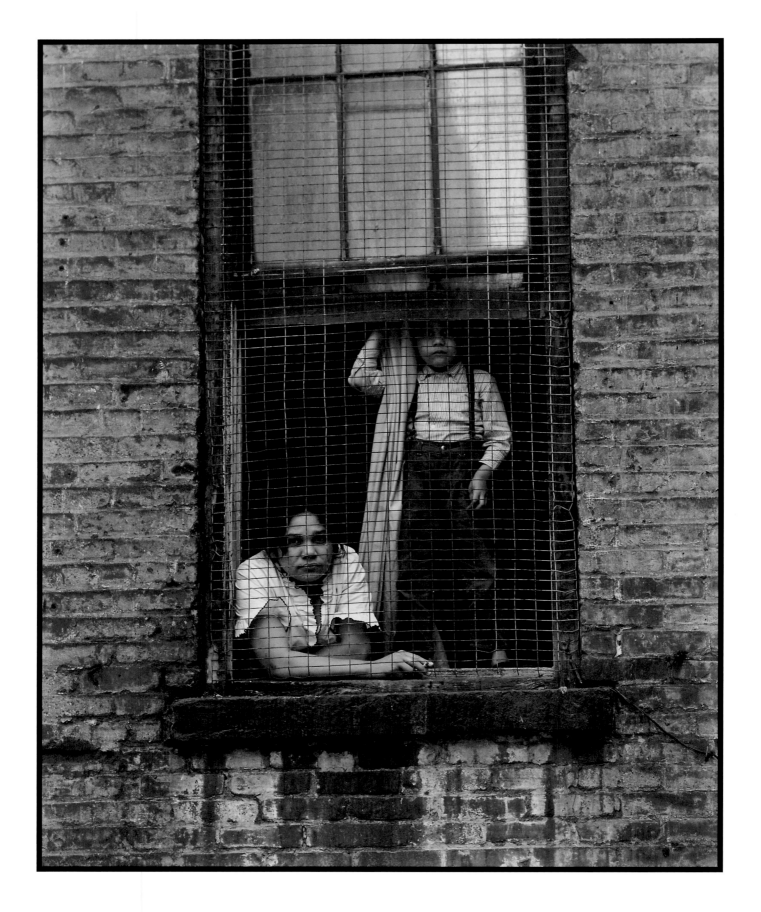

[USA. New York City. East 100th Street, 1966]

> **Gordon Parks**

I've known both misery and happiness, lived in so many different skins it is impossible for one skin to claim me. And I have felt like a wayfarer on an alien planet at times — walking, running, wondering about what brought me to this particular place, and why. But once I was here the dreams started moving in, and I went about devouring them as they devoured me. Since then I have tried to show picture by picture, word by word - things as they are: the darkness and the light, the cheerful...

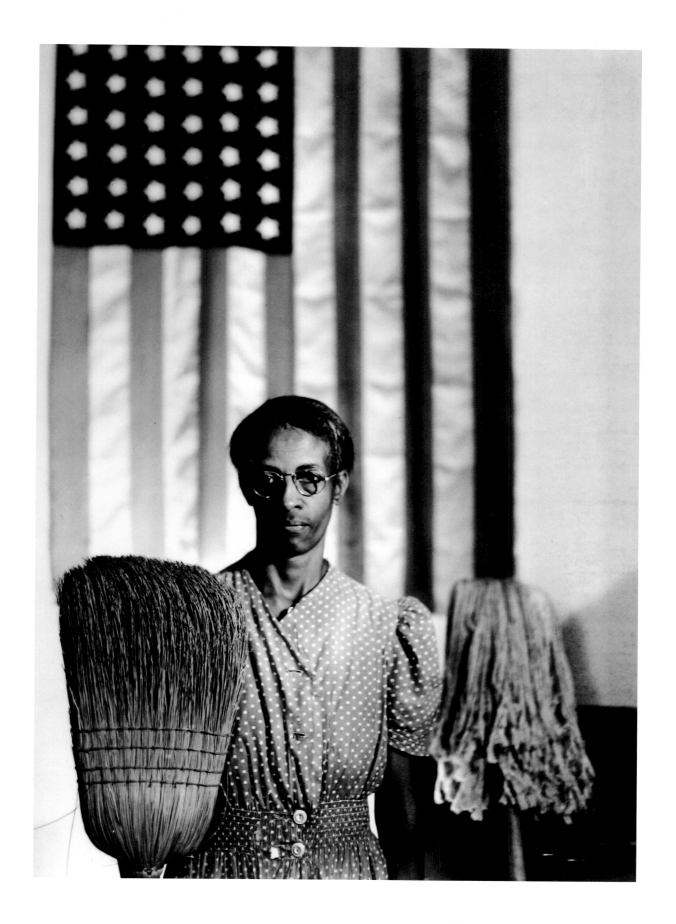

[American Gothic, 1942]

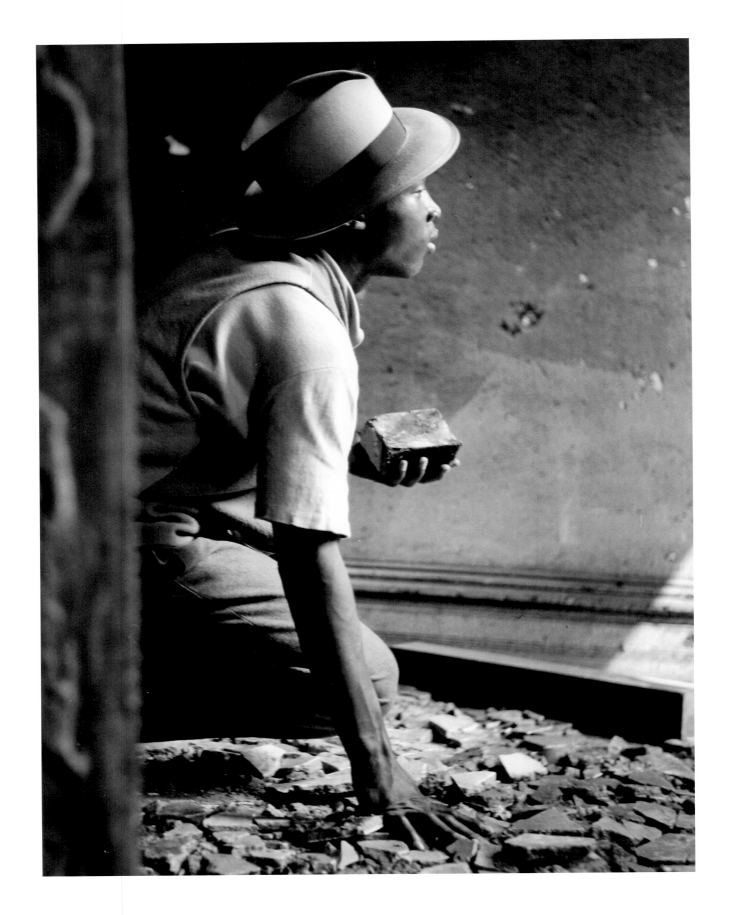

[Gang Member with Brick, 1948]

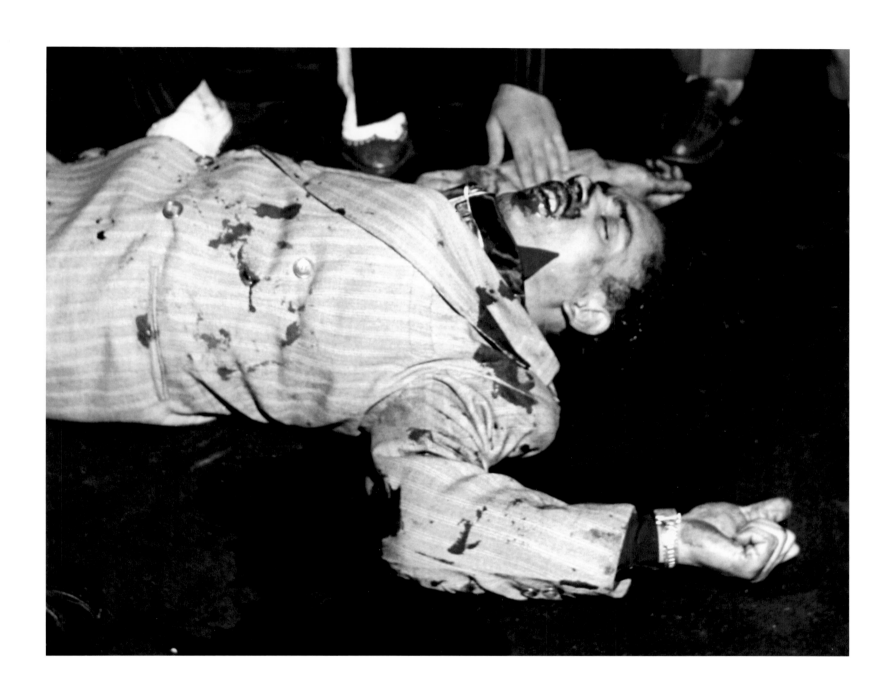

[Gang Victim, 1948]

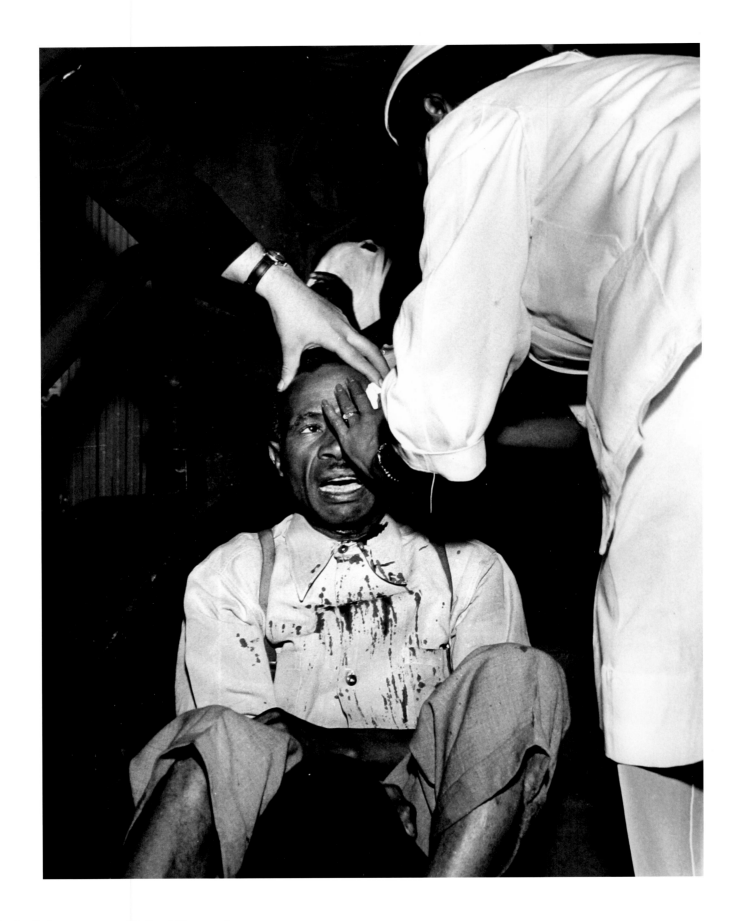

[Battered Man, 1943]

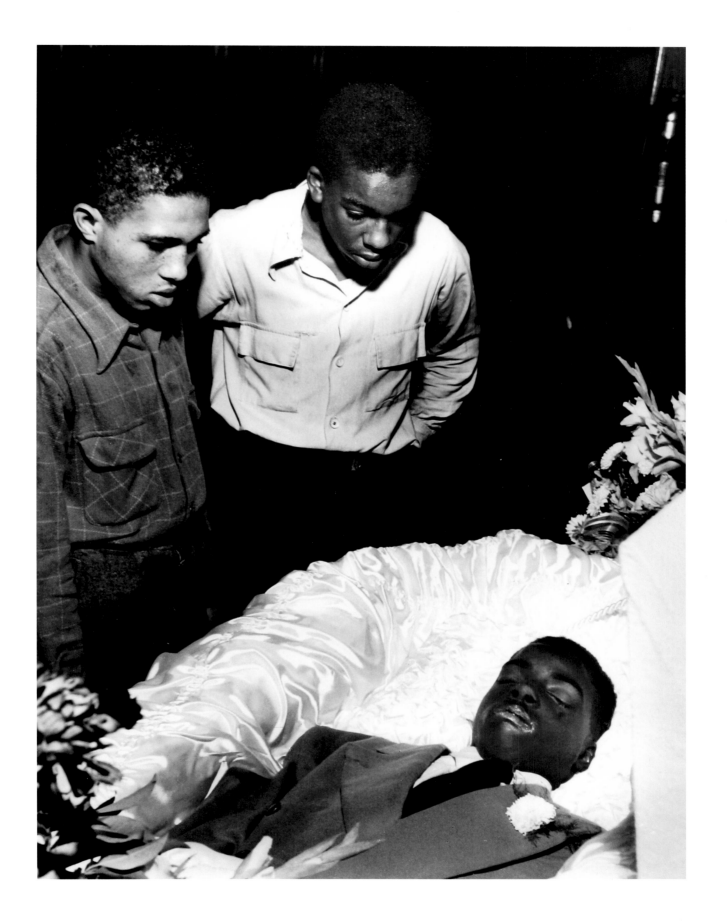

[Red Jackson & Hervie Levy study wounds on face of slain gang member Maurice Gaines, 1948]

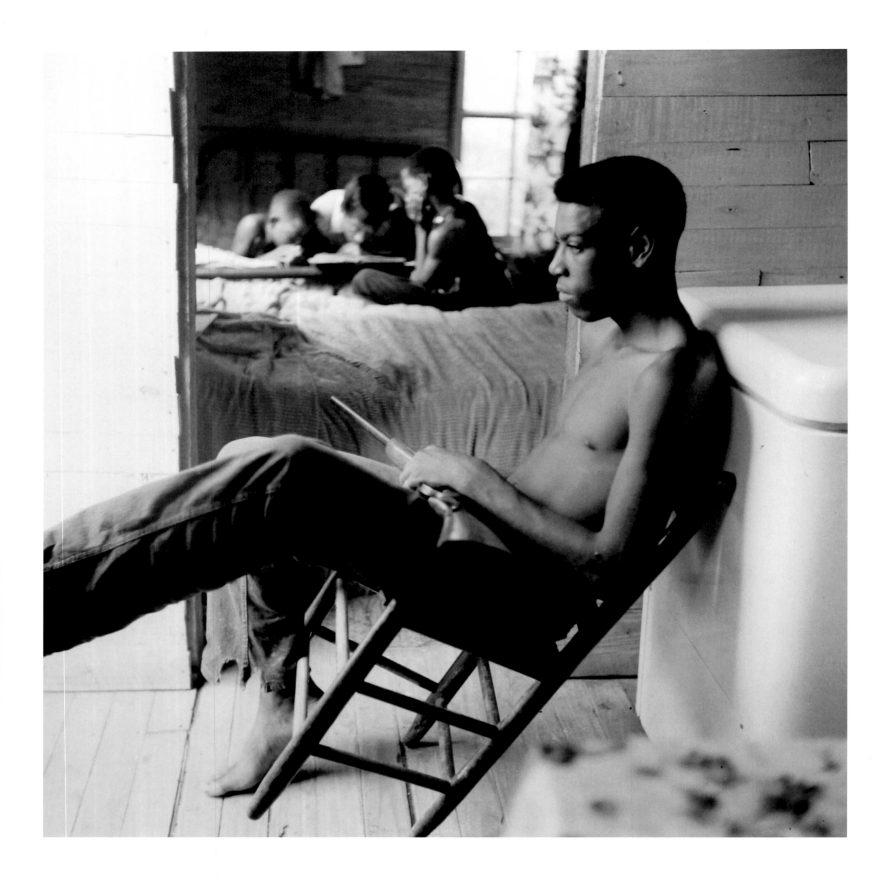

[William Causey's Son with Gun During Violence in Alabama, 1956]

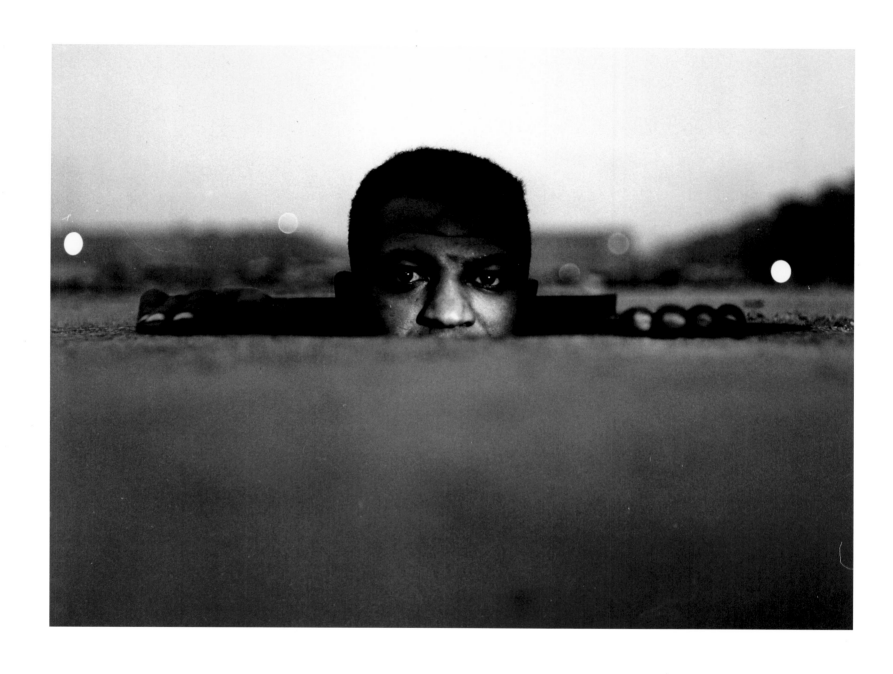

[Emerging Man, 1952]

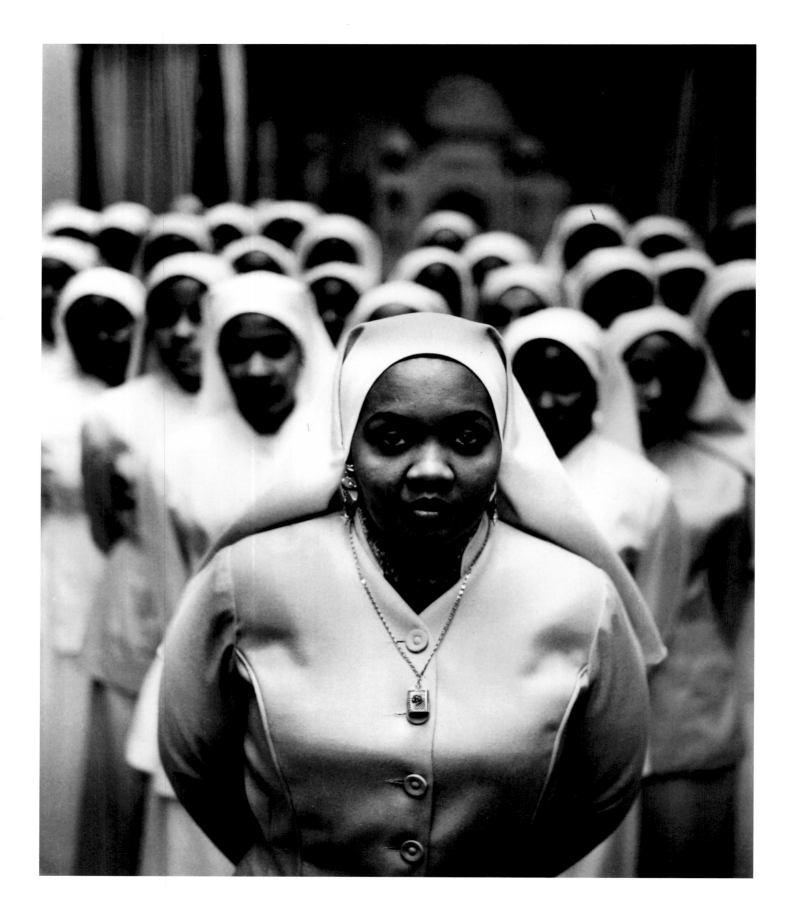

[Ethel Shariff in Chicago, 1963]

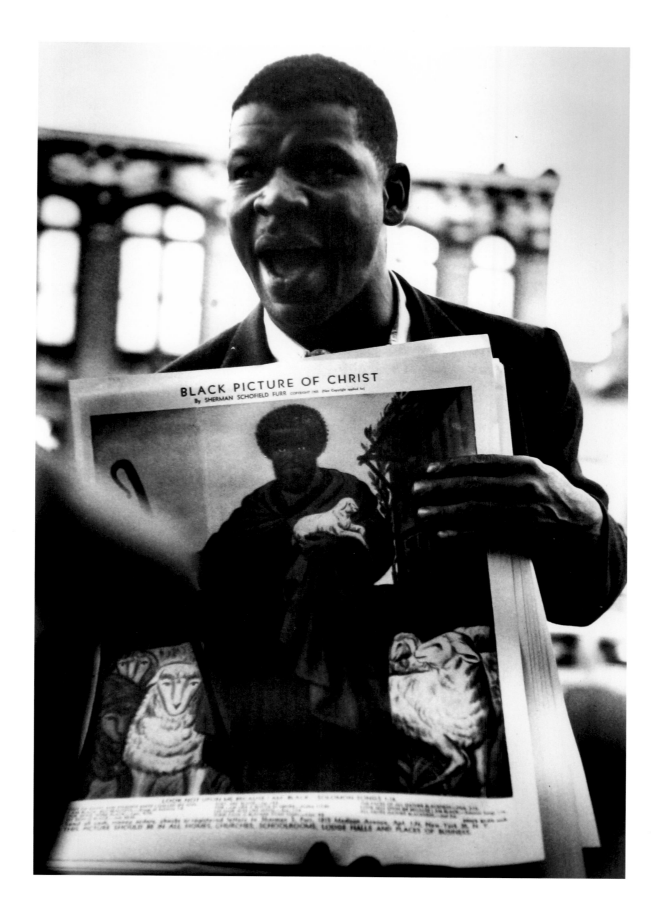

[Soapbox Orator, 1952]

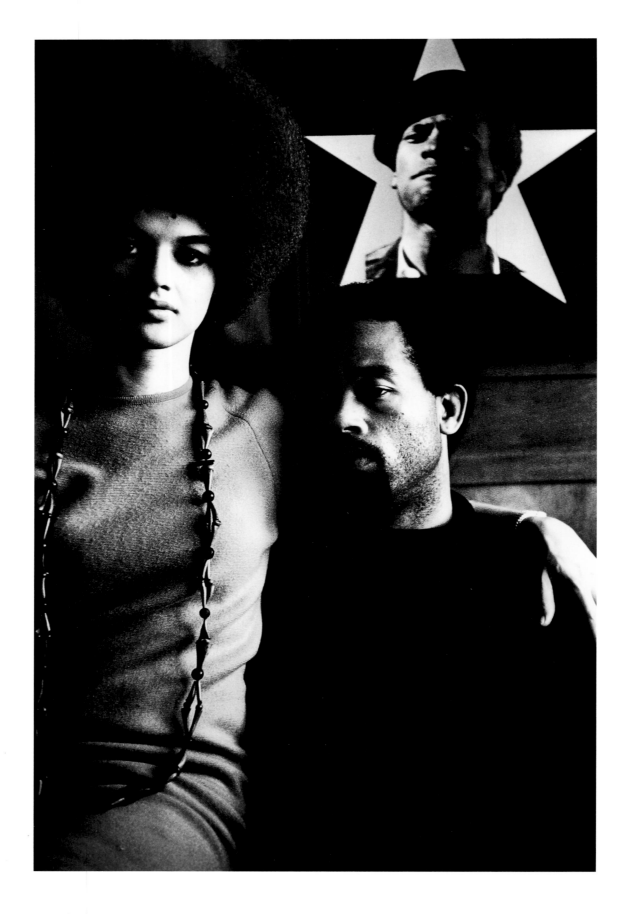

[Eldridge Cleaver and Wife, Kathleen with Portrait of Huey Newton, Algiers, 1970]

> **Burk Uzzle**

Come mothers and fathers
Throughout the land
And don't criticize
What you can't understand
Your sons and your daughters
Are beyond your command
Your old road is
Rapidly agin'.
Please get out of the new one
If you can't lend your hand
For the times they are a-changin'.

(Bob Dylan)

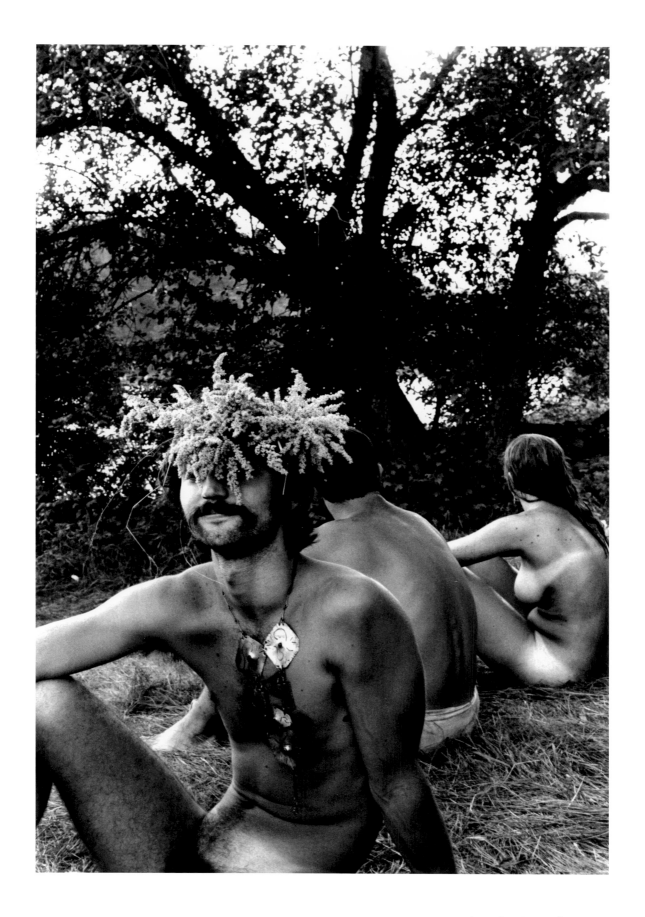

[Woodstock, 1969]

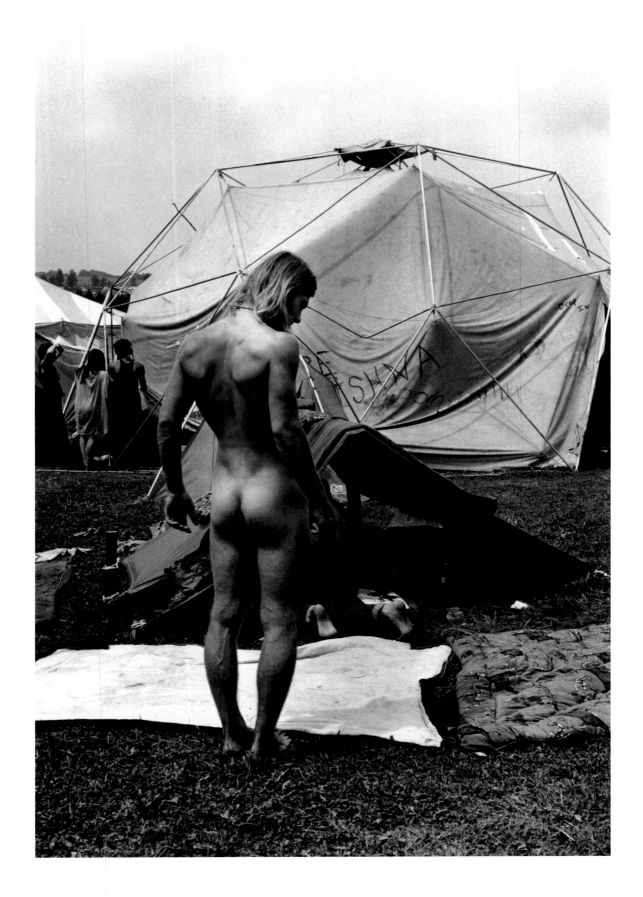

[Woodstock, 1969]

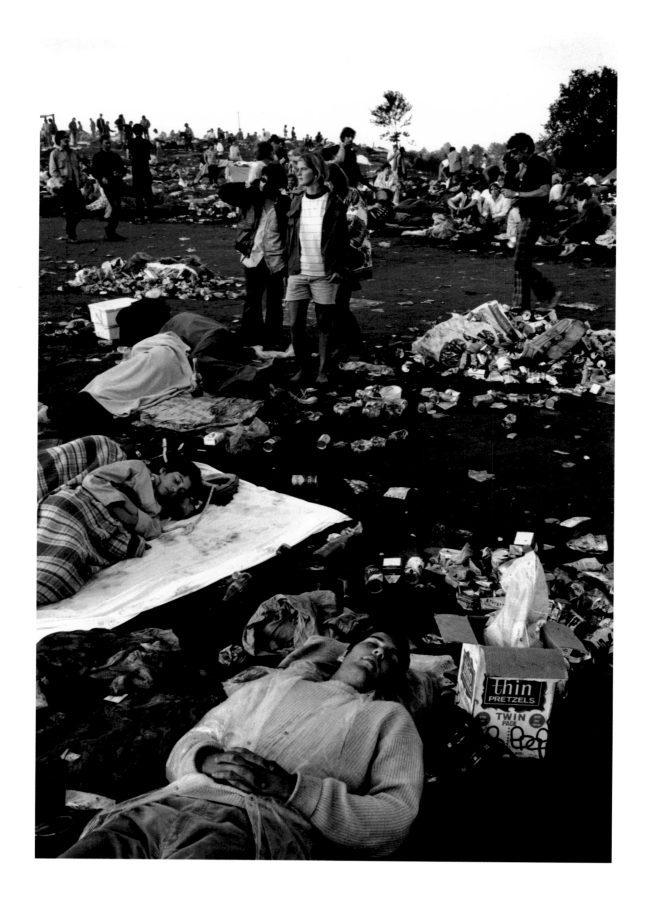

[Woodstock, 1969]

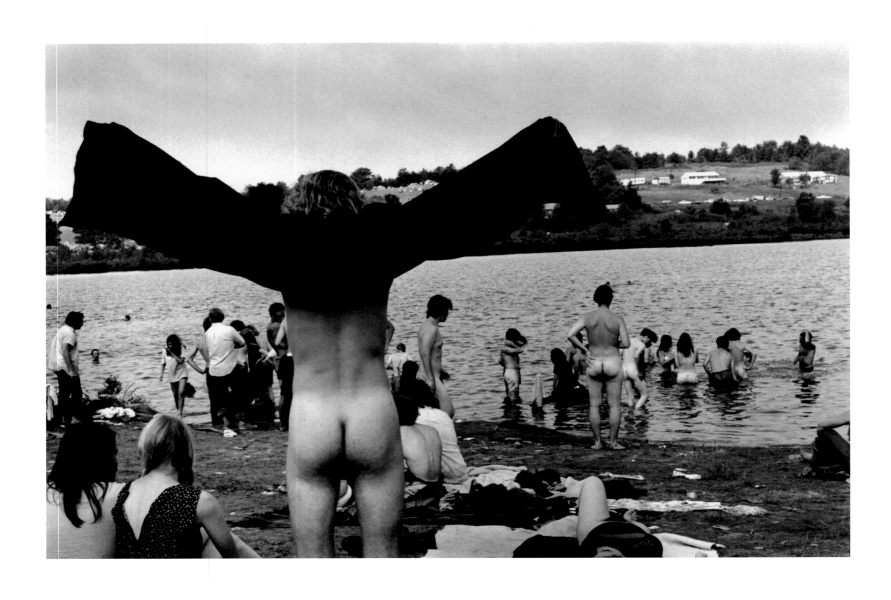

[Woodstock, 1969]

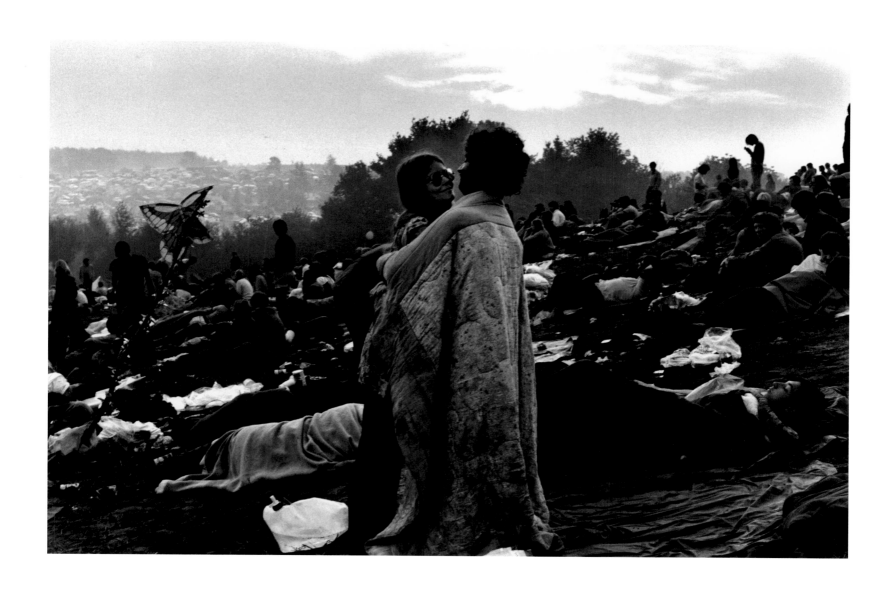

[Woodstock, 1969]

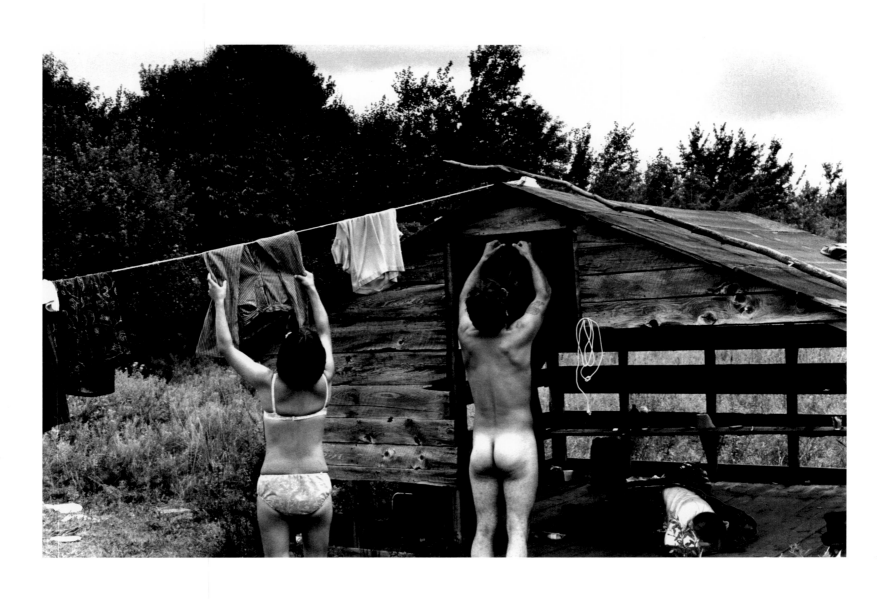

[**Woodstock, 1969**]

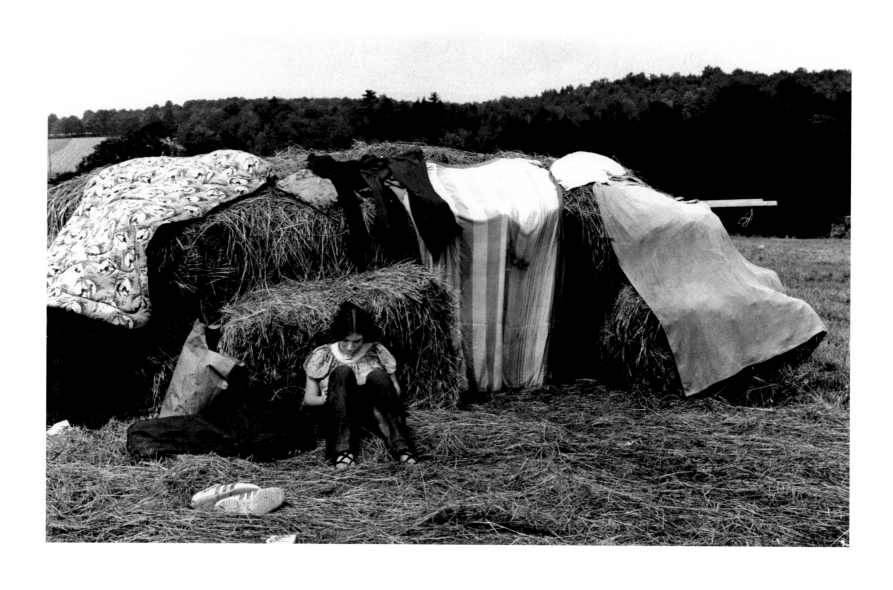

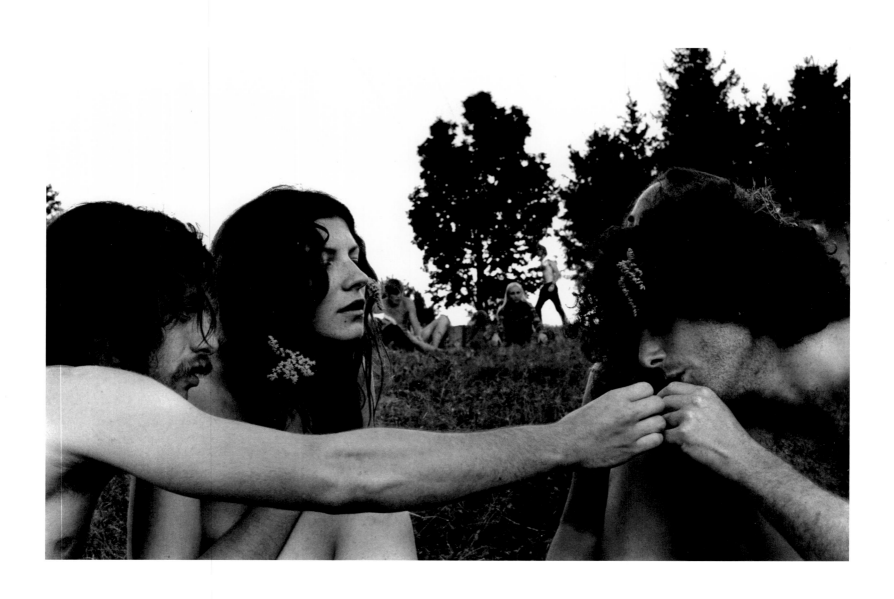

[Woodstock, 1969]

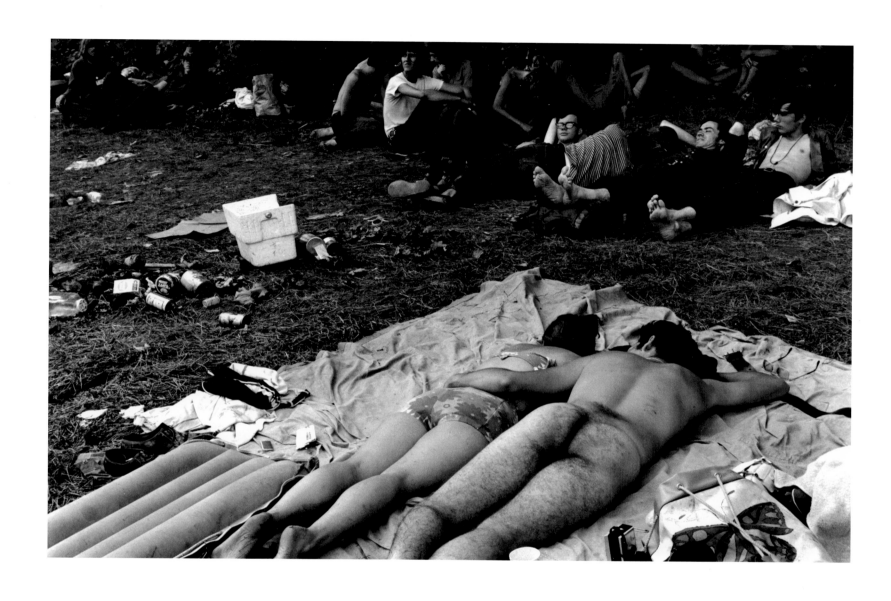

[Woodstock, 1969]

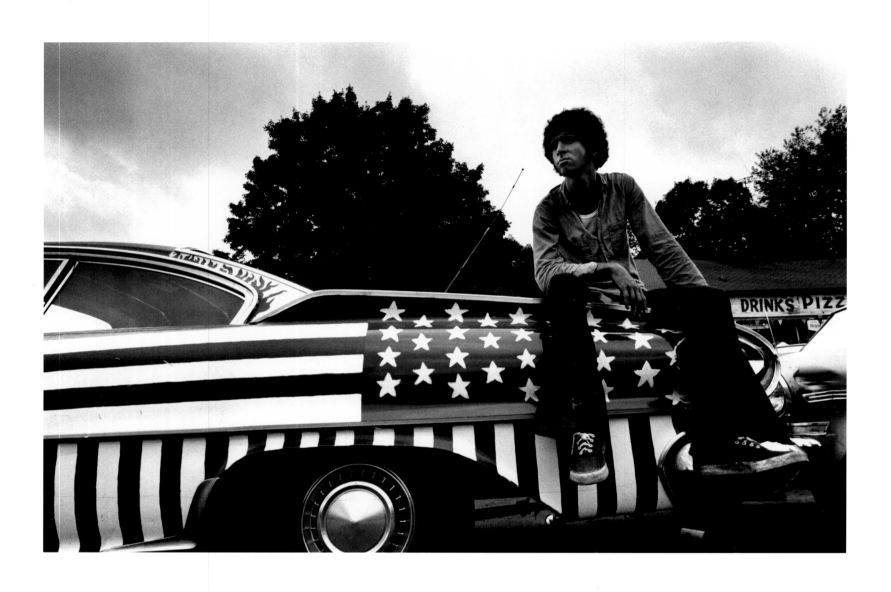

[Woodstock, 1969]

> **Diane Arbus**

A photograph is a secret about a secret.
The more it tells you the less you know.

I really believe there are things nobody
would see if I didn't photograph them.

My favourite thing is to go
where I've never been.

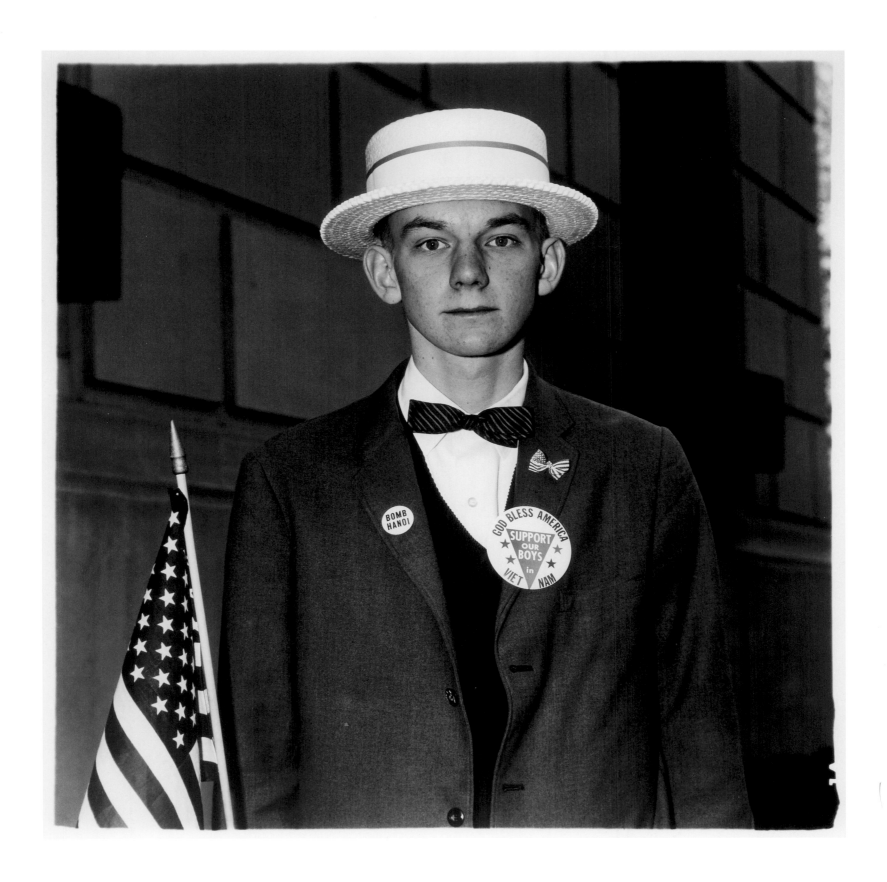

[Patriotic boy with a straw hat waiting to march in a pro-war parade, N.Y.C., 1967]

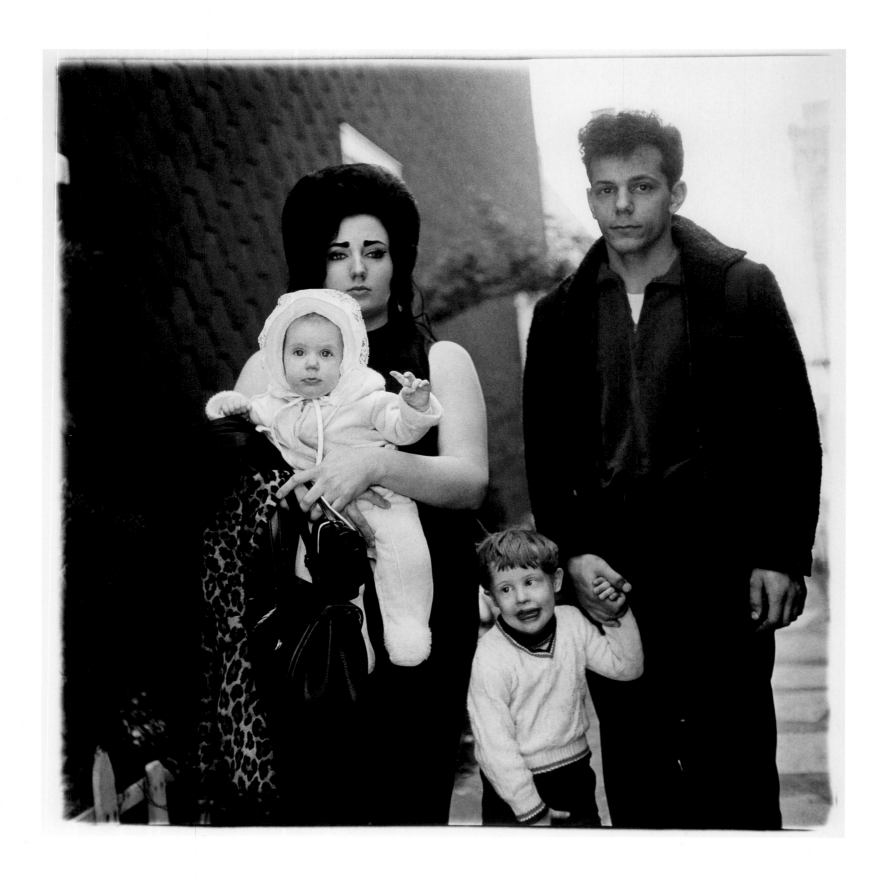

[A young Brooklyn family going for a Sunday outing, N.Y.C., 1966]

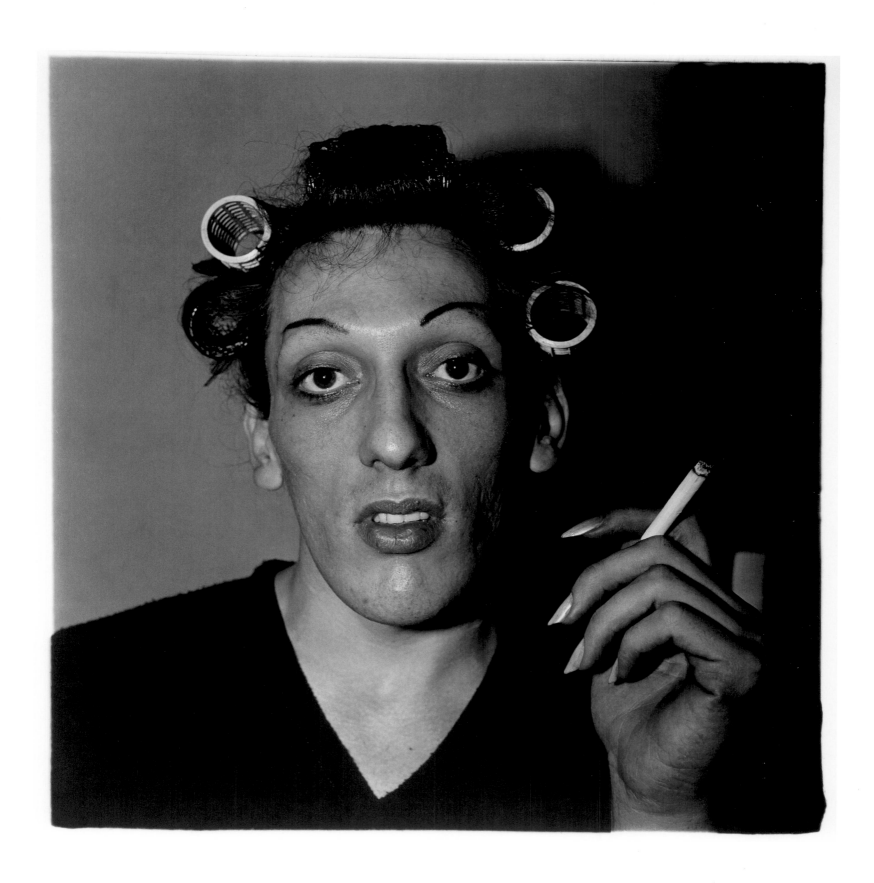

[A young man in curlers at home on West 20th Street, N.Y.C., 1966]

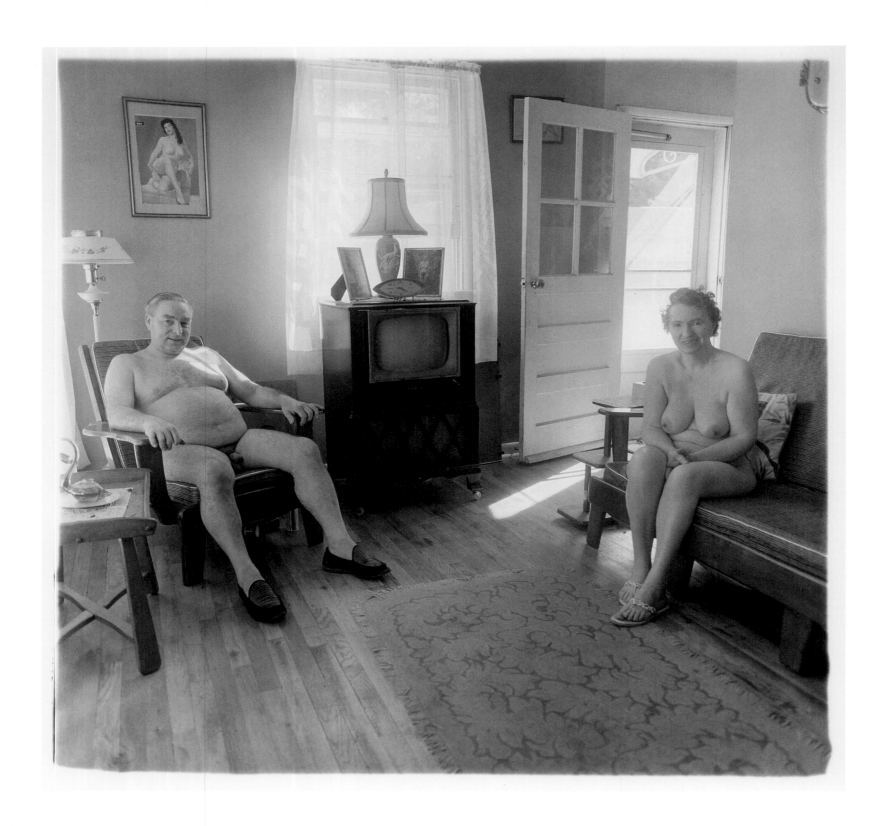

[Retired man and his wife at home in a nudist camp one morning, N.J., 1963]

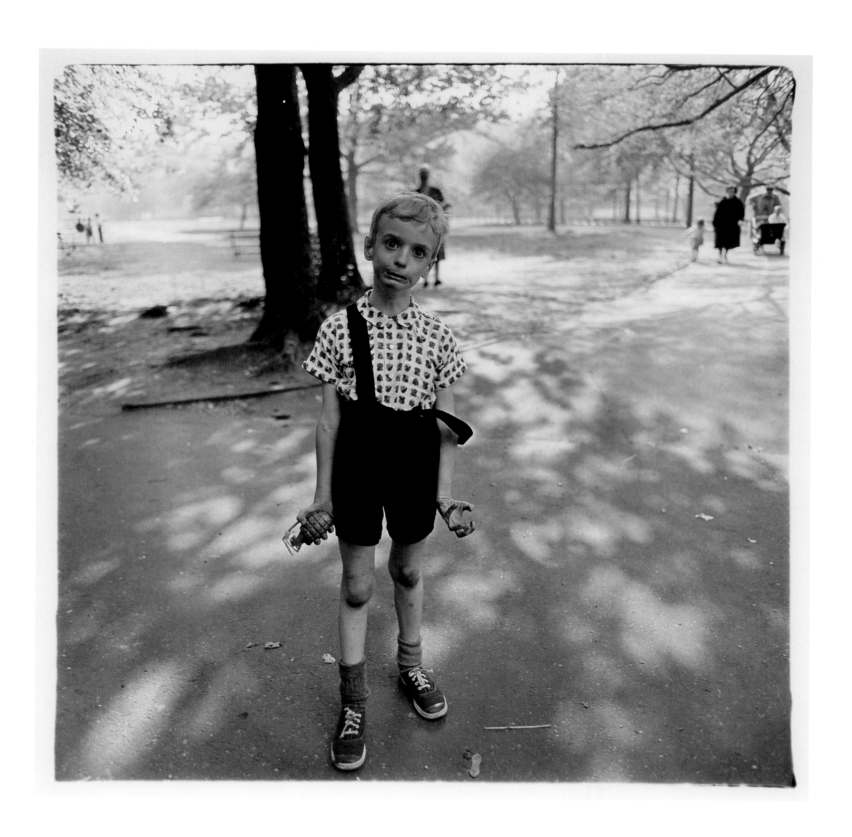

[Child with a toy hand grenade in Central Park, N.Y.C., 1962]

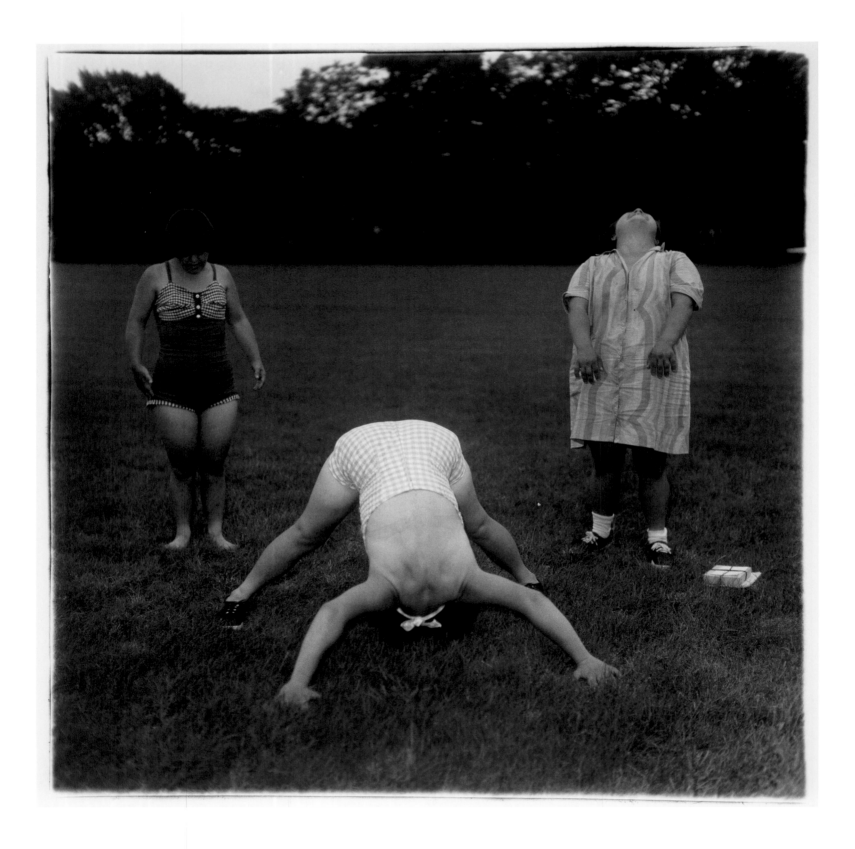

[Untitled (6), 1970-71]

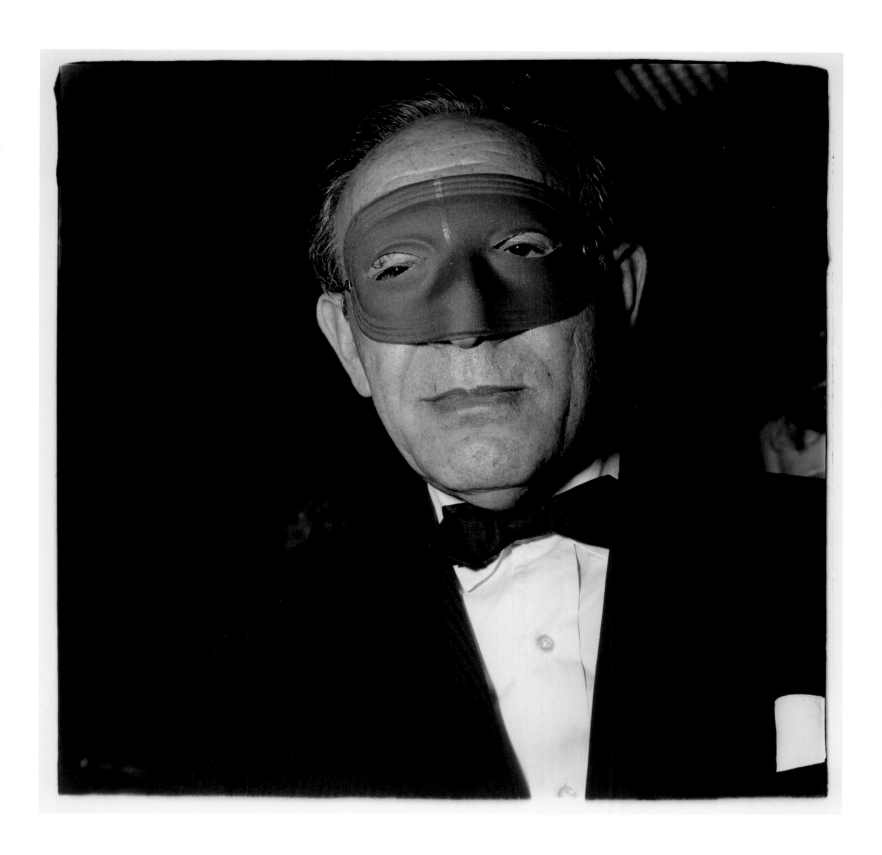

[Masked man at a ball, N.Y.C., 1967]

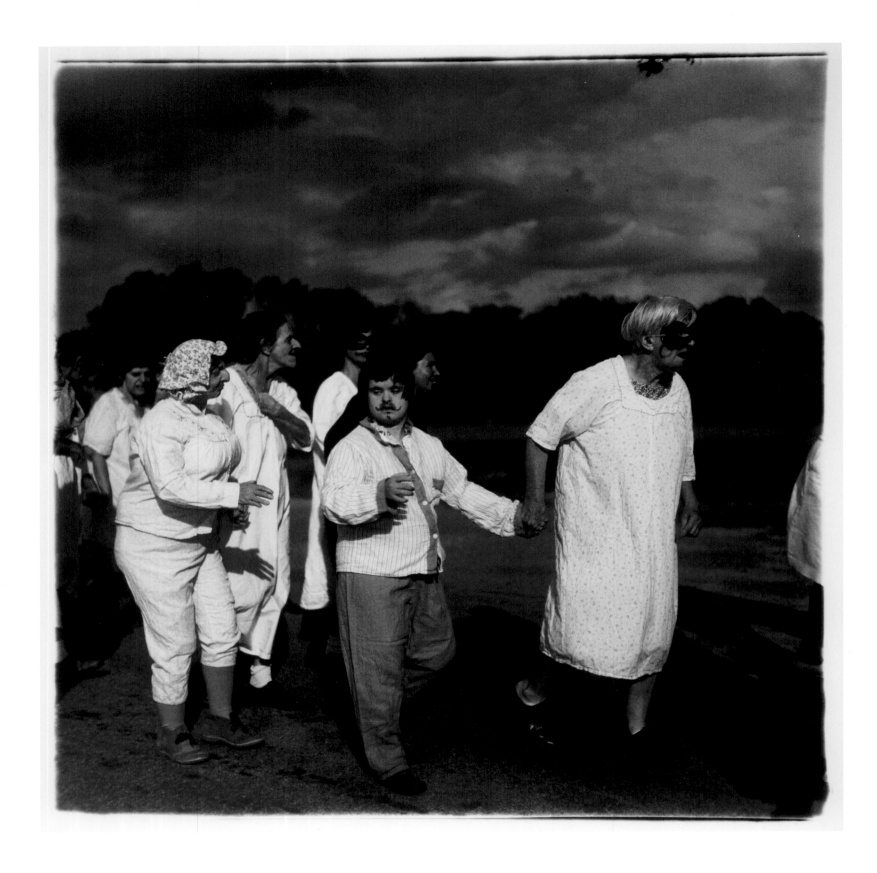

[Untitled (7), 1970-71]

> Peter Hujar

Are photographs just tiny windows looking onto
the world, frozen moments of it that lie flat and
quiet without sound or smell or movement? [...]
A camera in some hands can preserve
an alternate history.

(David Wojnarovicz)

[...] my anger is more about this culture's refusal
to deal with mortality. My rage is really about the
fact that WHEN I WAS TOLD THAT I'D
CONTRACTED THIS VIRUS IT DIDN'T TAKE ME
LONG TO REALIZE THAT I'D CONTRACTED A
DISEASED SOCIETY AS WELL.

(David Wojnarovicz)

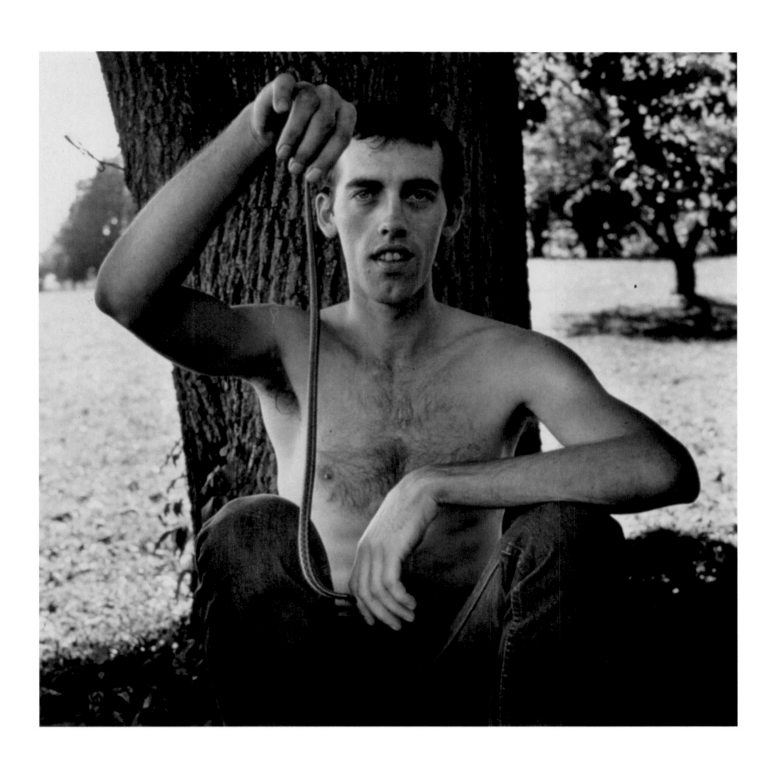

[David Wojnarowicz with a Snake, 1981]

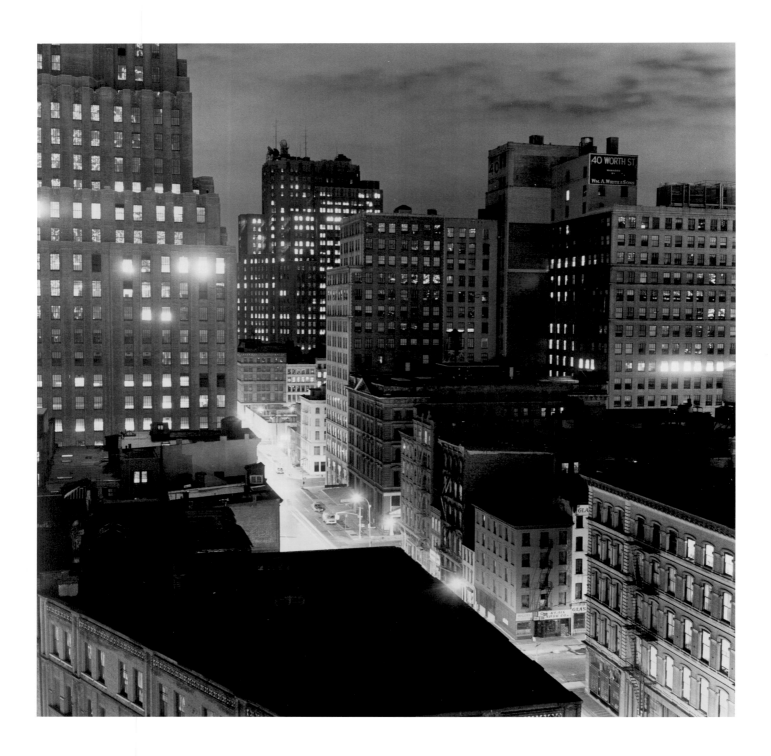

[Night, Downtown, 1976]

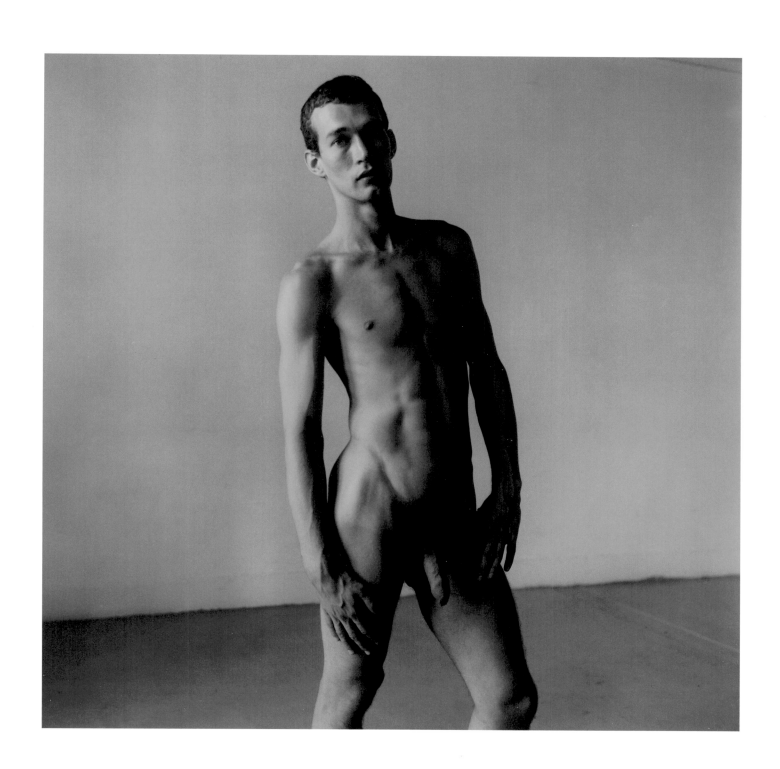

[Bruce de Saint Croix (Standing), 1976]

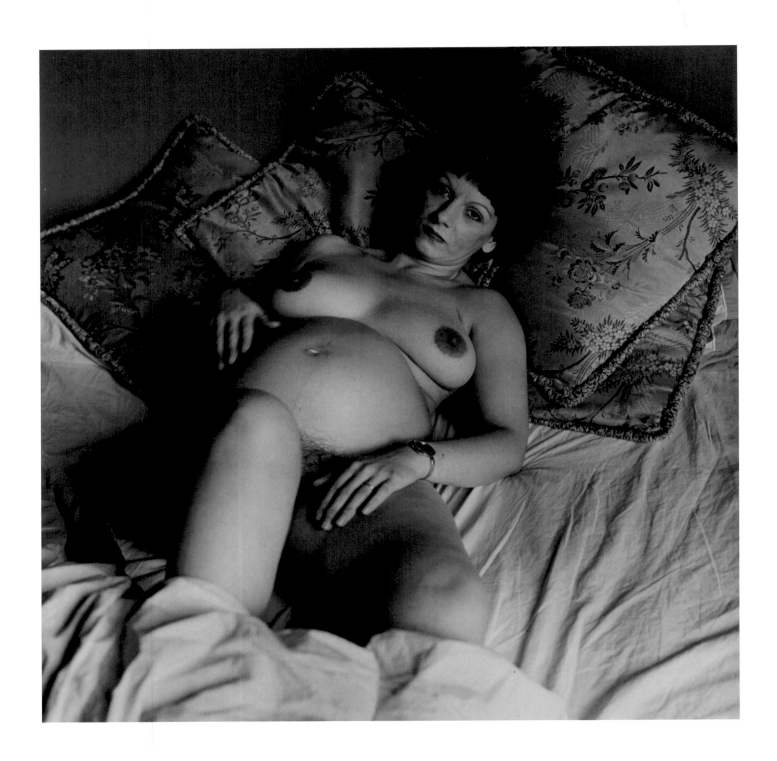

[Pregnant Nude, 1978]

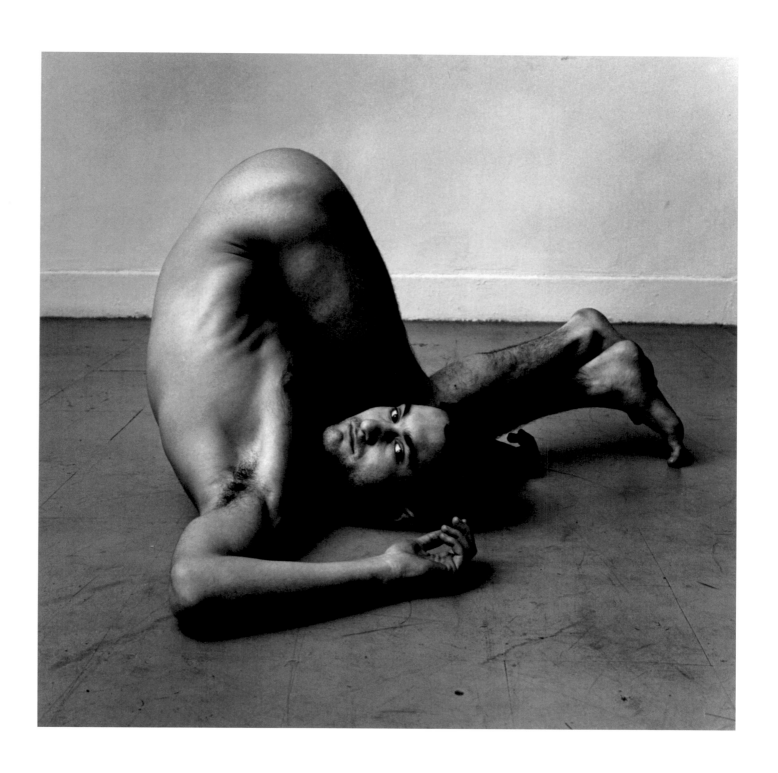

[Gary in Contortion, 1982]

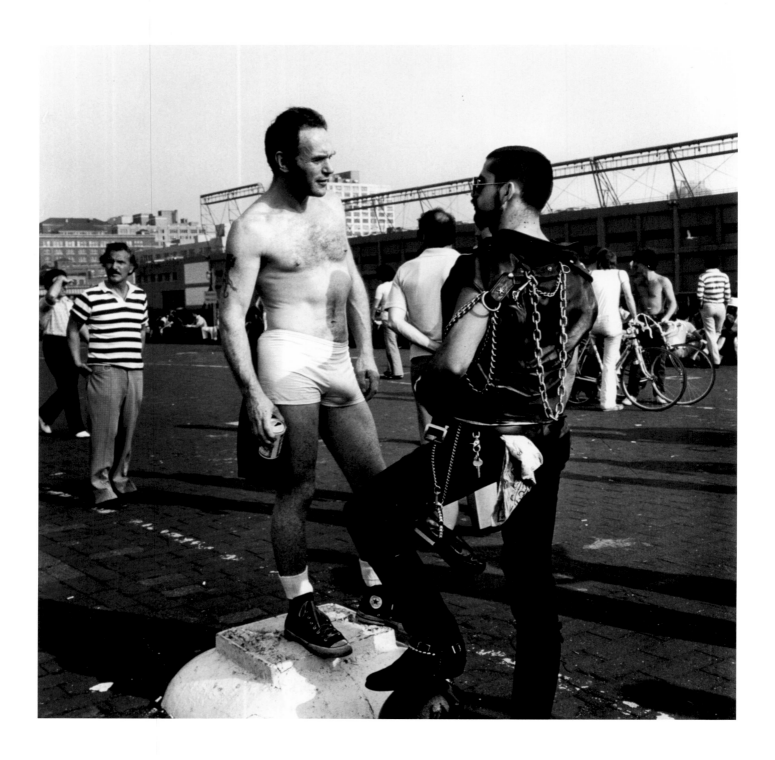

[Christopher Street Pier, 1976]

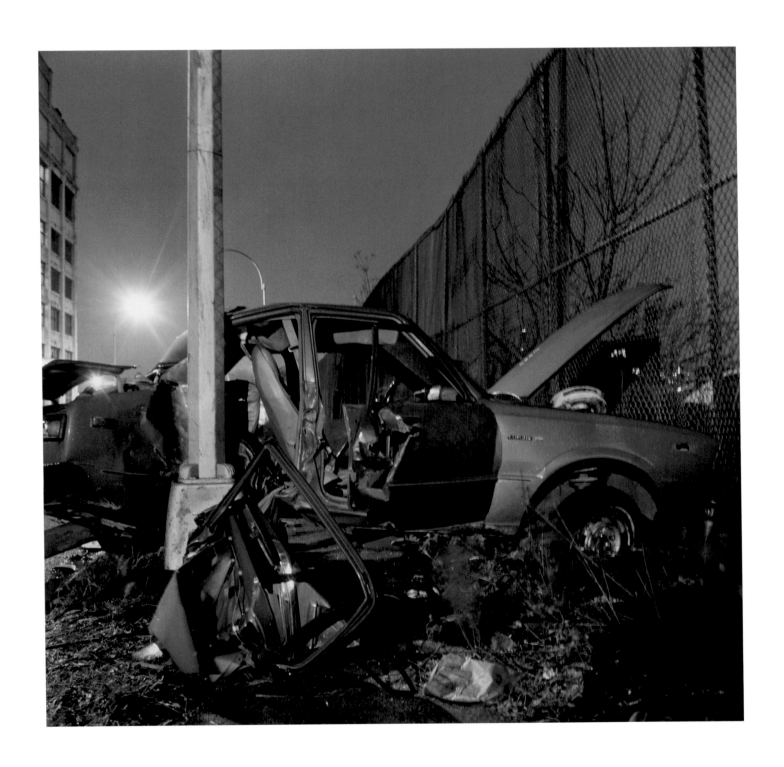

[Wreck, 1980]

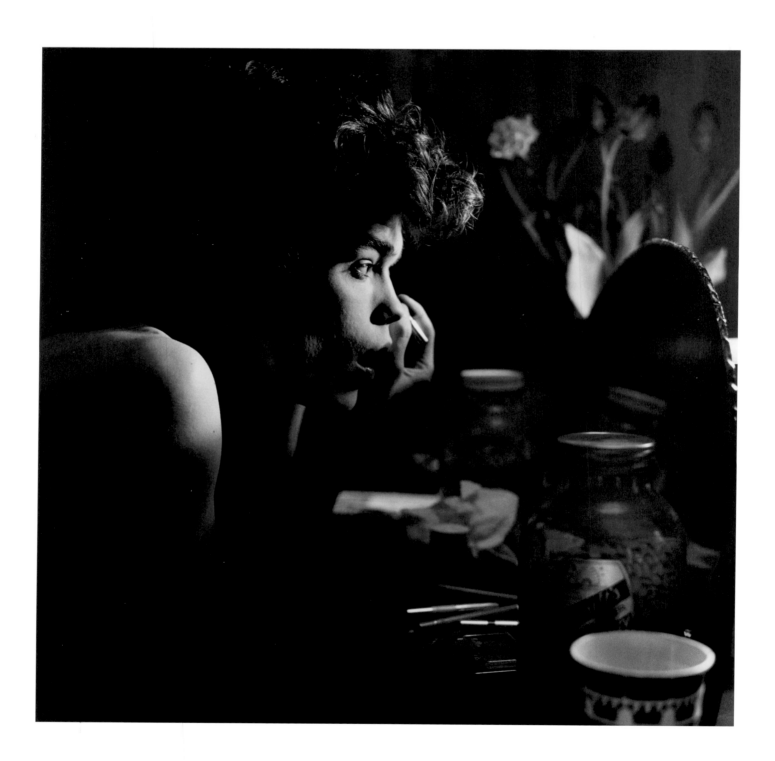

　　[David Brintzenhofe Putting on Make-Up, 1982]

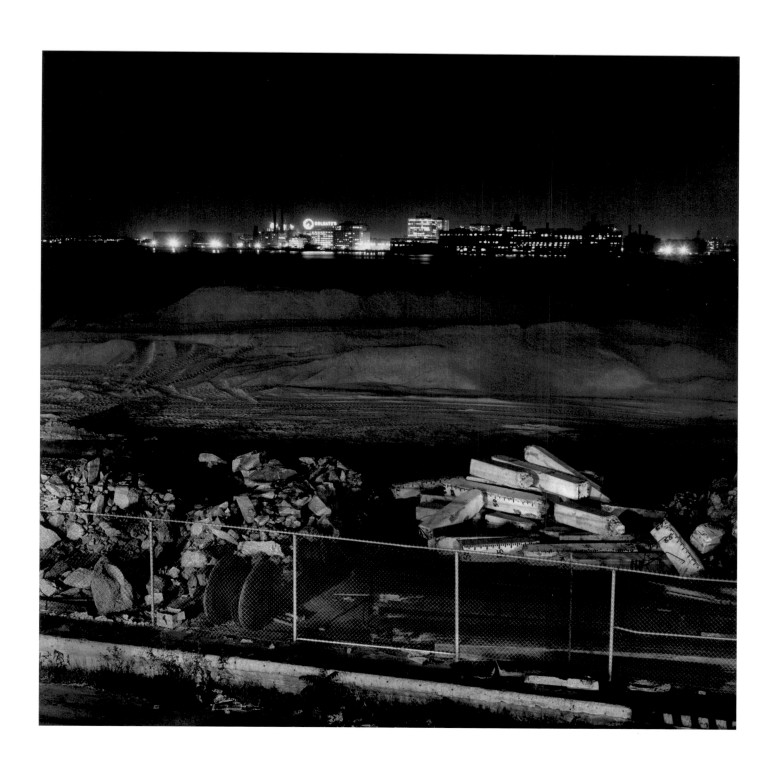

[Land Fill, Hudson River and NJ Skyline, 1976]

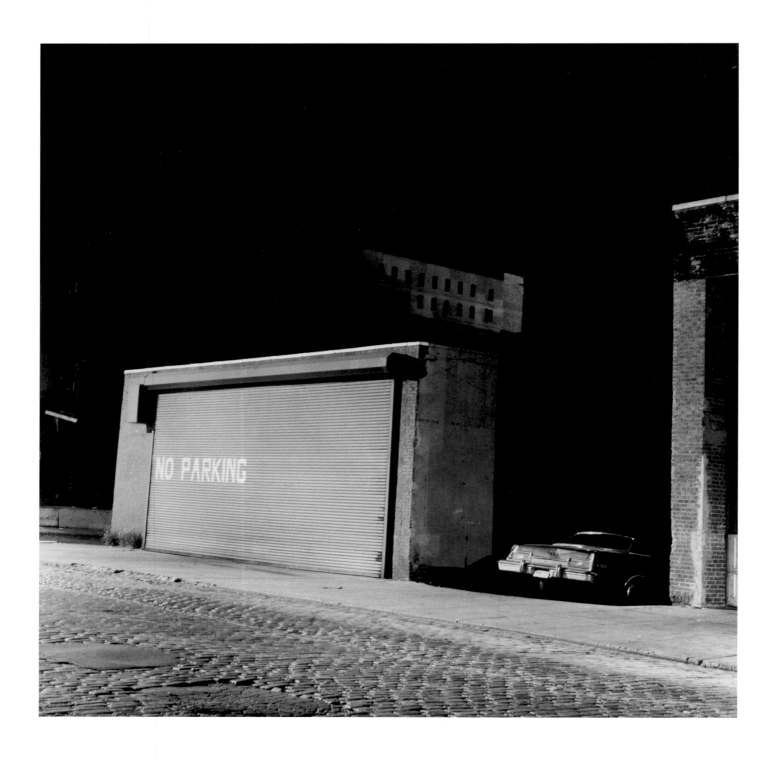

[No Parking, 1976]

> Richard Avedon

Sometimes I think all my pictures are just pictures of me. My concern is... the human predicament; only what I consider the human predicament may simply be my own.

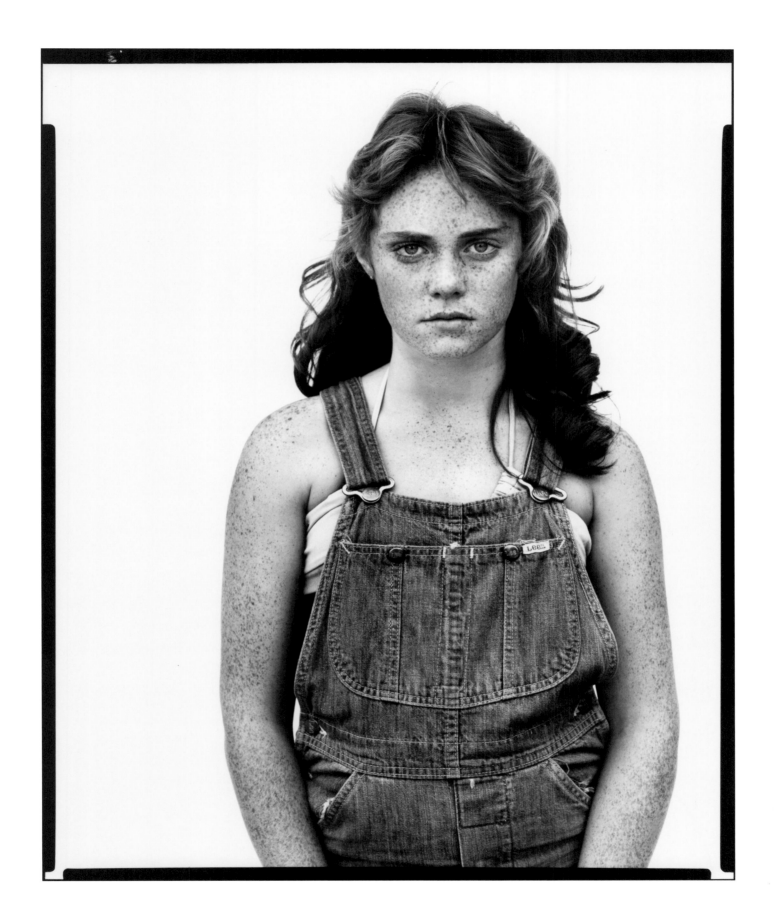

[Sandra Bennett, Twelve Year Old, Rocky Ford, Colorado, August 23, 1980]

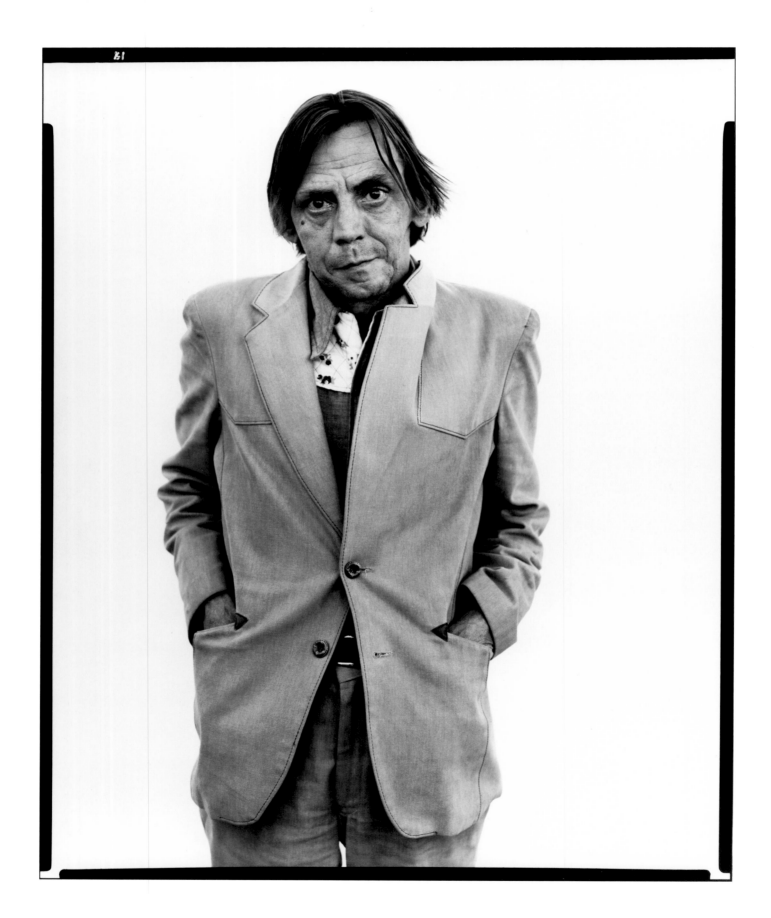

[Allen Silvy, Drifter, Route 93, Chloride, Nevada, December 14, 1980]

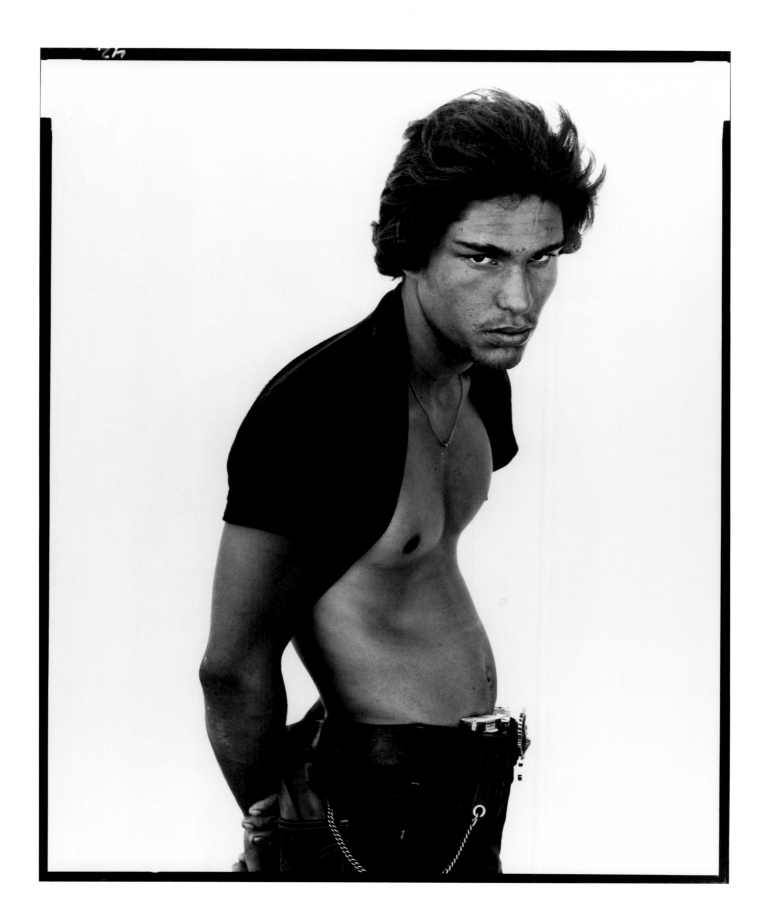

[Juan Patricio Lobato, Carney, Rocky Ford, Colorado, August 23, 1980]

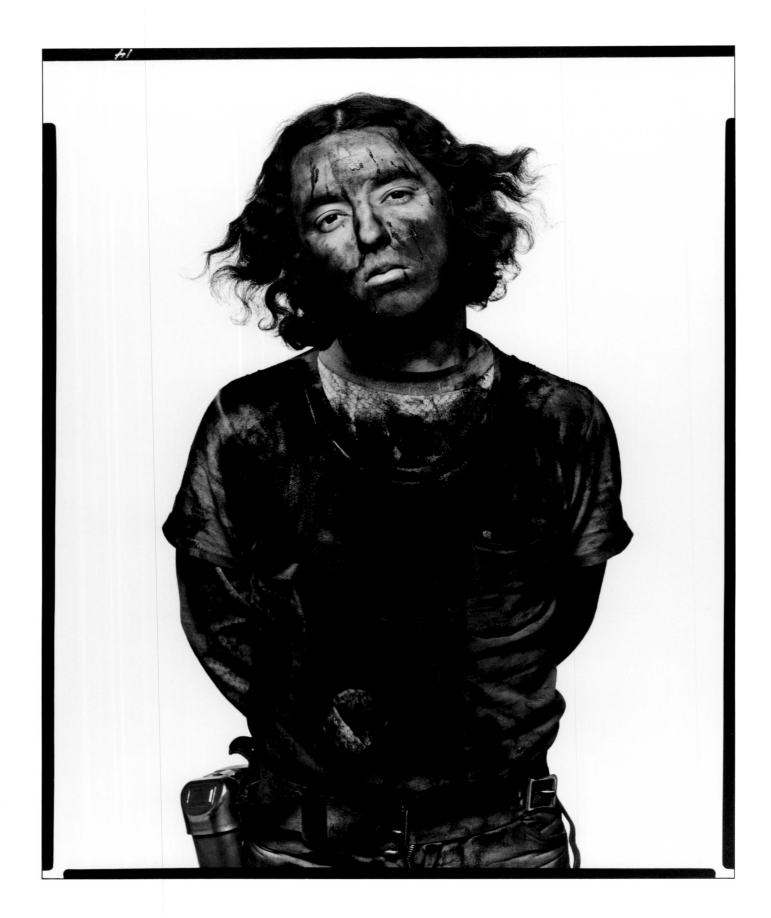

[James Story, Coal Miner, Somerset, Colorado, December 18, 1979]

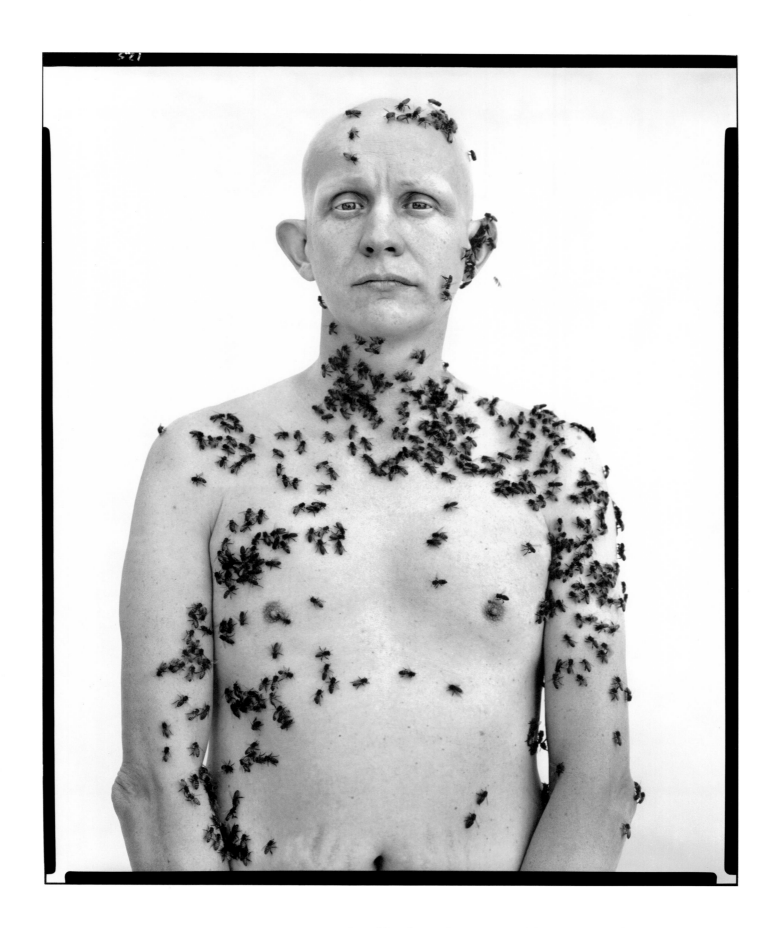

[Ronald Fischer, Beekeeper, Davis, California, May 9, 1981]

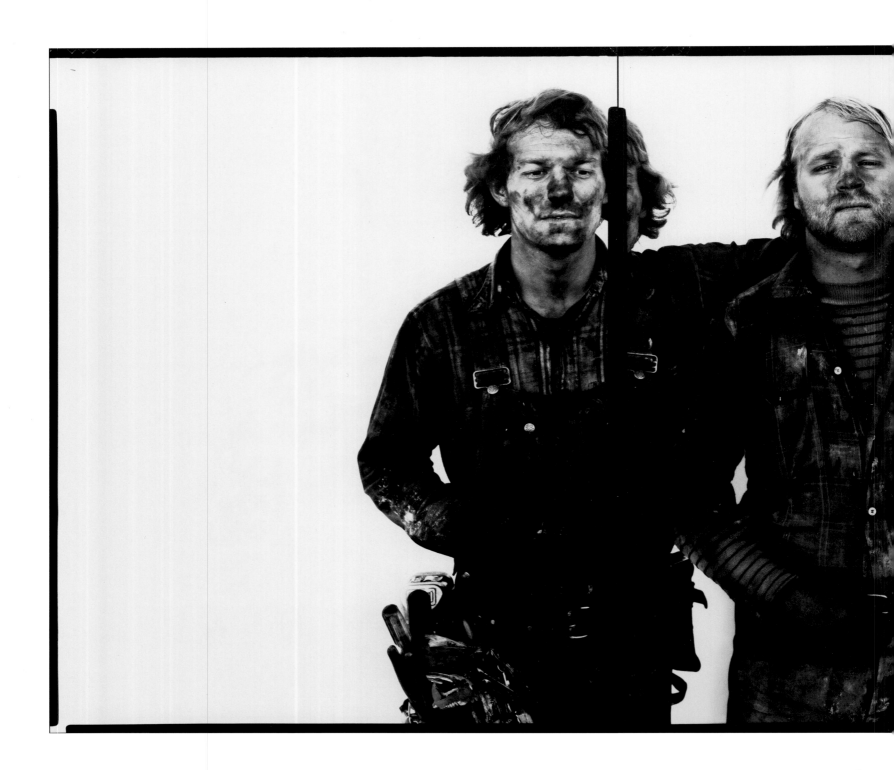

[Roger Tims, Jim Duncan, Leonard Markley, Don Belak, Coal Miners, Reliance, Wyoming, August 29, 1979]

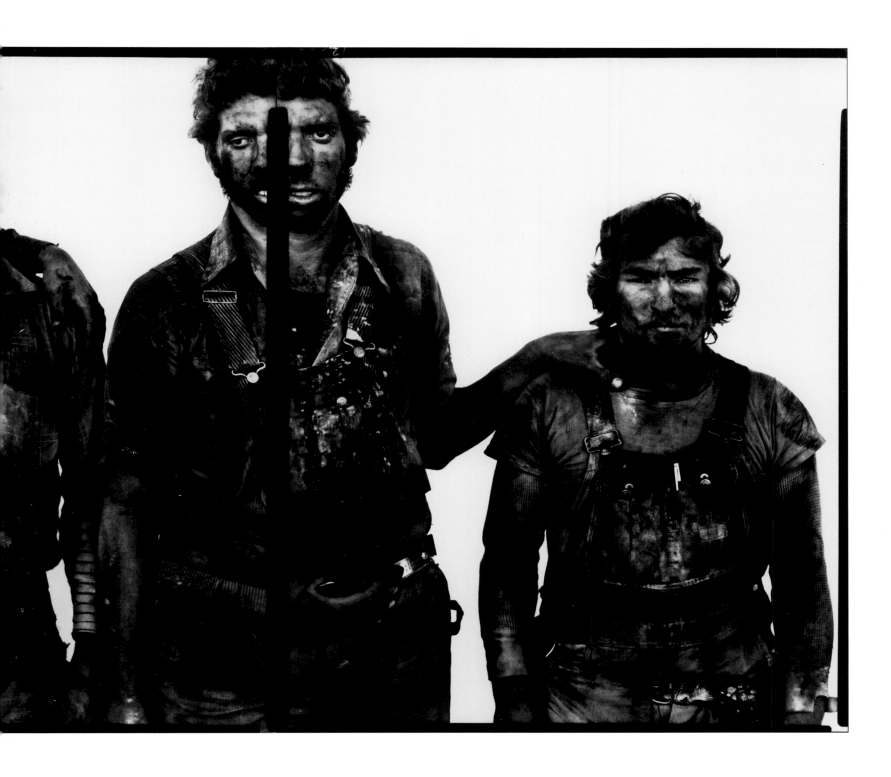

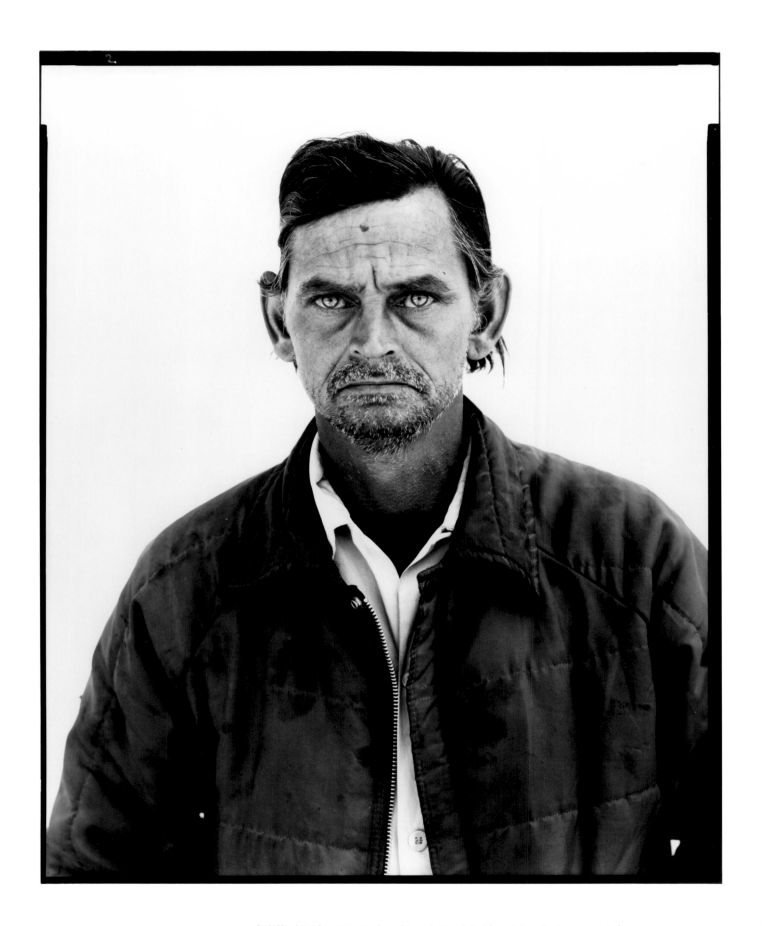

[Clifford Feldner, Unemployed Ranch Hand, Golden, Colorado, June 15, 1983]

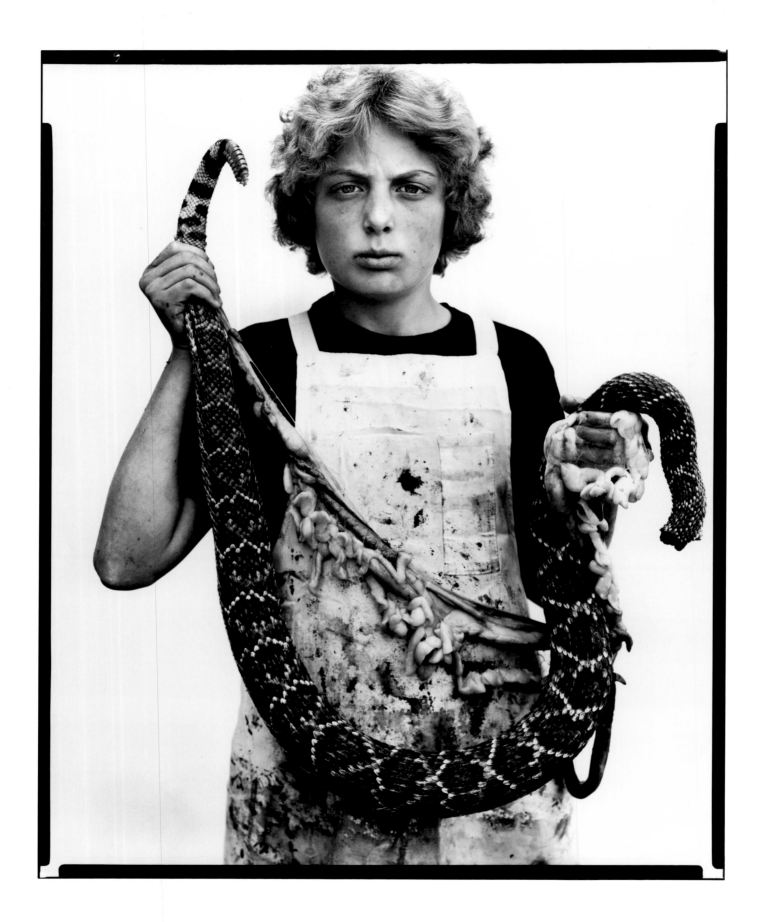

[Boyd Fortin, Thirteen Year Old Rattlesnake Skinner, Sweetwater, Texas, March 10, 1979]

> **Larry Clark**

Junk is the mold of monopoly and possession. [...] Junk is quantitative and accurately measurable. The more junk you use the less you have and the more you have the more you use. [...] Junk is the ideal product... the ultimate merchandise. No sales talk necessary. The client will crawl through a sewer and beg to buy... The junk merchant does not sell his product to the consumer, he sells the consumer to his product. He does not improve and simplify his merchandise. He degrades and simplifies the client. He pays his staff in junk.

(William Burroughs)

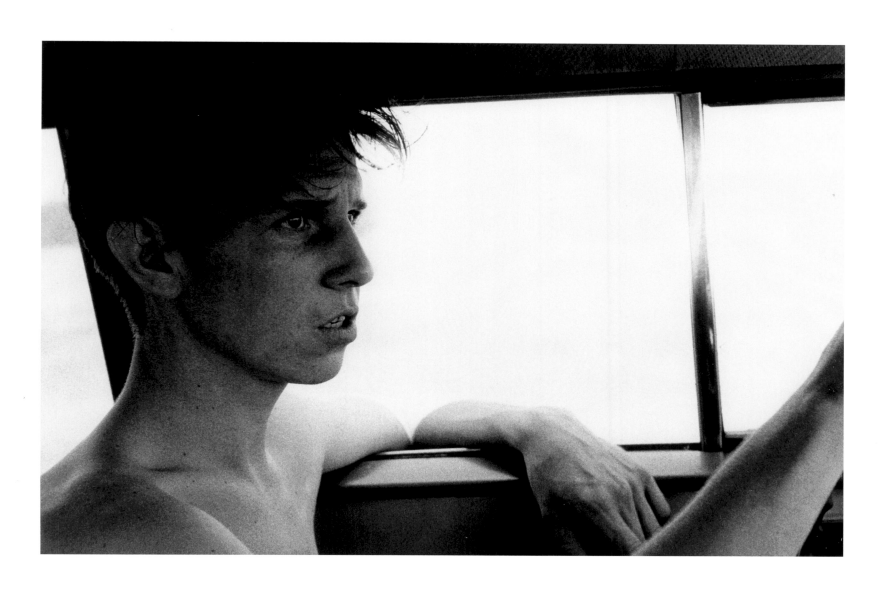

[Tulsa, 1983]

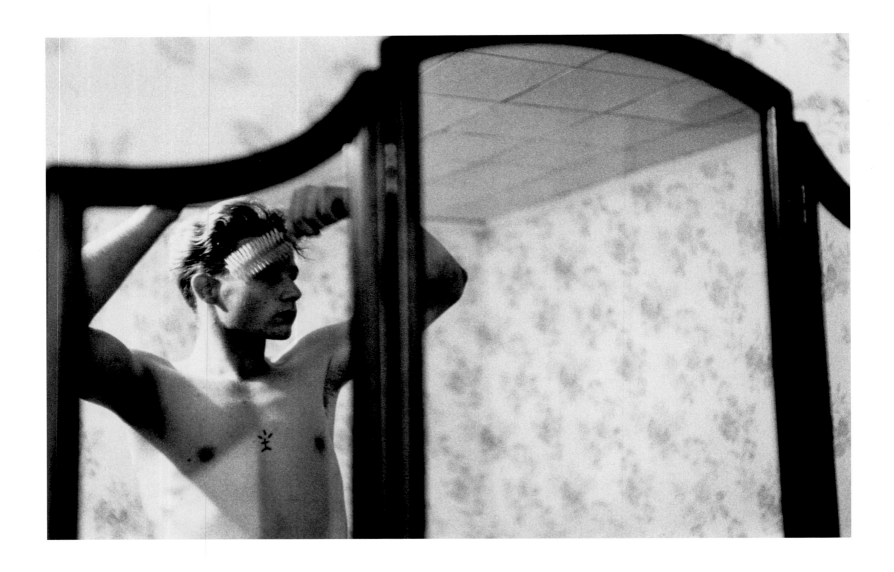

[Tulsa, 1983]

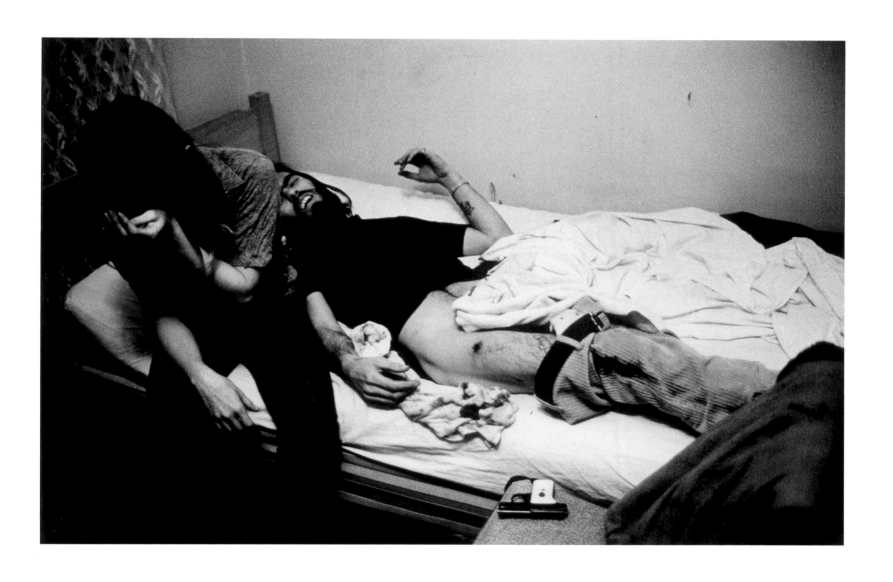

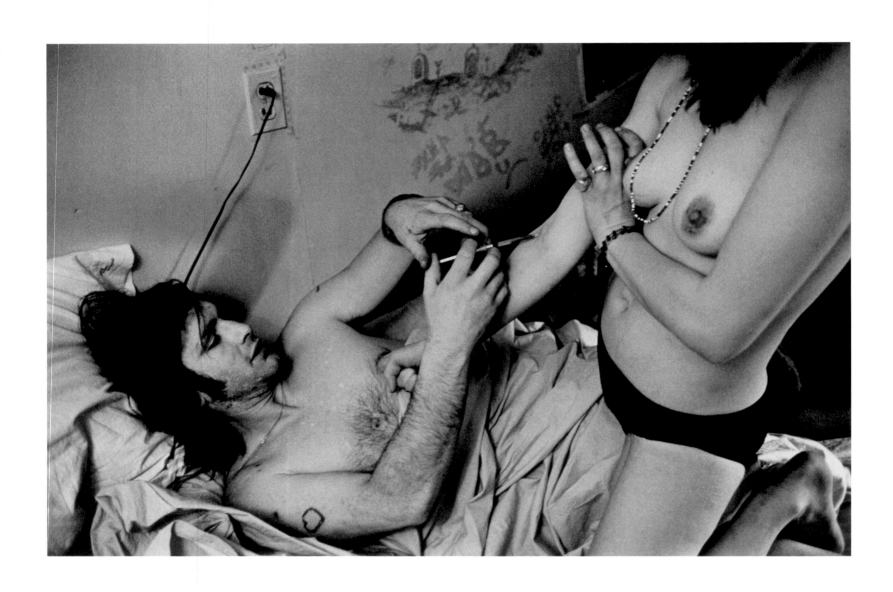

[Tulsa, 1983]

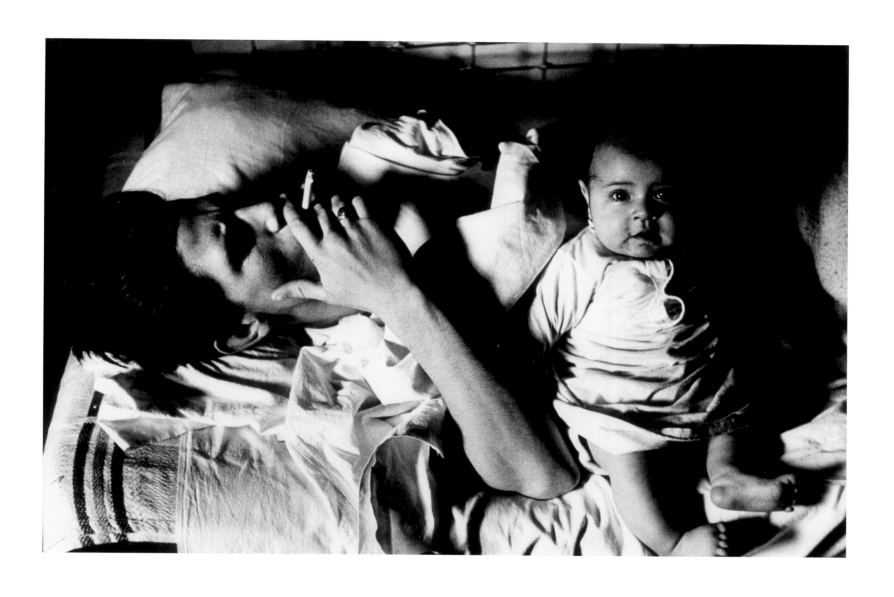

[Tulsa, 1983]

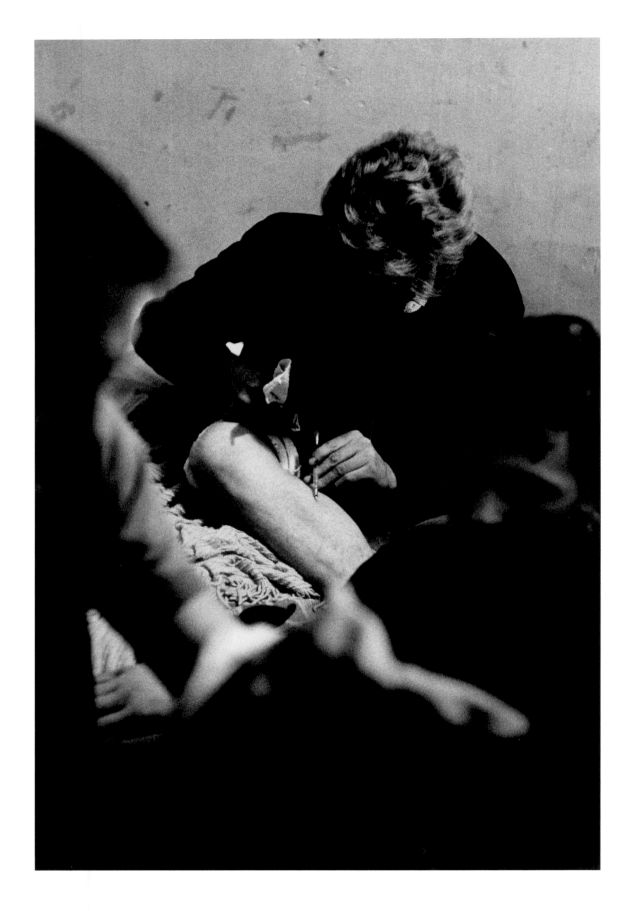

[Tulsa, 1983]

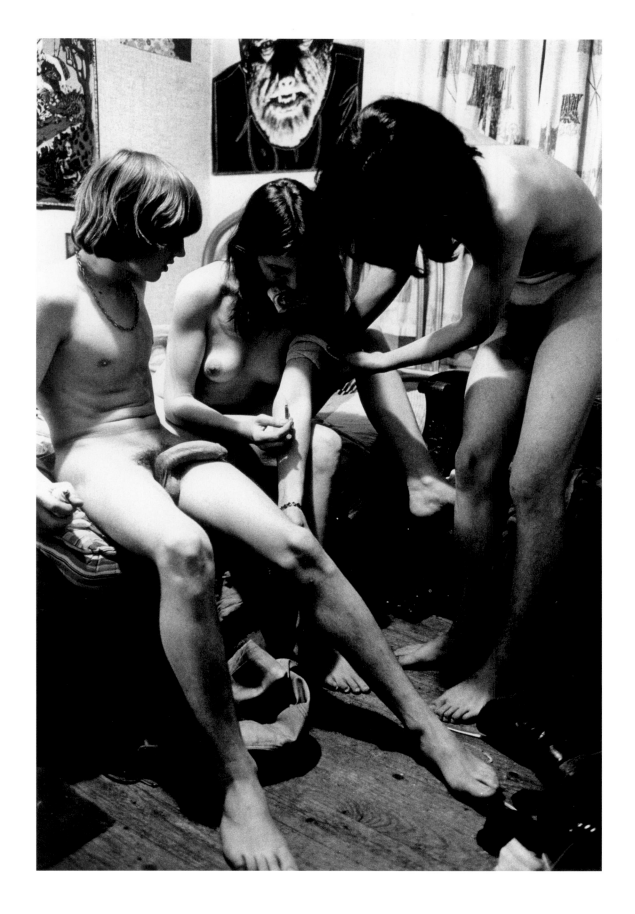

[Tulsa, 1983]

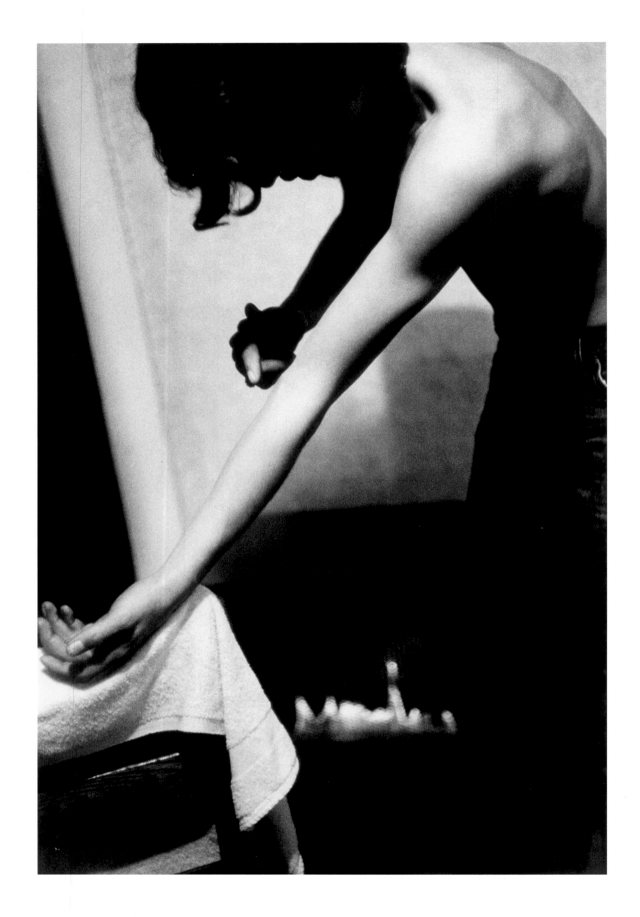

[Tulsa, 1983]

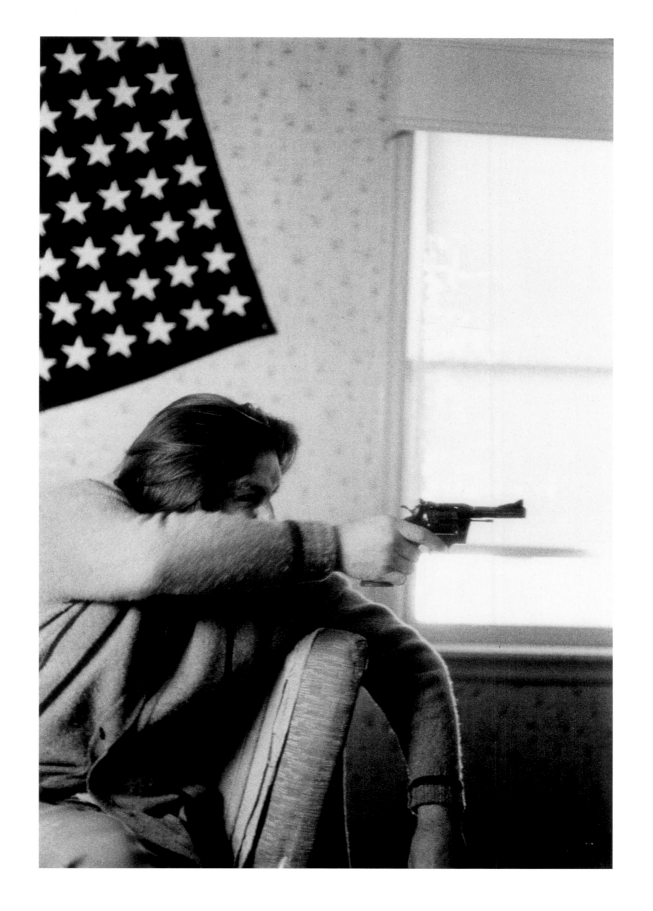

[Tulsa, 1983]

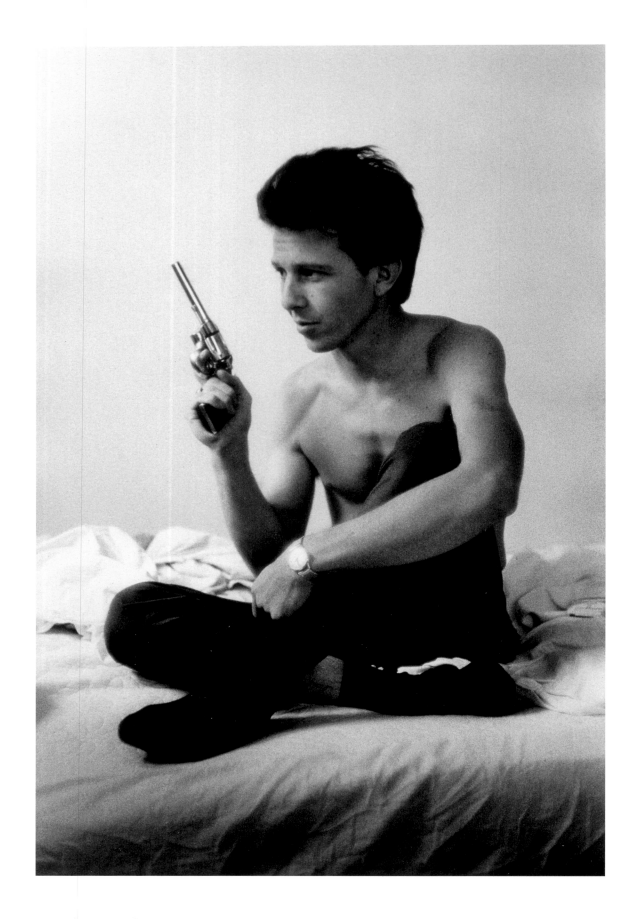

136 | Larry Clark [Tulsa, 1983]

> Rosalind Solomon

I cared about connecting with other people. Even though it was for brief moments I cared connecting on a meaningful level, on a gut level. I cared about trying to get away from stereotypes. And especially when I started to work in other countries I wanted to take portraits of people that showed them as real human beings, no matter where they were or what their background was.

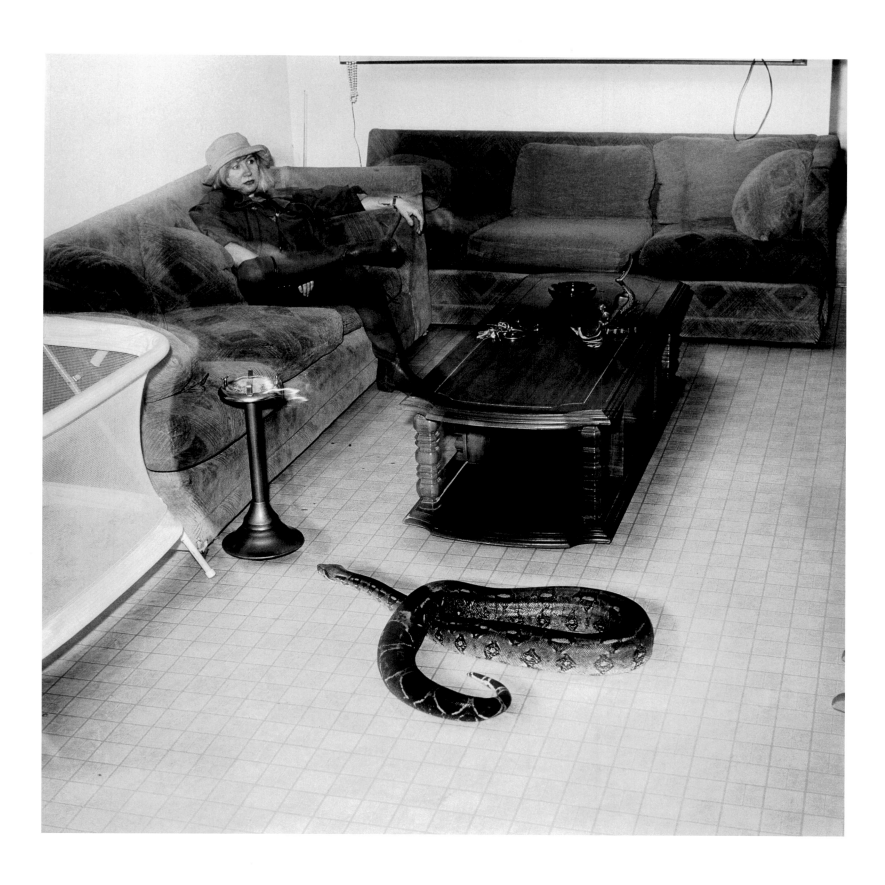

[A Snakehandler's Living Room, New Orleans, Louisiana, USA, 1992]

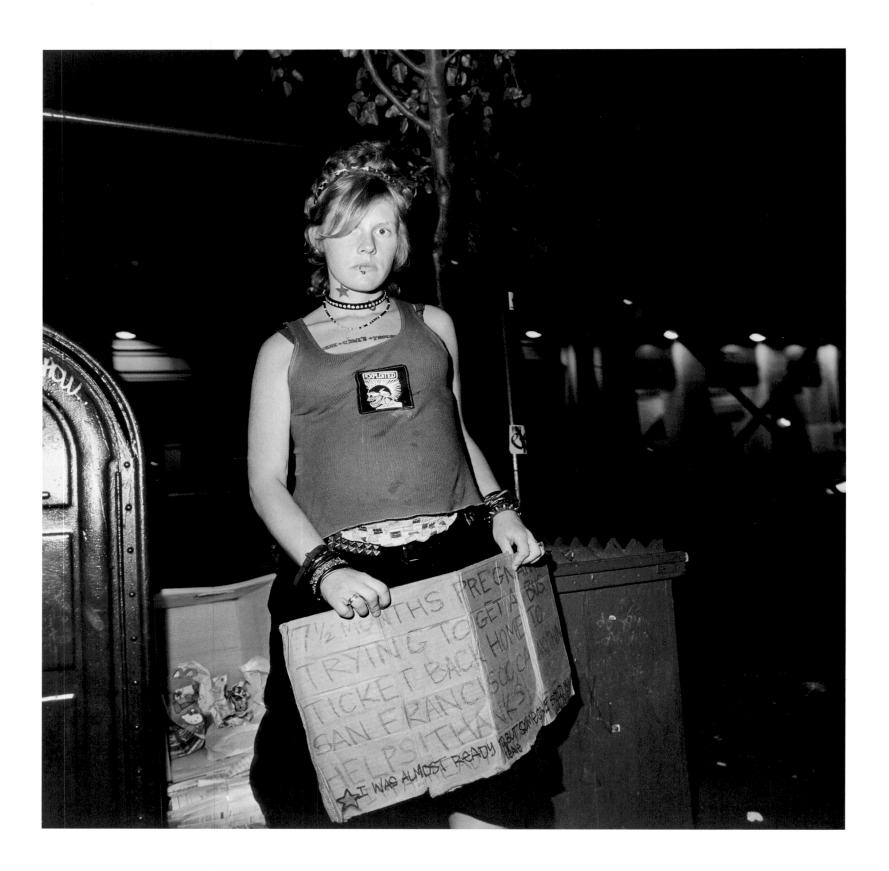

["Seven and a Half Months Pregnant and I Want to Go Home", New York, New York, USA, 2000]

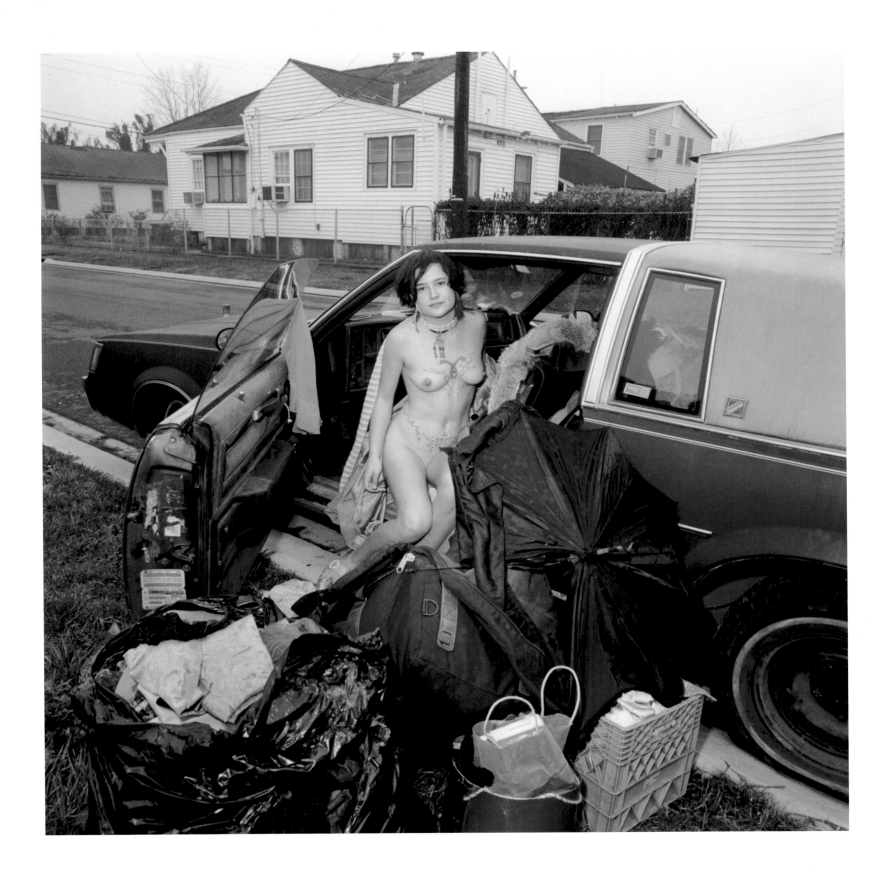

[Jane the Hatter, New Orleans, Louisiana, 1994]

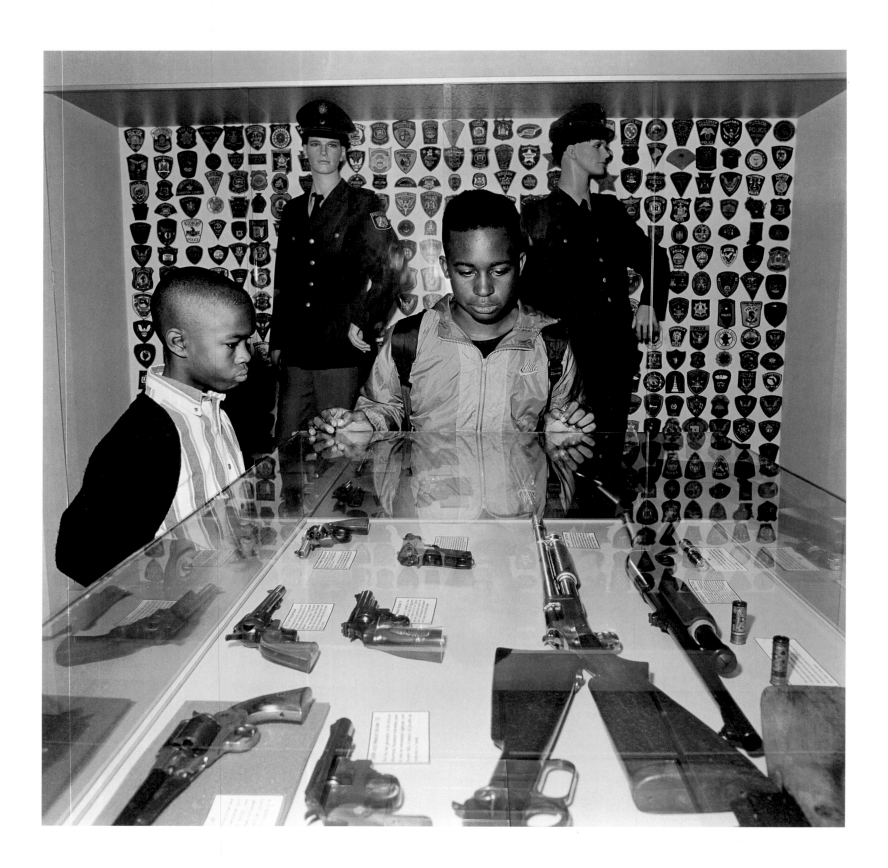

[Police Museum Tour, Miami, Florida, USA, 1994]

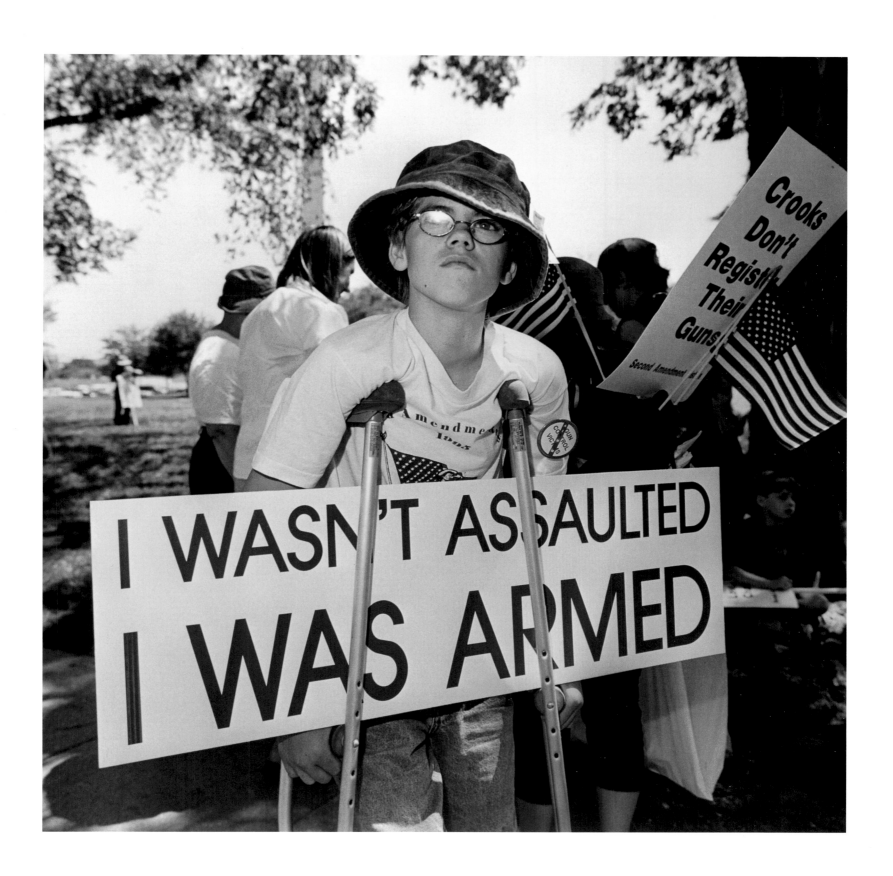

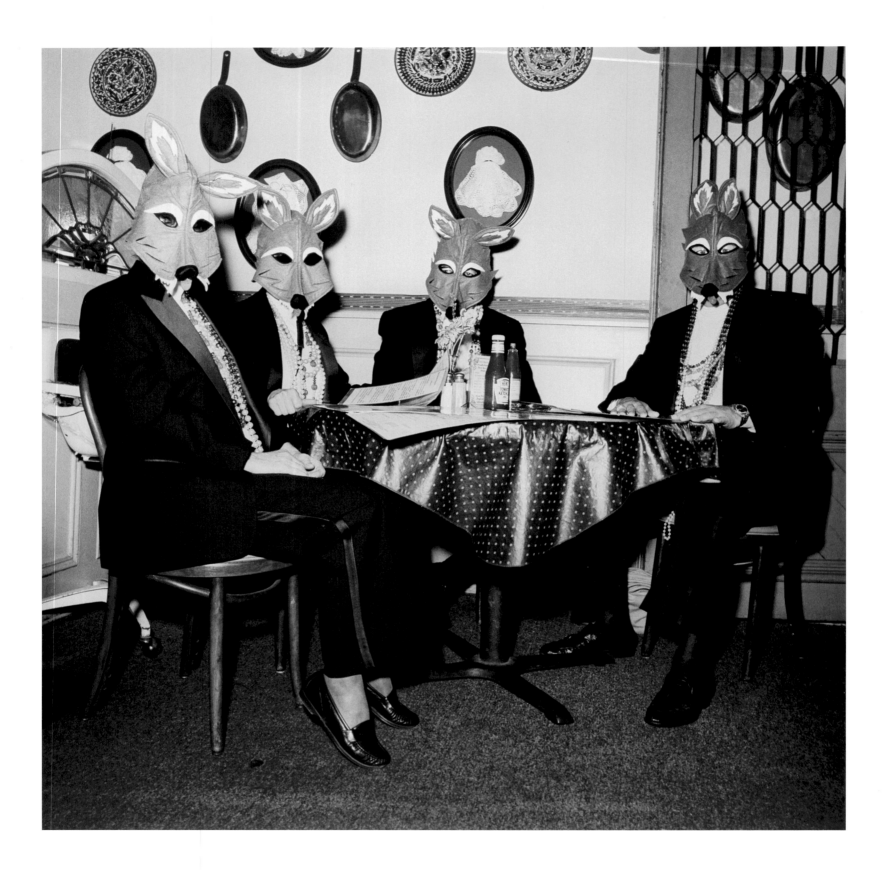

[Foxes' Masquerade, New Orleans, Louisiana, USA, 1993-1994]

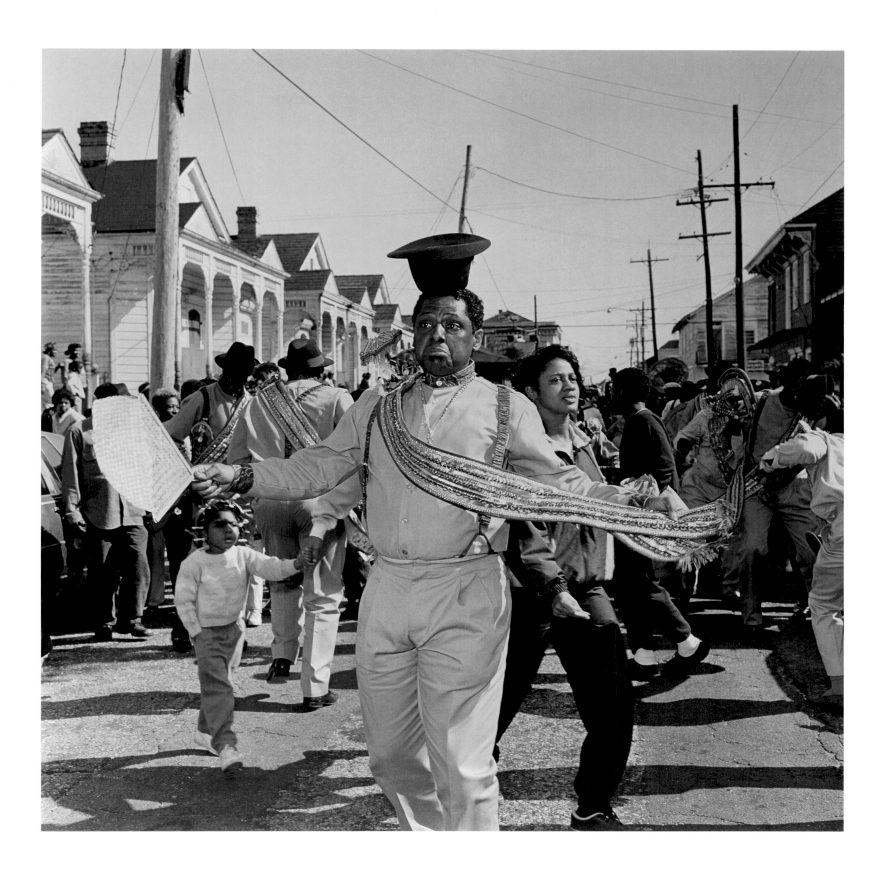

[Tremane Jazz Funeral Dancer, New Orleans, Louisiana, USA, 1993]

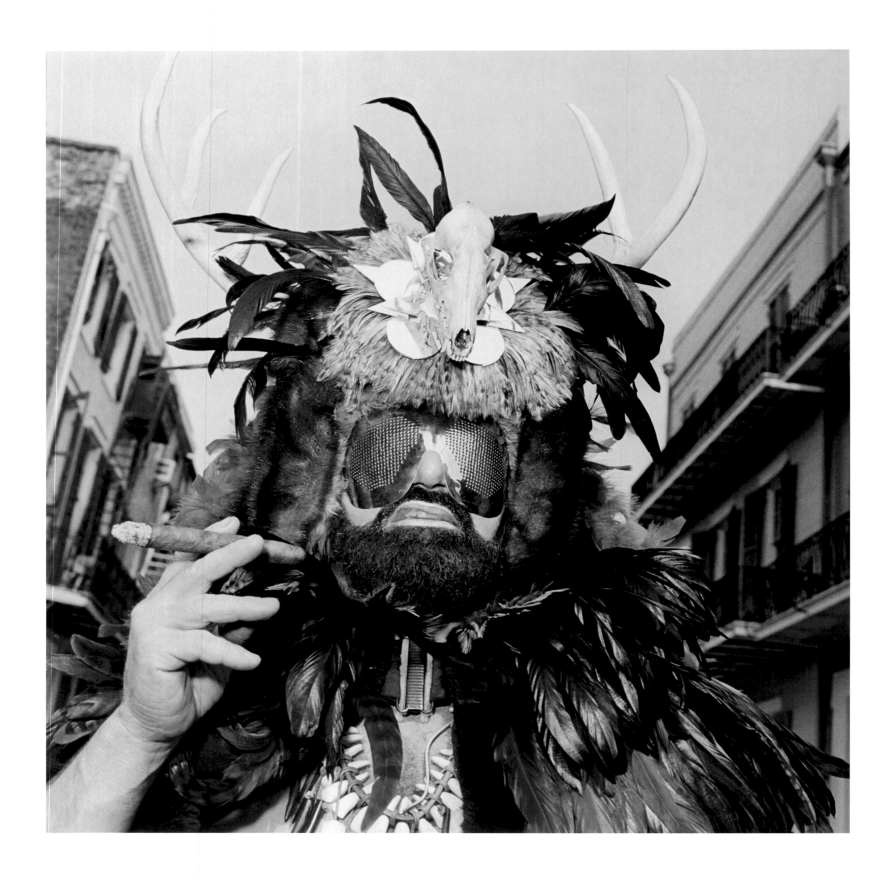

[Fat Tuesday in the Quarter, New Orleans, Louisiana, USA, 1993]

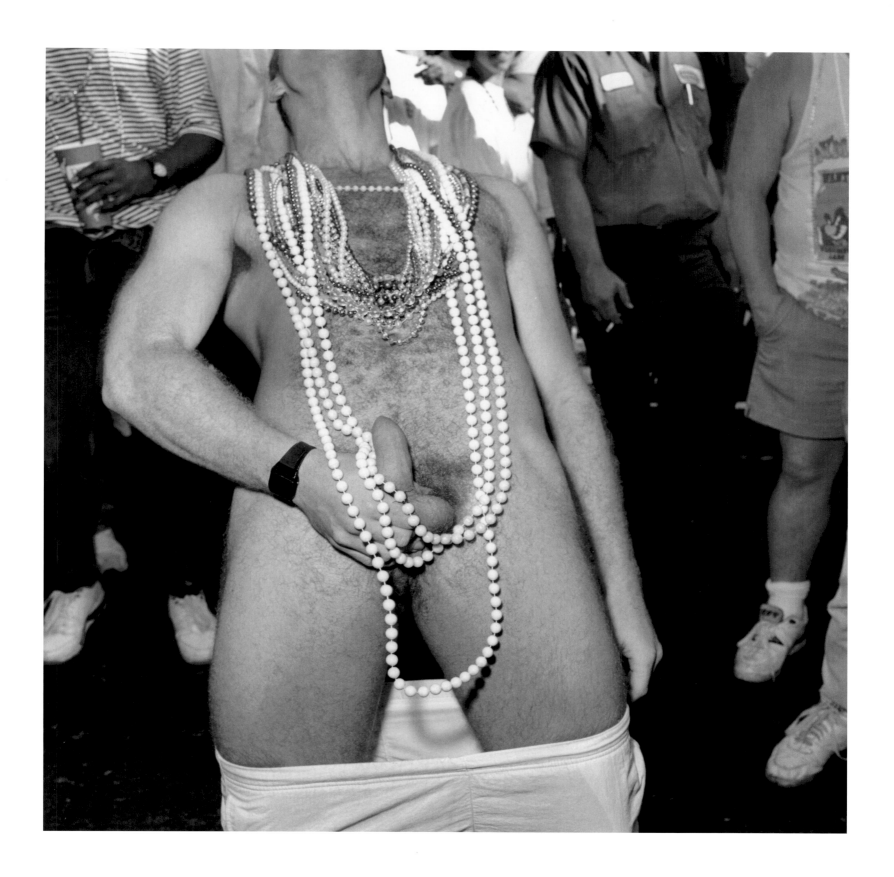

[Show Your Dick, New Orleans, Louisiana, 1992]

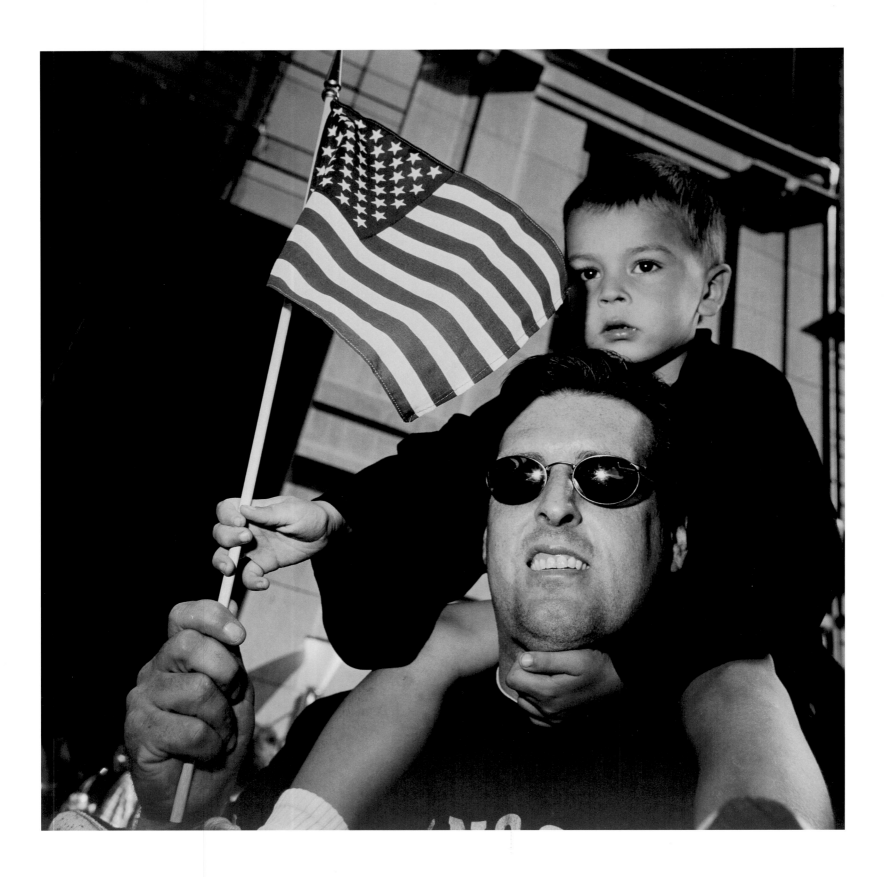

[Father and Son at the Labor Day Parade, New York, New York, USA, 2000]

> Ed Templeton

Place Position

...

All origins are accidental
You've got no papers & no roads lead home anymore
Chance is the root of all place position
All maps are random all scales are wrong
Legal – illegal-
no passion for the difference
Legal – illegal-
false premise forge the nation

May all your borders be porous
Free transmission
Smear genetics c'est la vie

yawn yawn yawn
I can't stifle my boredom
So why not act your age
Fear of contagion
The violence of a fence builder's dream
That masks the phrasing of
"All the pleasures of home"
Legal – illegal-
I want to go home

(Guy Picciotto)

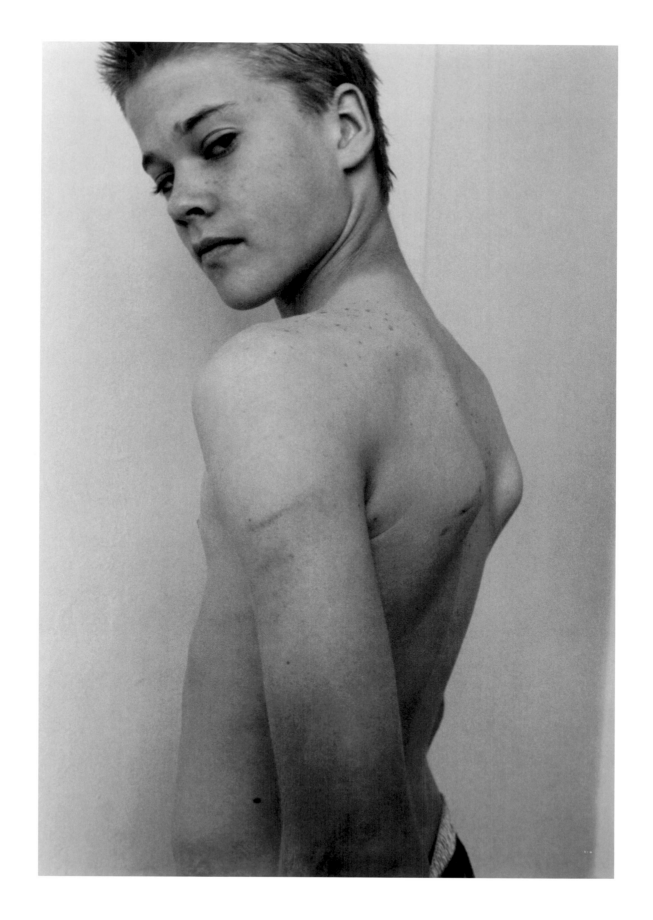

[Tosh, Sydney, 2000]

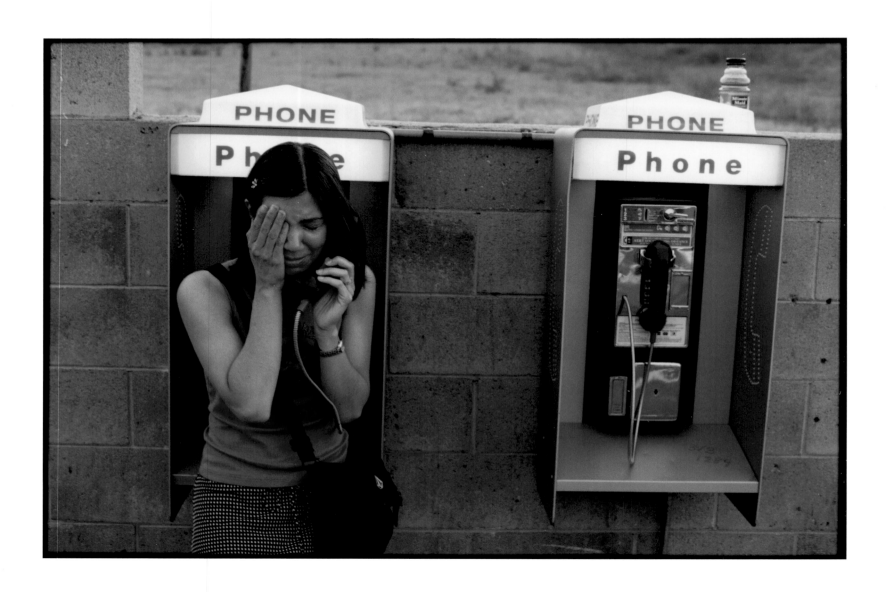

[Deanna gets bad news, California, 2003]

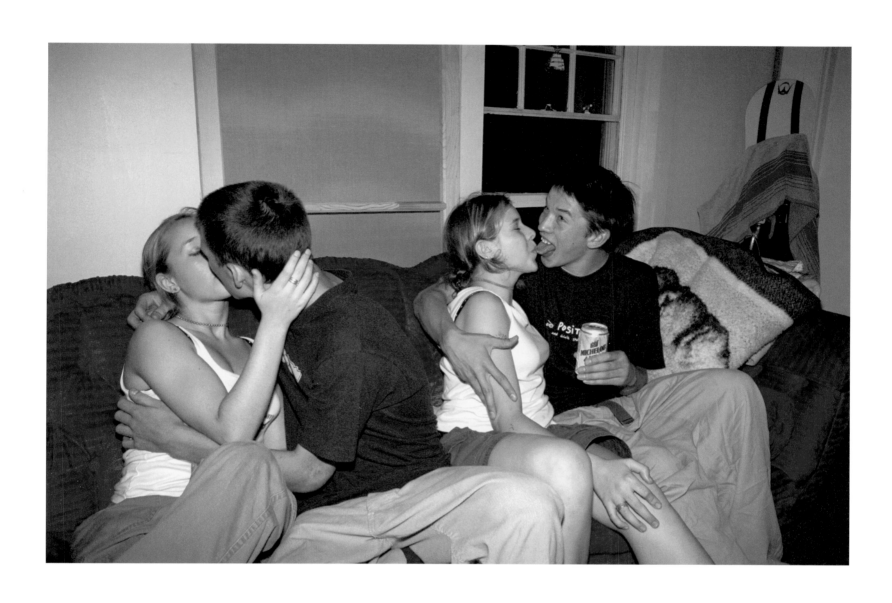

[Satva and Kerry with sisters, Laconia, New Hampshire, 1997]

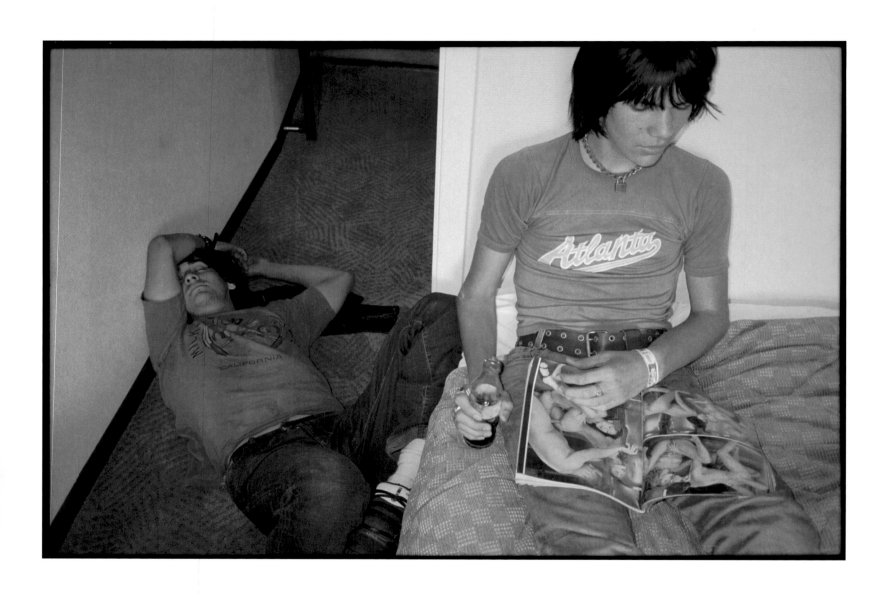

[**Amsterdam, 1998**]

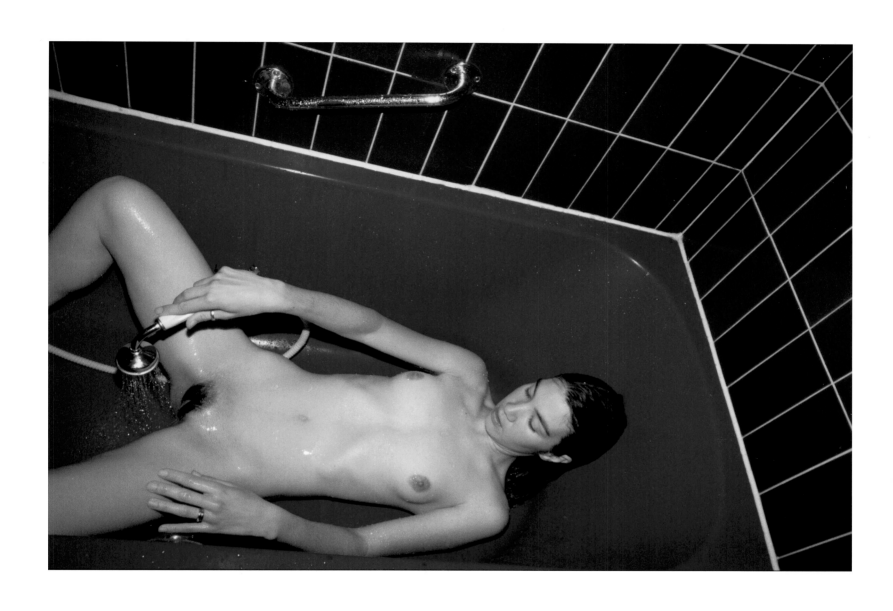

[Corey, Copenhagen, 2002]

　　　[Domestic Scene, Suburbia, 1997]

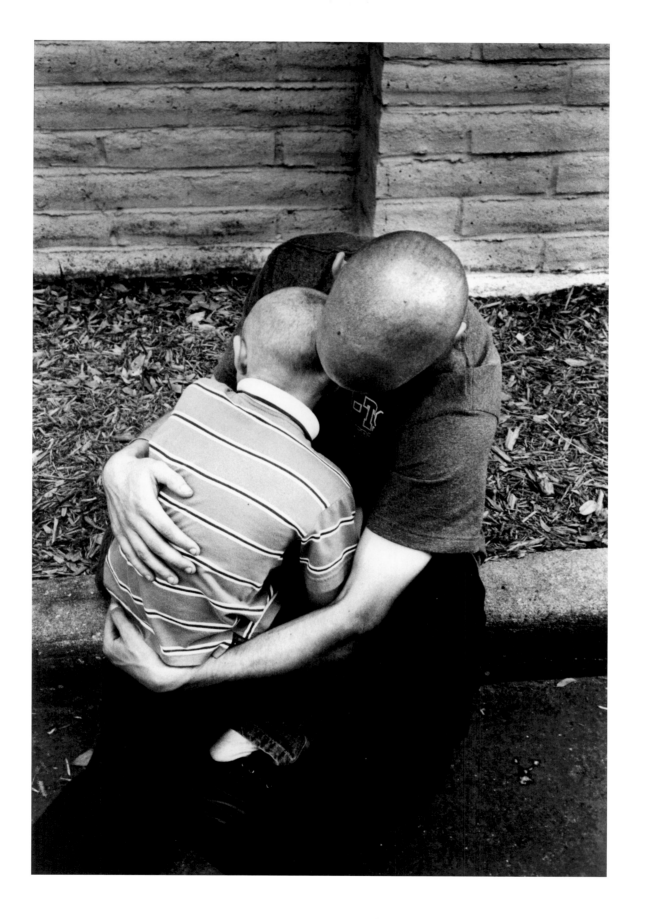

[Chris and Annakin, Florida, 1999]

[Suburban Domestic Lust, California, 1995]

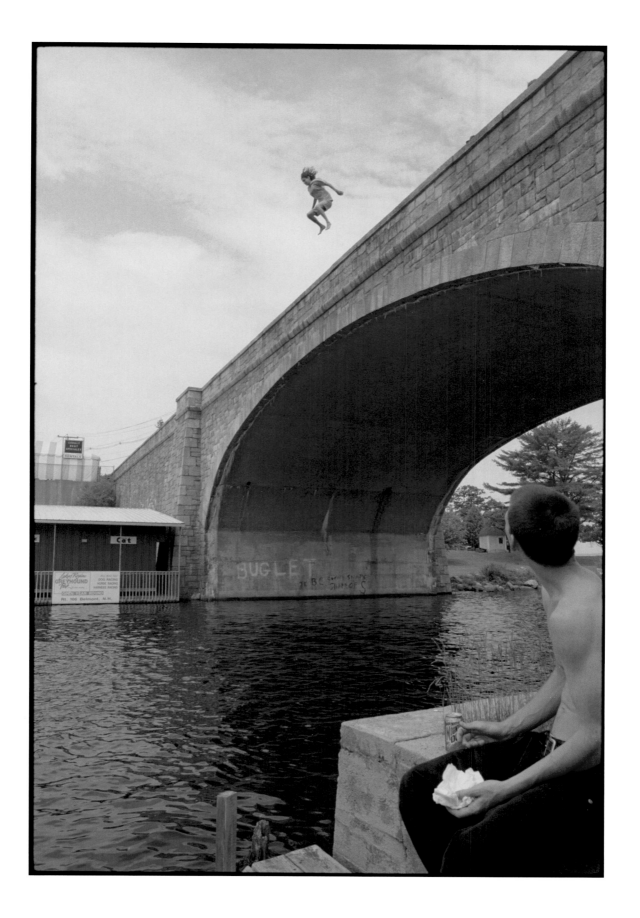

[Elissa, Laconia, New Hampshire, 1997]

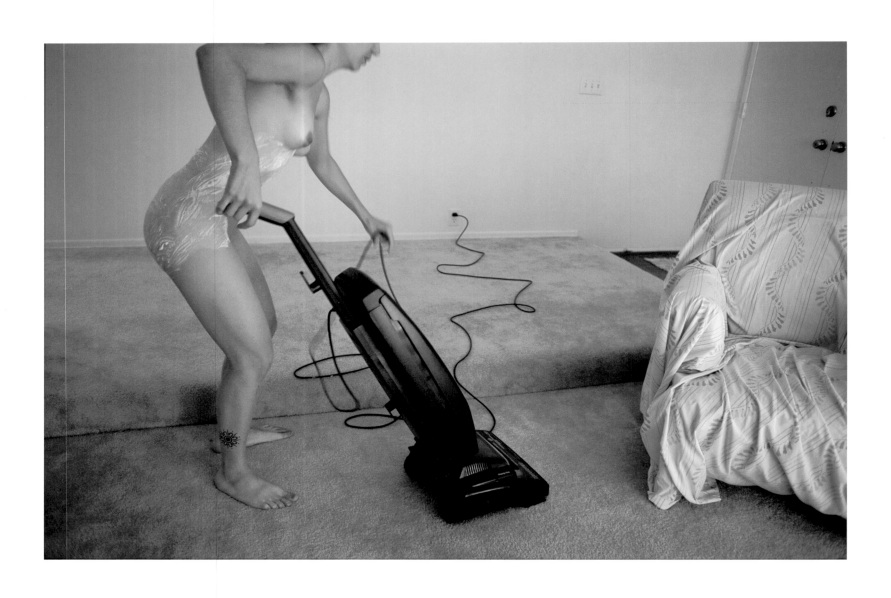

[Suburban Domestic Scene, California, 1998]

> Ryan McGinley

There`s A Place In Hell For Me And My Friends

There is a place
reserved
for me and my friends
and when we go
we all will go
so you see
I'm never alone
there is a place
with a bit more time
and a few more
gentler words
and looking back
we do forgive
(we had no choice
we always did)
all that we hope
is that when we go
our skin
and our blood
and our bones
don't get in your way
making you ill
the way they did
when we lived
There is a place
a place in hell
reserved
for me and my friends
and if ever I
wanted to cry
then I will
because I can

(Morrissey)

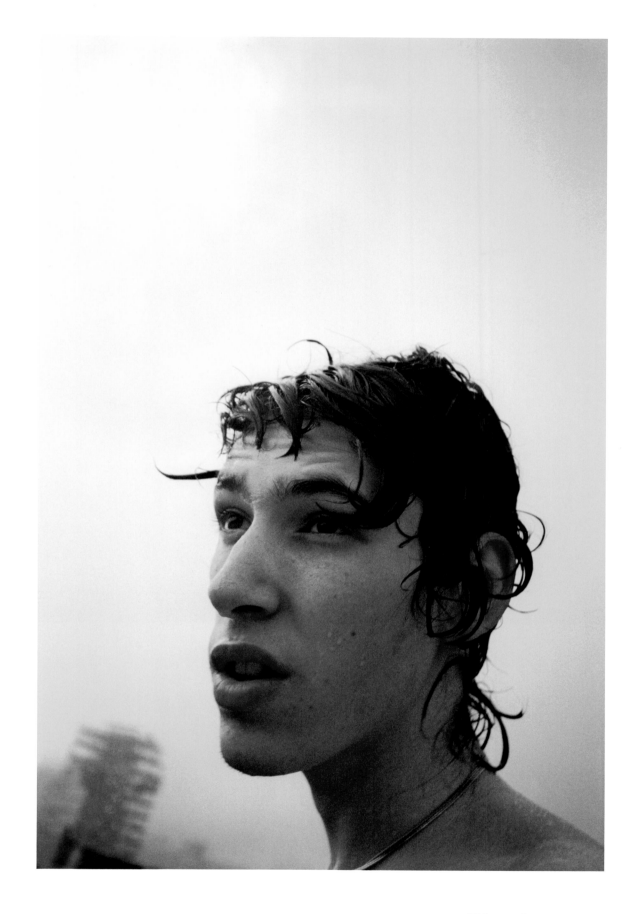

[Eric, 2001]

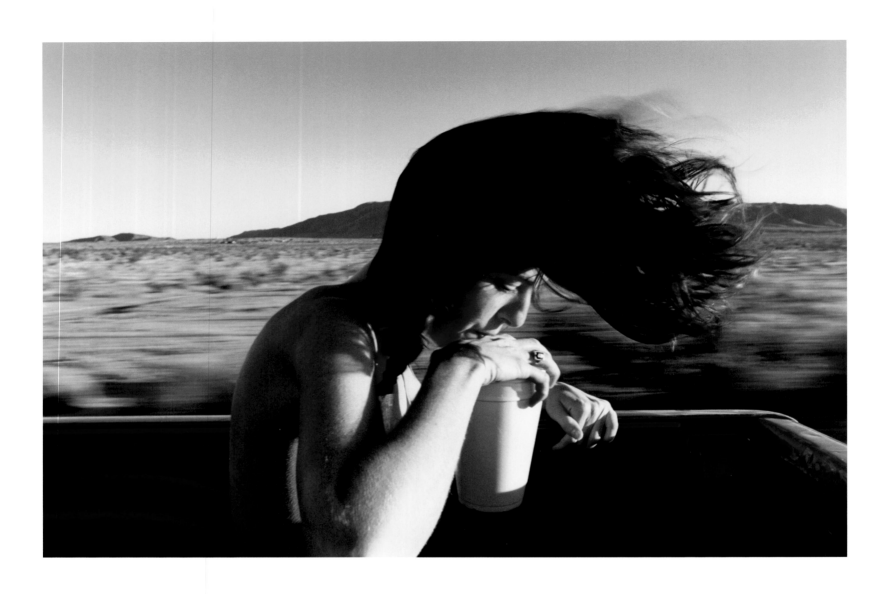

[Dakota (Hair), 2000]

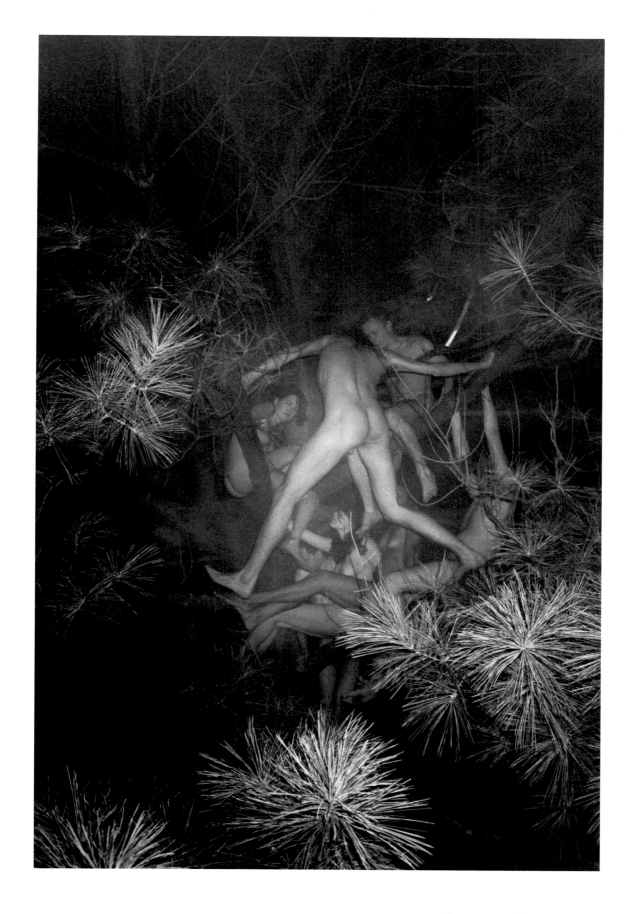

[Tree #1, 2003]

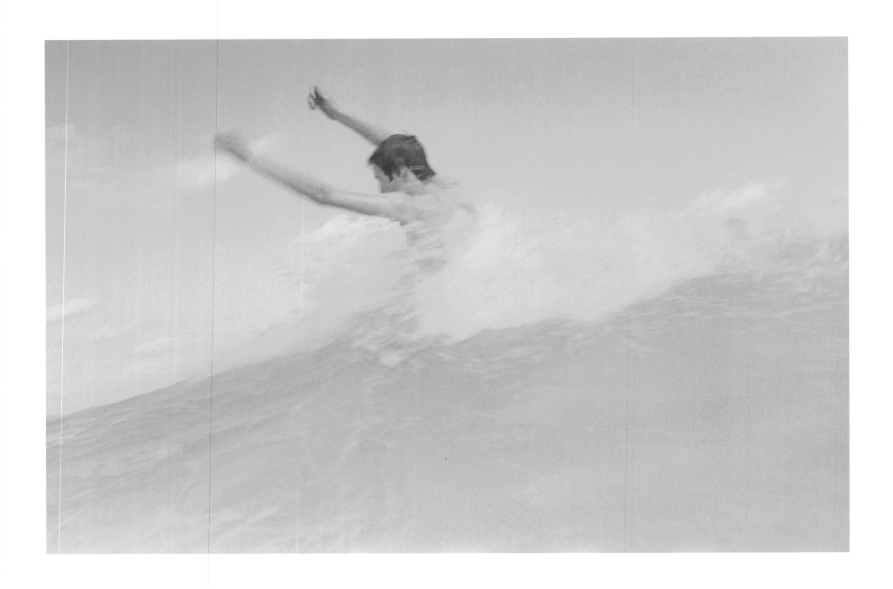

[Wade, Wave, 2004]

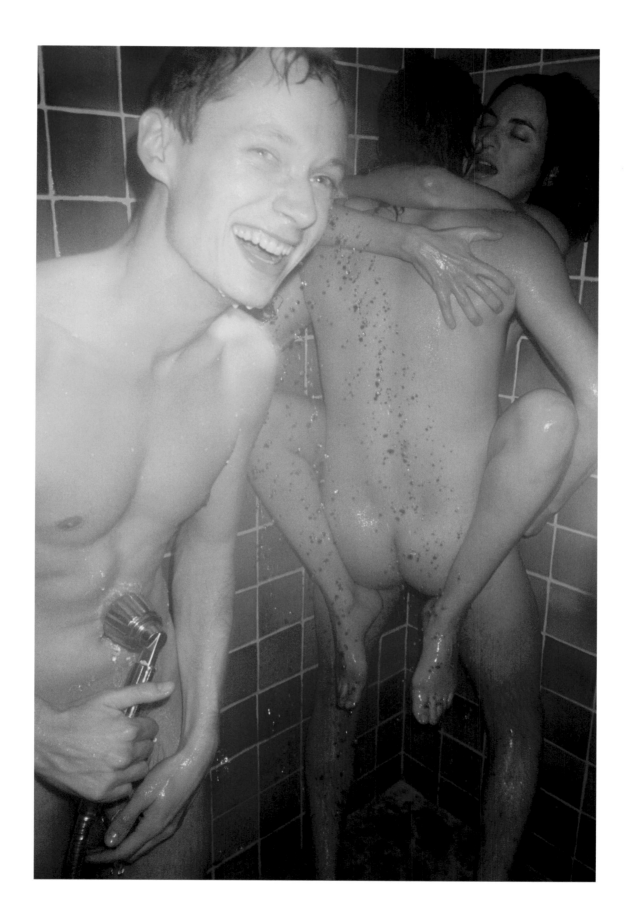

[Untitled (Shower), 2005]

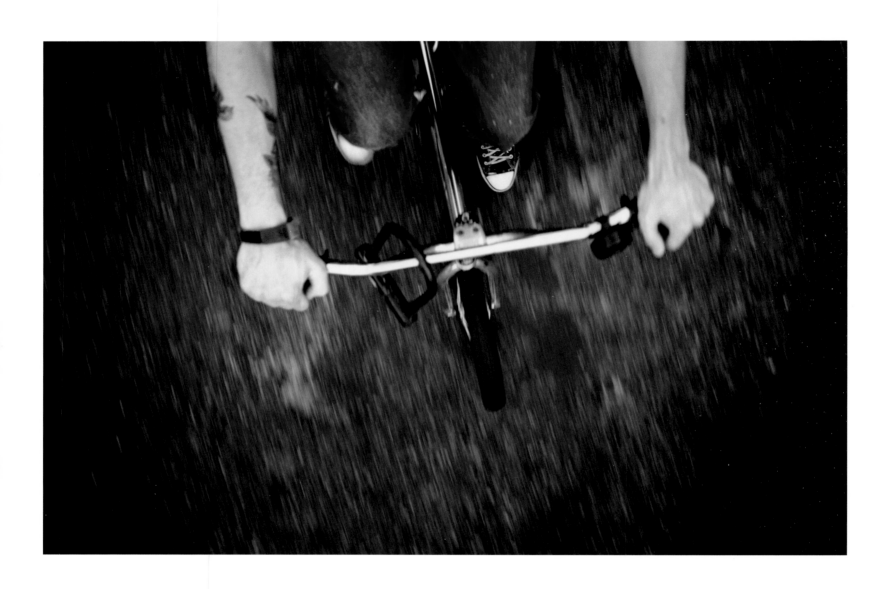

[BMX, 2000]

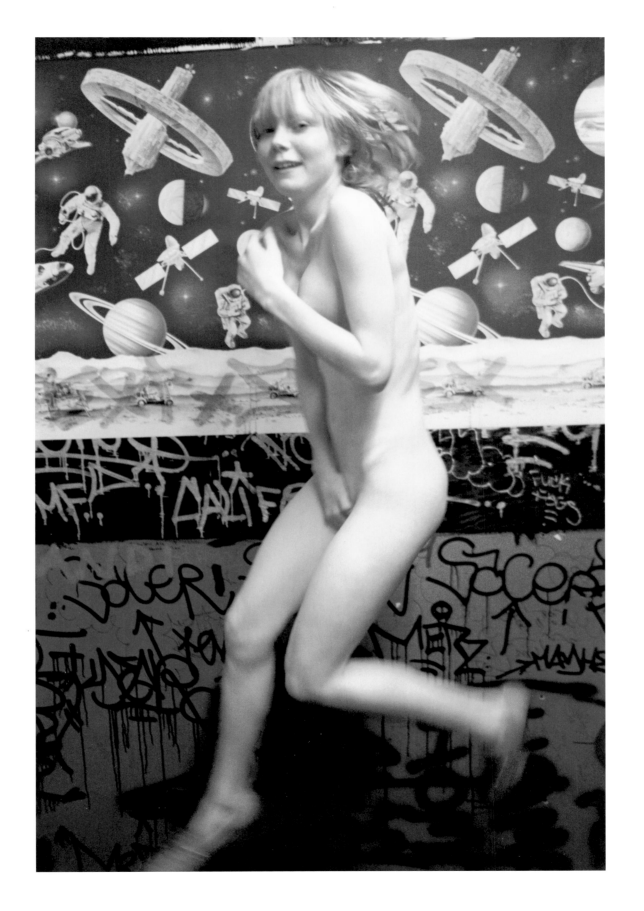

[Lizzy, 2002]

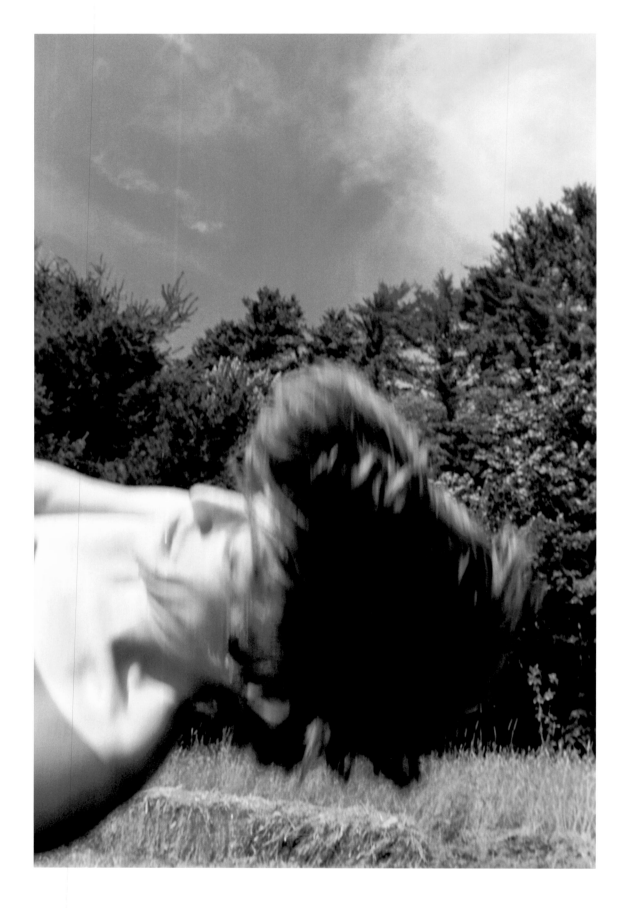

[Tim (Falling), 2003]

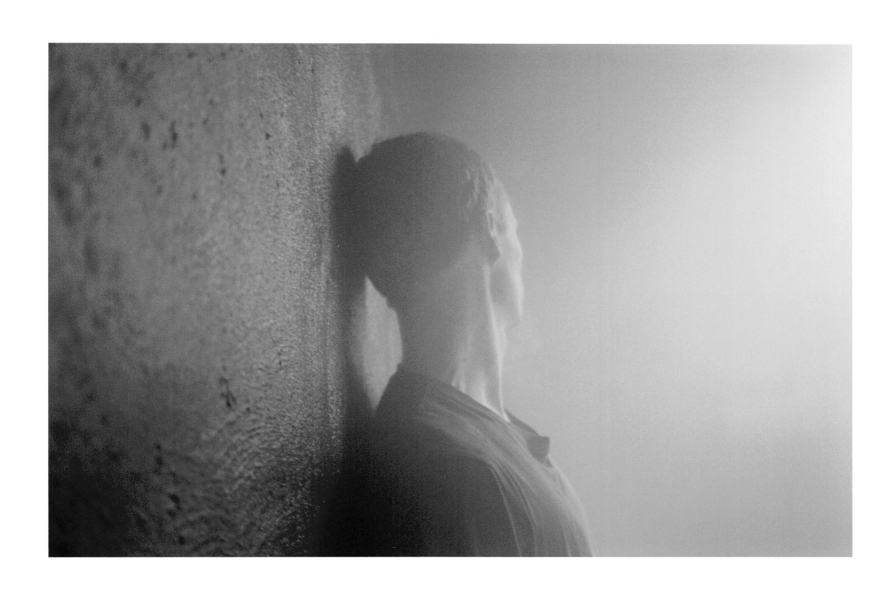

[Wall, 2004]

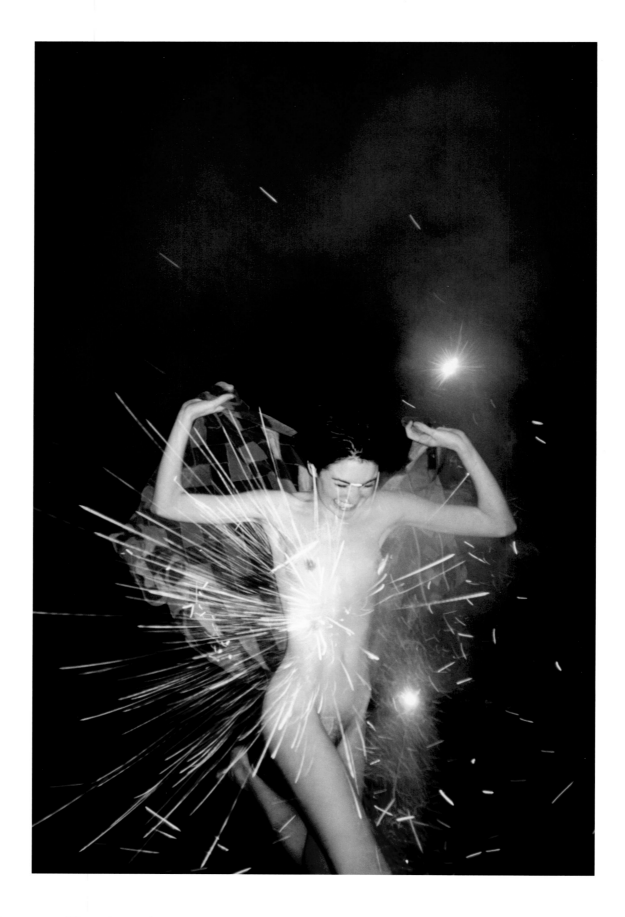

172 | Ryan McGinley [Fireworks, 2002]

Diane Arbus

Child with a toy hand grenade in Central Park, N.Y.C., 1962
Gelatin silver print, printed 1973
37,4 x 37,3 cm
© 1970 The Estate of Diane Arbus, LLC. Photo © National Gallery of Canada. Loan National Gallery of Canada, Ottawa. Purchased 1978
Image p. 97.

Retired man and his wife at home in a nudist camp one morning, N.J., 1963
Gelatin silver print, printed 1973
36,5 x 38,5 cm
© 1971 The Estate of Diane Arbus, LLC. Photo © National Gallery of Canada. Loan National Gallery of Canada, Ottawa. Purchased 1977
Image p. 96.

Xmas tree in a living room in Levittown, L.I., 1963
Gelatin silver print, printed 1973
36,9 x 36,6 cm
© The Estate of Diane Arbus, LLC. Loan National Gallery of Canada, Ottawa. Purchased 1977
Without image.

A young waitress at a nudist camp, N.J., 1963
Gelatin silver print, printed 1973
37,5 x 37 cm
© The Estate of Diane Arbus, LLC. Loan National Gallery of Canada, Ottawa. Purchased 1978
Without image.

Nudist lady with swan sunglasses, Pa., 1965
Gelatin silver print, printed 1973
37,5 x 36,4 cm
© The Estate of Diane Arbus, LLC. Loan National Gallery of Canada, Ottawa. Purchased 1978
Without image.

A young man in curlers at home on West 20th Street, N.Y.C., 1966
Gelatin silver print, printed 1973
39,2 x 38,3 cm
© The Estate of Diane Arbus, LLC. Photo © National Gallery of Canada. Loan National Gallery of Canada, Ottawa. Purchased 1977
Image p. 95.

A young Brooklyn family going for a Sunday outing, N.Y.C., 1966
Gelatin silver print, printed 1973
39,2 x 38 cm
© 1966 The Estate of Diane Arbus, LLC. Photo © National Gallery of Canada. Loan National Gallery of Canada, Ottawa. Purchased 1977
Image p. 94.

Identical twins, Roselle, N.J., 1967
Gelatin silver print, printed 1973
25,2 x 25,4 cm
© The Estate of Diane Arbus, LLC. Loan National Gallery of Canada, Ottawa. Purchased 1974
Without image.

A woman in a bird mask, N.Y.C., 1967
Gelatin silver print, printed 1973
26,8 x 36,9 cm
© The Estate of Diane Arbus, LLC. Loan National Gallery of Canada, Ottawa. Purchased 1977
Without image.

Patriotic boy with a straw hat waiting to march in a pro-war parade, N.Y.C., 1967
Gelatin silver print, printed 1973
38,6 x 38,6 cm
© 1969 The Estate of Diane Arbus, LLC. Photo © National Gallery of Canada. Loan National Gallery of Canada, Ottawa. Purchased 1977
Image p. 93.

A woman with pearl necklace and earrings, N.Y.C., 1967
Gelatin silver print, printed 1973
37,8 x 37 cm
© 1972 The Estate of Diane Arbus, LLC. Loan National Gallery of Canada, Ottawa. Purchased 1978
Without image.

Masked man at a ball, N.Y.C., 1967
Gelatin silver print, printed 1973
38 x 38,8 cm
© 1972 The Estate of Diane Arbus, LLC. Photo © National Gallery of Canada. Loan National Gallery of Canada, Ottawa. Purchased 1978
Image p. 99.

A family on their lawn one Sunday in Westchester, N.Y., 1968
Gelatin silver print
39,3 x 37,4 cm
© 1968 The Estate of Diane Arbus, LLC. Loan National Gallery of Canada, Ottawa. Purchased 1970
Without image.

Topless dancer in her dressing room, San Francisco, Cal., 1968
Gelatin silver print, printed 1973
37,7 x 37,5 cm
© 1972 The Estate of Diane Arbus, LLC. Loan National Gallery of Canada, Ottawa. Purchased 1978
Without image.

Albino sword swallower at a carnival, Md., 1970
Gelatin silver print, printed 1973
36,6 x 37 cm
© 1972 The Estate of Diane Arbus, LLC. Loan National Gallery of Canada, Ottawa. Purchased 1974
Without image.

The King and Queen of a Senior Citizens' Dance, N.Y.C., 1970
Gelatin silver print
37,6 x 36,9 cm
© 1971 The Estate of Diane Arbus, LLC. Loan National Gallery of Canada, Ottawa. Purchased 1977
Without image.

Untitled (6), 1970-71
Gelatin silver print, printed 1973
38,9 x 38,3 cm
© 1972 The Estate of Diane Arbus, LLC. Photo © National Gallery of Canada. Loan National Gallery of Canada, Ottawa. Purchased 1977
Image p. 98.

Untitled (7), 1970-71
Gelatin silver print, printed 1973
38,1 x 37,2 cm
© 1972 The Estate of Diane Arbus, LLC. Photo © National Gallery of Canada. Loan National Gallery of Canada, Ottawa. Purchased 1977
Image p. 100.

Richard Avedon

Boyd Fortin, Thirteen Year Old Rattlesnake Skinner, Sweetwater, Texas, March 10, 1979
Gelatin silver print
150 x 120 cm
AP2/2 edition of 6 + 2 Aps
Courtesy The Richard Avedon Foundation. Copyright © 1980 The Richard Avedon Foundation
Image p. 124.

James Story, Coal Miner, Somerset, Colorado, December 18, 1979
Gelatin silver print
150 x 120 cm
AP2/2 edition of 6 + 2 Aps
Courtesy The Richard Avedon Foundation. Copyright © 1980 The Richard Avedon Foundation
Image p. 118.

Roger Tims, Jim Duncan, Leonard Markley, Don Belak, Coal Miners, Reliance, Wyoming, August 29, 1979
Gelatin silver print
150 x 349 cm
AP2/2 edition of 6 + 2 Aps
Courtesy The Richard Avedon Foundation. Copyright © 1980 The Richard Avedon Foundation
Image pp. 120-121.

Sandra Bennett, Twelve Year Old, Rocky Ford, Colorado, August 23, 1980
Gelatin silver print
150 x 120 cm
AP2/2 edition of 6 + 2 Aps
Courtesy The Richard Avedon Foundation. Copyright © 1980 The Richard Avedon Foundation
Image p. 115.

Juan Patricio Lobato, Carney, Rocky Ford, Colorado, August 23, 1980
Gelatin silver print
150 x 120 cm
AP2/2 edition of 5 + 2 Aps
Courtesy The Richard Avedon Foundation. Copyright © 1980 The Richard Avedon Foundation
Image p. 117.

Allen Silvy, Drifter, Route 93, Chloride, Nevada, December 14, 1980
Gelatin silver print
150 x 120 cm
AP2/2 edition of 5 + 2 Aps
Courtesy The Richard Avedon Foundation.
Copyright © 1980 The Richard Avedon Foundation
Image p. 116.

Billy Mudd, Trucker, Alto, Texas, May 7, 1981
Gelatin silver print
150 x 120 cm
AP2/2 edition of 6 + 2 Aps
Courtesy The Richard Avedon Foundation.
Copyright © 1980 The Richard Avedon Foundation
Without image.

Ronald Fischer, Beekeeper, Davis, California, May 9, 1981
Gelatin silver print
150 x 120 cm
AP2/2 edition of 6 + 2 Aps
Courtesy The Richard Avedon Foundation.
Copyright © 1980 The Richard Avedon Foundation
Image p. 119.

Clifford Feldner, Unemployed Ranch Hand, Golden, Colorado, June 15, 1983
Gelatin silver print
150 x 120 cm
AP2/2 edition of 5 + 2 Aps
Courtesy The Richard Avedon Foundation.
Copyright © 1980 The Richard Avedon Foundation
Image p. 123.

Larry Clark
Tulsa, 1983
b/w-photography
35,5 x 27,8 cm
Museum für Moderne Kunst, Frankfurt am Main. Schenkung aus Privatbesitz.
Courtesy of the artist and Luhring Augustine, New York
Without image.

Tulsa, 1983
b/w-photography
27,8 x 35,5 cm
Museum für Moderne Kunst, Frankfurt am Main. Schenkung aus Privatbesitz.
Courtesy of the artist and Luhring Augustine, New York
Image p. 127.

Tulsa, 1983
b/w-photography
27,8 x 35,5 cm
Museum für Moderne Kunst, Frankfurt am Main. Schenkung aus Privatbesitz.
Courtesy of the artist and Luhring Augustine, New York
Image p. 128.

Tulsa, 1983
b/w-photography
35,5 x 27,8 cm
Museum für Moderne Kunst, Frankfurt am Main. Schenkung aus Privatbesitz. Courtesy of the artist and Luhring Augustine, New York
Image p. 132.

Tulsa, 1983
b/w-photography
27,8 x 35,5 cm
Museum für Moderne Kunst, Frankfurt am Main. Schenkung aus Privatbesitz.
Courtesy of the artist and Luhring Augustine, New York
Image p. 6.

Tulsa, 1983
b/w-photography
35,5 x 27,8 cm
Museum für Moderne Kunst, Frankfurt am Main. Schenkung aus Privatbesitz.
Courtesy of the artist and Luhring Augustine, New York
Image p. 131.

Tulsa, 1983
b/w-photography
35,5 x 27,8 cm
Museum für Moderne Kunst, Frankfurt am Main. Schenkung aus Privatbesitz.
Courtesy of the artist and Luhring Augustine, New York
Image p. 136.

Tulsa, 1983
b/w-photography
35,5 x 27,8 cm
Museum für Moderne Kunst, Frankfurt am Main. Schenkung aus Privatbesitz.
Courtesy of the artist and Luhring Augustine, New York
Image p. 135.

Tulsa, 1983
b/w-photography
27,8 x 35,5 cm
Museum für Moderne Kunst, Frankfurt am Main. Schenkung aus Privatbesitz.
Courtesy of the artist and Luhring Augustine, New York
Image p. 129.

Tulsa, 1983
b/w-photography
27,8 x 35,5 cm
Museum für Moderne Kunst, Frankfurt am Main. Schenkung aus Privatbesitz.
Courtesy of the artist and Luhring Augustine, New York
Image p. 130.

Tulsa, 1983
b/w-photography
35,5 x 27,8 cm
Museum für Moderne Kunst, Frankfurt am Main. Schenkung aus Privatbesitz.
Courtesy of the artist and Luhring Augustine, New York
Image p. 133.

Tulsa, 1983
b/w-photography
35,5 x 27,8 cm
Museum für Moderne Kunst, Frankfurt am Main. Schenkung aus Privatbesitz.
Courtesy of the artist and Luhring Augustine, New York
Image p. 134.

Bruce Davidson
USA. New York City. East 100th Street, 1966
Gelatin silver print
28 x 35 cm
© Bruce Davidson / Magnum Photos
Image p. 57.

USA. New York City. East 100th Street, 1966
Gelatin silver print - 28 x 35 cm
© Bruce Davidson / Magnum Photos
Image p. 58.

USA. New York City. East 100th Street, 1966
Gelatin silver print
28 x 35 cm
© Bruce Davidson / Magnum Photos
Image p. 60.

USA. New York City. East 100th Street, 1966
Gelatin silver print
28 x 35 cm
© Bruce Davidson / Magnum Photos
Image p. 61.

USA. New York City. East 100th Street, 1966
Gelatin silver print
28 x 35 cm
© Bruce Davidson / Magnum Photos
Image p. 62.

USA. New York City. East 100th Street, 1966
Gelatin silver print
28 x 35 cm
© Bruce Davidson / Magnum Photos
Image p. 63.

USA. New York City. East 100th Street, 1966
Gelatin silver print
28 x 35 cm
© Bruce Davidson / Magnum Photos
Image p. 64.

USA. New York City. East 100th Street, 1966
Gelatin silver print
28 x 35 cm
© Bruce Davidson / Magnum Photos
Image p. 65.

USA. New York City. East 100th Street, 1966
Gelatin silver print
28 x 35 cm
© Bruce Davidson / Magnum Photos
Image p. 66.

USA. New York City. East 100th Street, 1968
Gelatin silver print
28 x 35 cm
© Bruce Davidson / Magnum Photos
Image p. 59.

Robert Frank

Benny on 53rd 11th Street, NYC, 1951
Gelatin silver print, signed
35,3 x 27,9 cm
© Robert Frank. Leihgabe Sammlung
Fotomuseum Winterthur, Dauerleihgabe
Vorkart Stiftung
Without image.

Wallstreet (Welcome Home Gen. Mac Arthur), 1951
Gelatin silver print, signed
35,3 x 27,9 cm
© Robert Frank. Leihgabe Sammlung
Fotomuseum Winterthur, Dauerleihgabe
Vorkart Stiftung
Image p. 35.

Ticker Tape, New York, 1951
Gelatin silver print, signed
35,2 x 27,8 cm
© Robert Frank. Leihgabe Sammlung
Fotomuseum Winterthur, Dauerleihgabe
Vorkart Stiftung
Image p. 34.

Hoboken, New Jersey, 1955
Gelatin silver print, signed
80,5 x 60,5 cm
© Robert Frank. Leihgabe Sammlung
Fotomuseum Winterthur, Nachlass George
Reinhart
Without image.

Sagamore Cafeteria, New York City, 1955
Gelatin silver print, signed
40,6 x 50,8 cm
© Robert Frank. Leihgabe Sammlung
Fotomuseum Winterthur, Schenkung Volkart
Stiftung
Image p. 39.

Santa Fe, New Mexico, 1955
Gelatin silver print, signed
27,9 x 35,5 cm
© Robert Frank. Leihgabe Sammlung
Fotomuseum Winterthur, Dauerleihgabe
Vorkart Stiftung
Image p. 40.

Belle Isle, Detroit, 1955
Gelatin silver print, signed
27,8 x 35,4 cm
© Robert Frank. Leihgabe Sammlung
Fotomuseum Winterthur, Dauerleihgabe
Vorkart Stiftung
Without image.

Parade in Hoboken, 1955
Gelatin silver print, signed
20,3 x 25,4 cm
© Robert Frank. Leihgabe Sammlung
Fotomuseum Winterthur, Ankauf mit
Mitteln der Georg und Bertha Schwyzer-
Winiker Stiftung
Image p. 33.

US #285 New Mexico, 1955
Gelatin silver print, signed
35,4 x 27,9 cm
© Robert Frank. Leihgabe Sammlung
Fotomuseum Winterthur, Ankauf mit
Mitteln der Georg und Bertha Schwyzer-
Winiker Stiftung
Image p. 41.

Hoover Dam, Nevada, 1956
Gelatin silver print, signed
40,5 x 30,5 cm
© Robert Frank. Leihgabe Sammlung
Fotomuseum Winterthur, Dauerleihgabe
Vorkart Stiftung
Without image.

Jehova's Witness, Los Angeles, 1956
Gelatin silver print, signed
35,5 x 28 cm
© Robert Frank. Leihgabe Sammlung
Fotomuseum Winterthur, Ankauf mit
Mitteln der Georg und Bertha Schwyzer-
Winiker Stiftung
Image p. 38.

Butte Montana, 1956
Gelatin silver print, signed. Printed 1970
28 x 35,5 cm
© Robert Frank. Leihgabe Sammlung
Fotomuseum Winterthur, Ankauf mit
Mitteln der Georg und Bertha Schwyzer-
Winiker Stiftung
Image p. 42.

Chinese Cemetary, San Francisco, 1956-1960
Gelatin silver print, signed
35,5 x 28 cm
© Robert Frank. Leihgabe Sammlung
Fotomuseum Winterthur, Ankauf mit
Mitteln der Georg und Bertha Schwyzer-
Winiker Stiftung
Without image.

Coney Island, 4th of July, 1958
Gelatin silver print, signed
40,5 x 50,5 cm
© Robert Frank. Leihgabe Sammlung
Fotomuseum Winterthur, Dauerleihgabe
Vorkart Stiftung
Image p. 37.

Coney Island, 4th of July, 1958
Gelatin silver print, signed
50 x 40,5 cm
© Robert Frank. Leihgabe Sammlung
Fotomuseum Winterthur, Dauerleihgabe
Vorkart Stiftung
Image p. 36.

Lee Friedlander
Baltimore, 1962
Gelatin silver print, printed later
28 x 35 cm
© Lee Friedlander, Courtesy Janet Borden
Gallery, New York
Image p. 47.

Baltimore, 1962
Gelatin silver print, printed later
35 x 28 cm
© Lee Friedlander, Courtesy Janet Borden
Gallery, New York
Image p. 53.

Washington, DC, 1962
Gelatin silver print, printed later
28 x 35 cm
© Lee Friedlander, Courtesy Janet Borden
Gallery, New York
Image p. 51.

Nashville, 1963
Gelatin silver print, printed later
35 x 28 cm
© Lee Friedlander, Courtesy Janet Borden
Gallery, New York
Image p. 45.

New York City, 1963
Gelatin silver print, printed later
28 x 35 cm
© Lee Friedlander, Courtesy Janet Borden
Gallery, New York
Image p. 46.

New York City, 1963
Gelatin silver print, printed later
28 x 35 cm
© Lee Friedlander, Courtesy Janet Borden
Gallery, New York
Image p. 49.

New York State, 1965
Gelatin silver print, printed later
28 x 35 cm
© Lee Friedlander, Courtesy Janet Borden
Gallery, New York
Image p. 48.

New York City, 1966
Gelatin silver print, printed later
28 x 35 cm
© Lee Friedlander, Courtesy Janet Borden
Gallery, New York
Image p. 54.

Baltimore, 1968
Gelatin silver print, printed later
28 x 35 cm
© Lee Friedlander, Courtesy Janet Borden
Gallery, New York
Image p. 50.

New Jersey, 1969
Gelatin silver print, printed later
35 x 28 cm
© Lee Friedlander, Courtesy Janet Borden
Gallery, New York
Image p. 52.

Peter Hujar
Jackie Curtis and Lance Loud, 1975
Gelatin silver print
50 x 40 cm
© The Peter Hujar Archive. Courtesy
Matthew Marks Gallery, New York
Without image.

Divine, 1975
Gelatin silver print
38,7 x 38,7 cm
© The Peter Hujar Archive. Courtesy
Matthew Marks Gallery, New York
Without image.

Susan Sontag, 1975
Gelatin silver print
37,5 x 37,5 cm
© The Peter Hujar Archive. Courtesy
Matthew Marks Gallery, New York
Without image.

Night, Downtown, 1976
Gelatin silver print
37,5 x 37,5 cm
© The Peter Hujar Archive. Courtesy
Matthew Marks Gallery, New York
Image p. 104.

Girl in My Hallway, 1976
Gelatin silver print
36,8 x 36,8 cm
© The Peter Hujar Archive. Courtesy
Matthew Marks Gallery, New York
Without image.

No Parking, 1976
Gelatin silver print
36,8 x 37 cm
© The Peter Hujar Archive. Courtesy
Matthew Marks Gallery, New York
Image p. 112.

*Land Fill, Hudson River and New Jersey
Skyline, 1976*
Gelatin silver print
37,5 x 37,5 cm
© The Peter Hujar Archive. Courtesy
Matthew Marks Gallery, New York
Image p. 111.

Christopher Street Pier (#3), 1976
Gelatin silver print
37,5 x 37,5 cm
© The Peter Hujar Archive. Courtesy
Matthew Marks Gallery, New York
Image p. 113.

Bruce de Saint Croix (Standing), 1976
Gelatin silver print
37,3 x 37,3 cm
© The Peter Hujar Archive. Courtesy
Matthew Marks Gallery, New York
Image p. 105.

Pregnant Nude, 1978
Gelatin silver print
38 x 40,4 cm
© The Peter Hujar Archive. Courtesy
Matthew Marks Gallery, New York
Image p. 106.

John Heys in Lana Turner's Gown, 1979
Gelatin silver print
36,8 x 36,8 cm
© The Peter Hujar Archive. Courtesy
Matthew Marks Gallery, New York
Without image.

Gary in Contortion, 1979
Gelatin silver print
37,5 x 40 cm
© The Peter Hujar Archive. Courtesy
Matthew Marks Gallery, New York
Image p. 107.

Tomato du Plenty, 1979
Gelatin silver print
37,5 x 37,5 cm
© The Peter Hujar Archive. Courtesy
Matthew Marks Gallery, New York
Without image.

David Brintzenhofe, 1979
Gelatin silver print
37,5 x 37,5 cm
© The Peter Hujar Archive. Courtesy
Matthew Marks Gallery, New York
Without image.

Wreck, 1980
Gelatin silver print
37,5 x 37,5 cm
© The Peter Hujar Archive. Courtesy
Matthew Marks Gallery, New York
Image p. 109.

*Ethyl Eichelberger as Carlotta, Empress of
Mexico, 1980*
Gelatin silver print
37,5 x 37,5 cm
© The Peter Hujar Archive. Courtesy
Matthew Marks Gallery, New York
Without image.

Nude Blowing Spit Bubble, 1980
Gelatin silver print
37,5 x 37,5 cm
© The Peter Hujar Archive. Courtesy
Matthew Marks Gallery, New York
Without image.

Man Leaning Against Tree, 1981
Gelatin silver print
36,8 x 37,5 cm
© The Peter Hujar Archive. Courtesy
Matthew Marks Gallery, New York
Without image.

Boy on a Park Bench, 1981
Gelatin silver print
37,5 x 37,5 cm
© The Peter Hujar Archive. Courtesy
Matthew Marks Gallery, New York
Without image.

David Wojnarowicz, 1981
Gelatin silver print
37,5 x 37,5 cm
© The Peter Hujar Archive. Courtesy
Matthew Marks Gallery, New York
Image p. 105

Penny Laughing, 1981
Gelatin silver print
37,5 x 37,5 cm
© The Peter Hujar Archive. Courtesy
Matthew Marks Gallery, New York
Without image.

David Brintzenhofe Putting on Make-Up, 1982
Gelatin silver print
37,1 x 37,1 cm
© The Peter Hujar Archive. Courtesy
Matthew Marks Gallery, New York
Image p. 110 (not in exhibition).

Ruined Armchair with Record, 1985
Gelatin silver print
37,5 x 37,5 cm
© The Peter Hujar Archive. Courtesy
Matthew Marks Gallery, New York
Without image.

Sarah Jenkins with Skippy, 1985
Gelatin silver print
37,5 x 37,5 cm
© The Peter Hujar Archive. Courtesy
Matthew Marks Gallery, New York
Without image.

Helen Levitt
New York, c. 1940
Gelatin silver print
28 x 35 cm
Courtesy Laurence Miller Gallery
Image p. 21.

New York, c. 1940
Gelatin silver print
28 x 35 cm
Courtesy Laurence Miller Gallery
Image p. 22.

New York, c. 1940
Gelatin silver print
28 x 35 cm
Courtesy Laurence Miller Gallery
Image p. 23.

New York, c. 1940
Gelatin silver print
28 x 35 cm
Courtesy Laurence Miller Gallery
Image p. 24.
New York, c. 1940
Gelatin silver print
28 x 35 cm
Courtesy Laurence Miller Gallery
Image p. 25.

New York, c. 1940
Gelatin silver print
28 x 35 cm
Courtesy Laurence Miller Gallery
Image p. 26.

New York, c. 1940
Gelatin silver print
28 x 35 cm
Courtesy Laurence Miller Gallery
Image p. 27.

New York, c. 1940
Gelatin silver print
28 x 35 cm
Courtesy Laurence Miller Gallery
Image p. 28.

New York, c. 1940
Gelatin silver print
28 x 35 cm
Courtesy Laurence Miller Gallery
Image p. 29.

New York, c. 1940
Gelatin silver print
28 x 35 cm
Courtesy Laurence Miller Gallery
Image p. 30.

New York, c. 1940
Gelatin silver print
28 x 35 cm
Courtesy Laurence Miller Gallery
Without image.

New York, c. 1940
Gelatin silver print
28 x 35 cm
Courtesy Laurence Miller Gallery
Without image.

New York, c. 1940
Gelatin silver print
28 x 35 cm
Courtesy Laurence Miller Gallery
Without image.

New York, c. 1940
Gelatin silver print
40 x 50 cm
Courtesy Laurence Miller Gallery
Without image.

New York, c. 1940
Gelatin silver print
40 x 50 cm
Courtesy Laurence Miller Gallery
Without image.

Ryan McGinley
Dakota (Hair), 2000
c-print
76 x 101 cm
© Ryan McGinley, Courtesy Team Gallery,
New York
Image p. 164.
BMX, 2000
c-print
101 x 76 cm
© Ryan McGinley, Courtesy Team Gallery,
New York
Image p. 168 (not in exhibition).

Eric, 2001
c-print
76 x 101 cm
© Ryan McGinley, Courtesy Team Gallery,
New York
Image p. 163.

Lizzy, 2002
c-print
76 x 101 cm
© Ryan McGinley, Courtesy Team Gallery,
New York
Image p. 169.

Fireworks, 2002
c-print
101 x 76 cm
© Ryan McGinley, Courtesy Team Gallery,
New York
Image p. 174 (not in exhibition).

Tree #1, 2003
c-print
101 x 76 cm
© Ryan McGinley, image courtesy Team
Gallery, New York, collection of Paul Bright,
ontario, Canada
Image p. 165.

Tim (Falling), 2003
c-print
76 x 101 cm
© Ryan McGinley, Courtesy Team Gallery,
New York
Image p. 170.

Wade, Wave, 2004
c-print
101 x 76 cm
© Ryan McGinley, image courtesy Team
Gallery, New York
Image p. 166 (not in exhibition).

Wall, 2004
c-print
76 x 101 cm
© Ryan McGinley, Courtesy Team Gallery,
New York
Image p. 171.

Untitled (Shower), 2005
c-print
101 x 76 cm
© Ryan McGinley, Courtesy Team Gallery,
New York
Image p. 167.

Gordon Parks
American Gothic, 1942
Gelatin silver print, printed later
28 x 35 cm
© Gordon Parks Estate. Courtesy Howard
Greenberg Gallery
Image p. 69.

Battered Man, 1943
Gelatin silver print, printed 1943
28 x 35 cm
© Gordon Parks Estate. Courtesy Howard
Greenberg Gallery
Image p. 72.

Gang Member with Brick, 1948
Gelatin silver print, printed later
28 x 35 cm
© Gordon Parks Estate. Courtesy Howard
Greenberg Gallery
Image p. 70.

Gang Victim, 1948
Vintage gelatin silver print
28 x 35 cm
© Gordon Parks Estate. Courtesy Howard
Greenberg Gallery
Image p. 71.

*Red Jackson & Hervie Levy study wounds on
face of slain gang member Maurice Gaines,
1948*
Gelatin silver print; printed c. 1948
28 x 35 cm
© Gordon Parks Estate. Courtesy Howard
Greenberg Gallery
Image p. 73.

Emerging Man, 1952
Gelatin silver print, printed later
28 x 35 cm
© Gordon Parks Estate. Courtesy Howard
Greenberg Gallery
Image p. 75.

Soapbox Orator, 1952
Gelatin silver print, printed later
28 x 35 cm
© Gordon Parks Estate. Courtesy Howard
Greenberg Gallery
Image p. 77.

Black Classroom, Birmingham, Alabama, 1956
Gelatin silver print, printed later
28 x 35 cm
© Gordon Parks Estate. Courtesy Howard
Greenberg Gallery
Without image.

*William Causey's Son with Gun During
Violence in Alabama, 1956*
Gelatin silver print, printed later
28 x 35 cm
© Gordon Parks Estate. Courtesy Howard
Greenberg Gallery
Image p. 74.

Ethel Shariff in Chicago, 1963
Gelatin silver print, printed later
28 x 35 cm
© Gordon Parks Estate. Courtesy Howard
Greenberg Gallery
Image p. 76.

*Newsman being Frisked at Muslim rally in
Chicago, 1964*
Vintage gelatin silver print
28 x 35 cm
© Gordon Parks Estate. Courtesy Howard
Greenberg Gallery
Without image.

*Fontenelle Family at the Poverty Board: Bessie
and Kenneth, Little richard, Norman, Jr., and
Ellen, 1967*
Gelatin silver print, printed later
28 x 35 cm
© Gordon Parks Estate. Courtesy Howard
Greenberg Gallery
Without image.

Ellen, Crying, 1968
Gelatin silver print, printed later
28 x 35 cm
© Gordon Parks Estate. Courtesy Howard
Greenberg Gallery
Without image.

Eldridge Cleaver and Wife, Kathleen with Portrait of Huey Newton, Algiers, 1970
Gelatin silver print, printed later
28 x 35 cm
© Gordon Parks Estate. Courtesy Howard Greenberg Gallery
Image p. 78.

Rosalind Solomon
A Snakehandler's Living Room, New Orleans, Louisiana, USA, 1992
Gelatin silver print
38,7 x 38,7 cm
© 1992 Rosalind Solomon. All rights reserved.
Photographer: Rosalind Solomon
Image p. 139.

A Mardi Gras Party, New Orleans, Louisiana, USA, 1992
Gelatin silver print
38,7 x 38,7 cm
© 1992 Rosalind Solomon. All rights reserved.
Photographer: Rosalind Solomon
Without image.

Grey Fairy on Dauphine Street, New Orleans, Louisiana, USA, 1992
Gelatin silver print
38,7 x 38,7 cm
© 1992 Rosalind Solomon. All rights reserved.
Photographer: Rosalind Solomon
Without image.

Show Your Dick, New Orleans, Louisiana, 1992
Gelatin silver print
38,7 x 38,7 cm
© 1992 Rosalind Solomon. All rights reserved.
Photographer: Rosalind Solomon
Image p. 147.

Tremane Jazz Funeral Dancer, New Orleans, Louisiana, USA, 1993
Gelatin silver print
38,7 x 38,7 cm
© 1993 Rosalind Solomon. All rights reserved.
Photographer: Rosalind Solomon
Image p. 145.

Fat Tuesday in the Quarter, New Orleans, Louisiana, USA, 1993
Gelatin silver print
38,7 x 38,7 cm
© 1993 Rosalind Solomon. All rights reserved.
Photographer: Rosalind Solomon
Image p. 146.

Foxes' Masquerade, New Orleans, Louisiana, USA, 1993-1994
Gelatin silver print
38,7 x 38,7 cm
© 1994 Rosalind Solomon. All rights reserved.
Photographer: Rosalind Solomon
Image p. 144.

Mardi Gras Queen, New Orleans, Louisiana, USA, 1994
Gelatin silver print
38,7 x 38,7 cm
© 1994 Rosalind Solomon. All rights reserved.
Photographer: Rosalind Solomon
Without image.

Police Museum Tour, Miami, Florida, USA, 1994
Gelatin silver print
38,7 x 38,7 cm
© 1994 Rosalind Solomon. All rights reserved.
Photographer: Rosalind Solomon
Image p. 142.

Jane the Hatter, New Orleans, Louisiana, 1994
Gelatin silver print
38,7 x 38,7 cm
© 1994 Rosalind Solomon. All rights reserved.
Photographer: Rosalind Solomon
Image p. 141.

"Seven and a Half Months Pregnant and I Want to Go Home", New York, New York, USA, 2000
Gelatin silver print
38,7 x 38,7 cm
© 2000 Rosalind Solomon. All rights reserved. Photographer: Rosalind Solomon
Image p. 140.

"I Wasn't Assaulted I Was Armed", Washington D.C., USA, 2000
Gelatin silver print
38,7 x 38,7 cm
© 2000 Rosalind Solomon. All rights reserved. Photographer: Rosalind Solomon
Image p. 143.

Father and Son at the Labor Day Parade, New York, New York, USA, 2000
Gelatin silver print
38,7 x 38,7 cm
© 2000 Rosalind Solomon. All rights reserved. Photographer: Rosalind Solomon
Image p. 148.

Ed Templeton
30 seconds in my shoes, 2006
Installation, mixed media and variable dimensions
variable dimensions
Courtesy of the artist and Roberts & Tilton, Los Angeles
Images pp. 151-160.

Burk Uzzle
Woodstock, 1969
Gelatin silver print
35 x 28 cm
© Burk Uzzle. Courtesy Laurence Miller Gallery
Image p. 81.

Woodstock, 1969
Gelatin silver print
35 x 28 cm
© Burk Uzzle. Courtesy Laurence Miller Gallery
Image p. 82.

Woodstock, 1969
Gelatin silver print
35 x 28 cm
© Burk Uzzle. Courtesy Laurence Miller Gallery
Image p. 83.

Woodstock, 1969
Gelatin silver print
28 x 35 cm
© Burk Uzzle. Courtesy Laurence Miller Gallery
Image p. 84.

Woodstock, 1969
Gelatin silver print
28 x 35 cm
© Burk Uzzle. Courtesy Laurence Miller Gallery
Image p. 85.

Woodstock, 1969
Gelatin silver print
28 x 35 cm
© Burk Uzzle. Courtesy Laurence Miller Gallery
Image p. 86.

Woodstock, 1969
Gelatin silver print
28 x 35 cm
© Burk Uzzle. Courtesy Laurence Miller Gallery
Image p. 87.

Woodstock, 1969
Gelatin silver print
28 x 35 cm
© Burk Uzzle. Courtesy Laurence Miller Gallery
Image p. 88.

Woodstock, 1969
Gelatin silver print
28 x 35 cm
© Burk Uzzle. Courtesy Laurence Miller Gallery
Image p. 89.

Woodstock, 1969
Gelatin silver print
28 x 35 cm
© Burk Uzzle. Courtesy Laurence Miller Gallery
Image p. 90.

Woodstock, 1969
Gelatin silver print
28 x 35 cm
© Burk Uzzle. Courtesy Laurence Miller Gallery
Without image.

Woodstock, 1969
Gelatin silver print
28 x 35 cm
© Burk Uzzle. Courtesy Laurence Miller Gallery
Without image.

Woodstock, 1969
Gelatin silver print
28 x 35 cm
© Burk Uzzle. Courtesy Laurence Miller Gallery
Without image.

Geboren 1913 in Brooklyn, New York, lebt und arbeitet in New York.

Helen Levitt verließ die High School einen Monat vor dem Abschluss und begann als komerzielle Fotografin in der Bronx zu arbeiten. Bald fotografierte sie auch für sich selbst, wobei sie Sujets mit sozialem Hintergrund wählte: „Ich habe beschlossen Fotos von Menschen aus der Arbeiterklasse zu machen und zu sozialen Bewegungen beizutragen", sagt sie. „Was immer auch das für Bewegungen sein mögen – Sozialismus, Kommunismus, was immer eben stattfindet. Und ich habe die Bilder von Cartier Bresson gesehen und dabei verstanden, dass Fotografie eine Kunst sein kann, und das hat meinen Ambitionen geweckt."

Helen Levitt geht niemals mit dem sozialen Elend hausieren, die Gesten, die gesamte Körpersprache, die ihre Bilder einfangen, sind Zeugnisse von Ausstrahlung und Vitalität. Von ihr stammen einige der unvergesslichen Fotografien der Straßen im New York der 1930er und 1940er Jahre, einer Zeit als das Leben noch auf den Straßen stattfindet. Levitt geht fotografierend durch die Stadt, vor allem in Spanish Harlem. Ihre Bilder sind zärtlich, geistreich und intim.

Sie gehörte auch zur New Yorker Boheme. 1938 zeigte sie Walker Evans und dem Schriftsteller James Agee, mit dem sie auch befreundet ist, einige ihrer Fotografien und sie half Evans seine Ausstellung *American Photographs* im Museum of Modern Art vorzubereiten.

1941 reiste sie mit Agees Frau Alma nach Mexiko. Nach ihrer Rückkehr arbeitete sie als Cutterin bei Luis Buñuel, der zu jener Zeit Filme machte, die vom Museum of Modern Art, New York, gefördert wurden. 1943 fand Helen Levitts erste Einzelausstellung im Museum of Modern Art statt. Von 1944 bis 1945 arbeitete sie als Schnittassistentin in der Film Division of the Office of War Information (OWI) in New York. Da sie im Fotojournalismus für sich selbst keine Berufsaussichten sah, wandte sie sich mehr dem Dokumentarfilm zu. *In the Street* ist der Titel ihres ersten fünfzehnminütigen Filmes aus dem Jahr 1944. Er stellte auf gewisse Weise eine kinematografische Umsetzung ihrer fotografischen Arbeit dar. Gleichzeitig war er bahnbrechend für eine neue Tendenz des amerikanischen Experimentalfilms. In Zusammenarbeit mit James Agee und Janice Loeb entsand drei Jahre später *The Quiet One*, ein Film der 1948 als bester Dokumentarfilm für den Oscar nominiert wurde. Levitts Filme gelten als Vorläufer des unabhängigen Low-Budget-Kinos.

In den 1950er Jahren kehrte sie zur Fotografie zurück und begann in Farbe zu arbeiten. 1959 und 1960 erhielt sie jeweils ein Guggenheim-Stipendium. Ab Mitte der 1970er Jahre unterrichtete sie am Pratt Institute in Brooklyn. In den 1980er Jahren wandte sie sich erneut der Schwarzweißfotografie zu.

AUSGEWÄHLTE BIBLIOGRAFIE
> *Slide show*, PowerHouse Books, New York 2005.
> *Crosstown*, PowerHouse Books, New York 2002.
> *Helen Levitt*, Centre national de la Photographie, Paris 2001.
> *Helen Levitt*, Peter Weiermair, Prestel Verlag, München 1998.
> *Mexico City*, Center for Documentary Studies, New York 1997.
> *In the street*, Duke University Press, Durham 1992.

Born 1913 in Brooklyn, New York; lives in New York.

Helen Levitt left high school a month before examinations, and went to work for a commercial photographer in the Bronx. Soon she started taking pictures of her own, looking for subjects with social meaning. "I decided I should take pictures of working class people and contribute to the movements," she said. "Whatever movements there were – Socialism, Communism, whatever was happening. And then I saw pictures of Cartier Bresson, and realized that photography could be an art – and that made me ambitious."

Helen Levitt never exploits social injustice. The gestures and the body language in her photographs are testimonies of radiance and vitality. She created some of the most indelible photographs of New York City street scenes in the 1930s and 1940s. It was a time when indoor temptations didn't yet lure people off the street. Levitt would walk all over the city, shooting, for the most part, in the streets of Spanish Harlem. Her photographs are tender, and witty, and intimate.

Helen Levitt belongs to the New York bohemia. In 1938 she shows Walker Evans and writer James Agee, with whom she also shares a friendship, some of her photographs. She assists Evans in the preparation of his exhibition *American Photographs* at the Museum of Modern Art.

In 1941 she travels with Agees wife, Alma, to Mexico. After her return, she works as an editor for Luis Buñuel, who, at that time, was making films subsidized by the Museum of Modern Art in New York. In 1943 Helen Levitt has her first solo exhibition at the Museum of Modern Art. From 1944 to 1945 she works as an assistant editor at the Film Division of the Office of War Information (OWI) in New York. Since she did not see photojournalism as a career opportunity for herself, she directed her focus toward documentary film. *In the Street*, was the title of her 15 minute long movie from 1944. In a way, this film is a cinematographic translation of her photographic work. At the same time, the film is considered groundbreaking, for taking experimental film into a new direction. In cooperation with James Agee and Janice Loeb, she shot *The Quiet One*. In 1948, this film was nominated for an Oscar in the category for best documentary. Levitt is considered a trailblazer in the field of low-budget, independent cinema.

In 1950 she returns to photography, beginning to work in colour. In 1959 and 1960 she is awarded a Guggenheim Fellowship. In the mid-70's she begins teaching at the Pratt Institute in Brooklyn. During the 1980's she devotes herself to black and white photography once again.

SELECTED BIBLIOGRAPHY
> *Slide show*, PowerHouse Books, New York, 2005.
> *Crosstown*, PowerHouse Books, New York, 2002.
> *Helen Levitt*, Centre national de la Photographie, Paris, 2001.
> *Helen Levitt*, Peter Weiermair, Prestel Verlag, München, 1998.
> *Mexico City*, Center for Documentary Studies, New York, 1997.
> *In the Street*, Duke University Press, Durham, 1992.

Robert Frank

Geboren 1924 in Zürich/Schweiz, lebt und arbeitet in den USA und in Mabou/Kanada.

Robert Frank begann 1942 eine Ausbildung bei dem Züricher Fotografen und Grafiker Hermann Segesser. Im Jahr 1947 verließ er Europa und übersiedelte nach New York, wo er als Modefotograf für Alexey Brodovitch tätig war.

1950 nahm Robert Frank an der von Edward Steichen kuratierten Gruppenausstellung *51 American Photographers* teil, die das Museum of Modern Art in New York zeigte. Auf einer Reise zu einem 4th of July-Picknick nach Upstate New York im Jahr 1954 entstanden die ersten Aufnahmen für sein legendäres Buch *The Americans*. Als erster Europäer erhielt Robert Frank 1955 ein einjähriges Stipendium der John Simon Guggenheim Memorial Foundation für ein Fotoprojekt über die Vereinigten Staaten. Er reiste mit dem Auto quer durch die USA, u.a. nach North und South Carolina, Detroit, Florida, Atlanta, North Georgia, Alabama, den Mississippi entlang, nach New Orleans, Houston, Texas, New Mexico, Arizona, Nevada und auf der Route 66 nach Los Angeles. Aus dem Material dieser Reise entstand ein ungeschmicktes Portrait Amerikas.

Im Vorwort des 1958 erschienenen Buches *The Americans* schreibt Jack Kerouac: „Franks Bilder gewinnen Amerika ein trauriges süßes Gedicht ab", eine Traurigkeit, die sich im einsamen Blick von Kellnerinnen in billigen Absteigen, bei Begräbnisbesuchern oder in Gesichtern, verzerrt im grellen Licht der Jukeboxes findet. Die leicht versetzten Blickwinkel und die Verschwommenheit im Zentrum vieler Bilder vermitteln die Nervosität und Deplaziertheit der portraitierten Personen. Frank zerstreut romantische Vorstellungen vom amerikanischen Pioniergeist, indem er ein Bild von Menschen und Orten ohne jede Hoffnung und Aussicht zeigt.

Sein Abweichen von den damals vorherrschenden Konventionen in der Fotografie machte es Frank zunächst schwer einen amerikanischen Verleger zu finden. Das Buch wurde in Paris bei Robert Delpire unter dem Titel „*Les Americains*" veröffentlicht, ehe es bei 1959 Grove in den USA erschien, wo es zunächst heftige Kritik auslöste.

Zu dieser Zeit wandte sich Frank von der Fotografie ab und begann Filme zu machen. Darunter *Pull My Daisy* (1959), geschrieben und erzählt von Jack Kerouac, in dem neben anderen Größen des Beatcircle auch Alan Ginsburg mitwirkte. Die Beatphilosphie betonte den Wert der Spontaneität und so wirkt der Film zusammengewürfelt, fast improvisiert. Sein Dokumentarfilm über die Rolling Stones „*Cocksucker Blues*" (1975) ist wahrscheinlich sein bekanntester Film.

Obwohl sich Frank weiterhin für Film interessierte, kehrte er 1972 zur Fotografie zurück und publizierte seine zweiten Fotoband *Lines in my hand*. Diese Arbeit kann als fotografische Autobiografie betrachtet werden und enthält zum überwiegenden Teil persönliche Bilder.

„Ich mache immer wieder dieselben Bilder", sagt Robert Frank. „Ich versuche immer, im Draußen das Drinnen zu sehen. Ich versuche, etwas zu sagen, das wahr ist."

AUSGEWÄHLTE BIBLIOGRAFIE
> *New York to Nova Scotia*, Steidl, Göttingen 2005.
> *Storylines*, Steidl, Göttingen 2004.
> *Moving out*, Scalo, Zürich 1994.
> *The lines of my hand*, Lustrum Press, New York 1972.
> *The Americans*, Grove Press, 1959.
> *Les Americains*, Delpire, Paris 1958.

Born 1924 in Zurich/Switzerland; lives and works in the USA and in Mabou/Canada.

In 1942, Robert Frank began his training with Swiss photographer and graphic designer Hermann Segesser. In 1947, he left Europe to move to New York, where he worked as a fashion photographer for Alexey Brodovitch.

In 1950 Robert Frank participated in the group exhibition *51 American Photographers*, curated by Edward Steichen, at the Museum of Modern Art in New York. In 1954, on a trip to a 4th of July picnic in Upstate New York, Frank took his first photographs for his legendary book *The Americans*. In 1955, as the first European, Robert Frank received a one year fellowship from the John Simon Guggenheim Memorial Foundation, for a project about the United States. Subsequently, he travelled across the United States by car, driving through North and South Carolina, Detroit, Florida, Atlanta, North Georgia, Alabama, among others, along the Mississippi to New Orleans, Houston, Texas, New Mexico, Arizona, Nevada, and back to Los Angeles on Route 66. He returned with a bleak portrait of what the American road had to offer.

The book *The Americans* was published in 1958. In the introduction Jack Kerouac writes about Frank's photographs: "they sucked a sad, sweet, poem out of America", a sadness found in the forlorn looks of dime store waitresses, funeral attendees, and human faces rendered unrecognizable in the glare of jukeboxes. The slightly offset angles and the blurred focus of many of the photographs suggest the nervousness and dislocation of the people they capture. Frank dispels any romantic notions of the lingering pioneer spirit of America by presenting a landscape of people and places absent of hope and promise.

This divergence from contemporary photographic standards gave Frank difficulty at first in securing an American publisher. *Les Americains* was first published in 1958 by Robert Delpire in Paris, and finally in 1959 in the United States by Grove Press, where it initially received substantial criticism.

By that time, Frank had moved away from photography to concentrate on making films. Among them was the 1959 *Pull My Daisy*, which was written and narrated by Kerouac and starred Ginsberg and others from the Beat circle. The Beat philosophy emphasized spontaneity, and the film conveyed the quality of having been thrown together or even improvised. His 1972 documentary of the Rolling Stones, *Cocksucker Blues*, is arguably his best known film.

Though Frank continued to be interested in film and video, he returned to still images in the 1970s, publishing his second photographic book, *Lines of My Hand*, in 1972. This work has been described as a "visual autobiography", and consists largely of personal photographs.

Robert Frank says: "I keep on making the same pictures. Looking at the outside, I try to see the inside. I try to say something truthful."

SELECTED BIBLIOGRAPHY
> *New York to Nova Scotia*, Steidl, Goettingen, 2005.
> *Storylines*, Steidl, Goettingen, 2004.
> *Moving out*, Scalo, Zurich 1994.
> *The lines of my hand*, Lustrum Press, New York, 1972.
> *The Americans*, Grove Press, 1959.
> *Les Americains*, Delpire, Paris, 1958.

Geboren 1934 in Aberdeen, Washington, lebt und arbeitet in New York.

Lee Friedlander begann bereits im Alter von 14 Jahren zu fotografieren. Nach seinem Fotografie-Studium an der Art Center School in Los Angeles 1956 ging er nach New York, wo er Kontakt zu Walker Evans, Robert Frank, Garry Winogrand, Diane Arbus und anderen einflussreichen Fotografen knüpfte.

Vordergründig betrachtet sind Lee Friedlanders Bilder emotionslos. Speziell seine Fotografien aus den 1960ern sind stark von formalen Aspekten bestimmt. Die menschlichen Figuren in seinen Straßenbildern scheinen deplaziert zu sein, umgeben von der visuellen Verschmutzung durch Schilder und Werbung. Er verleiht der Banalität des täglichen Lebens einen Ausdruck und dokumentiert die Komplexität der sozialen Verhältnisse in den USA mit einem starken Bewußtsein für die Bedeutung des Formalen.

Friedlander arbeitet immer in Serien: Straßenbilder, Blumen, Bäume, Gärten, Landschaften, Akte, die industrielle und postindustrielle Umwelt, Portraits und Selbstportraits. Unter den wichtigen Serien, die Friedlander zwischen den späten 1970ern und frühen 1980ern gemacht hat, sind ein Reportage über vergessene Denkmäler der Geschichte Amerikas, Portraits der von Arbeitslosigkeit bedrohten Arbeiter in nordamerikanischen Industrieregionen und Portraits von Menschen an Computerarbeitsplätzen.

1963 fand Friedlanders erste Einzelausstellung am George Eastman House in Rochester statt und kurz danach veröffentlichte er einen Fotoessay für *Harper's Bazaar*. Einer der Fotografien dieser Serie, das Baby am TV-Schirm am Fuß eines Motelbetts, wird berühmt. Friedlanders Bilder sind ein unbarmherziger Spiegel der amerikanischen Gesellschaft. 1967 organisierte John Szarkowski, der Fotokurator des New York Musum of Modern Art, die legendäre Ausstellung *New Documents*. Dies war die erste Ausstellung, in der einer große Auswahl der Arbeiten von Diane Arbus, Gary Winogrand und Lee Friedlander gezeigt wurde, Fotografen, deren Arbeit nach Szarkowskis, für eine neue Entwicklung in der dokumentarischen Fotografie stand. In den folgenden vier Jahrzehnten wurden Lee Friedlanders Arbeiten in zahlreichen Gruppen- und Einzelausstellungen gezeigt. 2005 widmete ihm das Museum of Modern Art New York eine umfassende Werkschau.

AUSGEWÄHLTE BIBLIOGRAFIE
> *Friedlander*, The Museum of Modern Art, New York 2005.
> *Stems*, DPA, New York 2003.
> *At Work*, DPA, New York 2003.
> *American Musicians*, DPA, New York 1999.
> *Nudes*, Pantheon Books, New York 1991.
> *The American Monument*, Eakins Press, New York 1976.
> *Self Portrait*, Haywire Press, New York 1970.

Born 1934 in Aberdeen, Washington; lives and works in New York.

Lee Friedlander began taking pictures at the age of 14. After completing his course of study in photography at the Art Center School in Los Angeles in 1956, he moved to New York, where he was in contact with Walker Evans, Robert Frank, Garry Winogrand, Diane Arbus and other influential photographers.

Superficially viewed Lee Friedlander's images are free of emotion. His photographs from the 1960's, in particular, seem to be about the movement of formal elements with respect to one another. The human figures in his street images seem misplaced, surrounded by visual pollution such as signs and advertisements. He gave shape to the banality of daily life, and recorded the complexity of the American social landscape from a strong appreciation of the importance of formal values.

Friedlander always works in series: street images, flowers, trees, gardens, landscapes, nudes, the industrial and post-industrial environment, portraits, self-portraits. Among the important series produced by Friedlander in the late 1970's and early 1980's was a photo reportage about forgotten memorials to events in American history, portraits of workers in North American industrial areas threatened by unemployment, and portraits of computer operators.

In 1963 he got his first solo exhibition in the George Eastman House in Rochester, and shortly thereafter produced a photo essay for *Harper's Bazaar*. One of the photographs from this visual narrative, a baby on a TV screen at the foot of a motel bed, became famous. Friedlander's images were interpreted as a merciless mirror of American society. In 1967 John Szarkowski, the photography curator at New York's Museum of Modern Art, organized the legendary exhibition *New Documents*. It would be the first major public showcase for a wide selection of work by Diane Arbus, Gary Winogrand and Lee Friedlander, three photographers whose work, according to Szarkowski, showed new developments in documentary photography. In the four decades following, Lee Friedlander's work could be seen in numerous group and solo exhibitions. In the year 2005 the Museum of Modern Art New York devoted a comprehesive exhibition of his work.

SELECTED BIBLIOGRAPHY
> *Friedlander*, The Museum of Modern Art, New York, 2005.
> *Stems*, DPA, New York, 2003.
> *At Work*, DPA, New York, 2003.
> *American Musicians*, DPA, New York, 1999.
> *Nudes*, Pantheon Books, New York,1991.
> *The American Monument*, Eakins Press, New York, 1976.
> *Self Portrait*, Haywire Press, New York, 1970.

Bruce Davidson

Geboren 1933 in Oak Park, Illinois, lebt und arbeitet in New York.

Bruce Davidson begann bereits im Alter von zehn Jahren in Oak Park, Illinois zu fotografieren. Als Jugendlicher erkundete er mit seiner Kamera die Stadt und gewann 1949, im Alter von 16 Jahren den ersten Preis des Kodak-High-School-Wettbewerbs. Seiner Leidenschaft, der Fotografie blieb er auch in der Zeit des Studiums am Rochester Institute of Technology und an der Yale University treu. In seiner Abschlussarbeit, die im Oktober 1957 im *Life Magazine* publiziert wurde, hielt er die Emotionen der Footballspieler außerhalb des Spielfelds fest. Nach dem Studium wurde er in die Armee einberufen und in der Nähe von Paris stationiert, wo er die Bekanntschaft von Henri Cartier-Bresson machte, einem der vier Gründer der namhaften internationalen Fotoagentur *Magnum*. Als er 1957 das Militär verließ, begann er als freier Mitarbeiter für das *Life Magazine* zu arbeiten, 1958 wurde er Vollmitglied bei *Magnum*. Zwischen 1958 und 1961 schuf er richtungsweisende Arbeiten wie *The Dwarf*, *Brooklyn Gang* und *The Freedom Rides*. Ein Projekt, in dem er eine profunde Dokumentation der amerikanischen Bürgerrechtsbewegung lieferte, wurde 1962 mit einem Guggenheim-Stipendium honoriert. 1963 widmete ihm das Museum of Modern Art eine Einzelausstellung. Mit einer Arbeit, in der er über zwei Jahre die bedrückenden sozialen Verhältnisse in einem Block in Harlem dokumentiert hatte, wurde er 1967 der erste Preisträger für Fotografie des National Endowment for the Arts. Diese Arbeit wurde 1970 unter dem Titel *East 100th Street* bei Harvard University Press publiziert, später in erweiterter Form bei St. Anns Press herausgegeben und noch im selben Jahr am Museum of Modern Art in New York ausgestellt. 1980 fing er mit der Kamera die Vitalität der Unterwelt der New Yorker Metro ein, veröffentlichte diese Bilder später unter dem Titel *Subway* und stellte sie 1982 im International Center for Photography aus. 1995 fotografierte er die Landschaften und das Leben im Central Park. Teile seiner Arbeiten aus den 1950er Jahren sind heute Klassiker, sie sind vielfach in Monografien publiziert, und weltweit in jeder größeren Sammlung präsent. Davidson fotografiert und publiziert bis heute.

AUSGEWÄHLTE BIBLIOGRAFIE
> *Subway*, St. Ann's Press, Los Angeles 2003.
> *East 100th Street*, St. Ann's Press, Los Angeles 2003.
> *Time of Change*, Civil Rights Photographs 1961-1965, St. Ann's Press, Los Angeles 2002.
> *Portraits*, Aperture, New York 1999.
> *Brooklyn Gang*, Twin Palms Publisher, San Francisco 1998.
> *Central Park*, Aperture, New York 1995.
> *Subway*, Aperture, New York 1986.
> *Bruce Davidson Photographs*, Simon & Schuster, New York 1979.

Born 1933 in Oak Park, Illinois; lives and works in New York.

Bruce Davidson began photography at the age of ten in Oak Park, Illinois. As a youth, Davidson was given the freedom to explore the streets of the city alone with his camera and in 1949, at the age of 16, he won first prize at the Kodak National High School Competition. He continued his passion while attending Rochester Institute of Technology and Yale University. His college thesis pictured the emotions of football players behind the scenes of the game, and it was published in *Life Magazine* in October 1955. Later he was drafted into the army and stationed near Paris where he met Henri Cartier-Bresson, one of the four founders of the renowned international co-operative photography agency, *Magnum Photos*. When he left military service in 1957, Davidson worked as a freelance photographer for *Life Magazine* and in 1958 became a full member of *Magnum Photos*. From 1958 to 1961 he created such seminal bodies of work as *The Dwarf*, *Brooklyn Gang*, and *The Freedom Rides*.

He received a Guggenheim Fellowship in 1962 to photograph what became a profound documentation of the Civil Rights Movement in America. In 1963 the Museum of Modern Art in New York presented his work in a solo exhibition. In 1967 he was awarded the first grant for photography from the National Endowment for the Arts, having spent two years bearing witness to the dire social conditions on one block in East Harlem. This work was published by Harvard University Press in 1970 under the title *East 100th Street* and was later republished and expanded by St. Ann's Press. The work became an exhibition that same year at the Museum of Modern Art in New York. In 1980 he captured the vitality of the New York Metro's underworld that was later published in is book *Subway* and exhibited at the International Center for Photography in 1982. In 1995 he photographed the landscape and layers of life of Central Park. Classic bodies of work from his 50-year-career have been extensively published in monographs and are included in all the major public and private fine art collections around the world. He continues to photograph and produce new bodies of work.

SELECTED BIBLIOGRAPHY
> *Subway*, St. Ann's Press, Los Angeles, 2003.
> *East 100th Street*, St. Ann's Press, Los Angeles, 2003.
> *Time of Change, Civil Rights Photographs 1961-1965*, St. Ann's Press, Los Angeles, 2002
> *Portraits*, Aperture, New York, 1999.
> *Brooklyn Gang*, Twin Palms Publisher, San Francisco, 1998.
> *Central Park*, Aperture, New York, 1995.
> *Subway*, Aperture, New York, 1986.
> *Bruce Davidson Photographs*, Simon & Schuster, New York, 1979.

Geboren 1912 in Fort Scott, Kansas, gestorben 1922 in New York.

Gordon Parks wurde als das fünfzehnte und letzte Kind eines kleinen Farmers in Kansas geboren und wuchs in einer Welt der Armut und Diskriminierung auf. Mit fünfunzwanzig kaufte er sich seine erste Kamera und hielt sich in den darauffolgenden Jahren als Freiberufler mit Portrait- und Modefotografie über Wasser. Daneben begann er die Zwangslage der Armen und Unterprivilegierten in den USA fotografisch zu dokumentieren. 1941 erhielt er als erster Fotograf ein Julius Rosenberg Fellowship. Roy Striker lud ihn ein, dieses bei der Farmer Security Administration (FSA) in Washington zu verbringen. Hier entstand eines seiner berühmtesten Bilder: *American Gothic*: Es zeigt Ella Watson, eine Putzfrau des FSA-Buildings, die in einer Hand einen Besen in der anderen einen Wischmob hält und dabei starr vor einer amerikanischen Flagge steht. Parks dokumentierte das Leben der Ella Watson über einen Monat hinweg und entwickelte dabei seine persönliche künstlerische Arbeitsweise, gesellschaftliche Zusammenhänge anhand einzelner Personen darzustellen. Nach der Auflösung der FSA blieb Parks zunächst als Korrespondent des *Office of War* Information in Washington, von dem er sich dann aber, mit Vorurteilen konfrontiert, 1944 angewidert abwandte. Er zog nach Harlem und begann als freiberuflicher Modefotograf für *Vogue* zu arbeiten.

Aufgrund des Fotoessays über Red Jackson, den Anführer einer Gang in Harlem, wurde Parks eine feste Stelle als Fotograf und Schreiber bei *Life Magazine* angeboten. Zwanzig Jahre lang machte er hier Bilder über Mode, Sport, Broadway, Armut oder Rassentrennung, er portraitierte Malcolm X, Stokely Carmichael, Muhammed Ali und Barbara Streisand. Sein Fotoessay über Flavio da Silva, einen armen lungenkranken unterernährten brasilianischen Jungen, führte zu einer Flut an Spenden, mit denen das Leben des Kindes gerettet und ein neues Haus für ihn und seine Familie finanziert werden konnte.

1953 drehte Parks seinen ersten Film, *The Learning Tree*, der auf seinem gleichnamigen autobiographischen Roman beruht. Im Verlauf seiner erfolgreichen Filmkarriere drehte er zahlreiche Filme, darunter *Shaft* (1971). Daneben schrieb Parks Romane, Gedichte und Essays, er komponierte und veröffentlichte sogar ein Ballet mit dem Titel *Martin* über den Führer der amerikanischen Bürgerrechtsbewegung Marin Luther King Jr.

AUSGEWÄHLTE BIBLIOGRAFIE
> *Arias in Silence*, Bulfinch Press, Boston 1994.
> *Voices in the Mirror*, An Autobiography, Doubleday, New York 1990.
> *Shannon*, Little, Brown, Boston 1981.
> *To Smile in Autumn*, W.W. Norton, New York 1979.
> *Flavio*, W.W. Norton, New York 1978.
> *Moments Without Proper Names*, Viking Press, New York 1975.
> *Whispers of Intimate Things*, Viking Press, New York 1971.
> *In Love*, Lippincott, Philadelphia 1971.
> *Born Black*, Lippincott, Philadelphia 1971.
> *A Poet and His Camera*, Viking Press, New York 1968.
> *A Choice of Weapons*, Harper & Row, New York 1966.
> *The Learning Tree*, Harper & Row, New York 1963.
> *Camera Portraits: Techniques and Principles of Documentary Portraiture*, F. Watts, New York 1948.
> *Flash Photography*, Grosset and Dunlap, New York 1947.

Born 1912 in Fort Scott, Kansas; died 2006 in New York.

Gordon Parks was born as 15th and last child of a Kansas dirt farmer, into a life of poverty and discrimination. At the age of 25 he bought his first camera. Over the next few years, Parks moved from job to job, developing a freelance portrait and fashion photographer sideline, and beginning to chronicle the plight of the poor and underprivileged in America. In 1941 he won the first Julius Rosenwald Fellowship awarded to a photographer. Roy Stryker invited him to serve out his fellowship at the Farmer Security Administration (FSA) in Washington. There, he creates one of his best known photographs, *American Gothic*. The image shows Ella Watson, who worked on the cleaning crew for the FSA building, standing stiffly in front of an American flag, mop in one hand and broom in the other. Parks worked with Ella Watson for a month, documenting her life and defining his personal artistic signature: to tell a larger story about society through one person. After the FSA disbanded, Parks remained in Washington as a correspondent with the Office of War Information, but became disgusted with the prejudice he encountered and resigned in 1944. Moving to Harlem, Parks became a freelance fashion photographer for *Vogue*.

A 1948 photo essay on the young Harlem gang leader Red Jackson won Parks a staff job as a photographer and writer with *Life Magazine*. For 20 years, Parks produced photos on subject including fashion, sports, Broadway, poverty, racial segregation, and portraits of Malcolm X, Stokely Carmichael, Muhammad Ali, and Barbra Streisand. His 1961 photo essay on a poor Brazilian boy named Flavio da Silva, who was dying from bronchial pneumonia and malnutrition, brought donations that saved the boy's life and paid for a new home for his family.

Branching out from his photography in 1963, Parks directed his first film, *The Learning Tree*, based on his autobiographical novel of the same name. His filmmaking career launched, Parks went on to direct many films, including *Shaft* in 1971. In addition to film, Parks also wrote novels, volumes of poetry, books of essays, musical compositions and even a ballet entitled *Martin*, about the life of civil rights leader Martin Luther King Jr..

SELECTED BIBLIOGRAPHY
> *Arias in Silence*, Boston, Bulfinch Press, 1994.
> *Voices in the Mirror*, An Autobiography. New York: Doubleday, 1990.
> *Shannon*, Boston, Little, Brown, 1981.
> *To Smile in Autumn*, New York, W.W. Norton, 1979.
> *Flavio*, New York, W.W. Norton, 1978.
> *Moments Without Proper Names*, New York, Viking Press, 1975.
> *Whispers of Intimate Things*, New York, Viking Press, 1971.
> *In Love*, Philadelphia, Lippincott, 1971.
> *Born Black*, Philadelphia, Lippincott, 1971.
> *A Poet and His Camera*, New York, Viking Press, 1968.
> *A Choice of Weapons*, New York, Harper & Row, 1966.
> *The Learning Tree*, New York, Harper & Row, 1963.
> *Camera Portraits: Techniques and Principles of Documentary Portraiture*, New York, F. Watts, 1948.
> *Flash Photography*, New York, Grosset and Dunlap, 1947.

Burk Uzzle

Geboren in Raleigh, North Carolina, lebt in St. Petersburg, Florida.

Burke Uzzle begann seine Karriere als Künstler Mitte der fünfziger Jahre als Pressefotograf in seiner Heimatstatt Raleigh. Nach einer Zeit als freier Mitarbeiter bei der New Yorker Agentur *Star* arbeitete er zwischen 1962 und 1968 für *Life*. 1967 trat er der Agentur *Magnum* bei, wo er 15 Jahre lang Mitglied und 1979-1980 auch Präsident war. 1982 verließ er *Magnum*, um sich ganz seiner Arbeit als freiberuflicher Fotograf und den eigenen Buchprojekten zu widmen. Daneben arbeitete er regelmäßig für Magazine wie *The New York Times Magazine*, *Fast Company*, *Fortune*, *Sports Illustrated*, *Newsweek* und *US News & World Report*.

Burke Uzzle präsentiert seine Arbeiten seit 1970 regelmäßig in Einzelausstellungen und ist daneben auch immer wieder in wichtigen Sammelausstellungen von *Photography 68* am George Eastman House in New York bis hin zu *Contemporary Photographers* am Stedelijk Museum in den Niederlanden 1978 oder im Chrysler Museum in Norfolk 1992 vertreten.

In seiner Arbeit beschäftigt sich Burke Uzzle mit den schrulligen Ausdrucksformen von Patriotismus, mit Kindheit und mit Fantasievorstellungen, wie sie charakteristisch für die USA sind. Seine Fotografien sind nicht einfache visuelle Darstellungen, sie sind tiefgründiger und nuancierter. Uzzle versteht es, die Eigenart von Menschen und Orten in Bildern festzuhalten, die trotz ihrer Zeitlosigkeit eine genaue Interpretation eines Moments sind. Überraschende Details erschließen sich meist erst auf den zweiten Blick. Seine Fotodokumentation von Woodstock ist beinahe ebenso legendär geworden wie das Festival selbst. Die Fotografien der Serie *All American* entstanden über einen Zeitraum von zehn Jahren zwischen 1973 und 1983 auf seinen Streifzügen mit dem Motorrad durch die USA. Er lernte hier das Amerika der kleinen Leute und ihrer großen Sehnsüchte kennen und beobachtete es mit witziger Respektlosigkeit und dem besonderen Sinn des amerikanischen Südstaatlers für das Lächerliche, immer aber gepaart mit großem Einfühlungsvermögen. Als besessener „Biker", der ebenso zu den legendären Treffen der Motorradfans in Daytona Beach fährt, wie zu den Neujahrsumzügen in Philadelphia oder den Kleinbürgerstränden in Atlantic City, gelangt er an die „Rückseiten" der USA.

Uzzle, der als Fotograf viel in der Welt herumgekommen ist, sagt „Amerika ist das exotischste Land der Welt. Es ist auch das einsamste".

AUSGEWÄHLTE BIBLIOGRAFIE
> *Progress Report on cvilization*, The Crysler Museum, Norfolk 1992.
> *All American*, Aperture, New York 1985.
> *Landscapes*, Magnum, New York 1973.

Born 1938 in Raleigh, North Carolina, lives in St. Petersburg, Florida.

Burke Uzzle began his artistic career as a newspaper photographer in his hometown Raleigh in the mid-1950's. After having worked as freelancer for the New York agency *Star* he moved on to assignements for *Life* from 1962-1968. He joined *Magnum* in 1967, was a member for fifteen years, and served as its president from 1979-1980. In 1982 he leaves the agency to dedicate himself to freelance photography and to focus on his own book projects. He still regularly works for magazines including *The New York Times Magazine*, *Fast Company*, *Fortune*, *Sports Illustrated*, *Newsweek* and *US News & World Report*.

He had solo exhibitions regularly since 1970, and was included in many important survey exhibitions, from *Photography 68* at the George Eastman House, New York, to *Contemporary Photographers* at the Stedelijk Museum in the Netherlands in 1978 or the Chrysler Museum in Norfolk in 1992.

Burke Uzzle discovers and celebrates the quirky displays of patriotism, childhood, and fantasy that are unique to America. His photographs are richer, more nuanced, than straightforward visual reporting. The people and places seem fixed in specificity, as well as in a timeless canvas that interprets the moment. They usually demand a second, closer look, which is rewarded by delightful surprises.

His photo documentation of Woodstock is almost as legendary as the festival itself. Between 1973 and 1983, within a period of 10 years, he created the photographic series *All American*, a product of motorcycle trips he took across the United States. During this time he explores the America of "ordinary people", learning about their desires. His observations reflect a humorous disrespect, with a typically southern sense for the ridiculous, though it is always coupled with deep empathy. As a passionate motorcycle rider, Uzzle travels to the legendary gatherings of motorcycle enthusiasts in Daytona Beach, to the new year parades in Philadelphia and to the beaches of the petty bourgeoisie in Atlantic City, discovering the "back sides" of the United States.

As a photographer, Uzzle has traveled extensively and says: "America is the most exotic place in the world. It is also the loneliest."

SELECTED BIBLIOGRAPHY
> *Progress Report on cvilization*, The Chrysler Museum, Norfolk, 1992.
> *All American*, Aperture, New York, 1985.
> *Landscapes,* Magnum, New York, 1973.

Geboren 1923 in New York, gestorben 1971 in New York.

Diane Arbus begann in den frühen 1940er Jahren zu fotografieren. Während sie gemeinsam mit ihrem Mann Allan Arbus Modeaufnahmen machte, arbeitete sie weiter für sich und studierte in den vierziger Jahren bei Berenice Abbott und Mitte der fünfziger Jahre bei Alexey Brodovitch. 1956 besuchte sie dan den Fotoworkshop von Lisette Model, beendete die Zusammenarbeit mit ihrem Mann und begann sich ernsthaft der Art von Fotografie zu widmen, für die sie bekannt wurde.

Ihre ersten Arbeiten veröffentlichte sie 1960 unter dem Titel *The Vertical Journey* im *Esquire*. 1963 und 1966 bekam sie für ihr Projekt „American Rites, Manners and Customs" ein Guggenheim-Stipendium. „Ich möchte die wichtigen feierlichen Bräuche unserer Gegenwart fotografieren, weil wir, die wir hier und heute leben, dazu neigen, nur zu sehen, was zufällig und steril und formlos ist", schrieb sie. „Während wir bedauern, dass die Gegenwart nicht so ist wie die Vergangenheit und verzweifeln, ob sie wohl je Zukunft werden wird, harren ihre zahllosen unergründlichen Gewohnheiten ihrer Bedeutung. [...] Das sind unsere Symptome und Denkmäler. Ich möchte sie bloß retten, denn das Feierliche und Merkwürdige und Alltägliche wird einmal zur Legende werden."

Die in jenen Jahren entstandenen Fotografien erregten große Aufmerksamkeit, als eine Auswahl von dreißig Aufnahmen gemeinsam mit Arbeiten von Lee Friedlander und Garry Winogrand 1967 in der Ausstellung *New Documents* im Museum of Modern Art New York gezeigt wurde. Obwohl ihre Arbeiten Zeit ihres Lebens nur in wenigen Gruppenausstellungen auftauchten, riefen sie viele kritische Reaktionen hervor und fanden große Beachtung. Die Kühnheit ihrer Sujets und ihr fotografischer Ansatz wurden als revolutionär angesehen. 1970 legte sie die Mappe *A box of ten photographs* vor, von denen sie jede für sich gedruckt, signiert und kommentiert hatte. 1972, ein Jahr nach ihrem Tod durch Selbstmord, waren es diese Arbeiten, die als erste Werke der amerikanischen Fotografie bei der Viennale in Venedig gezeigt wurden. 2003 war im San Francisco Museum of Modern Art die umfangreiche Schau *Diane Arbus Revelations* zu sehen, die im Anschluss daran in verschiedenen Städten der USA und Europas gezeigt wurde.

Ihre „zeitgenössische Anthropologie" ist als eine Allegorie Amerikas nach dem Krieg zu verstehen, als Erkundung des Verhältnisses zwischen Schein und Identität, Illusion und Glauben, Theater und Wirklichkeit. Die Treue zu den Grundsätzen ihrer künstlerischen Tätigkeit brachte ein Œuvre hervor, das durch seine Reinheit ebenso schockiert wie durch sein kühnes Engagement, die Dinge so zu feiern, wie sie sind. Im Lauf einer Karriere, die gewissermaßen kaum länger als 15 Jahre dauerte, schuf sie ein Werk, dessen Stil und Inhalt ihr einen Platz als eine der bedeutendsten und einflussreichsten Personen im Bereich Fotografie gesichert haben.

AUSGEWÄHLTE BIBLIOGRAFIE
> *Diane Arbus Revelations,* Random House, New York 2003.
> *Untitled: Diane Arbus,* Aperture, New York 1995.
> *Diane Arbus Magazine Work,* Aperture, New York 1984.
> *Diane Arbus,* Aperture, New York 1972.

Born 1923 in New York, died 1971 in New York.

Diane Arbus first began taking pictures in the early 1940s. While working in partnership with her husband Allan Arbus in their fashion photography business, she continued to take pictures on her own, studying photography with Berenice Abbott in the 1940s and with Alexey Brodovitch in the mid-1950s. In 1956, she enrolled in Lisette Model's photographic workshop, ended her collaboration with her husband, and began seriously pursuing the work for which she has come to be known.

Her first published photographs appeared in *Esquire* in 1960 under the title *The Vertical Journey*. She was awarded Guggenheim Fellowships in 1963 and 1966 for her project on "American Rites, Manners and Customs." "I want to photograph the considerable ceremonies of our present because we tend while living here and now to perceive only what is random and barren and formless about it," she wrote. "While we regret that the present is not like the past and despair of its ever becoming the future, its innumerable, inscrutable habits lie in wait for their meaning [...]. These are our symptoms and our monuments. I want simply to save them, for what is ceremonious and curious and commonplace will be legendary."

The photographs she produced in those years attracted a great deal of attention when a selected group of 30 exhibited, with the work of Lee Friedlander and Garry Winogrand, in the 1967 *New Documents* show at the Museum of Modern Art, New York. Although her work appeared in only a few group shows during her lifetime, her photographs generated a good deal of critical and popular attention. The boldness of her subject matter and photographic approach were recognized as revolutionary. In 1970, she made a portfolio, *A box of ten photographs* individually printed, signed, and annotated. In 1972 (a year after her death by suicide), those ten photographs became the first work of an American photographer to be exhibited at the Venice Biennial. Most recently, in 2003, a comprehensive exhibition entitled *Diane Arbus Revelations* opened at the San Francisco Museum of Modern Art and traveled in the United States and Europe.

Her "contemporary anthropology" stands as an allegory of postwar America, an exploration of the relationship between appearance and identity, illusion and belief, theater and reality. Her devotion to the principles of the art she practiced has produced a body of work that is often shocking in its purity, in its bold commitment to the celebration of things as they are. In the course of a career that may be said to have lasted little more than fifteen years, she produced a body of work whose style and content have secured her a place as one of the most significant and influential photographers of our time.

SELECTED BIBLIOGRAPHY
> *Diane Arbus Revelations*, Random House, New York, 2003.
> *Untitled: Diane Arbus*, Aperture, New York, 1995.
> *Diane Arbus Magazine Work*, Aperture, New York, 1984.
> *Diane Arbus*, Aperture, New York, 1972.

Peter Hujar

Geboren 1934 in Trenton, New Jersey, gestorben 1987 in New York.

Peter Hujar arbeitete als komerzieller Fotograf für Magazine, Mode und Werbung, ehe er begann eigene Bilder zu machen. Ende der 60er Jahre eröffnete er sein eigenes Studio und begann immer radikaler einen eigenen Zugang zu Fotografie zu entwickeln. Obwohl Student von Lisette Model, Bewunderer von August Sander und Freund von Diane Arbus, arbeitete Hujar auf sehr eigenständige Weise. Seine Bilder spiegeln seinen eigenen Körper und das Umfeld, in dem er lebte, unverfälscht wider. Sie sind eindrucksvoll durch ihre Direktheit und die strikte Beschränkung auf das Wesentliche. Sein Leben spielte sich in New York ab und sein Werk besteht im Kern aus Schwarzweißfotografien seiner Freunde, unter ihnen viele Intellektuelle und Vertreter der homosexuellen Subkultur.

Hujar hat eine Vorliebe, seine Modelle sitzend oder in zurückgelehnter Haltung zu fotografieren. Auf einem Portrait aus dem Jahr 1975 sieht man Susan Sontag zurückgelehnt, die Hände hinter dem Kopf verschränkt, sie wirkt verträumt, Kiefer und Kinn treten stark hervor, es ist als ob Intelligenz geradezu von ihr ausstrahlen würde. Auch William Bourroughs, David Wojnarowicz (Hujars Liebhaber) oder Divine sind in ruhender Haltung portraitiert.

Bei seinen männlichen Akten gelingt Hujar Außerordentliches. *Bruce de Saint Croix* steht selbstbewußt vor der Kamera, sein schlanker, glatter Körper badet geradezu im Licht, die Genitalien sind durch Schatten besonders betont. In *Daniel Schook, Sucking Toe* ist eine eigenartige Form der Selbstbefriedigung in Schlangenmenschpose zu sehen, noch direkter ist *Masturbating Nude*. Diese Bilder verströmen kompromisslos maskuline Sexualität, ohne dabei aber pornographisch zu wirken. Nan Goldin schrieb über Hujars männliche Akte, dass sie der Erfahrung, im Körper eines Mannes zu stecken, nie so nahe gekommen sei, wie in diesen Bildern.

Hujar gelingt es, Sinnlichkeit und Leidenschaft in fein gewirkten Bildern voller psychologischer Einsicht einzufangen, die sich durch klassische Einfachheit auszeichnen. Seine Kunst ist subtil und raffiniert.

Peter Hujars Arbeiten sind seit 1982 regelmäßig in amerikanischen und europäischen Museen ausgestellt. Im Alter von 53 Jahren starb der Künstler an den Folgen von Aids. Sein Werk, das vom Peter Hujar Estate verwaltet wird, wurde in den letzten Jahren in einer Reihe umfassender Ausstellungen gewürdigt: 1994 zeigten Stedelijk Museum in Amsterdam und Fotomuseum Winterthur eine Retrospektive, 2000, 2002 und 2005 zeigte Matthew Marks in New York seine Arbeiten. Im Jahr 2005 widmete ihm auch der PS1 in New York eine Werkschau.

AUSGEWÄHLTE BIBLIOGRAFIE
> *Night*, Matthew Marks Gallery, New York 2005.
> *Portraits in Life & Death*, Twin Palms, New York 2003.
> *Animals and Nudes*, Twin Palms, New York 2002.
> *Eine Retrospective*, Scalo, Zürich 1994.
> *Peter Hujar*, Peter Weiermair ed., Allerheiligenpresse, Innsbruck 1985.

Born 1934 in Trenton, New Jersey; died 1987 in New York.

Peter Hujar paid his dues in commercial photography - magazines, fashion, advertising- on his way to developing his own voice. At the end of the 1960's, he opened his own studio and ever more radically developed his own approach to photography. A student of Lisette Model, admirer of August Sander, and friend of Diane Arbus, Hujar made his photographs distinctly his own: a perfect and unmistakable mirror of his own body and milieu. His images are striking in their directness, their disciplined focus and their astringent avoidance of extraneous elements. His milieu was New York and the core of his work was black-and-white portraiture of his friends, many of whom were drawn from the intelligentsia as well as the gay subculture of the city.

Hujar seems to have had a preference for posing his subjects sitting or reclining. A 1975 portrait of Susan Sontag, hands clasped behind her head as she lies back somewhat dreamily, captures the strong jaw and chin; intelligence seems to radiate from her face. William Burroughs, David Wojnarowicz (Hujar's lover), Divine—all are pictured recumbent.

In his photographs of male nudes Hujar accomplishes something truly extraordinary. *Bruce de Saint Croix* standing confidently before the camera, the light bathing his slim, smooth body, his genitals emphasized by shadow; *Daniel Schook, Sucking Toe* in a contortionist pose performing a somewhat odd self-pleasuring; the more direct *Masturbating Nude*. These pictures exude masculine sexuality without compromise, but also without any suggestion of pandering or pornographic exploitation. Nan Goldin wrote that looking at Hujar's male nudes "is the closest I ever came to experience what it is to inhabit male flesh."

Hujar captures and translates the sensual and the passionate into finely wrought, psychologically perceptive images that retain a classic simplicity. His photographs are subtle and refined art.

Since 1982, American and European museums regularly exhibit Peter Hujar's work. At the age of 53, the artist died of causes related to AIDS. His work is administered by the Peter Hujar Estate and was shown in several comprehensive exhibitions within the last years: in 1994 the Stedelijk Museum in Amsterdam and the Fotomuseum Winterthur showed a retrospective, Matthew Marks in New York featured his work in 2000, 2002 and 2005. In 2005, PS1 in New York dedicated a comprehensive exhibition to his work.

SELECTED BIBLIOGRAPHY
> *Night*, Matthew Marks Gallery, New York, 2005.
> *Portraits in Life & Death*, Twin Palms, New York, 2003.
> *Animals and Nudes*, Twin Palms, New York, 2002.
> *Eine Retrospective*, Scalo, Zurich 1994.
> *Peter Hujar*, Peter Weiermair ed., Allerheiligenpresse, Innsbruck 1985.

Geboren 1923 in New York, gestorben 2004 in San Antonio, Texas.

Richard Avedon ist ein bedeutender Chronist der zweiten Hälfte des 20. Jahrhunderts, berühmt für innovative Fotografie in Portrait, Mode und Reportage. Mit siebzehn trat in die Handelsmarine der Vereinigten Staaten ein, und fertigte dort Identifikationsfotografien an. 1944 begann er seine Karriere als Fotograf. Er arbeitete zuerst für *Harper's Bazaar* und später der *Vogue*.

Eine seiner größten Leistungen liegt in der Erneuerung der Portraitfotografie und seiner Fähigkeit, das Wesen seiner Sujets zu vermitteln. Avedon hat sich seine gesamte Karriere hindurch einen ganz eigenen Stil bewahrt. Berühmt für ihren Minimalismus drücken Avedons Portraits die Essenz des Portraitierten aus.

Die Begabung des Fotografen, persönliche Ansichten berühmter Menschen zu zeigen, wurde von der Öffentlichkeit wie von den Berühmtheiten selbst sofort erkannt. Avedon fotografierte ein breites Spektrum von Menschen, die Berühmten und die Nicht-Berühmten aus Kunst, Sport, Wissenschaft und Politik, und von allen schuf er wahre, intime, bleibende Portraits.

Im Vorwort zu *In the American West* beschreibt Avedon sein Vorgehen folgendermaßen:
„Ich stehe neben der Kamera, nicht dahinter, ein paar Zoll links vom Objektiv und 1,20 Meter vom Sujet entfernt. Ich muss mir beim Arbeiten die Bilder, die ich mache, vorstellen können, weil, da ich nicht durch das Objektiv schaue, nie wirklich sehe, was auf dem Film festgehalten wird. Das weiß ich erst, wenn ich den Abzug sehe. Ich bin so nah, dass ich das Sujet berühren kann, und zwischen uns ist nur das, was geschieht, während wir einander beim Machen des Porträts beobachten."

1989 erhielt Richard Avedon ein Ehrendoktorat des Royal College of Art in London. 1992 wurde er erster Hausfotograf des *New Yorker Magazine*. 1994 versammelte das Whitney Museum in New York Werke aus fünfzig Schaffensjahren für die Retrospektive *Richard Avedon: Evidence*. 2001 war im Kunstmuseum Wolfsburg die Schau „Richard Avedon: In the American West" zu sehen. Die Ausstellung zeigte erstmals alle 124 Porträts der Serie über Menschen der Arbeiterklasse im Westen Amerikas, die Avedon zwischen 1979 und 1984 aufgenommen hatte. Im Jahr 2002 waren in der Ausstellung *Richard Avedon: Portraits* im Metropolitan Museum of Art in New York etwa 180 Arbeiten Avedons zu sehen. 2003 wurde der Fotograf für sein Lebenswerk mit dem National Arts Award ausgezeichnet.

AUSGEWÄHLTE BIBLIOGRAFIE
> *Woman in the Mirror,* Schirmer und Mosel, München 2005.
> *Evidence: 1944–1994*, Random House, New York 1994.
> *An Autobiography,* Random House, New York 1993.
> *In the American West,* Harry N. Abrams: New York 1985.
> *Avedon: Photographs 1947–1977*, Farrar, Straus & Giroux, New York 1978.
> *Portraits,* Farrar, Straus & Giroux, New York 1976.
> *Nothing Personal,* Text von James Baldwin, Atheneum, New York 1964.
> *Observations,* Text von Truman Capote, C. J. Bucher, Camera Verlag, Luzern, 1959.

Born 1923 in New York; died in 2004 in San Antonio, Texas

Richard Avedon is the eminent chronicler of the second half of the twentieth century, renowned for innovative photography in portraiture, fashion, and reportage. At the age of 17 Richard Avedon joined the United States Merchant Marine taking identification photographs. In 1944 he began his career working as a photographer: first for *Harper's Bazaar* and later for *Vogue*.

One of his great achievements is the reinvention of portraiture. Throughout his career Avedon maintained a unique style all his own. Famous for minimalism, Avedon portraits express the essence of the subject. Avedon's ability to present personal views of public figures was immediately recognized by the public and celebrities themselves. He photographed a broad range of people, the celebrated and the uncelebrated in the arts, sports, academia and politics, creating true, intimate, and lasting photographs.

In the foreword to *In The American West* Richard Avedon describes:
"I stand next to the camera, not behind it, several inches to the left of the lens and about four feet from the subject. As I work I must imagine the pictures I am taking because, since I do not look through the lens, I never see precisely what the film records until the print is made. I am close enough to touch the subject and there is nothing between us except what happens as we observe one another during the making of the portrait."

In 1989 Richard Avedon received an honorary doctorate from the Royal College of Art in London and in 1992 he became the first staff photographer for *The New Yorker Magazine*. In 1994 the Whitney Museum in New York brought together fifty years of his work in the retrospective, *Richard Avedon: Evidence*. In 2001 the Kunstmuseum Wolfsburg, in Germany mounted *Richard Avedon: In the American West*. This exhibition showed, for the first time in Europe, the full sequence of 124 portraits of the working class people in the west of America, which Avedon took between 1979 and 1984. In 2002 the Metropolitan Museum of Art in New York featured approximately 180 works *Richard Avedon: Portraits*. In 2003, he received a National Arts Award for lifetime achievement.

SELECTED BIBLIOGRAPHY
> *Woman in the Mirror,* Schirmer / Mosel, Munich, 2005.
> *Evidence: 1944–1994*, Random House, New York, 1994.
> *An Autobiography,* Random House, New York, 1993.
> *In the American West,* Harry N. Abrams, New York, 1985.
> *Avedon: Photographs 1947–1977*, Farar, Straus & Giroux, New York, 1978.
> *Portraits,* Farar, Straus & Giroux, New York, 1976.
> *Nothing Personal,* with text by James Baldwin, Atheneum, New York, 1964.
> *Observations,* with text by Truman Capote, C. J. Bucher, Camera Verlag, Luzern, 1959.

Larry Clark

Geboren 1923 in Tulsa, Oklahoma; lebt und arbeitet in New York.

Schon im Alter von 14 Jahren begann Larry Clark zu fotografieren. Seine Mutter porträtierte professionell Babies, und er wuchs in diesen Familienbetrieb hinein. Später fing er an seine Freunde zu fotografieren und begann damit seine eigentliche Karriere als Fotograf. „Ich habe mich immer als Dokumentarfotografen empfunden," sagt der Künstler über sich selbst. „Ich begann, meine Freunde als Teenager zu fotografieren und machte dies auch über die nächsten zehn Jahre. Diese Fotografien wurden zu meinem ersten Buch, *Tulsa*. Es war wie eine visuelle Anthropologie, und ich habe das Buch wie einen Film aufgebaut. Ich wollte immer Filmemacher werden, doch zu jener Zeit war die Fotografie mein Werkzeug. Trotzdem dachte ich immer filmisch und habe überdies versucht, das Leben zu zeigen, wie es wirklich war. Ich bin in den 50er Jahren aufgewachsen, als alles versteckt und zu einem Geheimnis gemacht wurde. Als ich mit der Fotographie angefangen habe, fragte ich mich: ‚Warum können wir nicht alles zeigen?' Genau das versuchte ich als Dokumentarfotograf und Geschichtenerzähler."

Larry Clark berschäftigt sich hauptsächlich mit einer Jugend am Rande der Gesellschaft, die bereits minderjährig mit Drogen, Gewalt und Sex zu tun hat und Teil der Punk- oder Skatersubkultur ist, in der dies akzeptiert wird. Clark dokumentiert die tabuisierten Bereiche aus der Welt der Heranwachsenden, um einen gesellschaftlichen Dialog über die Probleme auszulösen, in die Menschen in der verletzlichsten Phase ihrer Entwicklung geraten können.

Sein Entschlossenheit, die Wirklichkeit authentisch zu dokumentieren, ist auch in Clarks Regiedebut *Kids* sichtbar, einem Film, der nach einem Drehbuch von Harmony Korine basierend auf einer Geschichte von Larry Clark und Jim Lewis gedreht wurde. Es ist der sehr verstörende, dokumentarisch wirkende Blick auf eine Gruppe von Jugendlichen, die einer zersetzenden Welt voll von Drogen und ungeschütztem Geschlechtverkehr ausgeliefert sind. *Kids* wurde 1995 beim Filmfestival in Cannes gezeigt und in Sundance begeistert aufgenommen.

Clarks Arbeiten sind fester Bestandteil bedeutender Sammlungen auf der ganzen Welt, unter anderem am Museum of Modern Art in New York, am Guggenheim Museum in New York oder am Museum of Contemporary Art in Los Angeles. Er wird als einer der bedeutensten Fotografen des 20. Jahrhunderts betrachtet.

AUSGEWÄHLTE BIBLIOGRAFIE
> *Kids*, Grove Press, New York 1995.
> *The Perfect Childhood*, Scalo, Zürich 1993.
> *Teenage Lust*, self published 1983.
> *Tulsa*, Lustrum Press, New York 1971.

Born 1943 in Tulsa / Oklahoma; lives and works in New York.

Larry Clark started to take pictures at the early age of 14. His mother took professional photographs of babies and Clark, as it were, grew into the family business. Later, he began to take photographs of his friends and that is how his real career as a photographer began. "I always thought of myself as a documentary photographer," says the artist. "I began taking pictures of my friends as a teenager and continued to do so over the next ten years. Those photographs were to become my first book *Tulsa*. The book was like a visual anthropology and I layered it like a film. I always wanted to become a filmmaker, but at that period, photography was my tool. Nevertheless, I always thought like a filmmaker and more importantly, I tried to show life as it really was. I grew up in the fifties, a time when everything was hidden and secretive. When I started out with photography, I asked myself: 'Why can't we show everything?' That is exactly what I tried to do as a documentary photographer and storyteller."

Larry Clark's most common subject is youth on the fringe of society who casually engage in underage drug use, violence or sex and who are part of a subculture like punk or skateboarding that "accepts" these activities. As adolescence is the most vulnerable time in life, Clark intends for his exposure of these teenage social taboos to be jumping-off points for popular dialogue. Known for his unflinching eye for authenticity, Clark made his directorial debut in 1995 with *Kids*, scripted by Harmony Korine from an original story by Larry Clark and Jim Lewis. A deeply disturbing, documentary-like vision of a group of Manhattan teenagers consumed by drug use and unprotected sex. *Kids* screened in Competition at the 1995 Cannes Film Festival and was a cause celebre at Sundance.

Clark's work is in the permanent collection of museums world-wide, among them, The Museum of Modern Art, The Whitney Museum of American Art, The Guggenheim Museum, and The Museum of Contemporary Art, Los Angeles. He is recognized as one of the most important photographers of the twentieth century.

SELECTED BIBLIOGRAPHY
> *Kids*, Grove Press, New York, 1995.
> *The Perfect Childhood*, Scalo, Zurich, 1993.
> *Teenage Lust*, self published, 1983.
> *Tulsa*, Lustrum Press, New York, 1971.

Geboren 1930, Highland Park, Illinois, lebt und arbeitet in New York.

Erst relativ spät, im Alter von 38 Jahren, kam die gelernte Politik-wissenschaftlerin Rosalind Solomon zur Fotografie. In den frühen 1970er-Jahren studierte sie zeitweilig bei Lisette Model, mit der sie bis zu deren Tod im Jahr 1983 in Kontakt blieb.

Rosalind Solomon steht in der Tradition der amerikanischen „Street Photography". Ihr Blick beschränkt sich dabei aber keineswegs nur auf Amerika. Ihre Schwarzweißfotografien entstanden in den Straßen von New York genau so wie in Dublin, Belgrad oder Kalkutta, sie portraitierte First Lady Rosalyn Carter in der Airforce 2 ebenso sorgfältig wie Minenopfer in Phnom Penh oder Aidskranke in New York. Solomon doku-mentierte Karnevalszenen in New Orleans, Begräbnisrituale in Peru oder heilige Stätten in Indien. Ihr umfangreiches Werk ist eine sensible Bestandsaufnahme des Globus, Ergebnis einer Entdeckungsreise mit kriti-schem aber auch sehr persönlichem Blick, ihre Bilder sind ungeschönt und doch voller Schönheit.

1979 wurde Rosalind Solomon das John-Simon-Guggenheim-Memorial-Foundation-Stipendium verliehen, von 1988 bis 1989 das National-Endowment-for-the-Arts-Stipendium, von 1981 bis 1984 fotografierte sie als Stipendiatin des American Institut of Indian Studies in Peru, Ecuador, Indien und Nepal.

Ihre Arbeiten wurden 1980 unter dem Titel *Rosalind Solomon: Washington* in der Corcoran Gallery of Art, und unter dem Titel *Rosalind Solomon, Photographs* in der Sander Gallery in Washington ausgestellt. Im Jahre 1986 eröffnete das Museum of Modern Art in New York die Ausstellung *Rosalind Solomon, Ritual, Photographs 1975–1985*. Im gleichem Jahr organi-sierte das Museum of Photographic Arts in San Diego, Kalifornien eine Ausstellung mit 86 Werken Solomons mit begleitendem Katalog: *Rosalind Solomon, Earthrites*. Im Jahre 1990 zeigte das Museum of Contemporary Photography die Einzelausstellung *Rosalind Solomon: Rites and Ritual*. In der Photographische Sammlung in Köln, Deutschland war 2003 die Ausstellung *Chapalingas, Photographs by Rosalind Solomon* zu sehen, begleitend erschien bei Steidl in Göttingen ein Katalog. Bilder aus Polen wurden 2004 im Willy-Brandt-Haus in Berlin, in der Ausstellung *Close and Distant. Poland 1988 and 2003* gezeigt.. Im Jahr 2006 präsentierte die Galerie Foley in New York die Ausstellung *American Pictures from Chapalingas 1976–2000*.

AUSGEWÄHLTE BIBLIOGRAFIE
> *Polish Shadow*, Steidl, Göttingen 2006.
> *Chapalingas*, Steidl, Göttingen 2003.
> *Women: Matter and Spirit*, Rosalind Solomon, Alan Fern, Palm Press, Concord, Massachusetts 2002.
> *El Peru Otros Lugares, Peru and Other Places*, Rosalind Solomon, Museo de Arte de Lima, Peru, 1996.
> *Portraits in the Time of AIDS*, Thomas Sokolowski, The Grey Gallery und New York University Study Center, New York, 1988.
> *Earthrites*, Arthur Ollman, Museum of Photographic Arts, San Diego, California, 1986.

Born 1930 in Highland Park, Illinois; lives and works in New York.

It was later in life, at the age of 38, when Rosalind Solomon, who had been trained as a political scientist, discovered photography. In the early seven-ties she periodically studied with Lisette Model, with whom she kept con-tact until her death in 1983.

Rosalind Solomon's work stands in the tradition of the American "Street Photography", although her focus is not only on America. In her black and white images she depicts streets in New York, Dublin, Belgrade or Calcutta. She portrays First Lady Rosalyn Carter in Air Force 2 as thoroughly, as she photographs mine victims in Phnom Penh or aids patients in New York. She documents the carnival in New Orleans, burial rituals in Peru or holy sites in India. Solomon's extensive work is a sensitive inventory of our world, the result of a very personal and critical voyage of discovery. Solomon does not aim to beautify, but her work is full of beauty.

Rosalind Solomon was awarded a John Simon Guggenheim Memorial Foundation Fellowship in 1979, the National Endowment for the Arts Fellowship for 1988-1989, and grants from the American Institute of Indian Studies from 1981 to 1984 to photograph in Peru, Ecuador, India, and Nepal.

In 1980, The Corcoran Gallery of Art in Washington, DC, exhibited *Rosalind Solomon: Washington*, and the Sander Gallery in Washington showed *Rosalind Solomon, Photographs*.
In 1986, the Museum of Modern Art in New York City opened the exhibi-tion, *Rosalind Solomon, Ritual, Photographs 1975-1985*. The same year The Museum of Photographic Arts in San Diego, California, mounted an exhi-bition of eighty-six Solomon works with a catalogue, *Rosalind Solomon, Earthrites*. The Museum of Contemporary Photography presented her solo exhibition *Rosalind Solomon: Rites and Ritual* in 1990.

Photographische Sammlung, Cologne, Germany showed the exhibition *Chapalingas, Photographs by Rosalind Solomon*, in 2003, accompagnied by a representative catalogue published by Steidl, Goettingen. In 2004 Willy-Brandt-Haus in Berlin, Germany, presented *Close and Distant. Poland 1988 and 2003*. In 2006 Foley Gallery in New York presented *American Pictures from Chapalingas 1976-2000*.

SELECTED BIBLIOGRAPHY
> *Polish Shadow*, Steidl, Göttingen, 2006.
> *Chapalingas*, Steidl, Göttingen, 2003.
> *Women: Matter and Spirit, Rosalind Solomon*, Alan Fern, Palm Press, Concord, Massachusetts, 2002.
> *El Peru Otros Lugares, Peru and Other Places*, Rosalind Solomon, Museo de Arte de Lima, Peru, 1996.
> *Portraits in the Time of AIDS*, Thomas Sokolowski, The Grey Gallery and New York University Study Center, New York, 1988.
> *Earthrites*, Arthur Ollman, Museum of Photographic Arts, San Diego, California, 1986.

Ed Templeton

Geboren 1972 in Garden Grove, Kalifornien, lebt und arbeitet in Huntington Beach, Kalifornien.

Ed Templeton ist Autodidakt. 1990 begann er eine Karriere als professioneller Skateboarder, 1993 gründete er die *Toy Machine* und beschäftigte sich mit der grafischen Gestaltung der Skateboards seiner Firma. Ermutigt von Thomas Campbell begann er ab 1994 seine Arbeit in zahlreichen Einzel- und Sammelausstellungen in Kunstkreisen zu präsentieren. Im Jahr 2000 wurde sein erstes Buch mit fotografischen Arbeiten beim Wettbewerb *Search For Art* in Italien mit dem ersten Preis ausgezeichnet.

Ed Templeton ist nach wie vor fixer Bestandteil der kalifornischen Skaterszene, und seine Kunst erzählt aus seinem eigenen Leben und dem seiner Freunde und Kollegen. Skateboarden und auf Tour zu sein sind die zentralen Inhalte seiner Existenz und seiner Arbeit als Maler und Fotograf. In Interviews kommt Templeton oft auf die Risiken zu sprechen, die mit dem rechtlichen Status und der Wahrnehmung eines Sports verbunden sind, der weithin praktiziert wird, gleichzeitig aber in den meisten amerikanischen Städten verboten ist. Die Skaterkultur entwickelt sich, wie andere Subkulturen auch, unabhängig aus sich selbst heraus. Wie das Skateboarding selbst, ist Templetons Arbeit tief im Leben auf der Straße und der Musik, graphischen Kultur und den Dresscodes, die hier eine Rolle spielen, verankert. Seine Fotografien vom Leben in der Skatersubkultur sind teilweise außerordentlich schockierend. Er zeigt das Leben auf Tour, das bei weitem nicht nur aus guter Laune und viel Geld besteht.

Templeton ist Teil der Skatersubkultur, und er ist sich auch seiner besonderen gesellschaftlichen Rolle innerhalb dieser bewusst: „Ich denke worum es geht, ist zu verstehen, dass die Kids auf dich schauen. Den Skatern von heute ist das nicht bewusst, sie sind selbst einfach Kinder, sie sehen nicht, dass Millionen anderer Kinder ihre Interviews verfolgen und so sein möchten wie sie. Wer möchte nicht so ein toller 17-jähriger radikaler Skater sein? Das möchte jeder sein, und deshalb nehmen sie sich zu Herzen, was gesagt wird. Wenn du eine Band gut findest, werden eine Menge Kids das Album dieser Band kaufen wollen, nur weil du es erwähnt hat. Ich habe das verstanden und versuche danach zu handeln und keine Dummheiten von mir zu geben."

AUSGEWÄHLTE BIBLIOGRAFIE
> *Deformer*, Greybull Press, Los Angeles 2006.
> *The Contagion of Suggestibility*, PAM Books, Australia 2005.
> *The Prevailing Nothing*, Roberts & Tilton, Los Angeles 2003.
> *The Golden Age of Neglect*, Drago, Rom 2002.
> *Situation Comedy*, Museum Het Domein, Holland 2001.
> *Teenage Smokers*, Alleged Press, New York 1999.

Born 1972 in Garden Grove, California; lives and works in Huntington Beach, California.

Ed Templeton is a self-taught artist. In 1990 he started his career as a professional skateboarder. In 1993 he founded *Toy Machine* and began painting board graphics for his company. Encouraged by Thomas Campbell he started participating in the art world in 1994 and has been showing his work in numerous group and solo exhibitions since then. In 2000, his first book of photography *Teenage Smokers* placed first in the *Search For Art* competition in Italy.

Ed Templeton is still a permanent fixture in the California skater scene. In his art he tells his own story, as well as the story of his friends and peers. Boarding and tours are the driving forces in his life, which he documents in photographs and paintings. In interviews, Templeton often comes back to risks that are bound up with both the legality and recognition of a sport that is widely practiced, yet banned in most American cities. The culture of skateboarding, like other urban subcultures, had to spring up by itself and evolve independently. Like skateboarding, Templeton's work is deeply anchored in street life and its music, graphic culture and dress code clearly feed into his oeuvre. In his photographs, Templeton documents the youth culture around skateboarding clearly and explicitly, and in part, the photographs are quite shocking. The artist and professional photographer shows us what life looks like on tour. Touring is not only about having fun or about making money. Templeton is part of the youth culture and he is very aware of his special role in it: „I guess what it boils down to is that kids are looking up at you. I think pro skaters nowadays, don't think about that, because they're just kids themselves and don't realize the real fact that there're a million kids in the middle of the country reading their interviews and fully following what they say and want to be that guy. Who doesn't want to be an amazing seventeen-year-old rad skateboarder kid? That's what they want to be, so they really take what he says to heart. If he mentions a band, chances are, there are a lot of kids that are going to go out and buy that band's album just because he mentioned it. I feel like I've realized that and acted accordingly and tried not to just say stupid things."

SELECTED BIBLIOGRAPHY
> *Deformer*, Greybull Press, Los Angeles, 2006.
> *The Contagion of Suggestibility*, PAM Books, Australia, 2005.
> *The Prevailing Nothing*, Roberts & Tilton, Los Angeles, 2003.
> *The Golden Age of Neglect*, Drago, Rome, 2002.
> *Situation Comedy*, Museum Het Domein, Holland, 2001.
> *Teenage Smokers*, Alleged Press, New York, 1999.

Geboren 1977 in New Jersey, lebt und arbeitet in New York.

1995 ging Ryan McGinley nach New York, um an der Parsons School of Design Grafikdesign zu studieren. Bald wechselte er aber zum Fach Fotografie über und begann seinen Alltag in New York mit der Kamera zu dokumentieren. Sein Werk beschäftigt sich mit Hip-Hop, Graffiti, der Homosexuellenszene im East Village, der Kunstszene und dem Nachtleben.

McGinley fotografiert seine Freunde, die Teil der Jugendkulturszene in der New Yorker Lower East Side sind. Er benützt Fotografie, um die Schranken zwischen dem privaten und öffentlichen Leben zu durchbrechen. Seine Sujets nimmt er aus einer Subkultur, in der sich alles um Skateboard, Musik und Grafitti dreht und deren Vertreter sich vor der Kamera freimütig exponieren, mit einem Selbstbewusstsein, das sehr charakteristisch für die Gegenwart ist. Die Kamera ist dabei sowohl Teil ihres Lebens, als auch ein Mittel, sich eine Welt nach den eigenen Wünschen zu erschaffen. Es entsteht das Bild einer Generation, die viel von visueller Sprache versteht und sich sehr bewusst ist, wie man Identität durch Fotografie vermitteln kann.

Am bekanntesten ist McGinley für diese sehr persönlichen Farbbilder aus dem Alltag seiner Freunde in und um die Lower Eastside. Seit neun Monaten arbeitet er aber fast ausschließlich an natürlichen Schauplätzen außerhalb von New York City. Zum ersten mal entwirft er hier seine Sujets selbst und kreiert dabei Situationen, in denen sich seine Personen im Moment verlieren können wie zum Beispiel, wenn eine Gruppe von jungen, unbekleideten Leuten in Baumkronen klettert, oder nachts unter Wasser taucht. In diesen Bildern wird die Natur zu einer Stätte der Freiheit, er sucht und findet hier ein Gefühl von Lebenskraft und Erlösung.

Seit 2000 wird Ryan McGinleys Arbeit in vielen Galerien gezeigt. Im Jahre 2002, im Alter von 24 Jahren, war er der jüngste Künstler einer Einzelausstellung in New Yorks Whitney Museum of American Art. Im Jahre 2004 zeigte das PS.1 Contemporary Art Center in New York seine Freilicht- und Unterwasserfarbfotografien. Er nahm an Ausstellungen in Europa und in den USA teil. Seine Bilder wurden in Magazinen wie *Vice*, *Dazed and Confused*, *Index*, *V*, *The Fader*, *I-D*, *Dutch*, *Butt* und *The New York Times Magazine* publiziert.

AUSGEWÄHLTE BIBLIOGRAFIE
> *Ryan McGinley*, Index Books, New York 2002.
> *The Kids Are Alright*, limited edition, New York 2000.

Born 1977 in New Jersey; lives and works in New York.

Ryan McGinley came to New York in 1995 to study graphic design at Parsons School of Design. While at Parsons, he switched to photography and started hanging out in New York, where he developed the habit of shooting around his lifestyle. McGinley's life and work lie at the crossroads of hip-hop and graffiti, the East Village gay scene, the art world and the nightlife.

McGinley makes colour photographs of his friends, a group that forms part of New York's Lower East Side youth culture. He uses photography to break down barriers between public and private spheres of activity. His subjects are drawn from skateboard, music, and graffiti subcultures, they perform for the camera and expose themselves with a frank self-awareness that is distinctly contemporary. The camera is both a part of their lives and an accomplice in the construction of the world they wish to create for themselves. The results form a portrait of a generation that is savvy about visual culture and acutely aware of how identity can be communicated through photography. While McGinley is best known for capturing intimate and everyday images of his extended family of friends in and around the Lower East Side, he has been working almost exclusively in natural settings outside of New York City over the past nine months. For the first time, he has set up situations specifically to be photographed, but he also creates the conditions in which his subjects can lose themselves in the moment - as when a group of young people climb naked into the upper branches of a tree or float underwater at night. In these pictures he has embraced nature as a site of freedom, and he searches for and captures a sense of buoyancy and release.

As of 2000, Ryan McGinley's works have been seen in many Galleries. In 2002, at the age of 24, he was the youngest artist to have a solo show in New York's Whitney Museum of American Art. 2004 PS.1 Contemporary Art Center in New York exhibited outdoor and underwater colour photographs. He participated in shows in Europe as well as in the USA. His magazine credits include *Vice*, *Dazed and Confused*, *Index*, *V*, *The Fader*, *I-D*, *Dutch*, *Butt* and *The New York Times Magazine*.

SELECTED BIBLIOGRAPHY
> *Ryan McGinley*, Index Books, New York, 2002.
> *The Kids Are Alright*, limited edition, New York, 2000.

Übersetzung der Zitate

Seite 20] **HELEN LEVITT**
Alles, was ich über die Arbeit, die ich zu machen versuche, sagen kann, ist, dass die Ästhetik in der Wirklichkeit selbst liegt.

Seite 32] **ROBERT FRANK**
Schwarz und Weiß ist die Vision von Hoffnung und Verzweiflung. Das ist es, was ich in meinen Fotos möchte.

Es ist immer die unmittelbare Reaktion auf sich selbst, die eine Fotografie entstehen lässt.

Eines muss eine Fotografie beinhalten: die Menschlichkeit des Augenblicks. Diese Art von Fotografie ist Realismus. Aber Realismus allein genügt nicht – es muss eine Vision da sein, und beide Seiten zusammen können eine gute Fotografie ergeben.

Seite 44] **LEE FRIEDLANDER**
Ich wollte immer ein Fotograf sein. Mich haben die Materialien fasziniert. Aber ich hätte mir nie träumen lassen, dass ich so viel Spaß dabei haben würde. Ich habe mir etwas viel leichter Fassbares, viel Prosaischeres vorgestellt.

Seite 56] **BRUCE DAVIDSON**
„Was Sie Ghetto nennen, nenne ich mein Zuhause." Das hat mir jemand gesagt, als ich zum ersten Mal nach East Harlem kam, und der Satz hat mich die zwei Jahre hindurch begleitet, in denen ich die Menschen der East 100th Street fotografiert habe. Zuhause – das war dann ein alter Mann, der in den Sprüngen der Betonplatten im Hinterhof einer Mietskaserne Gras anbaut, Kinder hinter Maschendrahtfenstern, Wände mit Bildern von Christus, Kennedy und der amerikanischen Flagge und ein pensioniertes Dienstmädchen in Uniform, das seinen Linoleumboden schrubbt. Zuhause – das hieß förmliche Familienfotos, ein Junge auf einem Dach, der ein Medaillon mit einem afrikanischen Kopf trägt und mich seine Tauben nicht fotografieren lässt, weil er will, dass sie frei sind, eine von sieben Brüdern zur Feier der Ankunft ihrer Mutter aus Puerto Rico gegebenes Fest, die sie achtzehn Jahre lang nicht gesehen haben, ein junger wortgewandter Dichter und Revolutionär, der Angst hat, dass sein Foto in einer FBI-Akte landen könnte, Narben von vier Schusswunden am Bauch des ehemaligen Schülers einer Besserungsanstalt und ein Congaspieler, der zwei Jobs hat und eine Abendschule besucht, weil er Luftfahrttechnik studieren will. Zuhause: ein ehrgeiziger Modedesigner, der Pendlerverkehr am East River Drive, ein Springfield-Gewehr unter einem penibel gemachten Bett, ein erblindeter Vietnamveteran der Marines, der seinen Stock zu gebrauchen lernt, Junkies in Kellern und unbewohnten Gebäuden, ein Musiker, der sich keine neue Geige leisten konnte, als seine gestohlen wurde, und daraufhin zur Luftwaffe ging, das Mädchen im weißen Sonntagskleid, die mich „Bildermann" nannte, der Taxifahrer, der seinem Sohn einen Vierteldollar gab, damit dieser damit das Foto bezahlen konnte, das ich ihnen gegeben hatte, die Theater- und Tanztruppe Soul and Latin mit T-Shirts, auf denen ihr Name steht, auf dem Weg zum Central Park, das schwangere Mädchen auf einem Stein inmitten von Schutt auf einem Grundstück, das geduldig wartet, bis ich mich für einen bestimmten Bildaufbau entschieden habe, und der Mann in der Bar, der meine weiße Haut ansah und mich bezichtigte, die Welt vergewaltigt zu haben. Ich habe mich auf einen Lebensstil eingelassen und liebe und hasse dieses Leben wie die Leute aus dem Viertel, in das ich immer wieder zurückkehre.

Seite 68] **GORDON PARKS**
Ich habe sowohl Elend als auch Glück kennen gelernt, in so unterschiedlichen Häuten gelebt, dass keine Haut Anspruch auf mich erheben kann. Und manchmal kam ich mir wie ein Reisender auf einem fremden Planeten vor – der geht, läuft und sich fragt, was ihn zu einem bestimmten Ort geführt hat und warum er dort gelandet ist. Wenn ich einmal da war, begannen die Träume einzusetzen, und ich habe mich daran gemacht, sie zu verschlingen, wie sie mich verschlungen haben. Seit damals habe ich die Dinge – Bild für Bild, Wort für Wort – zu zeigen versucht, wie sie sind: das Dunkel und das Licht, das Fröhliche …

Seite 80] **BURK UZZLE**
Come mothers and fathers
Throughout the land
And don't criticize
What you can't understand
Your sons and your daughters
Are beyond your command
Your old road is
Rapidly agin'.
Please get out of the new one
If you can't lend your hand
For the times they are a-changin'.
(Bob Dylan)

Seite 92] **DIANE ARBUS**
Eine Fotografie ist das Geheimnis von einem Geheimnis. Je mehr sie einem erzählt, desto weniger weiß man.

Ich glaube wirklich, dass es Dinge gibt, die niemand sehen würde, wenn ich sie nicht fotografierte.

Meine Lieblingsbeschäftigung: Orte aufsuchen, an denen ich nie gewesen bin.

PETER HUJAR

Sind Photos nur kleine Fenster auf die Welt, gefrorene Weltaugenblicke, die flach und still daliegen, ohne Geräusche, Gerüche oder Bewegungen? [...] Eine Kamera in den Händen von Jemandem kann eine alternative Geschichte bewahren. *(David Wojnarovicz)*

[...] mein Ärger hat mehr zu tun mit der Ablehnung dieser Kultur, mit dem Tod umzugehen. Mein Zorn hat damit zu tun, dass ich, ALS MIR GESAGT WURDE, ICH HATTE MICH MIT DIESEM VIRUS INFIZIERT, SCHNELL BEGRIFFEN HABE, DASS ICH MICH AUCH MIT EINER KRANKEN GESELLSCHAFT INFIZIERT HATTE. *(David Wojnarovicz)*

RICHARD AVEDON

Manchmal denke ich, dass alle Bilder nur Bilder von mir sind. Mir geht es um … die Situation des Menschen; was ich als Situation des Menschen ansehe, mag allerdings bloß meine Situation sein.

LARRY CLARK

Stoff ist schieres Monopol und Habenmüssen. [...] Stoff ist etwas Quantitatives, genau Messbares. Je mehr Stoff man nimmt, desto weniger hat man, und je mehr man hat, desto mehr nimmt man. [...] Stoff ist das ideale Produkt … die ultimative Ware. Man braucht dem Käufer nichts einzureden. Der Kunde kommt durch die Kloake angekrochen und bettelt darum, kaufen zu dürfen … Der Händler verkauft nicht sein Produkt dem Kunden, sondern den Kunden seinem Produkt. Er verbessert und vereinfacht nicht das Produkt, sondern entwürdigt und versimpelt den Kunden. Seine Angestellten bezahlt er mit Stoff.
(William Burroughs)

ROSALIND SOLOMON

Es war mit wichtig, Kontakt zu anderen Menschen zu haben. Und obwohl das jeweils nur kurze Momente dauerte, sollte es auf einer Ebene geschehen, die bedeutsam war, aus dem Bauch heraus. Ich wollte wegkommen von Klischees. Vor allem als ich in anderen Ländern zu arbeiten begann, wollte ich Portraits machen, die wirkliche Menschen zeigen, wo oder was immer ihr Hintergrund war.

ED TEMPLETON

Place Position

All origins are accidental
You've got no papers & no roads lead home anymore
Chance is the root of all place position
All maps are random all scales are wrong
Legal – illegal-

no passion for the difference
Legal – illegal-
false premise forge the nation

May all your borders be porous
Free transmission
Smear genetics c'est la vie

yawn yawn yawn
I can't stifle my boredom
So why not act your age
Fear of contagion
The violence of a fence builder's dream
That masks the phrasing of
"All the pleasures of home"
Legal – illegal-
I want to go home
(Guy Picciotto)

RYAN McGINLEY

There`s A Place In Hell For Me And My Friends

There is a place
reserved
for me and my friends
and when we go
we all will go
so you see
I'm never alone
there is a place
with a bit more time
and a few more
gentler words
and looking back
we do forgive
(we had no choice
we always did)
all that we hope
is that when we go
our skin
and our blood
and our bones
don't get in your way
making you ill
the way they did
when we lived
There is a place
a place in hell
reserved
for me and my friends
and if ever I
wanted to cry
then I will
because I can
(Morrissey)

Katalog | Catalogue

Herausgeber | Editors Kunsthalle Wien, Gerald Matt, Peter Weiermair
Idee und Konzept | Idea and concept Gerald Matt, Peter Weiermair
Redaktion | Editing Sigrid Mittersteiner, Peter Weiermair
Übersetzung | Translation Wolfgang Astelbauer, Segolen Koschu, David Westacott
Graphik | Grafic design Damiani Editore, Bologna

DAMIANI EDITORE
Via Zanardi, 376
40131 Bologna, Italy
tel +39 0516350805
fax +39 0516347188

info@damianieditore.it
www.damianieditore.com

Printed in Italy, October 2006 by Grafiche Damiani, Bologna

Printed on Magno Satin, 170 gr
distribuited by

ISBN 88-89431-68-7

Cover: Gordon Parks, *American Gothic,* 1942

Ausstellung | Exhibition

AMERICANS. Meisterwerke amerikanischer Fotografie 1940 – 2006
AMERICANS. Masterpieces of American Photography 1940 – 2006

Kunsthalle Wien, Halle 2
3. November 2006 – 4. Februar 2007 | November 3, 2006 – February 4, 2007

Ausstellungsidee und Ausstellungskomitee | Idea and Committee of Exhibition Gerald Matt, Peter Weiermair
Kurator | Curator: Peter Weiermair
Kuratorische Assistenz | Curatorial Assistance Sigrid Mittersteiner
Produktionsleitung | Production Manager Mario Kojetinsky
Presse, Marketing | Press, Marketing Claudia Bauer (Leitung | Head), Katharina Murschetz, Ellie Wyckoff (Marketing)
Kunstvermittlung | Educational Departement Claudia Ehgartner + Team
Technik | Technique Johannes Diboky
Restauratorische Betreuung | Restorer Sascha Höchtl
Transport: hs art service austria

Die Kunsthalle Wien ist die Institution der Stadt Wien für moderne und zeitgenössische Kunst und
wird durch die Kulturabteilung MA7 unterstützt.
Kunsthalle Wien is the institution of the City of Vienna devoted to modern and contemporary art and
is supported by the Departement for Cultural Affairs MA7.

Direktor | Director: Gerald Matt
Geschäftsführung | General Manager: Bettina Leidl
Leitende Kuratorin | Head of Exhibitions: Sabine Folie

Wir danken der Botschaft der USA in Wien für die Unterstützung der Ausstellung.
We want to express our thanks to the Embassy of the United States in Vienna for sponsoring the show.

Hamptons Entertaining

CREATING OCCASIONS TO REMEMBER

Annie Falk

with Aime Dunstan *and* Daphne Nikolopoulos

Foreword by ERIC RIPERT
Photographs by JERRY RABINOWITZ

STEWART, TABORI & CHANG / NEW YORK

Published in 2015 by Stewart, Tabori & Chang
An imprint of ABRAMS

Library of Congress Control Number: 2014942976

ISBN: 978-1-61769-145-4

Editor: Rebecca Kaplan
Production Manager: Anet Sirna-Bruder

The text of this book was composed in Freight Text Pro and
Futura.

Printed and bound in the United States

10 9 8 7 6 5 4 3 2

Stewart, Tabori & Chang books are available at special
discounts when purchased in quantity for premiums and
promotions as well as fundraising or educational use. Special
editions can also be created to specification. For details, con-
tact specialsales@abramsbooks.com or the address below.

THE ART OF BOOKS SINCE 1949
115 West 18th Street
New York, NY 10011
www.abramsbooks.com

DEDICATION

———

Inspired by our Waterkeepers
who make it their mission to defend our right to clean
water, who patrol and protect more than 100,000 miles
of rivers, streams and coastlines in North and South
America, Europe, Australia, Asia, and Africa.

Dedicated to the Peconic Baykeeper
who is solely devoted to the protection and
improvement of the aquatic ecosystems of the Peconic
and South Shore estuaries of Long Island.

Contents

About Peconic Baykeeper

Peconic Baykeeper is the only independent, not-for-profit advocate solely dedicated to the protection and improvement of the aquatic ecosystems of the Peconic and South Shore estuaries of Long Island, New York. Its clean-water mission is advanced through conservation and management initiatives, public education, research, monitoring, and participation in the public environmental review of projects and activities that may adversely impact the ecological health of the region's estuarine waters.

LIST OF IMPAIRED WATERBODIES
IN NEED OF RESTORATION IN SUFFOLK COUNTY

Accabonac Harbor
Awixa Creek, Upper and Tributaries
Beach and Island Ponds, Fishers Island
Beaverdam Creek and Tributaries
Bellport Bay
Big and Little Fresh Ponds
Budds Pond
Canaan Lake
Centerport Harbor
Champlin Creek, Upper and Tributaries
Cold Spring Harbor and Tidal Tributaries
Conscience Bay and Tidal Tributaries
Dering Harbor
Flanders Bay, East, Center, and Tributaries
Flanders Bay, West, Lower Sawmill Creek
Flax Pond
Forge River, Lower and Cove
Fresh Pond
Georgica Pond
Goldsmith Inlet
Goose Creek
Great Cove

Great Peconic Bay, North Shore Tidal Tributaries
Great South Bay, East, Middle, South, and West
Hashamomuck Pond
Heady and Taylor Creeks and Tributaries
Huntington Harbor
Lake Capri
Lake Montauk
Lake Ronkonkoma
Little Sebonac Creek
Long Island Sound, Suffolk County, Central
Marratooka Pond
Mattituck Inlet and Creek, Low and Tidal Tributaries
Mecox Bay and Tributaries
Meetinghouse and Terrys Creeks and Tributaries
Mill and Seven Ponds
Millers Pond
Moriches Bay, East, West, and Tidal Tributaries
Motts Creek, Upper and Tributaries
Mt. Sinai Harbor and Tidal Tributaries
Mud/East Creeks and Tributaries
New Mill Pond
Nicoll Bay

Nissequogue River, Upper, Lower, and Tributaries
North Sea Harbor and Tributaries
Northport Harbor
Northwest Creek and Tidal Tributaries
Noyack Creek and Tidal Tributaries
Ogden Pond
Orowoc Creek, Upper and Tributaries
Oyster Pond (Lake Munchogue)
Patchogue Bay
Peconic Lake and Swan Pond
Peconic River, Lower, Middle, and Tributaries
Penataquit Creek, Upper and Tributaries
Penniman Creek and Tidal Tributaries
Penny Pond, Wells and Smith Creeks
Phillips Mill Pond
Phillips Creek, Lower and Tidal Tributaries
Port Jefferson Harbor, North and Tributaries
Quantuck Bay
Quantuck Canal and Moneybogue Bay

Quogue Canal
Reeves Bay and Tidal Tributaries
Richmond Creek and Tidal Tributaries
Sag Harbor and Sag Harbor Cove
Sagaponack Pond
Sampawams Creek, Upper and Tributaries
Scallop Pond
Sebonac Creek and Bullhead Bay and Tidal Tributaries
Setauket Harbor
Shinnecock Bay and Inlet
Spring Pond
Spring Lake
Stirling (Sterling) Creek and Basin
Stony Brook Harbor and West Meadow Creek
Terrell River, Upper and Tributaries
Town and Jockey Creeks and Tidal Tributaries
Weesuck Creek and Tidal Tributaries
West Creek and Tidal Tributaries
West Harbor, Fishers Island
Wickham Creek and Tributaries
Wildwood Lake (Great Pond)
Wooley Pond

Though the notion of stewardship runs back to the Native Americans who lived here long ago, the challenges today's stewards face are varied and complex, with no simple solution or clearly defined path. The Peconic Baykeeper draws its strength from these challenges, secure in its belief that clean water is a right, not a privilege, and that our efforts, with your help and support, will resound to the greater good.

Brendan J. McCurdy
Chairman of the Board, Peconic Baykeeper

Many things about the East End have changed during my lifetime, often irreversibly. When I was young, there were 175 or 200 baymen working the waters around us; today there are 15 or 20. This small, determined group carries on the traditions that have run for generations in some of their families because they are passionate about this way of life. With education and cooperative action among homeowners, governmental bodies, and environmental organizations, the state of our bays can be reversed.

Ann Welker
Co-director, Two Tall Water People, Inc.

Long Island hosts some of the world's most beautiful beaches, bays, and estuaries and supports several robust fisheries. I've made it my life's work to help conserve and restore these ecosystems and their associated depleted fisheries. While it is an immense task, these issues are too important for Long Island to ignore.

Dr. Chris Gobler
Head of Marine Science at Stony Brook University, Southampton

Water is our lifeline in the Hamptons. But the quality of water in the ponds, rivers, bays, and ocean—due primarily to the influx of nitrogen from septic tanks—has suffered to such an extent that at times bays, ponds, and even beaches must be closed to swimming. The Sustainability Advisory Committee to the Southampton Town Council, which I chair, addresses issues of water quality, septic treatment, and waste disposal, and promotes the plastic shopping bag ban, improved transportation, and alternate energy to help stem the tide of unchecked development and environmental degradation, and therefore our quality of life.

Dieter von Lehsten
Co-chair of Sustainable Southampton Green Advisory Committee

My family has fished the water of eastern Long Island for generations, and many things in the environment have changed. Where we once had a healthy ecosystem, we now have red, brown, and rust tides that are taking a toll on the environment. The Baykeeper has been a steadfast voice advocating for and educating people about our fragile surroundings. The environment needs that voice.

Ed Warner
Bayman

Foreword

ERIC RIPERT

Entertaining in the Hamptons for me is a very special and unique experience that is centered on enjoying the energy and beauty of the surroundings. Like so many others featured in this book, when I host family and friends at my home in Sag Harbor, I always start the morning with a visit to my favorite farm stand, fishmonger, or butcher. I prepare and cook outside as much as possible, and prefer to enjoy the meal in the fresh air, among the trees, with a glass of North Fork wine in hand. There's a laid-back elegance to entertaining in the Hamptons that makes everyone present feel closer, more relaxed—but maybe that's just the wine.

Good food served in a personal setting has always been the best way to bring people together and create the most lasting memories. Opening your home to family and friends is a gesture of generosity as well as a mode for creative expression. That is what this book is really about, and the beautiful photos, unique recipes, and engaging storytelling make *Hamptons Entertaining* a true pleasure to read as well as a valuable resource.

This book embodies and celebrates all the nuances that make the Hamptons such a unique and welcoming escape from reality. It embraces a side of the East End that is often overlooked: the natural beauty of the area and the warmth of its residents. The deep appreciation for the unspoiled beauty of the countryside, and the different personalities of each town, beach, and waterway, are apparent in every story and on every page, while the playground of locally grown produce and seafood freshly drawn from the local waters are heralded in every recipe.

The spirit of entertaining is really about giving back—being appreciative for what you have and wanting to share it. Annie Falk conveys her appreciation for the Hamptons culture and dedication to its natural beauty through her philanthropic efforts. All profits from *Hamptons Entertaining* will benefit the Peconic Baykeeper, the only independent, not-for-profit advocate solely dedicated to the protection and improvement of the aquatic ecosystems of the Peconic and South Shore estuaries of Long Island. The book is not only a beautiful guide to entertaining in the Hamptons, it represents a commitment to maintaining that which makes it so magical.

Eric Ripert

Introduction

The weather is glorious, sunny, and breezy, and the scent of the ocean—mixed with the fragrance of ripe berries—seems to be everywhere. It is one of those perfect August weekends in the much-celebrated Hamptons, when the traffic isn't too bad and everything seems possible. I'm hosting a dinner and I'd like to serve something authentically Hamptons, impressive, and above all, easy. There will be no prepared food from one of the many fabulous gourmet markets here on the East End. I've done that one time too many. I want to amaze my boyfriend and pamper my friends.

It will be a great East-End feast that, thankfully, means simple, local ingredients and boiling water. Of the many ways I can be humbled in the kitchen, boiling water is not one of them. I am a master at making tea and toast, and

surely that will give me some natural agility in the kitchen.

Small roadside shops sprinkled along Montauk Highway showcase the centerpiece of my favorite summer meal and the inspiration for tonight's feast: fresh, live lobster. Local farm stands are plentiful and inspiring, beckoning even the novice cook with hand-painted signs offering fresh eggs, just-picked berries, bunches of wild flowers, and, of course, freshly picked, juicy corn on the cob.

I return to the house with a bit more produce than needed, and quickly set a few pots of water to boil on the stove. I drop the corn in one pot and approach the lively lobsters with care, using a pair of extra-long tongs to put the crustaceans into the boiling water one by one. As I drop the second lobster in the pot the first one climbs

on top of his friend, and both fall to the counter where they push the rest of their posse to the floor. They scurry around madly as I let out a terrifying scream. My boyfriend comes running into the kitchen to find me on the counter, where the lobsters used to be. I spend the next half hour on the phone with my cousin, a celebrated chef, who laughed out loud when I asked, "Really, you put wine in the water and leave the rubber bands on their claws?"

This kitchen memory occurs well before André Soltner, chef and owner of Manhattan's legendary Lutèce, set me on course for the South of France to study *cuisine de soleil* with renowned chef Roger Vergé in Mougins. There is a long line of great cooks in my family, so I blame my sharp learning curve on inattention. We ate out a lot that summer, but I embarked on my first of many culinary quests that day and still delight in hosting clambake-style parties, as you will see on page 36. And while he doesn't readily admit it, that was also the day my now-husband decided he should encourage me to study the culinary arts if he ever hoped to have a decent meal at home.

The Hamptons—beginning with manicured old Southampton and ending at the rock-strewn cliffs of Montauk Point—is a string of fashionable summer resorts that has long enjoyed an aura of mystery, wealth, and glamour, an aura that has endured through the decades and has been heightened to epic proportions by residents like Jacqueline Bouvier, Jackson Pollock, Andy Warhol, Frank Shields, and Henry Ford.

Synonymous with parties, it is often solely that aspect of the Hamptons that is showcased in the media, and it can take a special kind of perspective to find the real heart and soul of the East End. It's about a whole other unreported, but quite glamorous, life that centers on friends, family, and a desire to give of one's time and talent for the good of others. It is a more intimate side of the Hamptons and quite different than the one imagined by much of the world—a side where food and wine become the catalyst for sparkling conversation, the sharing of ideas, and memories in the making.

Bringing the famous Hamptons lifestyle to life, *Hamptons Entertaining* is an invitation to meet some of the most fascinating leaders from the worlds of finance, politics, fashion, and the arts—the most celebrated members of society, both in the Hamptons and on an international stage. Join me for an intimate glimpse behind the hedges of the Hamptons' most glamorous estates to attend parties by these individuals, where they share their recipes, resources, colorful anecdotes from parties past, and advice and tips for stylish entertaining.

Each party is unique and magically lifts one away from the constraints of reality; guests are transported back to childhood with pumpkin decorating at the Giulianis' and memories of a past autumn are evoked with the Hornigs' offering of fresh-pressed cider and an apple-inspired menu. Guests take a trip to Hungary with peach soup and warm, homemade doughnuts at the Roths', and my own gourmet s'mores recall favorite childhood treats. What makes these gatherings so memorable is the key to success for any event—thoughtfulness and attention to detail.

I know you will be inspired, as I have, by the portraits of lush gardens, elaborately decorated homes, heirloom china, unique menus, beautifully appointed tables, and lavish floral arrangements. It's always exciting to discover new and different ideas for your own gatherings, collecting the go-to recipes used by well-seasoned hosts and accessing their most prized resources. All hosts want their guests to enjoy a memorable, enriching visit, and these pages help define the nuances of accomplishing that goal.

Surrounded by water—the Atlantic Ocean on the south, Peconic Bay and Gardiner's Bay on the north—and renowned for its wide sandy beaches, delicious seafood, and exciting water sports, the Hamptons is a slice of paradise. The hosts and hostesses featured on these pages join me in a desire to help preserve the natural beauty and bounty of this stunning place. Toward that goal, and in the spirit of giving, proceeds from this book will assist the Peconic Baykeeper in carrying out its mission to protect and improve the aquatic ecosystems of the Peconic and South Shore of Long Island. For those of you who have made this book a part of your collection, thank you for joining us in our pursuit.

At the Water's Edge

COASTAL ENTERTAINING

Dinner in the Harbor

WITH RAYSA AND ALFY FANJUL

One of the pleasures of summer in the Hamptons is spending time on the water. Sailors and fishermen of every stripe enjoy cruising up and down the coast, on occasion docking at picturesque ports like Sag Harbor. The colorful, iconic Hamptons idyll is where worldly "old salts" gather to socialize between maritime excursions.

For Alfy Fanjul, the chairman and CEO of Florida Crystals and an avid fisherman, and his wife, Raysa, docking at Sag Harbor Yacht Club is also an opportunity to entertain. Hosting lunches, dinners, and weekends for friends and family onboard their motor yacht *Crili* is "a privilege," Raysa says. "We are blessed to have our guests join us and our family."

That sentiment comes across from the moment one steps onto the teak deck. The *Crili* is a laid-back, no-worries zone. Even conventional yachting requirements, such as asking guests to remove their shoes before boarding, do not apply here. "We want people to wear what they want and to be themselves," Raysa says.

Onboard the *Crili*, the Fanjuls have created a deeply personal environment. The first thing that greets guests upon entering is a collection of silver golf trophies won by Alfy at various tournaments in Palm Beach, Miami, the Dominican Republic, the Hamptons, and elsewhere. A passionate golfer, Alfy relishes every triumph on the

greens and proudly displays his spoils front and center.

His other avocation, fishing, takes the spotlight as guests sit down to dinner. The menu often features fresh fish Alfy has caught, along with seasonal produce sourced from farm stands around the Hamptons. "I love it when we dock at the Hamptons," Raysa says. "The tomatoes, corn, peaches . . . everything is so farm-fresh."

Raysa's talents shine in the menus, which she plans days in advance, and the beautiful, welcoming milieu she creates. Flowers make an immediate impact: orchids, roses, and hydrangeas, all in her beloved white, are provisioned through spring and summer at different ports and thoughtfully assembled in subtle, delicate arrangements.

Tables are always set with embroidered white linen place mats and napkins, and a mixture of china patterns. Though the space onboard a boat is not the same as in a house, Raysa manages to store "quite a few sets" of china. That's particularly important during weekends at sea, when every meal is served onboard and variety is key to guests' comfort.

Another signature element of Raysa's table designs: kidney-shaped crystal plates, positioned to the left of the dinner plate, for the salad. Butler service, where staff presents each course on silver platters so guests can take what they want, also distinguishes a Fanjul dinner party.

The Australian Bee-eater
MEROPS ORNATUS

Flowers add beauty and interest to the table, and Raysa is very thoughtful in choosing the right bouquets. The colors and size of the flowers, as well as their scent, are all considerations. Ever mindful of her guests' comfort, Raysa wants them to see across the table and chat without hindrance.

Focusing on healthful choices for her guests, Raysa prefers sauces on the side, when practical.

Guests are usually asked to remove their shoes before boarding a boat as lovely as the *Crili*, but Raysa and Alfy want guests to be comfortable, and everyone is invited onboard as they are.

"That service style is part of my husband's upbringing," Raysa says. "He prefers it that way."

The Fanjuls' Cuban heritage is evident in their generous hospitality and sometimes in what they serve. One of Raysa's favorite ways to welcome guests is with Champagne and chocolate. A carousel full of candies sits on top of the bar, inviting a sweet indulgence. "Wherever Raysa is," she says, winking, "there will always be chocolate."

And coffee. It must be said, the Fanjuls serve a fantastic *cafecito*, the famous Cuban espresso. It is often served in dainty Anna Weatherley cups and always with a sprinkling of sugar.

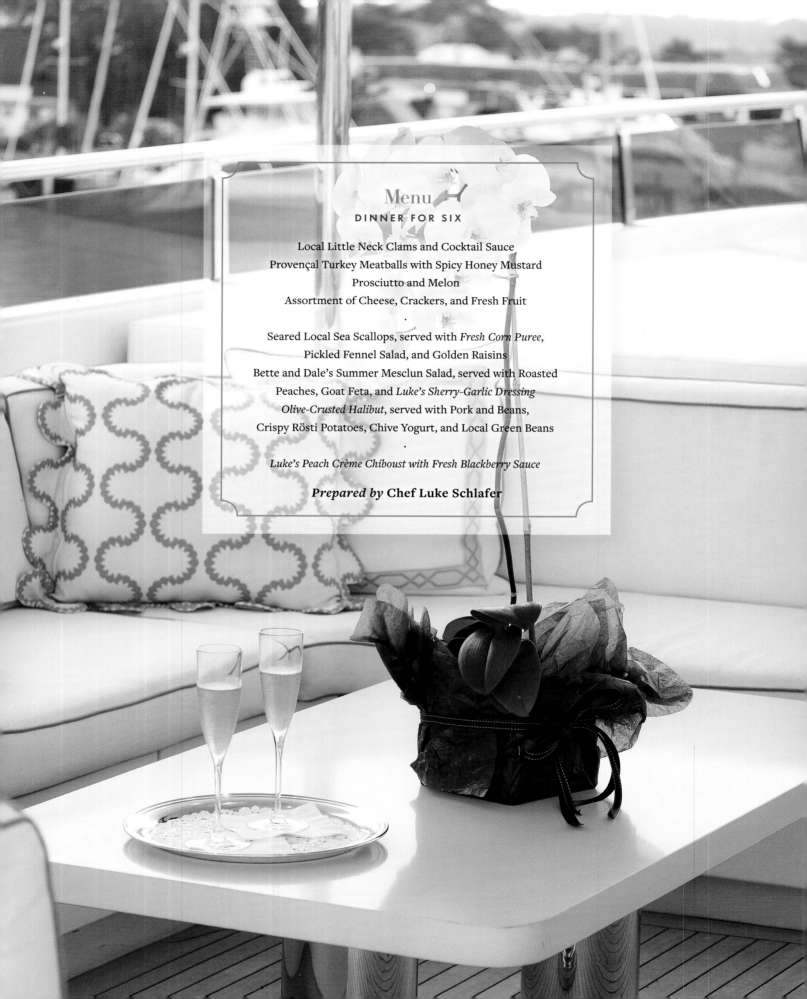

Menu

DINNER FOR SIX

Local Little Neck Clams and Cocktail Sauce
Provençal Turkey Meatballs with Spicy Honey Mustard
Prosciutto and Melon
Assortment of Cheese, Crackers, and Fresh Fruit

·

Seared Local Sea Scallops, served with *Fresh Corn Puree*,
Pickled Fennel Salad, and Golden Raisins
Bette and Dale's Summer Mesclun Salad, served with Roasted
Peaches, Goat Feta, and *Luke's Sherry-Garlic Dressing*
Olive-Crusted Halibut, served with Pork and Beans,
Crispy Rösti Potatoes, Chive Yogurt, and Local Green Beans

·

Luke's Peach Crème Chiboust with Fresh Blackberry Sauce

Prepared by Chef Luke Schlafer

FRESH CORN PUREE

MAKES 6 SERVINGS

This quick and easy dish takes advantage of one of the sweetest flavors of the Hamptons in summer. It is the perfect accompaniment to seared scallops and is delicious under balsamic chicken too. While it is appropriate for an elegant dinner, it can be served family style as well.

4 ears fresh corn, shucked
4 tablespoons (55 g) butter

1 teaspoon toasted fennel seeds
¼ teaspoon cayenne pepper

2 tablespoons crème fraîche
Salt and freshly ground black pepper

Separate the corn kernels from the cob using a sharp knife. With the back of the knife, scrape the cob to extract the "milk." Combine the corn kernels, butter, fennel seeds, and cayenne in a medium saucepan and heat through. Once the butter is melted and the corn is coated, combine the mixture with the crème fraîche in a food processor or blender and puree until smooth. Season with salt and pepper. Serve warm.

LUKE'S SHERRY-GARLIC DRESSING

MAKES 2 CUPS (480 ML)

½ cup (120 ml) sherry vinegar
2 tablespoons Dijon mustard

½ tablespoon lightly beaten egg yolk
1 tablespoon honey
2 cloves garlic, peeled

Salt and freshly ground black pepper
1½ cups (360 ml) peanut or safflower oil

In a blender, combine the vinegar, mustard, egg yolk, honey, garlic, and ¼ teaspoon each salt and pepper. Stream in the oil while the blender is running and add more salt and pepper, if needed. Transfer the dressing to a covered container and chill until ready to use.

OLIVE-CRUSTED HALIBUT

MAKES 6 SERVINGS

Cayenne pepper and crushed chile flakes combine with olives, capers, and raw garlic for a bold taste of the Mediterranean. The Fanjuls' presentation and combination of flavors is truly inspiring. Crispy rösti potatoes covered in chive yogurt, topped with local green beans, and pork 'n' beans complete this dish, all of which can be served on the side or passed family style with the halibut.

6 ounces (170 g) Niçoise olives, pitted
4 ounces (115 g) capers, rinsed and drained
1 clove garlic, crushed

½ teaspoon crushed chile flakes
Leaves from 1 small bunch fresh flat-leaf parsley
¼ cup (60 ml) olive oil

Six (5-ounce/140-g) fillets halibut, skinned
Salt and freshly ground black pepper
½ cup (55 g) flour
½ cup (1 stick/115 g) butter

Preheat the oven to 400°F (205°C).

Combine the olives, capers, garlic, chile flakes, and parsley in a food processor. Pulse while adding 2 tablespoons of the olive oil, until roughly blended. Set aside.

Preheat a large nonstick skillet on medium with the remaining 2 table-spoons olive oil until the oil runs smoothly and its aroma is apparent. Pat the fish fillets dry with a paper towel, season them with salt and pepper, and dredge them in the flour. Add 1 tablespoon of the butter to the hot pan, and place the fish fillets in the pan three at a time, serving side down. Keep the fillets still in the pan to achieve even coloring. If necessary, increase the heat to medium-high to maintain a nice even crackle.

Once the fillets have seared to a nice golden brown on the pan side, flip and cook for 5 to 10 seconds, then place them on a foil-lined cookie sheet. Repeat with the remaining fillets, adding 1 tablespoon of butter to the pan before the second batch. Once all the fish has been seared, divide the olive mixture among the fillets, coating the tops with a generous layer each. Place 1 tablespoon butter on top of each encrusted fillet and roast them for 3 minutes.

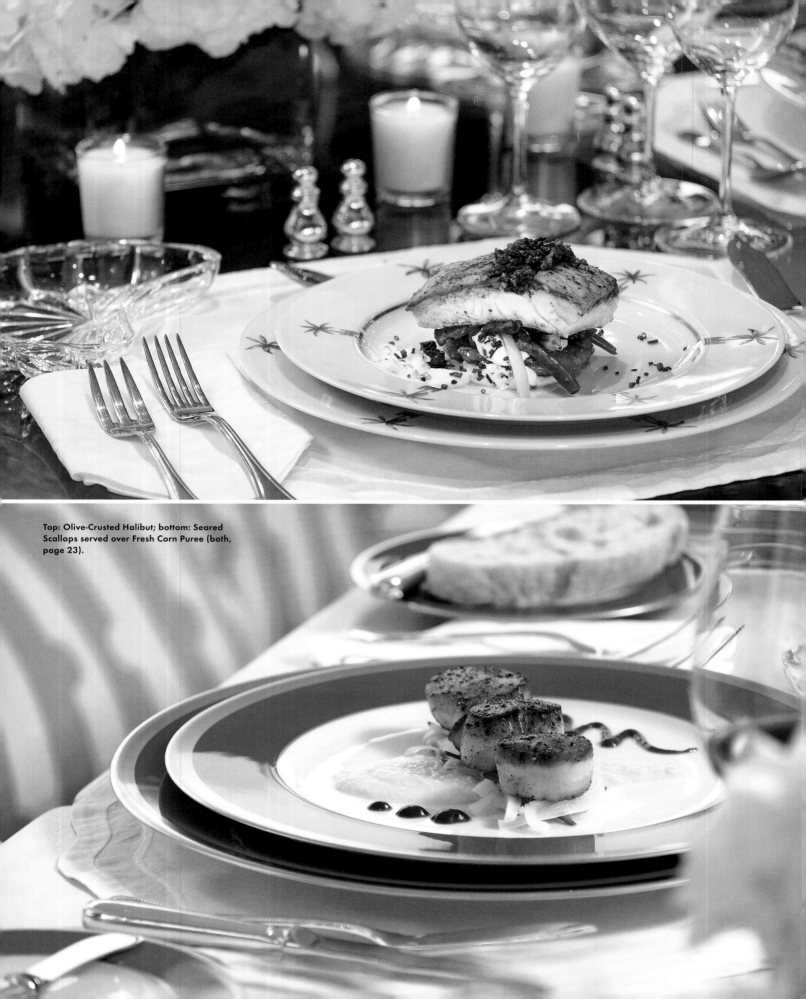

Top: Olive-Crusted Halibut; bottom: Seared Scallops served over Fresh Corn Puree (both, page 23).

LUKE'S PEACH CRÈME CHIBOUST WITH FRESH BLACKBERRY SAUCE

MAKES 6 SERVINGS

Pastry cream lightened with stiffly beaten eggs and flavored with fruit delights guests every time. Chef Luke creates these desserts especially for Mr. Fanjul, who is fond of Pepperidge Farm's Bordeaux cookies, and who enjoyed an earlier version, an orange crème Chiboust, that Luke served on a fishing trip to the Bahamas. This one features Hamptons peaches: so sweet and juicy, Luke was inspired to pair them with freshly picked blackberries for this delicious, beautifully presented *crème pâtissière*.

3 large peaches, peeled and pitted
1 tablespoon Tate & Lyles golden syrup
Juice of ½ lemon
14 Pepperidge Farm Bordeaux cookies
⅛ teaspoon salt
2 tablespoons butter, melted

4 egg whites
6 tablespoons (75 g) sugar
5 ounces (140 g) cream cheese, at room temperature
Seeds from 1 vanilla bean
2 ounces (60 ml) peach liqueur

1 ounce (28 grams) unflavored gelatin softened with ¼ cup (60 ml) ice water
½ cup (120 ml) heavy cream, whipped
2 pints blackberries
Juice of ½ lime
3 fresh figs, sliced, for garnish

Prepare the peach puree. Combine the peaches, golden syrup, and lemon juice in a blender. Puree until smooth. Place 6 tablespoons (90 ml) puree in a covered container and refrigerate to use later for the topping. Set the remainder aside.

Preheat the oven to 350°F (175°C). Line a baking sheet with parchment paper; place six 6-ounce (180 ml) ring molds on the paper and set aside.

In a food processor, pulse 8 of the Bordeaux cookies and the salt into fine crumbs, and then pulse in the melted butter. Divide the mixture evenly among the molds, pressing it in to fill the bottoms. Bake until golden, about 8 minutes. Set aside and let cool completely.

In a stand mixer using a whip attachment, whip the egg whites until soft and foamy. Add 3 tablespoons of the sugar in a stream and continue to beat the egg whites until they form stiff peaks. Set aside.

Using the stand mixer, in a separate clean bowl, begin to whip the cream cheese until it is smooth and creamy. Add the vanilla and remaining peach puree and mix until thoroughly incorporated. Set aside.

In a small saucepan over medium heat, warm the peach liqueur and add three-fourths of the softened gelatin. Heat until the gelatin is dissolved, then add it to the cream cheese mixture.

Fold the egg whites into the cream cheese mixture, then fold in the whipped cream. When the mixture is fully combined, transfer it to a piping bag. Pipe the mixture over the Bordeaux cookie crusts in the cooled ring molds, leaving ½ inch (12 mm) of space for topping. Refrigerate the desserts for 30 minutes to allow the pastry cream to set completely.

Heat the remaining fourth of the gelatin mixture in a small pan with 1 ice cube to soften (it will have solidified a bit while sitting). Remove the pan from the heat and add the reserved 6 tablespoons (90 ml) peach puree. Top the ring molds with the puree mixture and chill for at least 2 hours and up to 2 days, covered.

When you are almost ready to serve, combine the blackberries, the remaining 3 tablespoons sugar, and the lime juice in a blender and puree until smooth then pass through a fine-mesh sieve. Transfer the sauce to a squeeze bottle.

Decorate the dessert plates with the blackberry sauce; place a ring mold on each plate and run a toothpick around the top of the crème Chiboust to loosen the set peach puree from the molds. Then, using a hair dryer, briefly warm the outsides of the molds at the middle to gently release the creamy centers; remove the rings. Be careful not to overheat, or you will melt the dessert.

Garnish each plate with fresh fig slices and a Bordeaux cookie and serve immediately.

A Fashionable Table by the Bay

WITH KARA AND STEVE ROSS

While she prefers gatherings at her Southampton home to feel casual, Kara Ross enjoys elevating her table settings to an art form. Taking influence from a particular color palette, texture, or found *objet d'art*, she never sets the same table twice, layering a thoughtful combination of textures and colors with natural elements to spark a conversation.

"There are many different elements to think about," says Kara, who with husband, Steve Ross, also maintains a primary residence in Manhattan and a winter home in Palm Beach. "It's mixed media: you have china, glasses, flowers, fabric, plates, napkins, napkin rings. . . . You can think of it as building a piece of art and how many layers you can incorporate to make it feel unique, rich, and full."

Perhaps it is no mistake that accessorizing a table comes naturally to Kara. As founder of Kara Ross New York, a luxury fashion accessories company, her collections are known for bold combinations of exotic skins, precious stones, and vivid colors. "I think accessories make an outfit," she says. "When setting a table, 90 percent of the time, I don't use flowers because I have so many other interesting things around the home that we collect, and it's really different and unusual."

Still, this dinner party was no formal affair. Guests were invited via text, and nary a place card was set. "Nothing should be too stiff," she says. "I want it to be warm and welcoming."

Kara placed carafes of icy rosé wine, peach sangria, and watermelon margaritas atop an al fresco console overlooking the Peconic Bay. Cheerful cobalt blue goblets designed by another tabletop doyenne, Kara's dear friend Kim Seybert, complemented the palette set by porcelain vases brimming with local sunflowers.

As the sun set, with cheerful music humming in the background, the guests and Finn, the family Tibetan terrier, found a comfortable place to perch on the patio. The house chef, Angel Burbano, invited guests to enjoy healthful hors d'oeuvres like summer vegetable rolls and cucumber cups with fresh Hamptons crabmeat.

At the dinner table set by the nearby pool, guests discovered an azure tableau atop a colorful bolt of fabric procured from a Palm Beach fabric shop. "Using fabric instead of a tablecloth is a really easy way to bring color to the table," Kara says. "You just buy it by the yard, you don't have to hem it, you don't have to stitch it. In this case the fabric had so many beautiful colors I thought the flowers would reflect the cloth really well." Layered on top were Kim Seybert's signature capiz shell place mats, ombre glassware and napkins, and a mirrored tile

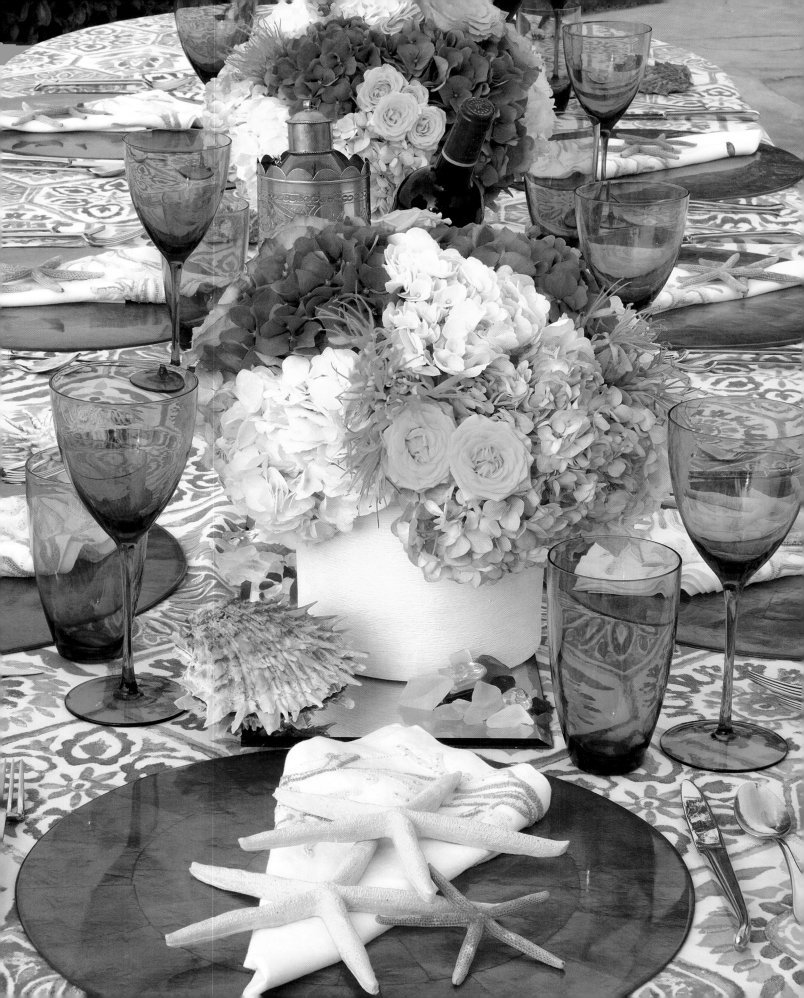

Clockwise from top right: Kim Seybert, Annie Falk, Darlene Perez, Regina Scully, and Kara Ross.

runner peppered with vibrant local hydrangeas, votives, and an eclectic mix of sea glass, shells, and starfish.

Beverages were readily available in antique silver carafes found in a Marrakech market, and Kara added coordinating ombre glassware by Seybert and whimsical crab-shaped wine bottle coasters. "I love nature, shells, and sea life," Kara says. "I have been collecting tabletop elements for so long that I have quite a lot, and I pick things up here and there when I travel or go to antiques shows or auctions."

For the first course, clamshell dishes found in an Italian seaport held fresh ceviche. Following a main course of watermelon and papaya–seared sea scallops and blood orange sorbet with seasonal fruit for dessert, the ladies lingered for conversation by candlelight. Gents comfortably retired to the living room with Steve—owner of the Miami Dolphins football franchise and founder and chairman of Related Companies, a premier global real estate company—to catch up on the day's sporting events.

"The summer can be so beautiful in the Hamptons; it's so conducive to entertaining," says Kara. "It's a luxury to be outside, and it lends itself to being more relaxed and easy."

Menu

DINNER FOR EIGHT

Verano Watermelon Margarita
Peach Sangria

·

Summer Vegetable Rolls with Dipping Sauce
Hamptons Cucumber Cups with Crabmeat

·

Angel's Ceviche
Seared Scallops with Watermelon and Papaya

·

Blood Orange Sorbet with Seasonal Fruit

***Prepared by* Chef Angel Burbano**

VERANO WATERMELON MARGARITA

MAKES 1 COCKTAIL

This refreshing take on the classic margarita is a wonderful summer cooler.

2 ounces (55 g) watermelon, cut into cubes, plus a small wedge for garnish

1½ ounces Silver Patrón tequila
Splash of agave nectar

Splash of peach liqueur
Juice of ½ lime

Muddle the watermelon to create a puree. Place the watermelon puree, tequila, agave, peach liqueur, and lime juice in a shaker. Fill to the halfway mark with ice. Shake vigorously. Strain into a margarita glass and garnish with the watermelon wedge.

PEACH SANGRIA

MAKES 1½ GALLONS (5.7 L)

The Rosses' Peach Sangria is a summer favorite among friends. Made with a dry red wine to balance the sweetness of juicy, farm-fresh peaches, rum, and orange juice, this recipe will entice guests to linger for one more glass.

9 peaches, pitted
3 cups (720 ml) good-quality rum
2 cups (480 ml) freshly squeezed orange juice

2 (750-ml) bottles dry red wine
1 cup (240 ml) peach liqueur
1 cup (200 g) sugar

1 cup (240 ml) hot water
2 lemons, rinds left on, sliced into rounds and seeded

Cut 8 of the peaches into cubes and place them in a drink dispenser with the rum, orange juice, wine, and peach liqueur; mix and refrigerate. Dissolve the sugar in the hot water and allow it to cool.

Add the cooled sugar mixture and lemon rounds to the wine mixture and chill for at least 2 hours. Slice the remaining peach very thinly. Transfer the sangria to a pitcher or drink dispenser before serving it cold with a slice of fresh peach in each glass.

SUMMER VEGETABLE ROLLS WITH DIPPING SAUCE

MAKES 24 PIECES

A cleansing mouthful of fresh vegetables, these rolls make a delectable appetizer and are a wonderfully simple way to enjoy produce fresh from the farmers' market.

12 rice paper sheets
2 large carrots, julienned

1 head romaine lettuce, shredded
1 large cucumber, peeled, seeded, and julienned

1 large avocado, pitted, peeled, and thinly sliced
Dipping sauce (recipe follows)

Dip a rice paper sheet in a bowl filled with warm water and place it on a flat work surface. If you like, use a little nonstick cooking spray on the surface to make your work easier. Lay a small amount of carrots, lettuce, cucumber, and avocado on the lower third of the rice paper, about ½ inch (12 mm) from the bottom. Fold in the bottom

and sides, and roll tightly. The paper will stick to itself creating a seal. Repeat with the remaining rice paper sheets and fillings. Slice the vegetable rolls in half on the diagonal and serve with the dipping sauce, below.

DIPPING SAUCE MAKES ½ CUP (120 ML)

3 tablespoons rice wine vinegar
¼ cup (60 ml) low-sodium soy sauce

1 tablespoon black sesame seeds
1 teaspoon toasted sesame oil

1 teaspoon organic raw blue agave

In a mixing bowl combine all ingredients, chill until ready to serve, then transfer to a decorative bowl and place alongside the summer rolls.

HAMPTONS CUCUMBER CUPS WITH CRABMEAT

MAKES ABOUT 36 PIECES

Guests will devour these delicious yet simple to prepare hors d'oeuvres.

4 English (seedless) cucumbers, peeled
½ cup (85 g) jumbo lump crabmeat
Juice of 1 lime

½ cup mayonnaise
¼ cup finely chopped onion
1 tablespoon chopped fresh flat-leaf parsley, leaves

3 dashes hot sauce
Kosher salt and cracked black pepper
4 fresh chives, finely chopped

Remove the ends and cut the cucumbers into 1-inch (2.5-cm) sections. Using a small melon baller, scoop out some flesh and scrape away part of the wall. Leave the bottom intact.

In a medium bowl, toss together the crabmeat and lime juice and set aside.

In a separate bowl, combine the mayonnaise, onion, parsley, and hot sauce. Season with salt and pepper to taste. Toss the crabmeat in the mayonnaise mixture.

Spoon the mixture into the cucumber cups, garnish with the chives, and serve immediately.

ANGEL'S CEVICHE

SERVES 8 AS AN APPETIZER

The freshest firm-fleshed fish works best for this citrusy preparation. While the Rosses served it as an appetizer, the recipe is quite versatile. It makes a terrific light main course, and it can also be used as a filling for tacos: simply spoon it into warm tortillas and garnish with avocado slices.

2 pounds (910 g) firm-fleshed fish fillets, such as red snapper or sand tilapia, deboned and diced
½ red onion, diced
½ cup (90 g) diced red bell pepper
½ cup (90 g) diced yellow bell pepper

1 serrano chile pepper, seeded and finely diced
2 teaspoons sea salt
⅛ teaspoon cayenne pepper
⅛ teaspoon ground oregano
½ cup (120 ml) freshly squeezed lime juice

½ cup (120 ml) freshly squeezed lemon juice
Micro greens
Leaves from 2 sprigs fresh cilantro, chopped
Tortilla chips

In a nonreactive dish, toss the fish, onion, peppers, chile pepper, salt, cayenne, and oregano. Pour the lime and lemon juices over the top and mix. Cover the dish and refrigerate.

After 1 hour, stir the ceviche so that all the fish pieces are coated with citrus juice. Return the dish to the refrigerator and let it marinate for another 2 to 3 hours.

The ceviche will be ready when the fish color has changed from translucent pink/gray to opaque white. Be sure not to over-marinate, or the fish will become dry.

When you're ready to serve, place a handful of micro greens at the bottom of each small bowl or plate. Divide the ceviche among the prepared plates, sprinkle it with cilantro, and serve it with the tortilla chips on the side.

Opposite, clockwise from top left: Verano Watermelon Margarita, Summer Vegetable Rolls with Dipping Sauce, and Peach Sangria (all, page 31); Hamptons Cucumber Cups with Crabmeat.

SEARED SCALLOPS WITH WATERMELON AND PAPAYA

SERVES 8

Hamptons watermelon and local scallops combine with a taste of the Caribbean to create a wonderfully refreshing entrée for a hot summer evening. It's the perfect dish for a late-night dinner with friends.

1 cup (240 ml) balsamic vinegar
½ cup (110 g) packed brown sugar
1½ cups (228 g) diced seeded or seedless watermelon
32 cherry tomatoes, sliced in half

1½ cups (220 g) diced ripe papayas, seeds removed
5 tablespoons (75 ml) extra-virgin olive oil
3 tablespoons freshly squeezed lime juice
⅛ teaspoon crushed black pepper

2 tablespoons kosher salt
4 cups (120 g) baby arugula
32 large sea scallops
2 tablespoons butter, clarified or unsalted
2 tablespoons vegetable oil

Make a balsamic glaze by combining the vinegar and brown sugar in a small saucepan. Bring the mixture to a boil and reduce to a simmer. Cook until it has the consistency of syrup, about 10 to 15 minutes. Remove from heat and let cool completely. Transfer to a squeeze bottle and set aside.

Combine the watermelon, tomatoes, papaya, olive oil, lime juice, pepper and ½ tablespoon salt. Mix to incorporate and set aside.

Divide the arugula evenly over 8 plates, and set aside.

Rinse the scallops, then pat them dry with paper towels. Season with 1½ tablespoons kosher salt.

Heat a nonstick sauté pan over high heat, and add a tablespoon of butter and a tablespoon of vegetable oil. The oil/butter mixture needs to be very hot before you add the scallops. You want to see a bit of smoke coming off the pan. Working in batches, place the scallops flat side down in the hot pan. To ensure the pan remains hot, don't overcrowd the pan. Sear the scallops until there is a nice, caramel-colored crust on the underside, about 3 to 4 minutes. Flip the scallops and cook another 2 to 3 minutes. Scallops should be removed from the pan while their centers are still slightly translucent, because they will continue to cook after you take them off the heat. If they are very firm or stiff, they are overcooked. You may add another tablespoon of butter and a tablespoon of vegetable oil before cooking the final batches.

Spread the watermelon and papaya mixture evenly over the arugula and immediately place the scallops on top of the salad. Be sure to serve the scallops with the beautiful caramel-colored crust facing up. Drizzle balsamic glaze over the scallops and salad and serve immediately.

BLOOD ORANGE SORBET WITH SEASONAL FRUIT

MAKES 8 SERVINGS

Easy, delicious, and healthful—your guests will enjoy this sweet ending to a delightful summer meal. The pistachio garnish gives this a nice crunch; you may wish to use a favorite cookie or edible flowers instead.

1 peach, pitted and diced
½ cup (75 g) blueberries
½ cup (85 g) strawberries, hulled and diced
1 nectarine, pitted and diced

1 plum, pitted and diced
1 apricot, pitted and diced
½ cup (80 g) white cherries, pitted and diced
2 tablespoons Grand Marnier liqueur

1 tablespoon wildflower blossom honey
2 pints (960 ml) blood orange sorbet (such as Ciao Bella brand)
½ cup (60 g) crushed roasted pistachio nuts (optional), for garnish
1 bunch mint leaves, for garnish

In a mixing bowl, combine the fruits, Grand Marnier, and honey. Stir and place the bowl in the refrigerator to chill. When you're ready to serve, scoop some sorbet into a martini glass and ladle fruit mixture over the top, dividing it equally among the glasses.

Sprinkle the crushed pistachios, if using, over the sorbet and fruit and garnish with mint leaves. Serve immediately.

Opposite, bottom, center: Angel's Ceviche (page 32).

Lobster and Libations by the Sea

WITH ANNIE AND MICHAEL FALK

As the sun plunged behind the dunes of Southampton and the supermoon illuminated the darkening sky, the long wail of a conch shell invited guests beachside. They rounded the dunes to an exquisite panorama: two long tables perched on the sand, linen tablecloths billowing in the gathering breeze, and a fire pit surrounded by enormous white cushions and hay bales, all encircled by a perimeter of torches and framed by the gently breaking waves of the Atlantic.

It even gave pause to one of the evening's most notable guests, film director Oliver Stone: "I had to stop on the top of the dune and take photos," he said. "This is surreal. It looks like something out of a Fellini movie."

For Annie and Michael Falk, who planned this clambake-style beach party for seventy guests, the scene was the essence of entertaining in the Hamptons: relaxed and effortlessly glamorous, an authentic celebration of friends in the embrace of nature.

"Life on the east end of Long Island centers around family, friends, and community, but also the pull that nature has on you," Annie says. "There is something about the light, the smell of the Atlantic, the fog that constantly rolls in. . . . There is a sense of groundedness and peace here that few places can offer."

That sensibility informs much of the Falks' summer lifestyle, from dressing (a wardrobe of breezy fabrics and layers is a nod to seaside living) to entertaining. "Entertaining here is not fussy or contrived," Annie says. "Flowers are always from the garden, and tabletop items are usually handcrafted, created locally, or amazing found treasures. And the food is so fresh. You can taste the heart and soul that went into growing it."

All these concepts came to life at the Falks' clambake, where the tables were set with objects from nature—seashells, coral, and succulents—and the menu echoed the couple's philosophy of eating organic, seasonal, sustainable, and locally produced fare. From the lobster and steamers to the farm-raised chicken and corn on the cob, everything was as fresh as nature intended.

After a magical dinner under the stars, guests moved to the bonfire area for s'mores or were delivered by golf cart back to the Falks' house for a lavish dessert buffet. As everyone wound down the evening with stories and laughter, Annie recalled one of her fondest memories of summer in the Hamptons: "When our girls were little, my extended family would come out for Sunday dinner," she says. "My dad would turn up the music, and we would all dance and laugh hysterically. Then we'd go to the porch

Gigi, Michael, and Annie Falk.

and sit by the fire with tea as my dad told jokes and war stories. The girls would fall asleep with smiles on their faces."

Years later, the smiles persist, creating perfect summer memories for yet another generation.

TIPS AND IDEAS
from Annie Falk

In the early summer, when friends are traveling and transitioning homes, e-mail is the surest way to deliver invitations in a timely manner—and it reduces your carbon footprint.

When hosting a clambake, be mindful of shellfish allergies and have other options available.

Place cards can seem a bit fussy on the beach; instead, invite guests to the table in small groups of friends whom you know will enjoy meeting one another and encourage them to sit together.

When your guests leave the beach and it's time to put their shoes back on, they will surely appreciate a tub of water, fresh towels, and a bench to sit on.

Menu

BEACHSIDE DINNER FOR EIGHT

Sebonack Southside, Cyril's Bloody Mary, Southampton Publick
House's Summer Blonde, Pinot Grigio, Pinot Noir, and Rosé Wines

.

Fresh, Local Little Necks and Hand-Shucked Oysters, served with
Spicy Cocktail Sauce, Lemon, and Minuet Sauce
Large Shrimp Cocktail, served with Cocktail Sauce and Lemon
Grilled Local Chicken Satay with Garlic and Garden Herb Marinade
Fresh Seasonal Julienned Vegetables from the Falks' Garden in Zuc-
chini Cups Filled with Tomato-Roasted Hummus
Mussels in White Wine Broth
Steamers in Natural Broth and Sautéed Vidalia Onions
Local Corn on the Cob
Creamy Homemade Coleslaw with Tarragon
Creamy Homemade Broccoli Slaw
Local Corn and Black Bean Salad with Garden Herbs
Farm-Fresh Chicken with Garlic and Garden Herbs

.

Gigi's Éclairs
Blueberry Buckle
Annie's Gourmet S'mores
Chocolate Mousse Cake
Vanilla and Strawberry Napoleons
Marta's Individual Apple Pies
Assorted Gourmet Cookies
Coffee, Cappuccino, Artisanal Tea, and Espresso
Ice Wine, Espresso Vodka, and Port

CREAMY HOMEMADE BROCCOLI SLAW

MAKES 8 SERVINGS

This slaw is perfect for a clambake, barbecue, or casual dinner and a great addition to your menu for guests who don't enjoy cabbage. This easy-to-make vegan salad should be prepared in advance to allow the flavors to meld, the broccoli to soften—and to give you more time with guests. Try substituting cranberries for the raisins or sprinkling in some crushed pistachio nuts for variation. The Falks use a vegan, all-natural mayonnaise-like dressing that's a healthy alternative to traditional mayonnaise.

1 cup (240 ml) vegan mayonnaise (such as Earth Balance Mindful Mayo)

⅓ cup (75 ml) white vinegar

2 tablespoons sugar

½ cup (85 g) organic raisins

4 cups (12¾ ounces/360 g) organic broccoli slaw

8 to 10 small broccoli florets, blanched, for garnish

In a medium mixing bowl, combine the mayonnaise, vinegar, and sugar. Mix until well integrated. Add the raisins and coat completely. Add the broccoli slaw and toss until well combined. Cover and refrigerate for 2 hours. When you're ready to serve, transfer the slaw to a decorative bowl and garnish it with blanched broccoli florets.

LOCAL CORN AND
BLACK BEAN SALAD WITH GARDEN HERBS

MAKES 8 SERVINGS

This beautiful, colorful salad is created with the bounty of the Falks' garden, locally grown non-GMO corn and organic black beans. Simple and delicious, it is great for casual barbecues and warm-weather buffet dinners. Don't hesitate to add or substitute ingredients to incorporate what is fresh, ripe, and locally grown in your area.

3 tablespoons olive oil

Kernels from 4 ears fresh corn

1½ teaspoons salt

1 teaspoon ground black pepper

1 red bell pepper, diced

1 cup (185 g) seeded, diced heirloom tomatoes

½ cup (65 g) trimmed, finely chopped green beans

⅛ teaspoon crushed red pepper

1 (15-ounce/425-g) can organic black beans, drained and rinsed

1 teaspoon chopped fresh oregano leaves

Juice and zest of ½ lemon

5 basil leaves, chopped, plus whole leaves for garnish

In a medium pan, heat 2 tablespoons of the olive oil. Add the corn, 1 teaspoon of the salt, and pepper and sauté until golden brown. Set pan aside to cool.

In a decorative bowl, combine the cooled corn with the bell pepper, tomatoes, green beans, crushed red pepper, black beans, and oregano. Sprinkle the lemon juice, zest, remaining 1 tablespoon olive oil, and ½ teaspoon salt over the vegetables and toss to coat thoroughly. Garnish with fresh basil and serve at room temperature or chilled.

BLUEBERRY BUCKLE

MAKES 8 SERVINGS

Kathleen King of Tates Bake Shop created this fantastic cake for the Peconic Land Trust fundraiser. It's loaded with fresh blueberries and even won first place for the best blueberry dessert at a competition in the state of Maine. The Falks serve it with warm, home-made blueberry jam (page 62) on the side as both a dessert and a decadent breakfast option.

FOR THE CAKE:
½ cup (1 stick/115 g) unsalted butter
¾ cup (150 g) granulated sugar
1 large egg
½ cup (120 ml) whole milk
2 teaspoons baking powder
½ teaspoon salt
2 cups (255 g) all-purpose flour
2½ cups (370 g) fresh blueberries

FOR THE TOPPING:
1 cup firmly packed (220 g) dark brown sugar
1 cup (125 g) all-purpose flour
1 teaspoon ground cinnamon
½ cup (1 stick/115 g) unsalted butter, cut into pieces

FOR THE SOUR CREAM DRIZZLE:
1 cup (240 ml) sour cream
2 tablespoons honey
¼ teaspoon vanilla extract

Preheat the oven to 375°F (190°C). Grease a 9-inch (23-cm) square baking pan.

In a large bowl, cream together the butter and sugar. Add the egg, milk, baking powder, and salt. Mix well. Stir in half of the flour, then incorporate the remaining half. Fold in the blueberries. Pour the batter into the prepared pan and set it aside.

Make the topping. Combine the brown sugar, flour, cinnamon, and butter in a medium-sized bowl. Mix with a pastry cutter or your hands until combined and crumbly. Sprinkle the topping evenly over the cake batter. Bake the buckle for 45 to 50 minutes, or until a cake tester inserted in the center comes out clean.

Make the sour cream drizzle. While the cake is baking, whisk the sour cream, honey, and vanilla together until combined.

Cut the buckle into squares and serve it on dessert plates, with the sour cream drizzled on top.

ANNIE'S GOURMET S'MORES

MAKES 24 PIECES

Everyone loves a warm, just-off-the-fire s'more and the nostalgic feelings it inspires. The Falks offered both the classic bonfire s'mores and these little gourmet treats that Annie created for her guests. No overflowing chocolate or dripping marshmallow; just the delicious flavors of everyone's favorite childhood dessert. Using large and small marshmallows adds to the presentation.

4 bars (1.55 ounces/43 g each) organic milk chocolate
16 organic honey graham crackers
½ cup (50 g) organic confectioners' sugar
¾ cup (1½ sticks/170 g) organic butter, melted
Black Hawaiian sea salt
72 mini marshmallows and 6 large marshmallows, cut in half

Preheat the oven to 350°F (175°C). Grease a 24-cup mini muffin pan.

Unwrap and break 2 chocolate bars into 24 pieces and set them aside.

In a food processor, crush the graham crackers into fine crumbs. Transfer them to a small mixing bowl and combine them with the confectioners' sugar and melted butter. Immediately place 1 table-spoon of the crumb mixture in each muffin well; press the crumbs up the sides to form cups. Bake until the edges begin to bubble slightly, about 4 minutes.

Remove the pan from the oven, drop 1 piece of chocolate into each cup, and sprinkle lightly with sea salt. Place 6 mini marshmallows in 12 cups, over the salted chocolate and place a large marshmallow half, cut side down, in each of the remaining 12 cups. Return the pan to the oven until the marshmallows are slightly softened, but not melted, 3 to 4 minutes. Let them cool completely.

Melt the remaining 2 bars of chocolate in a double boiler or in a non-reactive bowl set over a hot water bath. Transfer it to a pastry bag and pipe the warm chocolate over the tops of the marshmallows. Serve at room temperature.

MARTA'S INDIVIDUAL APPLE PIES

MAKES 8 MINI PIES

These scrumptious pies are a Falk family favorite! By popular demand, they make their way onto holiday dessert buffets, appear at festive gatherings, and are served to special guests after intimate dinners. The best way to enjoy one of these pies is when it's warm and gooey, just out of the oven, with homemade ice cream on the side. You will need two mini pie pan sets with decorative cookie cutters.

⅓ cup (75 ml) freshly squeezed orange juice

8 Granny Smith apples, peeled, cored, and cut into ½-inch (12-mm) cubes

½ cup (1 stick/115 g) unsalted butter, at room temperature

3 tablespoons flour, sifted

½ cup (100 g) granulated sugar

½ cup packed (110 g) brown sugar

4 store-bought deep-dish double-crust piecrusts

Preheat the oven to 375°F (190°C).

Pour the orange juice over the apples and toss to prevent them from turning brown. Stir, strain, and set the apples aside.

In a saucepan mix together the butter, flour, granulated and brown sugars, and ¼ cup (60 ml) water. Cook over medium heat, stirring, until the butter is melted and all the ingredients are incorporated, about 5 minutes. Set aside.

Remove the piecrusts from their packaging and, with a rolling pin, roll one crust until it is about ¼ inch (6 mm) thick.

Using a 4½-inch (11-cm) round cookie cutter to make the bottom crusts and a suitably sized decorative cookie cutter for the top crusts, cut the dough (rolling more as needed) into 8 rounds of each type. Cut vents into the 8 top crusts.

Place 1 bottom crust in each pie pan, molding the dough up the sides. Divide the apple filling among the pans and cover each pie completely with a vented top crust. Using a fork, crimp to seal the edges.

Slowly pour 3 tablespoons of the butter mixture over the top of each pie, allowing the mixture to seep into the crust and soak the apples.

Bake until the pies are golden brown, about 20 minutes. Serve warm.

Opposite, top: Kayla Falk, serving Creamy Homemade Broccoli Slaw and Local Corn and Black Bean Salad with Garden Herbs (page 41).

Preserving the Past

In the Port of Missing Men, everything has a story—including the name of the place itself. Back in the 1600s, the story goes, a ship was lost in a hurricane off the Long Island coast. A rudder, but nary a sailor, was found near Peconic Bay.

Three centuries later, Colonel Henry Huttleston Rogers, Standard Oil heir and gentleman hunter, bought 2,000 acres of woods and wetlands in the Peconic region and gave the property its peculiar name. It was as much in deference to its eerie past as to his new vision for a hunting estate where women were not welcome and men went "missing" inside a tangle of duck blinds.

This men's refuge from polite society was not without its luxuries. Col. Rogers had two things in spades: exquisite taste and a penchant for collecting American treasures such as hooked rugs, Queen Anne American maple furniture, and nautical objects; he assembled the world's largest ship model collection after that of the British Admiralty.

Many of the antiques amassed by the estate's founder remain today, displayed in the house and its guest apartments, each of which is named for a different subject—Sailor's Return, the Dog, Room of the Canton, the Ruined Roman Virgins, and the chillingly titled Room of the Haunt. Presiding over these spoils is Wiltraud,

Countess von Salm-Hoogstraeten, wife of the late Peter Salm, the Colonel's grandson and eldest son of legendary fashion icon Millicent Rogers.

Wiltraud Salm takes her appointed task very seriously. "I feel like a curator, because all of these collections need my full attention," she says, "especially the section of the house dating 1661."

She also continues, with great passion, the family tradition of preservation that Col. Rogers started in the 1920s. Much of the land today is protected under conservation easements, meaning it can never be developed. These wide-open spaces are a lure for friends who come to the Port of Missing Men to enjoy outdoor sports and share stories over the lunches and dinners that Countess Salm plans to the letter.

Her tables are set with the gorgeous china, crystal, and objects amassed by the Rogers family over generations—Tiffany silver from the 1800s, for example, and crystal plates engraved with the initials of the family patriarch, Henry Huttleston "Hell Hound" Rogers.

She insists on the freshest seasonal fare—locally caught game and produce harvested from the estate's large vegetable garden—prepared by a gourmet chef and presented with thoughtful touches from the family's heritage. Wines are equally important. The countess always

TIPS AND IDEAS
from Countess Salm

Designing a table using family heirlooms is lovely, but sometimes it's fun to introduce an unexpected element. "I like to freshen things up with something that is not as serious, as long as it harmonizes with the rest of the house."

Upholding tradition may be rigorous, but Countess Salm sees it as an exercise in preservation. "Shining a piece of old brass or silver is never too much work. Someone put a lot of skill and craft into it, and I respect that. It is a privilege to look after old things."

serves the best of the cellar, often pouring from prized bottles such as an 1835 port wine. Her guests are invariably impressed, and that's something, considering the legacy she has to live up to.

One of the causes she has championed is the Peconic Baykeeper, because of the "terrible problem with pollution," which often results in sea turtle deaths. Every year, Countess Salm holds a fund-raising cocktail party on the lawn, featuring a lavish raw bar with seafood donated by local fishermen. Guests enjoy the local fare along with a view of the waters that need looking after—an iconic aspect of the Hamptons landscape. VIPs also have the opportunity to tour the house and admire their hostess's celebrated table settings.

A devoted conservationist, Countess Salm is happy to contribute, not only by opening her home, but also by doing her part. "I regularly patrol my land to watch for pollution and do not allow my staff to do anything that harms nature," she says. "If you want to change the world, you have to start at home."

Menu

HORS D'OEUVRES
ON THE LAWN FOR EIGHT TO TEN

Signature Russian Vodka
Blue Point Draft Beer
Wölffer Estate Vineyard Wines

·

Raw Bar of Local Seafood
Skewers of Mozzarella and Local Tomatoes
POMM Pulled-Duck Crostini
Tuna Tacos
POMM *Pheasant with Truffled Wild Mushroom Cream in Filo Cups*
Smoked Montauk Striped Bass Dip on Crackers
POMM Venison Crostini
Lobster Salad on Buttery Crostini
Babinski Farms Blueberry Pie

Prepared by Tim Burke Productions
presents 230 Elm Caterers

POMM PHEASANT WITH TRUFFLED
WILD MUSHROOM CREAM IN FILO CUPS

MAKES 16 TO 20 HORS D'OEUVRES

This wild game bird has a distinct natural flavor, and its leanness makes it a bit healthier than fattier, farm-raised birds. Pheasant is naturally tougher than other poultry so it's best to brine the bird. It will add moisture and ensure that the rich gamey flavor is not too overpowering but rather a subtle, delicious taste everyone will enjoy. If you are cooking dinner for four, save the phyllo cups for another occasion and, instead of dicing the pheasant, slice and serve it atop a heaping ladleful of the cream sauce.

¼ cup (45 g) kosher salt

1 tablespoon brown sugar

2 bay leaves

1 clove garlic, minced

2 sprigs fresh thyme, coarsely chopped

4 (5-ounce/140-g) pheasant breasts

½ cup (120 ml) olive oil

20 store-bought mini phyllo dough shells (phyllo cups)

Cream Sauce (recipe follows)

3 ounces (85 g) store-bought foie gras pâté, diced

Combine the salt, brown sugar, bay leaves, garlic, and thyme in a large bowl with 4 cups (960 ml) of water.

Add the cleaned pheasant breasts to the brine and refrigerate for about 2 hours. Remove the pheasant from the brine, rinse well, and place it in a bowl of cold water for 10 minutes.

Heat the olive oil in a sauté pan over medium-high heat. Pat the pheasant breasts dry with paper towels and when the olive oil is hot, lay them skin side down in the pan. Sear until they are golden brown, about 8 minutes.

Let the pheasant breasts rest on a cutting board, skin side up. When the pheasant is cool enough to handle, remove the skin and dice the meat into ¼-inch (6-mm) cubes. Spread in a single layer on a baking pan and set the pan aside while you prepare the cream sauce.

Preheat the oven to 375°F (190°C). Place the pheasant in the oven for 5 minutes or until all the pieces are cooked through. Place the phyllo cups in the oven to warm, about 2 minutes.

To assemble the hors d'oeuvres, spoon ½ teaspoon of warm cream sauce into each phyllo cup. Place a few cubes of pheasant breast and a few cubes of foie gras pâté on top of the sauce and serve immediately.

CREAM SAUCE MAKES 2 CUPS (480 ML)

This sauce is so delicious you may want to try it over your favorite pasta.

1½ packed cup (125 g) fresh mixed mushrooms (field, wild, and chanterelle)

2 tablespoons olive oil

⅛ teaspoon salt

⅛ teaspoon freshly ground black pepper

½ cup (55.9 g) sliced shallots

1½ medium leeks, sliced

½ cup (120 ml) brandy

1½ cups (360 ml) heavy cream

3 tablespoons ground dried porcini mushrooms

⅓ cup (96 g) minced fresh thyme

2 tablespoons white truffle oil, plus more to taste

¼ cup (55 g) butter, at room temperature

Preheat the oven to 425°F (220°C) and set the rack in the center position.

On a heavy-duty rimmed baking sheet, toss the mushrooms with the olive oil to coat generously, and add the salt and pepper. Arrange the mushrooms in a single layer and roast until they are brown, about 15 minutes. Let them cool enough to be handled, then dice them and toss them back on the baking sheet and set aside. Be sure to reserve any liquid.

Place a large stainless-steel saucepan over medium-high heat.

When the pan is warm, toss the shallots and leeks in the pan with the brandy. When the vegetables are completely coated, let them simmer until the pan is almost dry, about 6 minutes.

Add the cream and porcini mushrooms, bring the mixture to a simmer, lower the heat to avoid scorching the cream, and reduce by one-third, about 15 minutes.

Add the roasted mushrooms and any reserved liquid and simmer for 10 minutes. Add thyme and truffle oil and whisk in the butter. Add salt and pepper and set aside, but keep warm.

SMOKED MONTAUK STRIPED BASS DIP ON CRACKERS

MAKES ABOUT 48 HORS D'OEUVRES

Fish, like fruits and vegetables, have seasons, and when Montauk striped bass is at its peak, there is nothing more delicious. It's a dream fish and whether grilled, pan-roasted, or served raw, striped bass delivers an extraordinarily rich but subtle flavor. One can never have too many bass recipes, and this dip is truly a crowd pleaser. You can serve it on crackers, as Countess Salm did, or simply mold the dip onto a serving plate and surround it with small wedges of apples and crackers or New York–style flatbread. Black bass and halibut are good substitutes.

10 ¾ ounces (305 g) smoked wild Montauk striped bass, shredded
2 Granny Smith apples, peeled and diced

3 tablespoons prepared horseradish
½ cup (120 ml) mayonnaise
⅔ cup (60 g) minced fresh chives

⅓ cup (75 ml) freshly squeezed lemon juice
⅛ teaspoon freshly ground black pepper
Crackers for serving

In a medium stainless-steel mixing bowl, combine the striped bass, half of the diced apple, the horseradish, mayonnaise, chives, lemon juice, and pepper.

Mix with gloved hands to blend the ingredients, further shredding the fish and removing any remaining bones.

Spoon a generous teaspoon of dip onto each cracker, garnish with the remaining diced apple, and arrange on serving trays.

Any remaining dip can be refrigerated for up to 3 days.

LOBSTER SALAD ON BUTTERY CROSTINI

MAKES ABOUT 25 HORS D'OEUVRES

There are no fancy seasonings here; the lobster is showcased in a simple mayonnaise dressing. Try a vegan mayonnaise; it's a healthy alternative that allows the lobster to take center stage. This salad is also great over greens for a main dish or served in a warm, grilled hot dog bun with lettuce, as a classic lobster roll.

1 pound (455 g) fresh lobster meat, diced (from two 1¼-pound/570-g cooked lobsters)
½ cup (120 ml) mayonnaise or vegan mayo (such as Earth Balance Mindful Mayo)

Kernels from 1 ear roasted corn
¼ cup (25 g) minced celery
2 tablespoons freshly squeezed lemon juice
½ teaspoon of celery salt or Old Bay seasoning, plus more to taste

⅛ teaspoon ground white pepper
1 baguette
2 tablespoons butter, melted

In a medium bowl, toss the lobster meat very lightly with the mayonnaise, using a fork. You want to just moisten the lobster meat and not overhandle it. Add the corn, celery, lemon juice, celery salt, and the white pepper. Toss gently and add more celery salt to taste. Cover and chill the salad for 1 hour.

Preheat the oven to 300°F (150°C).

Slice the baguette into rounds about 1 inch (2.5 cm) thick and place them on a baking sheet. Brush them with the butter and bake until crisp, about 10 minutes.

Spoon generous portions of the lobster salad onto the crostini and arrange the hors d'oeuvres on serving trays.

Opposite, top right: POMM Pheasant with Truffled Wild Mushroom Cream in Filo Cups (page 51); bottom left, clockwise from top right: skewers of mozzarella and local tomatoes, tuna tacos, Lobster Salad on Buttery Crostini, POMM pulled duck, and Smoked Montauk Striped Bass Dip on Crackers.

Dinner on the Dunes

WITH LISA AND JIMMY COHEN

On the perfect evening, when the sea is calm and the moon is full, Lisa and James Cohen like to set a table on the dunes outside their East Hampton house, invite a few good friends, and let the magic happen.

It seems like a simple enough formula—an interesting group, good food, and the expansive beauty of nature—but for the Cohens, even a small, impromptu dinner party is executed with great flair. Consider the source: James—Jimmy to his friends—is president and CEO of the family business, Hudson News, and Lisa is home editor of *DuJour* magazine, one of Hudson's media concerns. Years spent within creative as well as elite business circles, to say nothing of the couple's extensive travels, have sharpened their eye for authentic design that comes across even in the subtlest details.

To host dinner on the dunes, Lisa had the evening planned to the letter, yet the flow was organic, as if it all came together spontaneously. As friends arrived at their home, known as First Jetty because of its location, the Cohens welcomed them with cocktails and invited them to the living room, where massive windows framed an ocean view worthy of a "Wish You Were Here" postcard.

The windows also offered a taste of what lay beyond: a fire pit whose flames beckoned as night fell and a teak table and yachting chairs atop a sand dune surrounded by sea grasses and ocean blues. Before long, the party progressed outside, first to the fire pit for more hors d'oeuvres and aperitifs, and then to the dinner table.

Lisa's studied approach to table design—relaxed yet super-chic—was apparent in her effortless mixing of blue-and-white patterns, the just-picked informality of a bouquet of wildflowers, the pop of color from Italian glass, and the picnic-style draping of a gorgeous tablecloth.

"Entertaining on the dunes is casual by nature," she says. "It takes you away from a formal table and allows you to sink your feet in the sand and connect to the outdoors. Being surrounded by beautiful scenery, water, and candlelight is special in itself. You don't need anything else."

Except, perhaps, good company—which is always guaranteed at a Cohen party. A master at putting people together, Lisa often sits back and marvels at the sparks of creativity that emerge from a well-orchestrated group of people. "I like to bring interesting people together," she says. "I feel good when people mingle and exchange thoughts. Good things always come out of that. I love it when our home can be the setting for laughter, conversation, and ideas."

TIPS AND IDEAS
from Lisa Cohen

Keep things moving. Starting in one part of the house and moving to another keeps things fresh and inspires conversation. As people change seats, they tend to talk to different people.

Seating is very important. Place people who have something in common next to each other at the table. There is nothing worse than when you're sitting next to someone and neither of you has anything to say.

A sense of humor always elevates the mood. I'm lucky; my husband tells great jokes. Don't be afraid to lighten the mood and get people laughing.

Menu

SEASIDE DINNER FOR EIGHT

Truffled White Bean Dip with Crudités
Assortment of Cheese, Crackers, and Fresh Fruit

·

Napoleon Tower of Heirloom Tomatoes and Homemade
Mozzarella topped with Aged Balsamic Glaze and Fresh
Basil Sprigs, served with Fresh-Baked Italian Garlic Bread
West Indian–Spiced Grilled Wild King Salmon
Parmesan-Tossed Grilled Corn and Zucchini Succotash

·

Strawberry-Rhubarb Granita
Home-Baked Blueberry Oatmeal Squares

TRUFFLED WHITE BEAN DIP WITH CRUDITÉS

MAKES 1 CUP (240 ML)

Quick, easy, versatile, and delicious, this dish is a healthful addition to any gathering. When entertaining vegans, leave out the Parmesan and replace it with a little cayenne pepper. For a more decadent presentation, add a few shavings of fresh truffles over the top just before serving.

1 (15-ounce/425-g) can organic no-salt-added navy beans, drained

3 cloves garlic, peeled

2 teaspoons white truffle oil

2 tablespoons freshly grated Parmesan cheese

¼ teaspoon fresh thyme

¼ teaspoon salt

⅛ teaspoon ground black pepper

1 tablespoon extra-virgin olive oil

Raw sliced vegetables for serving

Combine three-quarters of the navy beans, the garlic, truffle oil, Parmesan, thyme, salt, pepper, and olive oil in a food processor and puree until smooth. Add the remaining navy beans and pulse to give the dip a slightly chunky texture. Place the dip in a decorative bowl, surround it with your favorite raw sliced vegetable, and serve.

PARMESAN-TOSSED GRILLED CORN AND ZUCCHINI SUCCOTASH

MAKES 8 SERVINGS

This colorful summer succotash looks lovely on the buffet. The flavors work especially well with salmon and chicken.

2 tablespoons extra-virgin olive oil

1 large Vidalia onion, chopped

Kernels from 3 to 4 ears grilled white and yellow corn

2 green zucchini, sliced

2 yellow zucchini, sliced

1 red bell pepper, chopped

¼ teaspoon salt

¼ teaspoon ground black pepper

¼ cup (30 g) freshly grated Parmesan cheese

Heat the olive oil in a large saucepan over medium heat. Add the onion and sauté until soft and translucent, about 5 minutes. Add the corn, green and yellow zucchinis, bell pepper, salt, and pepper, and cook until tender, about 5 minutes. Remove from heat, toss with the Parmesan cheese, and serve warm.

STRAWBERRY-RHUBARB GRANITA

MAKES 8 SERVINGS

Strawberry-rhubarb pie is considered the quintessence of Hamptons desserts. Since both fruit and vegetable are at their peak in early summer, this delightfully cooling frozen dessert, infused with spices, allows you to enjoy the flavors of summer in a new and refreshing way. Your guests will be delighted by these fabulous "pie" flavors. The Cohens served their granita as dessert, but you may also serve it as an amuse-bouche or palate cleanser during a sumptuous multicourse dinner.

2¾ cups (660 ml) filtered water

¾ cup (150 g) organic cane sugar

10 whole cloves

8 whole cardamom pods, crushed

1 cinnamon stick, broken in half

2 small slices peeled fresh ginger

Zest of 1 blood orange

2 tablespoons blood orange juice

1 large stalk fresh rhubarb, sliced into 1-inch (2.5-cm) pieces

8 fresh strawberries, hulled

(CONTINUED ON PAGE 62)

Combine the water, sugar, cloves, cardamom, cinnamon, ginger, and orange zest and juice in a medium-sized pot over medium-high heat. Bring the mixture to a boil, and then reduce the heat and simmer, covered, for 5 minutes. Set the pot aside to let the spices steep for 30 minutes while the mixture cools.

Strain the liquid through a medium-mesh strainer, pressing with a wooden spoon to release all the flavors. Discard the solids, return the liquid to the pot, and bring it to a boil.

Add the rhubarb; cover and simmer until the rhubarb softens, 5 minutes. Add the strawberries, stir, and remove the pot from the heat. Let it cool completely.

In a blender, puree the mixture until smooth. Strain the liquid through a medium-mesh strainer into a metal 8-by-11 inch (20-by-28-cm) rectangular pan suitable for the freezer or a shallow glass baking dish. Cover tightly with plastic wrap, then aluminum foil.

Freeze the granita for 1 hour, then remove it from the freezer and, using a fork, scrape the crystals from the edge of the mixture into the center; mix thoroughly and return it to the freezer. Continue to scrape and stir the granita once an hour until it is evenly frozen and icy; this will take 4 to 6 hours.

When you're ready to serve, scoop the granita into glasses immediately. (If stored in an airtight container in the freezer, it will keep for up to 24 hours.)

HOME-BAKED BLUEBERRY OATMEAL BARS
MAKES 8 BARS

These home-baked bars are so popular with guests you may want to make a second batch for them to take home at the end of the evening. The Cohens served them alongside the strawberry-rhubarb granita, garnished with fresh fruit. This recipe was adapted from caterer Karen Sheer, who blogs at azestforlife.com, one of the Cohens' go-to resources for entertaining.

½ cup (1 stick/115 g) unsalted organic butter, at room temperature

¾ cup (75 g) confectioners' sugar

1 cup (125 g) all-purpose flour

1¼ cups (130 g) ground nuts (a mix of pecans and almonds)

¼ cup (40 g) organic old-fashioned rolled oats

1½ teaspoons ground cinnamon

¼ teaspoon sea salt

½ teaspoon almond extract

⅔ cup (165 ml) Farm Stand Blueberry Jam (recipe follows)

Preheat the oven to 350°F (175°C). Line a 9-inch (23-cm) square pan with parchment paper and lightly butter it.

Place the butter, confectioners' sugar, flour, nuts, 3 tablespoons of the oats, the cinnamon, salt, and almond extract in a stand mixer, and mix until combined but crumbly.

With your hands, press two-thirds of the mixture into the bottom of the prepared pan. Spread the jam over the pastry layer. Sprinkle the remaining pastry mixture on top and press it gently into the jam. Some exposed jam is lovely and adds to the homemade look. Sprinkle with the remaining 1 tablespoon oats and press down slightly.

Bake until the pastry just turns golden and the filling is a little bubbly, about 15 minutes. Let it cool completely, then cut into 8 bars. Serve warm or at room temperature.

FARM STAND BLUEBERRY JAM MAKES 1½ CUPS (360 ML)

This easy jam requires no pectin. This recipe makes enough for the Home-Baked Blueberry Oatmeal bars plus leftovers for your morning toast! Consider doubling or tripling the recipe, as this jam is a wonderful way to preserve fresh seasonal fruit and is delightful over crepes, homemade ice cream, or muffins. You can use the same recipe for wild blackberries, local raspberries, strawberries, or a combination of your favorite berries.

3 cups (400 g) fresh blueberries

1 cup (200 g) organic cane sugar

Zest of ¼ lemon

2 tablespoons freshly squeezed lemon juice

⅛ teaspoon coarse salt

Puree half of the blueberries in a food processor. Transfer the mixture to a medium-sized pot and add the remaining blueberries, the sugar, lemon zest and juice, and salt. Bring it to a boil, stir, and lower the heat to a simmer. Cover and cook the mixture over low heat for 5 minutes, then uncover, stir, and cook it for 30 minutes longer. Stir occasionally, using the back of a wooden spoon to crush the whole blueberries. The jam is ready when the liquid is condensed and thickened. Remove the jam from the heat; it will thicken a bit more as it cools. Refrigerate in a tightly sealed glass jar.

Clockwise from top left: Parmesan-Tossed Grilled Corn and Zucchini Succotash, Strawberry-Rhubarb Granita, Home-Baked Blueberry Oatmeal Bars, and Truffled White Bean Dip with Crudités (pages 61 and 62).

The Art of the Party

CREATIVE SUMMER GATHERINGS

A Preppy Picnic

WITH J. CHRISTOPHER BURCH

A man who spends most of his time in an airplane sometimes needs a down-to-earth place to get away. So when J. Christopher Burch—founder and CEO of Burch Creative Capital and the man behind the retro-prep lifestyle retailer C. Wonder—settled on a new Hamptons address in 2011, he opted for a cozy shingled cottage with just enough room for entertaining friends and family.

"I go to the Hamptons to hang out with my children and friends," says Chris, who has six children and divides his time largely between New York, Miami, and the islands of Indonesia, where he is co-owner of Nihiwatu, a 580-acre eco resort. At the Hamptons, he says, "It's relaxed, casual, and fun."

Those three ingredients were key when Chris, along with Bill Finneran, Suzie Finneran, and Jeff, Lizzete, and Danielle Winick, hosted a private cocktail reception and picnic-style dinner to benefit Operation Smile, an international children's charity that provides reconstructive surgery and related medical care for children born with facial deformities.

"I want my guests to feel welcome and have fun," says Chris, who loosened the collar of his white linen shirt and threw on some hot pink pants and flip flops at the top of the party.

As guests arrived, handsome waiters—all with suntans and coiffed hair—greeted guests at the door with cocktails aplenty, inviting everyone to tour the house and gardens at their leisure. In the backyard, picnic tables were set atop a verdant lawn with pots of fresh mums, dahlias, and wildflowers. Classic blue and white vases dotted highboy tables meant for mingling, and politely placed apple-green C. Wonder beach umbrellas and pompom-trimmed picnic blankets offered picnic seating.

A live trio crooned on the back porch as swarms of beautiful people settled in for a Burch signature cocktail and bite-size "picnic" dishes like North Carolina barbecue chicken, black truffle mac and cheese, and truffle fries served in a parchment cone with a mini mug of summer ale.

It was just the beginning of another legendary night in the Hamptons.

"Whether it is a planned or spontaneous event, I am always entertaining. I love having people over," says Chris, co-founder of the Tory Burch fashion label.

Modest by Hamptons standards at 6,000 square feet, the interiors of Chris's home are layered with bold-patterned fabrics, lacquer finishes, glass cloth, and rattan. Architectural designer Marina Lanina took the structure down to its frame and modernized the floor plan just outside the original footprint, and New York interior

Opposite, top right: the C. Wonder car; above: J. Christopher Burch, Suzie Finneran, Danielle Winick, and Bill Finneran.

TIPS AND IDEAS
from J. Christopher Burch

Music is one way to make guests feel welcome and have fun. Play a little Motown; it puts you in a good mood.

Inviting a great mix of people makes all the difference!

designer Christopher Maya helped infuse the modified space with Burch's eclectic yet traditional sense of style.

On just under three acres, Bridgehampton landscape designer Joseph Tyree planted a veritable Hamptons wonderland, brimming with fruit trees, hydrangeas, roses, and bright summer annuals. An expanded kitchen at the rear of the house allows for easy catering access to the pool area and grounds. "In the Hamptons, I spend more time outside, especially because I love my gardens, and they are a fantastic place to entertain."

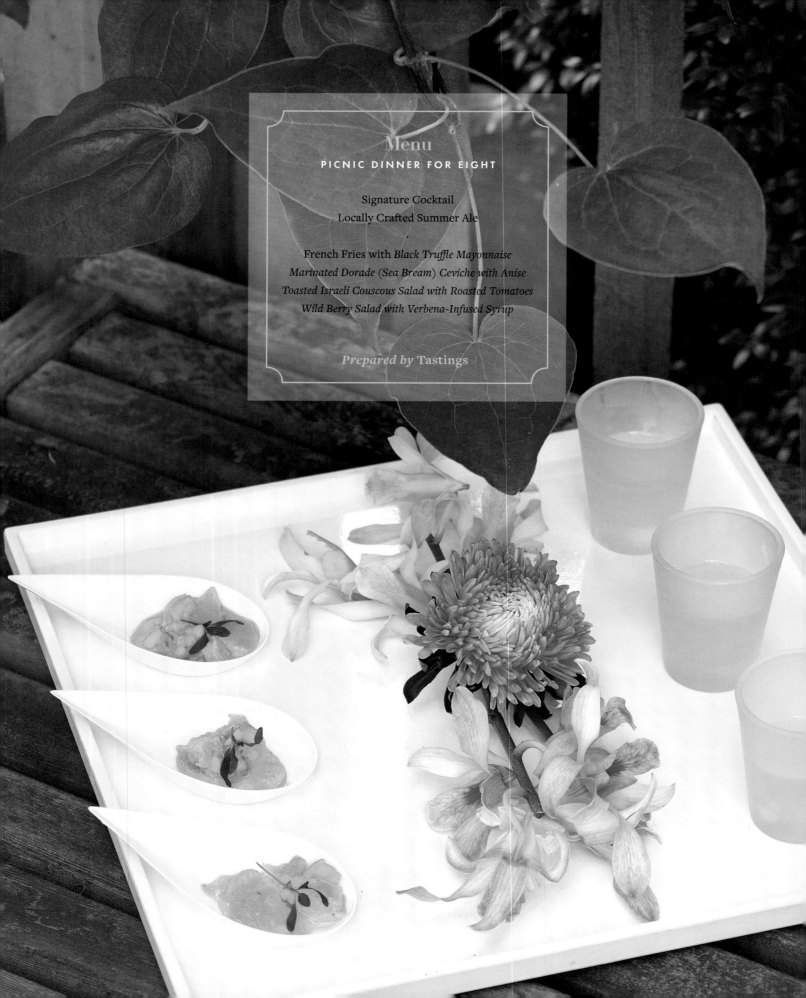

Menu

PICNIC DINNER FOR EIGHT

Signature Cocktail
Locally Crafted Summer Ale

·

French Fries with *Black Truffle Mayonnaise*
Marinated Dorade (Sea Bream) Ceviche with Anise
Toasted Israeli Couscous Salad with Roasted Tomatoes
Wild Berry Salad with Verbena-Infused Syrup

Prepared by Tastings

BLACK TRUFFLE MAYONNAISE

MAKES 1 CUP (240 ML)

Whether you like your potatoes oven baked or deep fried, this quick and easy dipping sauce will add a touch of elegance and unexpected flavor to your favorite spud.

2 tablespoons white truffle oil

1 teaspoon soy sauce

1 cup (240 ml) mayonnaise

Ground white pepper

1 tablespoon minced black winter truffle

In a mixing bowl, slowly whisk the truffle oil and soy sauce into the mayonnaise until the mixture begins to emulsify. Add white pepper to taste, then fold in the truffle. Refrigerate and serve cold as a dipping sauce for your favorite fries.

MARINATED DORADE (SEA BREAM) CEVICHE WITH ANISE

MAKES 8 SERVINGS

Ceviche is one of the easiest cook-free dishes of all time, and when there is a heat wave in the Hamptons, no one wants to be standing over a hot stove. With fresh fish and luscious peaches at their best in August, our hottest month, this is a great go-to dish. You can substitute snapper, sole, or sea bass for the dorade—just be sure that the fish is absolutely fresh. Your fishmonger can also remove the skin and pin bones for you. Serve this dish as a light supper, appetizer, or an amuse-bouche on tasting spoons as presented at the Burch party.

6 (6-ounce/170-g) fillets of dorade, extra fresh, pin bones and skin removed

1 tablespoon anise seeds

1 cup (240 ml) olive oil

⅓ cup (75 ml) freshly squeezed lemon juice, plus more to taste

⅓ cup (75 ml) white balsamic vinegar

2 drops food-grade tangerine oil (optional)

1 tablespoon freshly squeezed tangerine juice, plus more to taste

Salt and freshly ground black pepper

2 fresh peaches, peeled, pitted, and diced

¼ cup (0.5 g) beet sprouts or micro greens

Cut the fish fillets into bite-size cubes. Return the fish to the fridge to keep it nicely chilled.

Heat a small, ungreased sauté pan over medium-high heat.

Once it is warm, place the anise seeds in the pan and shake the pan continuously until the seeds are lightly browned and fragrant, 3 to 4 minutes. Remove seeds from the pan immediately and let them cool.

In a glass bowl, mix together the olive oil, lemon juice, vinegar, anise seeds, tangerine oil (if desired) and juice, and ¼ teaspoon each salt and pepper. Season according to taste by adding more lemon or tangerine juice, salt or pepper.

Mix the dorade in the marinade so the pieces are completely coated. Return the ceviche to the refrigerator to marinate for 1 hour.

When you are ready to serve, add the peaches to the ceviche and toss. Divide the marinated fish among rimmed plates or shallow bowls, sprinkle with beet sprouts, and serve immediately.

TOASTED ISRAELI COUSCOUS SALAD WITH ROASTED TOMATOES

MAKES 8 SERVINGS

This easy, healthful salad is a great side for chicken or fish. It's also quite versatile. Change it up with diced cucumbers, bell peppers, celery, onion—or any of your favorite farm-fresh vegetables.

1½ cups (250 g) cherry tomatoes
½ cup (120 ml) olive oil
1 tablespoon kosher salt
¼ teaspoon freshly ground black pepper

2 cups (280 g) Israeli couscous (also called pearl couscous)
2 cups (480 ml) hot vegetable stock
1 cup (240 ml) hot water

1 cup (140 g) Kalamata olives, drained and chopped
3 tablespoons freshly squeezed lemon juice
⅛ teaspoon table salt

Preheat the oven to 450°F (230°C).

In a glass baking dish, toss the tomatoes lightly with 1 tablespoon of the olive oil; spread them out into one layer and sprinkle with the kosher salt and ⅛ teaspoon of the pepper. Roast until the tomatoes are just beginning to caramelize, about 20 minutes. Set them aside to cool.

Heat 2 tablespoons of the olive oil in a pot over medium-high heat, add the couscous, and toast until it is lightly golden brown, stirring constantly, about 8 minutes. Slowly pour the hot stock and water over the couscous, covering it completely. Bring it to a boil and cook until it is al dente, about 8 minutes. Drain the couscous in a colander, rinse it with cold water, and drain well. Let it cool completely.

When you are ready to serve, toss the couscous with the remaining 5 tablespoons (75 ml) olive oil, the olives, and lemon juice. Add the table salt and the remaining ⅛ teaspoon pepper, and then add the roasted tomatoes and any juice in the baking dish. Season to taste. Serve at room temperature.

WILD BERRY SALAD WITH VERBENA-INFUSED SYRUP

MAKES 8 SERVINGS

What could better than fresh, local summer berries? Berries drizzled with verbena-infused syrup! One of the best ways to get the most from summer herbs is to make simple syrups, and verbena is, perhaps, the most versatile. It's a great way to sweeten hot or iced tea, delicious when drizzled over ice cream, and especially so over fresh fruit. At the Burch party, the berries were served in shot glasses—a terrific idea for a big crowd.

FOR THE SYRUP:
1 cup (200 g) sugar
1 cup (50 g) dried lemon verbena, preferably whole-leaf

FOR THE SALAD:
8 ounces (225 g) fresh strawberries, hulled and diced

6 ounces (170 g) fresh raspberries
5 ounces (140 g) fresh blueberries
6 ounces (170 g) fresh blackberries

Combine the sugar with 1 cup (240 ml) water in a medium saucepan and bring the mixture to a boil, stirring to dissolve the sugar. Reduce the heat, add the verbena, then remove the pan from the heat and allow the verbena to infuse for 10 minutes. Strain, discarding the verbena, and let the syrup cool. It can be refrigerated in an airtight container for up to 1 month.

When you are ready to serve, toss the berries together in a large mixing bowl. Divide the berries equally among 8 dessert coupes and drizzle each serving with 2 tablespoons of the simple syrup.

Surrealist Southampton Luncheon

WITH MARIE AND WILLIAM SAMUELS

Tech entrepreneur Bill Samuels may be one of New York's most active reform politicians. He holds degrees from MIT and Harvard Law, but the atmosphere in the Southampton home he shares with his wife Marie Samuels is anything but buttoned up.

The Samuelses are avid art collectors and patrons of the Chamber Music Society of Lincoln Center, Artadia: The Fund for Art and Dialogue, and the Armory Art Center. They often entertain sculptors, painters, fashion designers, and friends in what Marie calls her "funky beach house."

"This is the home where I take more chances in interior design and collecting," she says, choosing not to name names when asked who her favorite artists are. "I don't need to be that serious out here!"

Marie hosted a poolside trunk show featuring exotic kaftans by Kathy Comelli. The next day, the mannequins used the night before were disrobed and stored before Marie feted the artist and houseguest Yvonne Parker along with supporters of Artadia, for which Marie serves as vice president and executive board member.

"Marie's incredible energy and unique creative spirit brings our mission to life," says Carolyn Ramo, Artadia's executive director. "Her luncheon is a beautiful and fun way to focus on art and allows us to make crucial connections with curators and patrons on behalf of artists."

From Marie's tabletop canvas of crisp linens in contrasting shades, Parker's mixed-media sculptures peeked from all angles over arrangements of seasonal hydrangeas, peonies, and alliums. As guests settled in for a healthful spin on the wedge salad, savory citrus-grilled shrimp with kale and spinach linguini, and a Jackson Pollock-inspired ice cream cake, it was difficult to tell where the artwork ended and the entertainment began—certainly a reflection of the hostess herself.

"I like seasonal flowers to be interacting with the art as if they are one and the same. Even the shyest guest will perk up and question what they are looking at. It's the surest way to keep a party lively!" says Marie, who considers the tabletop her own temporary art installation. "The table and environment are an extension of my interests in contemporary art and my creative independent spirit."

Although her tabletop designs reach the level of art installations, they remain warm and welcoming—and approachable. On a rainy summer weekend with a houseful of guests, noshing on the back porch gave way to swimming in the rain. "It reminds us that the Hamptons is really about the casual warmth of our home and

TIPS AND IDEAS
from Marie Samuels

Always seat polar-opposite guests next to each other. No one has ever accused me of being a boring hostess! Keeps the party unpredictable and great for a few laughs.

The menu out East should be uncomplicated and homespun. Like my favorite flowers, the food must be in season and very accessible.

My entertaining mantra is *simple pleasures mixed with the unconventional.*

Get inspiration from style icons and entertaining gurus. For tabletops and home design, I look to Kelly Wearstler, who inspires me always with her bold sense of color and whimsical designs, and tastemaker Mica Ertegun, who has an amazing sense of timeless, international style, creating effortless backdrops for entertaining.

the companionship of friends," she says. "When it came time to set the table, I just blew up some ridiculous and crazy-looking inflatable lobsters, alligators, and frogs. They made excellent centerpieces!"

She'd made lemons into lemonade—or perhaps pool toys into Jeff Koons—and everyone splashed late into the evening.

Menu
POOLSIDE LUNCHEON FOR EIGHT

Oyster Shooters
The Skinny Wedge with Yogurt and Roquefort Dressing
Citrus Grilled Shrimp with Kale and Spinach Linguini
Jackson Pollock Gelato

OYSTER SHOOTERS

MAKES 24 SHOOTERS

A freshly shucked oyster dropped into a shot glass with a spicy mixture of tomato, ginger, and citrus will surely delight your guests. Add ice-cold vodka for the adults and to stay true to the original recipe, which is said to have been created on the West Coast during the gold rush. Large Atlantic oysters are best; the Samuelses served Blue Point, but you may use Malpeque or Wellfleet—or any local, large briny oyster. It's best to shuck the oysters yourself, but you can certainly have them shucked at the fishmonger so long as you use them the same day. Note that the tomato juice mixture should be made one day ahead of serving.

2 to 2½ cups (480 to 600 ml) tomato juice

2 tablespoons tomato paste

2 teaspoons peeled, grated fresh ginger

Zest of 1 lime

Zest of 1 orange

¼ cup (60 ml) freshly squeezed lemon juice

1 jalapeño chile, seeded and finely chopped

¼ teaspoon sea salt

24 fresh oysters

½ cup (120 ml) vodka (optional)

¼ cup (25 g) chopped fresh cilantro

In a large glass mixing bowl or pitcher, pour the tomato juice, using 2 cups (480 ml) if you will be using vodka and 2½ cups (600 ml) if you are making virgin shooters. Add the tomato paste, ginger, citrus zests, lemon juice, jalapeño, and sea salt. Stir and chill in the refrigerator overnight.

When you're ready to serve, pour approximately 2 tablespoons of the mixture into shot glasses or small cordials. The amount will depend upon the size of your glass, and if you are adding vodka, be sure to leave a little more room. Drop a fresh oyster into each glass; add a splash of vodka, if using; and garnish with freshly chopped cilantro. Serve immediately.

THE SKINNY WEDGE WITH YOGURT AND ROQUEFORT DRESSING

MAKES 8 SERVINGS

This "skinny" take on a classic is just as delicious as its more caloric cousin. The creamy dressing is so wonderful, you may want to use it as a dip for Buffalo wings or spread it on warm, crusty bread for a gourmet roast beef sandwich. If you like a thinner dressing, add a little skim milk. For a variation on the theme, swap the bacon out for toasted almonds, fried shallots, croutons, or diced avocado.

2 cups (480 ml) fat-free Greek yogurt

1¾ cups (180 g) crumbled Roquefort cheese

2 tablespoons apple cider vinegar

Sea salt and freshly ground black pepper

8 ounces (225 g) fresh bacon (classic or turkey), cooked crispy

2 heads iceberg lettuce

Smoked paprika

In a bowl, mash the yogurt and 1½ (155 g) cups of the blue cheese together with a fork. Stir in the vinegar until blended well. Season to taste with salt and pepper. Chill the dressing in an airtight container until ready to use. Dressing will keep for up to 7 days in the refrigerator.

When ready to serve, crush the cooked bacon into small pieces. Core and quarter each head of lettuce. Serve a generous dollop of dressing over each lettuce wedge; toss the remaining ¼ (25 g) cup blue cheese crumbles over the top, sprinkle with smoked paprika, and top with crushed bacon bits.

CITRUS GRILLED SHRIMP WITH KALE AND SPINACH LINGUINI

MAKES 8 SERVINGS

Perfect for warm summer nights, this pasta dish is delightfully cooling. The addition of kale strips gives it an especially nourishing feel, and the lemony shrimp and citrus sauce will work well over any type of pasta. You may want to serve this with some fresh bread so your guests can enjoy every last drop of sauce (there will be extra, so you can serve it on the table). Be sure to use jumbo shrimp, as they are easier to handle, harder to overcook, and add to the beautiful presentation.

FOR THE MARINADE:

1 cup (240 ml) extra-virgin olive oil

Zest of 2 lemons

¾ cup (180 ml) lemon juice, freshly squeezed (about 3 lemons)

3 teaspoons hot sauce

2 tablespoons chopped fresh oregano

½ cup (20 g) chopped fresh parsley

3 cloves garlic, minced

24 to 32 fresh jumbo shrimp, deveined and peeled, tails intact

FOR THE CITRUS SAUCE:

Zest of 2 lemons

1½ cups freshly squeezed lemon juice (from about 7 lemons)

5 cloves garlic, minced

1 cup (240 ml) extra-virgin olive oil

1 cup (2 sticks/225 g) salted butter, cut into pieces, at room temperature

⅛ teaspoon sea salt

¼ teaspoon freshly ground black pepper

FOR THE PASTA:

1 cup (125 g) pine nuts

10 to 12 large leaves fresh green kale

1½ (13.25-ounce/375-g) boxes spinach linguini

¼ cup (10 g) fresh parsley, chopped, for garnish

To make the marinade, in a glass bowl with a tight-fitting lid, combine the olive oil, lemon zest and juice, hot sauce, oregano, parsley, garlic, and shrimp. Cover and refrigerate for up to 1 hour. Be sure not to over marinate, as the citrus will begin to cook the shrimp.

To assemble the sauce, in a large glass bowl, combine the lemon zest and juice, garlic, olive oil, butter, and salt and pepper; cover and set aside.

Preheat the oven to 400°F (205°C).

Spread the pine nuts on a baking sheet and toast them in the oven until lightly browned, about 5 minutes, tossing them halfway through. Set them aside to cool.

Using kitchen shears, cut the kale leaves into spaghetti-like strips and set aside.

Cook the linguini until al dente, following the directions on the package. Drain the pasta in a colander, reserving 1 cup (240 ml) of the pasta water. Immediately toss the hot pasta in the large bowl with the citrus sauce. Add the kale strips and pine nuts; toss until the butter melts and the pasta and kale are evenly coated. If needed, add a little pasta water to thin out the sauce.

While the pasta is cooking, grill the marinated shrimp. Preheat a grill or grill pan to medium high and when hot, brush with oil. Lay the shrimp on the hot grill and cook 1 to 2 minutes on each side, or until shrimp turns pink on the outside. (The cooking time will vary depending on size of the shrimp and temperature of the grill.) The shrimp will continue to cook when removed from the heat, so be sure not to overcook; shrimp is done when it is pink on the outside and opaque through the center.

To serve, use tongs to grab and swirl a portion of linguini into a nest-like pile on the center of each plate. Arrange 3 to 4 shrimp on top of each pasta nest and garnish with fresh parsley.

JACKSON POLLOCK GELATO

MAKES 8 SERVINGS

An egg-based custard is at the core of this rich, creamy, delicious gelato. It is well worth the effort, and your guests will love the wonderful aromatic flavor of vanilla that comes through in every bite. If you are not hosting an art-inspired lunch, you can skip the decorating instructions and serve this with your favorite toppings, alongside the Plum-Filled Potato Dumplings (page 167) or atop Marta's Individual Apple Pies (page 45).

(CONTINUED ON PAGE 83)

Opposite, top left: Oyster Shooters; top right: the Skinny Wedge with Yogurt and Roquefort Dressing (both, page 79).

FOR THE GELATO:
4 cups (960 ml) organic whole milk
2 cups (480 ml) organic heavy cream
2 teaspoons vanilla extract
6 Bourbon vanilla beans, split lengthwise

8 egg yolks
1 cup (200 g) sugar

FOR DECORATING THE GELATO:
18 ounces (510 g) white chocolate, chopped

1 tablespoon unsalted butter
3 bottles of food coloring (your choice of colors)
Fresh fruit or mint leaves for garnish

To make the gelato, in a large saucepan, combine the milk, cream, and vanilla extract. Then, with the tip of a small knife, scrape the seeds of the vanilla beans into the mixture and add the bean pods. Heat until the mixture starts to bubble around the edges, then remove the pan from the heat. Do not let the mixture boil.

In a separate bowl, whisk together the egg yolks and sugar until frothed. Whisking constantly, slowly pour the hot cream mixture into the yolks, then whisk the yolk mixture back into the saucepan. Return the pan to medium heat and cook until the mixture is thick enough to coat the back of a wooden spoon. Let it cool to room temperature. Remove and discard the vanilla bean pods and pour the mixture into a bowl with a tight-fitting lid. Cover and refrigerate overnight or for at least 4 hours.

Pour the chilled gelato mixture into an ice-cream maker and churn according to the manufacturer's instructions. When the consistency

is smooth and creamy, using a spatula, spread the gelato evenly into an 8-by-11-inch (20-by-28-cm) baking pan. Cover tightly and freeze.

The gelato will be ready to decorate or serve when it is thoroughly frozen, after about 4 hours.

To decorate it, melt one-third of the white chocolate in a stainless-steel bowl over a boiling hot water, stir in 1 teaspoon of the butter, and tint it with the food coloring of your choice. Drip the colored chocolate over the top of the ice cream and return it to the freezer to allow the chocolate to harden. Repeat with remaining chocolate, butter, and colors.

When you're ready to serve, use a warmed knife to cut the ice cream into 8 even rectangles. Place a piece at the center of each plate and garnish with fresh fruit, mint leaves, or both, and serve immediately.

A Cultivated Life

WITH VICTORIA AND DAVID ELENOWITZ

When the Elenowitzes purchased Concordia, their four-acre property in Southampton, the first thing Victoria Elenowitz wanted to see—even before the house itself—was the garden. Walking through the grounds, she noticed hedges, trees, and the requisite hydrangeas, but little else.

For a Briton with a green thumb and a passion for traditional English gardens, that simply would not do. So when they bought the house, she had her hands full—of dirt, that is.

"We put in all the flower beds and all the trees bordering the property ourselves," she says, the "we" being the royal we. "We chose plants that gave the sense of abundance and spilled over the borders—all in the muted colors of British landscaping: blues, creams, pale pinks, apricots."

To this day, Victoria is out in the garden every day, clipping and trimming and even teaching the gardeners a few tricks. In the spirit of doing it all herself, she also picks her own flowers for her arrangements at home, especially when it comes to parties.

"For me, a big part of entertaining is doing the flowers, the invitations, everything myself," she says. "It's an expression of my hospitality."

For a late-summer lunch with friends, she picked and arranged flowers based on a single inspiration: a pair of

vintage Japanese screens decorated with delicate botanicals. The flowers and table décor echoed the colors on the screens. A pair of ceramic cranes and a low centerpiece were decorated with pink and white gerbera daisies and grasses for that spillover effect. On the mantel, slim silver vessels sourced from Bespoke Global, a super-luxury startup of which she is chairman, held the same daisies and grasses with creeping Jenny cascading down the sides. Simple, yet wholly appropriate for the occasion.

Arranging flowers is one thing, but cooking and serving lunch? For her parties, Victoria insists on doing it all. "Cooking is fun for me," she says. "I choose a menu that will allow me to be both host and cook. You have to have something that can be done beforehand or cooked quickly after guests arrive."

For this lunch, she began with a lovely green gazpacho made with fresh greens and nuts that is "very virtuous in every way." She prepared it ahead of her guests' arrival and served it from a goose-shaped soup tureen.

For the main course, "I had a bit of an eye to something colorful and reasonably healthy that could be prepared in advance," she says. "Duck is one of the stalwarts for me."

With the stovetop portion done earlier, she popped the duck in the oven as guests enjoyed the soup. Fourteen

"I don't like to ruin people's appetites when I have cooked a nice lunch for them, so I don't typically serve hors d'oeuvres," says Victoria. Instead, she offers guests a lovely selection of nuts and dried fruits, and serves lunch promptly.

Offering coffee in a French press, and setting down a teapot wrapped in a lovely cozy is elegant, but it also makes your guests feel pampered, and invites them to linger and continue good conversation. Victoria steeps coffee for 4 minutes before pressing the plunger and steeps tea for 5 minutes under a tea cozy for optimal taste.

minutes later, it was sliced, drizzled with orange sauce, and plated with Long Island sweet corn, red cabbage with hazelnuts, and pea shoots. *Voilà*.

Remarkably, Victoria also opted to serve. "It's a home-cooked meal, so I'm delighted to serve it," she says. "It's more of an intimate gesture."

For dessert, she went all out with not one, but three options. "I love dessert," she says. "The whole thing is an excuse to make a lot of desserts!"

Two cakes—German chocolate and coconut passion fruit raspberry—and a panna cotta were presented whole at the dining table. Guests were encouraged to enjoy a slice (or two) in one of the sunrooms, amid views of her prolific gardens. It was the perfect culmination of all the hostess's passions: gardening, cooking, and time spent among friends.

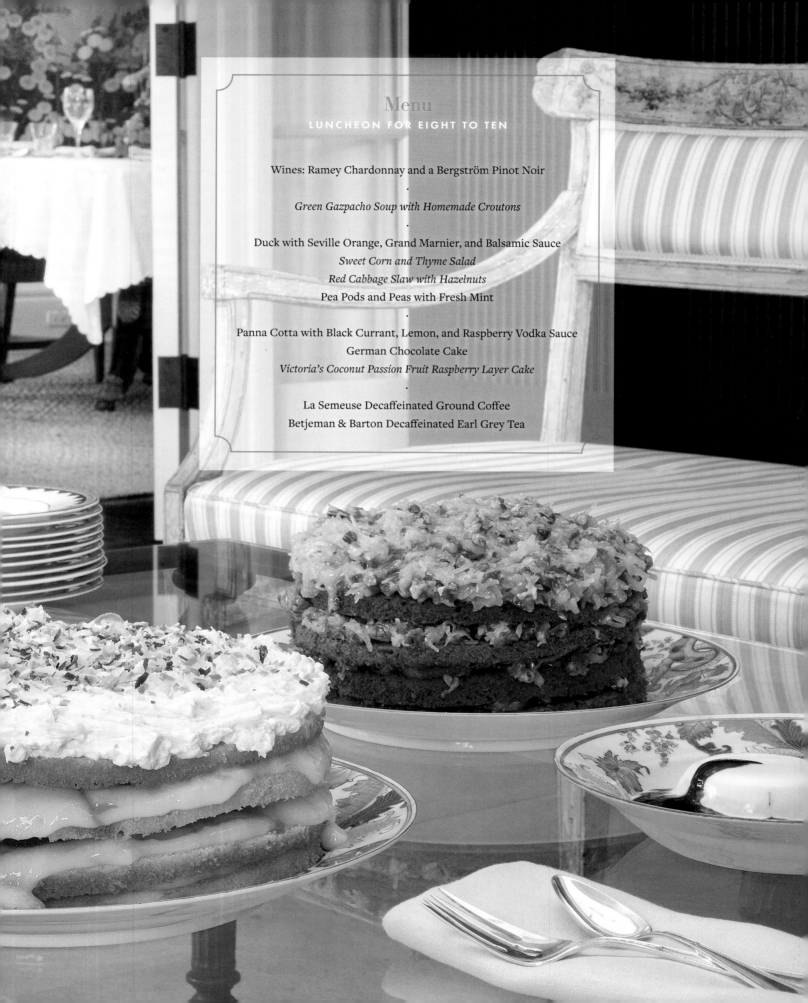

Menu

LUNCHEON FOR EIGHT TO TEN

Wines: Ramey Chardonnay and a Bergström Pinot Noir

·

Green Gazpacho Soup with Homemade Croutons

·

Duck with Seville Orange, Grand Marnier, and Balsamic Sauce
Sweet Corn and Thyme Salad
Red Cabbage Slaw with Hazelnuts
Pea Pods and Peas with Fresh Mint

·

Panna Cotta with Black Currant, Lemon, and Raspberry Vodka Sauce
German Chocolate Cake
Victoria's Coconut Passion Fruit Raspberry Layer Cake

La Semeuse Decaffeinated Ground Coffee
Betjeman & Barton Decaffeinated Earl Grey Tea

GREEN GAZPACHO SOUP WITH HOMEMADE CROUTONS

MAKES 20 SERVINGS

There are so many gazpacho recipes out there, but this is one you will want to add to the file. The refreshing flavor of yogurt and cucumber is surprising and makes a terrific summer soup. There is no better way to highlight summer's bounty or your latest purchase from the farmers' market. Victoria suggests adjusting the ingredients and seasonings to suit your personal taste and to incorporate the freshest vegetables available. She adapted this recipe from one in Yotam Ottolenghi's *Plenty*, one of her go-to cookbooks. This will serve ten, with more than enough for second helpings and leftovers (the soup will keep in the refrigerator for 3 to 4 days). You may choose to cut the recipe in half.

FOR THE SOUP:

3½ cups (350 g) walnuts

4 celery stalks, roughly chopped

4 green bell peppers, roughly chopped

7 cucumbers, peeled and seeds removed, roughly chopped

3 slices white bread, crusts removed (day-old bread or lightly toasted is best)

1 teaspoon sriracha chile sauce

5 cloves garlic, peeled

2 teaspoons sugar

12 cups (360 g) baby spinach

2 cups (80 g) basil leaves

2 tablespoons roughly chopped flat-leaf parsley

½ cup (120 ml) sherry vinegar

2 cups (480 ml) olive oil

6 tablespoons (90 ml) Greek yogurt

3 cups (720 ml) ice cubes

4 teaspoons salt

1 teaspoon ground white pepper

FOR THE CROUTONS AND FINISH:

6 slices white bread, crusts removed, cut into small cubes

Olive oil

⅛ teaspoon salt

Preheat the oven to 400°F (205°C). Spread the walnuts in a single layer on a cookie sheet and lightly toast them in the oven, about 4 minutes. Set them aside to cool.

Working in batches, in a food processor or blender, puree the toasted walnuts, celery, bell peppers, cucumbers, bread, sriracha, garlic, sugar, spinach, basil, parsley, vinegar, oil, yogurt, ice cubes, salt, and white pepper with 4 cups (960 ml) water until smooth.

Pour the puree into a large container and stir well; add more water if needed. Chill the soup until you are ready to serve.

Preheat the oven to 375°F (190°C). Scatter the bread onto a baking sheet. Drizzle 2 tablespoons of olive oil over the bread and sprinkle it with the salt. Give everything a toss to coat the bread. Toast in the oven for 10 minutes or until you have nice golden croutons, tossing them halfway through. Set them aside to cool.

Before serving, sprinkle a few croutons on top of the soup and add a drizzle of olive oil to each bowl. Leftovers can be kept for 3 to 4 days, refrigerated. Some separation is normal; stir before serving.

SWEET CORN AND THYME SALAD

MAKES 8 TO 10 SERVINGS

Sweet corn is a staple in the Hamptons, and in August when it is tender and sweet, it makes an appearance at every barbecue and clambake on the East End. Corn is the flavor of summer, and this recipe is a simple, elegant way to prepare it.

8 ears fresh corn, shucked

2 tablespoons Japanese rice vinegar

2 tablespoons peanut oil or mild vegetable oil

⅛ teaspoon salt

⅛ teaspoon freshly ground black pepper

2 sprigs fresh thyme, chopped

Place the corn in a large pot of boiling water; let it boil for 1 minute then turn off the heat. Leave the corn in the water for 5 minutes or so, then drain. Wait until the cobs are cool enough to handle, then cut the corn kernels from each cob using a sharp knife.

Place the corn kernels in a large bowl and add the vinegar, oil, salt, pepper, and thyme. Mix well and let the salad sit for 1 hour before serving to ensure that the flavor of the fresh thyme comes through.

Opposite: Victoria's Coconut Passion Fruit Raspberry Layer Cake (page 93), German Chocolate Cake (page 90), and Panna Cotta with Black Currant, Lemon, and Raspberry Vodka Sauce.

RED CABBAGE SLAW WITH HAZELNUTS

MAKES 8 TO 10 SERVINGS

For many Hamptonites, attending a barbecue during the summer is a weekly affair. Offering a variety of gourmet slaws keeps the menu interesting. Lingonberry adds terrific flavor and sweetness to the cabbage in this refreshing take on an old standard.

1½ cups (200 g) whole hazelnuts

½ head red cabbage, finely grated (about 4 cups/360 g)

2 tablespoons red wine vinegar

2 tablespoons lingonberry preserves

⅛ teaspoon salt

Preheat the oven to 400°F (205°C). Place the hazelnuts on a cookie sheet and toast them in the oven until they are pale brown, about 7 minutes. Place nuts in a clean kitchen towel and rub to remove skins. Set them aside to cool, then chop them coarsely.

Combine the cabbage and vinegar in a large bowl; stir thoroughly and let the mixture sit for 1 to 2 hours.

Add the lingonberry preserves, hazelnuts, and salt to the cabbage and mix well.

GERMAN CHOCOLATE CAKE

MAKES 1 LAYER CAKE TO SERVE 12 TO 16

This cake will get rave reviews for both its presentation and taste—it's moist and delicious! Victoria adapted this recipe from one in the book *Baking Illustrated*, by the editors of *Cook's Illustrated* magazine.

FOR THE CAKE:

¼ cup (20 g) nonalkalized cocoa powder

2 teaspoons instant coffee powder

⅓ cup (75 ml) hot water

⅓ cup (75 ml) plain full-fat yogurt

2 teaspoons vanilla extract

¾ cup (1½ sticks/170 g) unsalted butter, at room temperature

1¼ cups (250 g) sugar

3 large eggs

1¼ cups (155 g) flour, sifted

½ teaspoon baking soda

½ teaspoon salt

FOR THE FROSTING:

½ cup (1 stick/115 g) unsalted butter

4 large egg yolks

1 cup (200 g) sugar

¼ teaspoon salt

1 cup (240 ml) heavy cream

1 teaspoon vanilla extract

2½ cups (275 g) toasted, chopped pecans

3 cups (255 g) sweetened flaked coconut

To make the cake, preheat the oven to 350°F (175°C) and grease two 8-inch (20-cm) round cake plans. Place parchment rounds in the bottom of each pan.

Mix the cocoa, coffee, and hot water together, and then add the yogurt and vanilla. Set aside.

In a separate bowl, beat together the butter and sugar, then add the eggs one at a time. Beat thoroughly, until the mixture is white.

In another bowl, mix the flour, baking soda, and salt together and add it and the cocoa mixture to the butter mixture in stages, alternating between flour and cocoa. Beat briefly until the batter is shiny. Pour half of the batter into each prepared cake pan and bake until a toothpick inserted in the center comes out clean, about 25 minutes.

Remove each cake from its pan and, using a serrated knife, split it in half horizontally. Set the layers aside to cool completely before frosting.

Make the frosting. In a saucepan, mix together the butter, egg yolks, sugar, salt, cream, and vanilla until fairly smooth. Cook over low heat, stirring all the time, until the mixture forms pillowy ridges and registers 180°F (80°C) on a candy thermometer. Set the pan aside to cool, then stir in the pecans and coconut.

To assemble the cake, place 1 cake layer on a serving dish or cake plate. Spread one-fourth of the frosting over the cake, letting it drip over the side a little. Place the second cake layer on top and repeat, then top with the third cake layer and repeat. Place the fourth layer of cake on top, flat side up. Spread the frosting over the top of the cake (leave the sides exposed) and again, let some drip over the sides.

Opposite, top left: Duck with Seville Orange, Grand Marnier, and Balsamic Sauce, Sweet Corn and Thyme Salad (page 89), Red Cabbage Slaw with Hazelnuts (this page), and Pea Pods and Peas with Fresh Mint; bottom: Green Gazpacho Soup with Homemade Croutons (page 89).

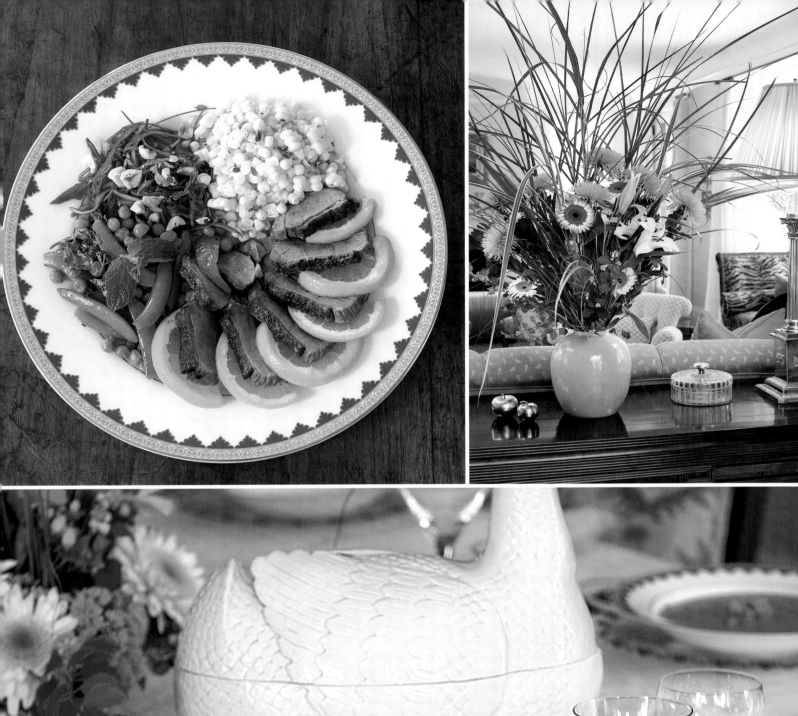

VICTORIA'S COCONUT PASSION FRUIT RASPBERRY LAYER CAKE

MAKES 1 LAYER CAKE TO SERVE 12 TO 16

Baking this cake is truly a labor of love and is well worth the effort. You will enjoy creating it, and your guests will love you for it. In the Hamptons, where many of the men spend Monday through Friday in the city, some groups of friends takes turns hosting "girls' night out" at their homes. Victoria has served this at many such occasions, and even the ladies watching their figures go back for seconds.

FOR THE CAKE:

¾ cup (180 ml) cream of coconut

1 teaspoon coconut extract

1 teaspoon vanilla extract

1 large egg

5 egg whites

2¼ cups (280 g) flour, sifted

1 cup (200 g) sugar

1 tablespoon baking powder

¾ teaspoon salt

¾ cup (1½ sticks/170 g), unsalted butter, cut into cubes, at room temperature

FOR THE PASSION FRUIT FILLING:

¼ cup (30 g) cornstarch

1½ cups (360 ml) cold water

1 cup (200 g) sugar

6 egg yolks

¾ cup (180 ml) Perfect Purée Passion Fruit Concentrate

2 tablespoons unsalted butter, cut into cubes, at room temperature

⅛ teaspoon salt

FOR THE RASPBERRY FILLING:

12 ounces (340 g) fresh raspberries

1 tablespoon sugar

FOR THE COCONUT BUTTERCREAM FROSTING:

2 egg whites

Pinch of salt

½ cup (100 g) sugar

½ teaspoon coconut extract

½ teaspoon vanilla extract

¼ cup (60 ml) cream of coconut

1 cup (2 sticks/225 g) unsalted butter, cut into cubes, at room temperature

1 cup (90 g) sweetened shredded coconut

Make the cake. Preheat the oven to 325°F (165°C). Butter two 9-inch (23-cm) round cake pans and line the bottoms with parchment paper.

In a medium bowl, beat together the cream of coconut, coconut extract, vanilla, egg, egg whites, and ¼ cup (60 ml) water and set aside.

In a standing mixer fitted with the paddle attachment, combine the flour, sugar, baking powder, and salt, then add the butter, one cube at a time, and mix at low speed until the mixture looks like small bread crumbs.

Raise the mixer speed to medium and add the egg mixture to the dry ingredients. Mix until the batter thickens, about 1 minute.

Divide the batter between the prepared pans. Bake the cakes until they are dark golden on top, a toothpick inserted into the center comes out clean, and the cake pulls away very slightly from the pan, about 30 minutes.

Turn the cakes out onto racks and, using a serrated knife, split each one in half horizontally. Let the layers cool completely while you make the filling and frosting.

Make the passion fruit filling. In a saucepan, combine the cornstarch with the cold water, and whisk until it is completely dissolved.

Add the sugar and cook the mixture over medium-high heat, whisking constantly until it is somewhat thickened, about 5 minutes. Add the egg yolks and passion fruit concentrate, and stir vigorously while simmering for 4 to 5 minutes. Add the butter and salt, and continue to stir until incorporated. Set the filling aside to cool.

Make the raspberry filling. Put half of the raspberries, the sugar, and 2 teaspoons of water in a small saucepan over medium-high heat. Stir with a sturdy wooden spoon and cook until the mixture has a

jamlike texture, about 5 minutes. Add the remainder of the fresh raspberries, and remove the pan from the heat. Slightly mash the mixture with the back of the spoon, breaking some of the fresh berries. Set the filling aside to cool.

Make the frosting. Preheat the oven to 350°F (175°C). Combine the egg whites, salt, and sugar in a double boiler and heat, stirring constantly, until the egg whites start to become opaque, about 5 minutes, or when the mixture reaches 120°F (50°C).

Transfer the egg white mixture to a stand mixer fitted with the whisk attachment and beat at high speed until the frosting is shiny, white, and stiff, about 6 minutes.

Beat in the coconut and vanilla extracts and cream of coconut, then add the butter a piece at a time and beat at high speed for about 1 minute. Set aside.

Spread the shredded coconut in a baking pan and toast it in the oven for about 6 minutes, or until it is golden brown. Set aside to cool.

Assemble the cake. Place one cake layer on a serving dish or cake plate. Spread one-third of the passion fruit filling over the cake, letting it drip over the side a little. Spread one-third of the raspberry mixture on top of the passion fruit. Place the second cake layer on top and repeat, spreading the passion fruit and raspberries. Top with the third cake layer and spread with the remainder of the passion fruit and raspberries. Place the fourth layer of cake on top, flat side up. Spread the buttercream over the top of the cake (leave the sides exposed) and sprinkle the toasted coconut evenly over the frosting.

NOTE: After a couple of hours sitting out, any leftover cake does need to be refrigerated, but it's best to serve it initially without prior refrigeration. That way, the buttercream remains soft and the cake texture is springy. The taste is the same after refrigeration, but the chilled buttercream gets hard.

Panamanian Fare with Friends

WITH MARGARITA AND EDWARD ALLINSON

Growing up in Panama taught Margarita Allinson to appreciate the bounty of the land, to treasure family, and to honor cultural traditions. Though she left her native

country when she was ten years old and was educated in Europe, she has never forsaken her roots. On the contrary: to this day, she celebrates her heritage as often as she can.

"I enjoy honoring the past and my roots and traditions, especially when it comes to entertaining," she says. "Parties that have a Panamanian flavor are among my most cherished."

Summer lunches in the Hamptons are the perfect forum to showcase her innate Latin hospitality. That, of course, begins with food. "I like to share with my guests the tastes I remember from growing up in Panama," she says. "My sister handed me some recipes from a very old cookbook written by my grandmother's sister. They are not typical; my great aunt definitely put a twist on them."

When hosting friends for a leisurely lunch on the terrace overlooking the garden, Margarita served some of the dishes favored by generations of women in her family: chicken pie with olives, prunes, and spices; king prawns with mango chutney; and a "secret recipe" tres leches cake. Though the menu sounds straightforward, getting the nuances right is an art that Margarita did not want to leave to chance. She spent a great deal of time in the kitchen making sure such things as the flaky, crackerlike crust of the chicken pie and the consistency of the cake's caramel center came out exactly the way her great aunt intended.

TIPS AND IDEAS
from Margarita Allinson

Do as much as possible ahead of time so you're not exhausted or stressed for your guests. Consider setting your table the night before the party, cover it with a light blanket, and add the flowers just before guests arrive.

If you put hydrangeas in the refrigerator overnight, they stay totally crisp and open the next day.

When washing lettuce or vegetables, add some white vinegar to your wash basin. It makes all the dust and dirt sink to the bottom.

SUMMER LUNCHEON FOR EIGHT

King Prawns with Mango Chutney
Bay Scallop Ceviche
Beef Empanadas
Traditional Panamanian Chicken Pie
Tres Leches Cake

Ginger Tea and White Sangria

KING PRAWNS WITH MANGO CHUTNEY

MAKES ABOUT 35 HORS D'OEUVRES

Served on ceramic appetizer spoons, both the blend of flavors and presentation make these hors d'oeuvres irresistible! For an equally beautiful starter, leave the prawns whole and serve them in lettuce cups, garnished with grapes. If king prawns are not available, jumbo shrimp work just as well. Both are easy to handle, harder to overcook, and when cut into bite-size pieces offer a meaty mouthful of shrimp with every bite.

FOR THE PRAWNS:
½ teaspoon coarse sea salt
½ onion, roughly chopped
1 celery stalk, cut in half
2 pounds (910 g) king prawns

FOR THE DRESSING:
½ cup (120 ml) mayonnaise
½ cup (120 ml) sour cream
3 tablespoons mango chutney
2 tablespoons diced onion
2 tablespoons diced celery
¼ teaspoon salt

¼ teaspoon ground black pepper
½ green chile pepper, seeded and grated (or more for extra heat)
¼ cup chopped (22 g) seedless green grapes
2½ tablespoons diced pineapple
Green onions, sliced, for garnish

Make the prawns. To a pot of salted water, add the chopped onion and celery and bring the mixture to a boil. Add the prawns and simmer, uncovered, until they are bright pink and firm, about 5 minutes. Using a slotted spoon, remove the prawns from the poaching liquid and let them cool thoroughly before peeling, deveining, and removing the tails.

Meanwhile, prepare the dressing in a medium-sized bowl by mixing together the mayonnaise, sour cream, mango chutney, onion, and celery. Season with the salt, pepper, and green chile. Cut the prawns into bite-size pieces and fold them into the dressing along with the grapes and pineapple. Cover and chill the mixture until you are ready to serve, then scoop small portions onto individual tasting spoons and garnish with green onion. Place the spoons on a decorative platter to pass for serving.

BAY SCALLOP CEVICHE

MAKES 8 SERVINGS

Healthful, flavorful, and easy to prepare, sweet bay scallops "cooked" in a citrus marinade make the perfect starter for a summer dinner with friends. The Allinsons serve theirs in beautiful martini glasses, garnished with lime slices—so festive! If the scallops are too large, they may be cut in half before marinating or, if you substitute sea scallops, you may cut them into ¼-inch (6-mm) pieces. For a bit more heat, add one green or red serrano chile, seeded and minced.

2 pounds (910 g) bay scallops
4 tomatoes, seeds removed, diced
10 green onions, minced
Juice of 16 limes (about 2 cups/480 ml), plus 1 lime for garnish, sliced

4 stalks celery, diced
1 ripe mango, peeled and diced
1 green bell pepper, minced
1 cup (40 g) chopped fresh flat-leaf parsley leaves

3 tablespoons olive oil
½ teaspoon sea salt
⅛ teaspoon freshly ground black pepper
¼ cup (10 g) chopped fresh cilantro leaves

Rinse the scallops and place them in a medium-sized stainless-steel or glass bowl. Add the tomatoes, onions, lime juice, celery, mango, bell pepper, parsley, olive oil, salt, pepper, and half of the cilantro. Stir to combine, cover, and refrigerate for at least 2 hours. The scallops will turn opaque when "cooked." Do not over marinate, as they will become tough.

When you're ready to serve, stir, then drain half of the lime juice from the bowl and set it aside. Stir in the remaining cilantro and divide the ceviche among 8 chilled martini glasses. Garnish with lime slices and spoon some of the reserved lime juice over each, if needed.

BEEF EMPANADAS

MAKES 25 TO 30 PIECES

The Allinsons like to make these gourmet bite-size empanadas for their guests to enjoy as hors d'oeuvres. A modern twist on a classic Central American food, these are perfect for any occasion, from cocktail parties to a light dinner at home, and can be stored, uncooked, in the freezer for up to 10 weeks. Let frozen empanadas thaw completely before frying. When pressed for time, pre-made empanada dough can be substituted for homemade.

FOR THE EMPANADA DOUGH:

3 cups (385 g) flour, sifted

1 teaspoon salt

2 egg yolks

1 tablespoon sugar

1 tablespoon wine

4 tablespoons (55 g) margarine, at room temperature

½ to 1 cup (120 to 240 ml) cold water

FOR THE FILLING:

2 tablespoons olive oil

½ cup (80 g) minced onion

¼ cup (38 g) chopped chile peppers

1 pound (455 g) ground beef

1 clove garlic, minced

1 tablespoon raisins, cut in half

6 pitted black olives, minced

1 teaspoon salt

1 hard-boiled egg, minced

Oil for frying

To make the dough, combine the flour and salt in a mixing bowl. Add the egg yolks, sugar, wine, and margarine. Work the mixture with your hands until it has an even, coarse texture. Slowly add the cold water and continue to knead until the dough is completely combined and smooth. Wrap the dough in plastic and place it in the refrigerator for about 30 minutes.

Meanwhile, make the filling by heating the olive oil in a large saucepan over medium heat. Add the onion and sauté until it is soft and translucent, about 5 minutes. Add the chile, increase the heat to medium-high, and add the ground beef. As the beef cooks, use a wooden spoon to break it into very small clumps; cook until the meat is lightly browned, about 8 minutes. Drain off any excess fat. Add the garlic, raisins, olives, salt, and egg, and cook 5 minutes more. Set the filling aside to cool.

Place the dough on a floured surface. Knead it with the heel of your hand to create a disk and slowly roll it out into a layer ⅛ to ¼ inch (3 to 6 mm) thick. Cut the dough into 3-inch (7.5-cm) circles using a round cookie cutter and flour them lightly.

Spoon 1 tablespoon of filling into the center of each disk and fold the dough over, creating a half-moon shape. The filling should fit snugly inside the pocket without spilling out or breaking the dough. Using a fork, press down on the flat edge of the empanada to close the pocket.

Fill a deep fryer or large, deep frying pan with cooking oil and heat until the oil is bubbly and starting to smoke. Working in batches and taking care not to crowd the pan, place the empanadas in the hot oil and cook until they are golden brown and crispy, 5 to 7 minutes, turning to brown both sides. Drain the empanadas on paper towels and transfer them to a serving platter. Serve them warm.

TRADITIONAL PANAMANIAN CHICKEN PIE

MAKES 1 CASSEROLE TO SERVE 8

This pot pie is quite different from the American version; it is really an empanada pot pie. A typical dish served in many Panamanian homes, it is quite versatile, and the Allinsons' version is delicious! Much like their empanadas, you can make the dough using your favorite recipe or a store-bought dough and substitute beef for chicken, adding carrots or other ingredients to suit your palate. Traditionally most chicken in Panama is cooked on the bone, which makes for a richer flavor. Decorate the pie top with any number of shapes or as shown on page 101 with circles of varying size.

FOR THE DOUGH:

4 cups (510 g) flour, sifted

3 tablespoons sugar

2 teaspoons salt

2 teaspoons baking powder

1 cup (2 sticks/225 g) butter

4 egg yolks

5 to 9 tablespoons (75 to 135 ml) evaporated milk

FOR THE FILLING AND FINISH:

¼ cup (60 ml) vegetable oil

2 onions, chopped

2 chile peppers, seeded and chopped

4 cloves garlic, crushed

2 whole chickens (about 3 pounds/1.4 kg each), each cut into 8 pieces

12 ounces (340 g) tomato paste

3 teaspoons salt

½ teaspoon freshly ground black pepper

½ teaspoon ground cumin

½ cup (120 ml) white wine

8 ounces (225 g) pitted prunes, cut in half

½ cup (70 g) pitted green olives, cut in half

1 large egg

(CONTINUED ON PAGE 102)

THE GREAT BOOK OF **SEAFOOD COOKING**

FRANCE *A Culinary Journey*

STYLE BY **SALADINO**

To make the dough, combine the flour, sugar, salt, and baking powder in a mixing bowl. Add the butter, egg yolks, and 5 tablespoons (75 ml) of the evaporated milk and work with your hands until the flour mixture has an even, coarse texture. Slowly add more evaporated milk, if needed, and continue to work the dough until it is fully combined and smooth. Divide the dough into two balls, wrap each separately in plastic, and place them in the refrigerator to cool, about 30 minutes.

Meanwhile, make the filling by heating the vegetable oil in a large saucepan over medium heat. Add the onions, chiles, and garlic and sauté until the onions are soft and translucent, about 5 minutes. Raise the heat to medium-high and add the chicken pieces. Cook until lightly browned, about 5 minutes. Stir in the tomato paste, salt, pepper, cumin, wine, prunes, and olives. Reduce the temperature to medium and cook for about 15 minutes. Set the filling aside to cool completely.

Grease a 9-by-13-inch (23-by-33-cm) oven-safe casserole.

Place both pieces of dough on a floured surface. Knead each mound with the heel of your hand to create two disks. Place one disk in the baking dish and, using your hands, stretch the dough to cover the bottom and sides of the dish. Roll out the second disk and, using a cookie cutter, cut out various shapes; make sure you have enough to completely cover the pie filling.

When the chicken is cool enough to handle, skin and debone each piece, cut the meat into bite-size pieces, and return it to the filling mixture, combining well. Don't worry if some of the chicken is still a little pink at the center—it will continue to cook as you bake the pie. Spread the filling evenly into the baking dish. Cover it completely with the dough cutouts, overlapping as you go. Pierce the surface to allow air to escape. Cover the casserole with plastic wrap and refrigerate it for at least 1 hour.

Preheat the oven to 350°F (175°C). Lightly beat the egg and, with a cooking brush, paint the top of your pie with the egg wash.

Bake until the top is golden brown, 40 to 50 minutes. Serve hot.

TRES LECHES CAKE

MAKES 1 SQUARE LAYER CAKE TO SERVE 9 TO 16

This family recipe has been passed from one generation to the next and prepared on special occasions for honored guests. It is absolutely delicious and so elegant when served in beautiful silver bowls and garnished with edible silver-leaf hearts. One of the Allinsons' guests has been known to eat this cake for breakfast! Crema de Leche, a key ingredient in the soaking mixture, can be found in the international food aisle of most supermarkets, Latin grocery stores, and some gourmet markets. If you are concerned about consuming undercooked eggs, be sure to use pasteurized egg whites in this recipe.

FOR THE CAKE:

2 (14-ounce/400-g) cans sweetened condensed milk

8 large eggs, separated, at room temperature

2 cups (400 g) sugar

2 tablespoons chilled water

2 cups (255 g) flour

2 teaspoons baking powder

2 cups (480 ml) heavy cream

2 (10.4-ounce/295-g) cans Crema de Leche

1 teaspoon vanilla extract

FOR THE TOPPING:

1¼ cups (300 ml) light corn syrup with vanilla

4 egg whites

¼ cup (50 g) sugar

½ teaspoon cream of tartar

Edible silver leaf, for garnish (optional)

Fill a large pot of water three-quarters full and bring it to a boil; reduce the heat to medium high. Peel the labels from the condensed milk cans and slowly and carefully place the bare, unopened cans in the pot of boiling water for 1 hour. Be sure the cans are completely submerged for 1 hour; this will yield a surprisingly delicious result. Drain the water from the pot and allow cans to cool.

Preheat the oven to 350°F (175°C). In the bowl of a stand mixer fitted with the whisk attachment, beat the egg whites until they form soft peaks. Add the sugar in a slow stream. Continue whipping the egg whites until they are shiny and hold stiff peaks. Add the egg yolks one at a time while beating, and then add the chilled water. Sift together the flour and baking powder and gently fold into the batter. Divide the mixture into two 8-inch (20-cm) square baking pans. Bake until the cakes are lightly golden, 25 minutes.

Meanwhile, in a medium pot, combine the heavy cream, Crema de Leche, and vanilla. Slowly bring the mixture to a boil, then remove it from the heat.

Using a skewer, pierce the entire surface of one of the cakes, then run a knife around the edges to loosen it, but don't remove it from the pan. Pour half of the liquid (or as much as the cake will absorb) over the cake. You may need to do this in batches, allowing the cake to absorb as much soaking liquid as possible. Remove the second cake from its pan and set it aside.

When the condensed milk cans are cool enough to handle, open them and generously cover the top of the soaked cake with the caramel to create your cake filling. Carefully place the second cake on top of the soaked cake. Using the skewer, pierce the entire surface of the top layer and repeat the soaking process. Cover and refrigerate overnight.

When you are ready to serve the cake, prepare the topping. In a medium pot, bring the corn syrup to a boil. In the mixing bowl of a stand mixer fitted with the whisk attachment, beat the egg whites until they are white, foamy, and form peaks. Slowly add the sugar and cream of tartar. Fold in the hot corn syrup.

Drain off any excess soaking mixture from the cake. Cut generous slices of cake and place them into individual bowls, cover them completely with topping, garnish with edible silver-leaf, if using, and serve.

A Real Classic

WITH GEORGINA BLOOMBERG

The Hampton Classic, one of the nation's most beloved horse shows and the first U.S. stop for North American East Coast League riders on a World Cup Quest, heralds summer's end in the Hamptons. Held each year at the end of August, the show brings top equestrians from around the world to Bridgehampton for an exciting week of competition—and parties.

For professional show jumper Georgina Bloomberg, the Hampton Classic is a must on the riding circuit. Not only is it a meeting ground for the fiercest competitors, it also is a wonderful way to connect with colleagues and fans. "It's one of the shows everyone goes to," she says. "It's a very busy week. Every night, there's some sort of barbecue or dinner."

Georgina, the daughter of Susan Brown and former New York City Mayor Michael Bloomberg, treats the Classic as a home away from home. The native New Yorker who lives on her farm in North Salem known as Gotham North, rents a house in Bridgehampton for the week, which she shares with her son, Jasper, and various other family members and staff. The move allows her to focus on the competition and related events that are near and dear to her.

As a board member of the Hampton Classic and the Equestrian Aid Foundation, she is an advocate for the horse community. She also takes part in the ASPCA Adoption and Animal Welfare Day, held annually at the Classic to promote one of the causes she is most passionate about: animal rescue. She walks that walk herself, having adopted four rescue dogs, two mules, four mini horses, and a pig named Wilbur, all of whom live with her at Gotham North.

Between riding and her philanthropic and social duties, she doesn't have time for much else. In fact, she hardly has time for a sit-down meal. "I always bring my own food," she says. "I try to eat very healthy while I'm on the road."

That includes lots of salads, grilled or roasted fish, pasta variations (pesto is a favorite), and seasonal vegetables like tomatoes, corn, pumpkin, and squash. She likes turkey and chicken, particularly barbecued, but rarely eats beef—and pork is strictly off the menu. "Since adopting Wilbur, I do not eat pork," she says. "I will never touch it again."

Though Georgina is laser-focused on riding during Classic week, when her schedule eases up she enjoys visiting with friends and supporters during the traditional luncheon on Grand Prix Sunday. The luncheon, a must-attend social gathering celebrating the show's most exciting event, is a showcase of creative table

Page 105 and page 106 (lower left): Tabletop design for Benhamo/Thomas with china by Artfully Equestrian; page 106 (lower right): Tabletop design for Dr. Betsee Parker & Huntland with china by Villeroy & Boch.

TIPS AND IDEAS
from Georgina Bloomberg

Life tends to get so busy that when I can have friends visit, I keep it simple. Though I genuinely like cooking, we usually get take-out and have a few glasses of wine—so we can just enjoy the evening.

I love making homemade baby food for Jasper. I have a baby blender and use it to puree cooked vegetables and fruit. I buy organic produce whenever possible.

When away from home, I always pack my own food. I plan ahead, checking on available refrigeration and local food resources, then buy accordingly. My meals consist mostly of pastas, breads, salads, grilled vegetables, fish, chicken and turkey, prepared with simple, light seasonings and no heavy sauces.

design and amazing food. Georgina's menu selections lean toward clean, healthful items, such as grilled chicken skewers, roasted vegetables, and cedar-planked salmon served with simple gremolata.

Outside of Classic week, most of her entertaining takes place at the farm. Gatherings are admittedly simple, focused more on relaxing with family and friends than on lavish menus. Over the summer, balmy evenings call for barbecue and salads—often served outdoors overlooking the sprawling grounds. Family, including her mother and Jasper, who was born in 2013 to Georgina and partner Ramiro Quintana, is always by her side. There is no fanfare—only the important things: loved ones, animals, and the land.

Menu
RINGSIDE BUFFET LUNCHEON FOR SIX

Farm Stand Green Bean, Wax Bean, and Cranberry Bean Salad
Oven-Roasted Tomatoes and Mediterranean Vegetables
Succotash of Roasted Corn, Quinoa, Red Rice, and Toasted Oats

·

Cavatappi with Grilled Artichokes, Broccoli Rabe, and Crumbled Goat Cheese

Cedar Plank–Roasted Salmon with Sorrel Gremolata
Quinoa Tabbouleh with Roasted Baby Kale

Grilled Organic Chicken Kebabs with Bourbon Barbecue Sauce
Smashed Long Island Red Bliss Potato Salad

Tropical Fruit Salad with Shaved Toasted Coconut,
Alcohol-Free Dark Rum, and Lemon Syrup

Prepared by **Robbins Wolfe Eventeurs,**
the official caterer of the Hampton Classic

CAVATAPPI WITH GRILLED ARTICHOKES, BROCCOLI RABE, AND CRUMBLED GOAT CHEESE

MAKES 6 SERVINGS

In the summer, pasta salads are *de rigueur*. Substantial yet light enough to serve as an accompaniment, they are guaranteed crowd pleasers at luncheons and casual dinners. Brimming with farm-fresh vegetables and crumbled goat cheese, this flavorful cavatappi salad is the perfect side for grilled dishes.

2 (9-ounce/255-g) packages frozen artichoke hearts, thawed

1 (14-ounce/400-g) package dried cavatappi or spiral (corkscrew) pasta

2 tablespoons olive oil

2 cloves garlic, minced

1 bunch broccoli rabe, trimmed and chopped into 1-inch pieces

½ teaspoon sea salt

Smoked or black truffle sea salt

Coarsely ground black pepper

1 cup (120 g) crumbled goat cheese or feta

Soak 6 wooden skewers in water for 1 hour.

Prepare a charcoal or gas grill for grilling over low heat. Thread the artichoke hearts onto the prepared skewers and grill them for about 10 minutes, turning the skewers every 3 minutes, until the artichokes are lightly charred. Remove the artichokes from the skewers and let cool.

Cook the pasta until al dente, following the directions on the package. Drain and rinse with cold water. Set the pasta aside to cool.

In a large pan, heat the olive oil over medium heat. Add the garlic and sauté until lightly browned, about 2 minutes. Add the broccoli rabe, sprinkle with the salt and sauté until the broccoli rabe is tender, about 5 minutes. Remove from heat. Using tongs, transfer the greens to a plate; discard any excess oil.

In a large bowl, combine the pasta, broccoli rabe, artichoke hearts, and smoked sea salt and coarsely ground pepper to taste. Toss until all the ingredients are incorporated. Add the goat cheese and toss gently. Serve at room temperature.

CEDAR PLANK–ROASTED SALMON WITH SORREL GREMOLATA

MAKES 6 SERVINGS

Roasting on a cedar plank helps the fish retain its juices and imparts a gentle woodsy note. The slightly sour sorrel and Meyer lemon gremolata add a bright, fresh flavor to the dish. If you cannot find sorrel, arugula works just as well and adds a lovely peppery note to this raw green sauce. You can reuse your cedar planks again and again. When washing them, do not use soap; simply clean in warm water with a little lemon juice.

FOR THE SALMON:

2 1-pound (455 g) salmon fillets, skin on

2 tablespoons olive oil, plus more for rubbing planks

Sea salt

Cracked black pepper

FOR THE GREMOLATA:

1 Meyer lemon

⅓ cup (45 g) pine nuts

1 tablespoon minced garlic

2 cups (40 g) sorrel or arugula leaves, rinsed

Sea salt

2 tablespoons extra-virgin olive oil

Preheat the oven to 350°F (175°C). Soak two 12-inch cedar planks in warm water for 2 hours. Place a weight on them, if needed, to ensure that they are completely submerged. Drain and pat dry. Dip a paper towel in olive oil and rub the oil on both sides of the planks. Preheat the planks in the oven for 10 minutes.

To prepare the salmon, rub a thin coat of olive oil on both sides of the fillets, then season generously with salt and pepper on both sides. Remove the planks from the oven and place the prepared fillets on them, skin side down. Increase the oven temperature to 400°F (205°C) and roast the salmon for 15 minutes.

Meanwhile, prepare the gremolata. Zest the lemon and set aside. Cut the lemon in half and squeeze the juice (you should have about 2 tablespoons). Place the lemon zest, pine nuts, and garlic in a small food processor and chop until fine. Add the sorrel in batches if necessary, pulsing until the greens are finely chopped but not bruised. Transfer the chopped sorrel mixture to a mixing bowl. Add the salt, olive oil, and reserved lemon juice and stir until incorporated. Set the gremolata aside.

When the salmon has roasted for 15 minutes and the fillets are just opaque throughout, turn the oven to broil for the last 3 minutes of cooking. Broiling will give the salmon a burnished appearance and further seal in the juices. Divide the salmon into 6 portions and remove the skin (it should separate easily from the fish). Plate the salmon, spoon some of the gremolata on top of the fish, and serve immediately.

Opposite: Tabletop design for Michael Bloomberg.

QUINOA TABBOULEH WITH ROASTED BABY KALE

MAKES 6 SERVINGS

This creative take on tabbouleh, a salad that's traditionally made with bulgur wheat, is healthful and high in protein. It can be served as a side dish or light, vegetarian main course. For a summery variation, add halved cherry tomatoes and sliced green onions.

5 ounces (142g) baby kale or 1 bunch tender kale, stems removed, chopped or torn into ½-inch pieces (about 6 cups/ 300 g)

2 cloves garlic, thinly sliced

6 tablespoons (90 ml) extra-virgin olive oil

½ teaspoon sea salt, plus more for seasoning

1 cup (170 g) quinoa, well rinsed

2 cups (120 g) chopped curly parsley

1 red bell pepper, diced

1 English (seedless) cucumber, diced

½ cup (120 ml) freshly squeezed lemon juice (from 2 to 3 medium lemons)

Salt

Coarsely ground black pepper

Preheat the oven to 350°F (175°C). In a large bowl, toss together the kale, garlic, 2 tablespoons of the olive oil, and the salt. Spread on a baking sheet and bake until the kale is crisp, about 20 minutes. Let cool.

Meanwhile, in a small saucepan, bring 2 cups (480 ml) water to a boil. Toast the quinoa in a small dry pan. When the water comes to a boil, add the toasted quinoa to the water and reduce the heat to a simmer. Cover and simmer until all water is absorbed, about 10 minutes. Remove from heat and let cool.

In a large salad bowl, toss together the cooked quinoa, parsley, bell pepper, and cucumber. Add the remaining ¼ cup (60 ml) of the olive oil and the lemon juice and toss until all ingredients are moistened. Season with salt and black pepper to taste. Add the kale and toss gently to combine.

The tabbouleh may be made ahead and refrigerated up to 48 hours. Before preparing salad, bring the tabbouleh to room temperature. Toss with other ingredients and serve.

GRILLED ORGANIC CHICKEN KEBABS
WITH BOURBON BARBECUE SAUCE

MAKES 6 SERVINGS

This is the perfect summer recipe—easy to prepare and versatile, it's ideal for a casual outdoor gathering. The spicy-sweet bourbon barbecue sauce can also be served with sirloin kebabs.

3 pounds (1.4 kg) organic skinless chicken breast

2 cups (480 ml) ketchup

½ cup (120 ml) honey or light molasses

⅓ cup (75 ml) bourbon

¼ cup (60 ml) Dijon mustard

2 tablespoons Tabasco (or any hot sauce)

2 tablespoons Worcestershire sauce

1 tablespoon peeled, minced fresh ginger

1 teaspoon chili powder

1 teaspoon onion powder

1 teaspoon garlic powder

Kosher salt

Black pepper

Soak six wooden skewers in water for 1 hour.

Cut the chicken into 2-inch (5-cm) cubes and thread the chicken pieces onto the prepared skewers. Cover loosely and refrigerate.

In a medium saucepan, heat the ketchup, molasses, bourbon, mustard, Tabasco, and Worcestershire sauce over medium heat, stirring constantly until the mixture boils. Reduce the heat to low and add the ginger along with the chili, onion, and garlic powders. Simmer for 15 minutes, stirring constantly. Add salt and black pepper to taste.

Remove the sauce from heat and let stand until cool.

Prepare a charcoal or gas grill over medium heat. Pour half the sauce in a bowl and brush liberally over the raw chicken. Reserve the remaining sauce in a separate bowl for basting. Grill the chicken about 15 minutes, turning the skewers a quarter turn every 3 minutes and basting with the sauce at every other turn. When the chicken kebabs are browned and slightly charred, they're done. Serve immediately.

Opposite, clockwise from top right: Cedar Plank–Roasted Salmon with Sorrel Gremolata, Cavatappi with Grilled Artichokes, Broccoli Rabe, and Crumbled Goat Cheese (both, page 109); Grilled Organic Chicken Kebabs with Bourbon Barbecue Sauce, Smashed Long Island Red Bliss Potato Salad.

Seasonal Splendor

FROM SUMMER TO AUTUMN

A Solstice Soiree

WITH LAUREN AND BOB ROBERTS

If the old adage "Every day is cause for celebration" is true, then the longest day of the year really deserves some special merriment. That was the thinking of Lauren and Bob Roberts, who truly treat every day as an occasion to celebrate life in the company of friends and family.

"We love to have people in our home," says Lauren Roberts. "I take such joy from entertaining and giving everyone a great time. It makes me very happy."

The home—a 28,000-square-foot Tuscan-style estate with sprawling formal gardens in Southampton—was made for gatherings. Formerly the Magda Gabor manor, it was purchased by Bob Roberts and his late wife, Lucille (of Lucille Roberts women's gyms fame), in the eighties and was eventually augmented and transformed into one of the grandest homes in the Hamptons.

In the early aughts, a fire destroyed the house. Bob and Lauren Roberts saw it as an opportunity to rebuild in an even more glorious fashion. Both fond of entertaining, they ensured that the new spaces were big enough to accommodate large numbers of guests but also intimate enough to make everyone feel welcome and well looked after.

Parties may be held by the 4,000-square-foot indoor swimming pool, over which the Robertses often place a Plexiglas floor so guests can dance over the water. The pool transitions into gracious indoor areas that include a

1,500-square-foot Tuscan-style country kitchen, a solarium overlooking the eight-acre grounds, a screening room, and the formal living and dining rooms. That connection among spaces allows for an ideal flow, whether entertaining twenty or two hundred.

For a party to celebrate the summer solstice, and to show a Genevan friend visiting the Hamptons for the first time some "wonderful American hospitality," Bob and Lauren hired master chef Brian Pancir, formerly with the New York Yankees and private chef to various sports and entertainment greats. Pancir's menu included perennial crowd-pleasers like pistachio-crusted salmon and tuna tartare with figs, and a few surprises as well. His rabbit terrine, in particular, was a hit with guests.

The festivities began outside as guests enjoyed hors d'oeuvres and libations on the terrace before progressing to the kitchen and dining room for dinner. In the kitchen, guests were seated at two long tables, including a French oak table and benches, circa 1800s. In the dining room, the seating arrangement was more intimate. "We have four round tables that seat six to eight people each," Lauren says. "We find that facilitates conversation."

In both spaces, tables were set with mixed-and-matched Italian dinnerware that the couple sourced from artisans in Tuscan villages, votive candles, and simple

TIPS AND IDEAS
from Lauren Roberts

Be visible. Your guests are there to see you, so don't disappear to tend to party details.

Introduce your guests to people they don't know. That can be interesting for everybody.

"At all our parties, I like to get everybody dancing at the end. If you're looking for classical music, I'm not your girl. Sultry Saint-Tropez dance songs are more my style."

floral arrangements utilizing flowers from their garden. Dinner was served buffet-style to encourage getting up and mingling, and the playlist was lively to keep spirits high.

By the time dessert was served, the music had escalated to get everyone in the mood to dance. "At dessert time, everyone starts huddling around the kitchen," Lauren says. "That's when we start playing hot popular tunes or European music. We open the French doors, and the pool is all lit up, and the music is going full tilt everywhere."

That high-energy finale, she says, ensures that everyone has a memorable evening. "Regardless of how big the party is, the most important thing is that people leave not wanting the evening to end."

Menu
AN ELEGANT PARTY BUFFET

Hors d'Oeuvres
Grilled Fig and Tuna Tartar over Cucumber Slices
Stuffed Mushrooms with Mascarpone, Crabmeat, and Local Herbs
Endive Spoons with Sweet and Spicy Walnut Crumble and Herb-Infused Goat Cheese
Prosciutto-Wrapped Watermelon Skewers
Rabbit Terrine with Guacamole, Green Onions, and Smoked Paprika

·

Plated First Course
Pan-Seared Crab Cakes with Whole-Grain Mustard Vinaigrette
over Frisée and Watercress Salad

·

Buffet
Pan-Seared Salmon with Creamy Mustard and Pistachio Crust Topping
Farm Stand Grilled Vegetable Platter
Local Heirloom Tomato Salad with Buttermilk Basil Dressing
Applewood-Smoked Bourbon-Marinated Grilled Beef Tenderloin
Farm-Fresh Broccolini with Homemade Pork Sausage, Pasta, and White Navy
Beans Sautéed in Garlic Butter and Topped with Aged Asiago Shavings
Basmati Rice with Mixed Peppers, Black Beans, Herbs, and Brown Butter Drizzle

·

Dessert
An assortment of local pies and Tate's cookies and cakes

Prepared by **Executive Chef Brian Pancir**

ENDIVE SPOONS WITH SWEET AND SPICY WALNUT CRUMBLE AND HERB-INFUSED GOAT CHEESE

MAKES 40 PIECES

This savory hors d'oeuvre is so easy to make, yet full of flavor and terrific for gatherings large and small. It's lovely with a glass of wine and pairs equally well with Sauvignon Blanc and Pinot Noir.

8 ounces (225 g) soft fresh goat cheese

8 ounces (225 g) herb-infused feta cheese

1 cup (130 g) spiced candied walnuts

2 tablespoons extra-virgin olive oil

1 tablespoon freshly squeezed lemon juice

2 generous teaspoons freshly grated lemon zest

3 tablespoons finely chopped fresh cilantro

3 tablespoons finely chopped fresh chives

8 long, slender heads Belgian endive

1 bunch small, fresh cilantro sprigs, for garnish

1 tablespoon smashed coriander seeds

Salt and ground black pepper

Mix the goat and feta cheeses, walnuts, olive oil, lemon juice, and lemon zest in a food processor until well combined but still slightly chunky. Transfer the mixture to a medium bowl and stir in the cilantro and chives. Cover and refrigerate until cold, at least 1 hour.

Cut off and discard the root ends and cores of the endive, separate the leaves, and arrange them on a tray or serving platter. Spoon about 1½ teaspoons of cheese mixture onto the wide end of each endive leaf. Garnish each with 1 small sprig of cilantro and sprinkle with the coriander seeds, salt, and pepper.

PAN-SEARED CRAB CAKES WITH WHOLE-GRAIN MUSTARD VINAIGRETTE OVER FRISÉE AND WATERCRESS SALAD

MAKES 12 CRAB CAKES

A New England favorite with a tropical twist, these crab cakes—incorporating crisp apple and sweet mango— make for refreshing summer fare.

FOR THE WHOLE-GRAIN MUSTARD VINAIGRETTE:

MAKES 1 CUP (240 ML)

½ cup (120 ml) walnut oil

¼ cup (60 ml) white wine vinegar

¼ cup (60 ml) whole-grain mustard

2 teaspoons maple syrup

½ teaspoon fine sea salt

½ teaspoon freshly ground black pepper

FOR THE CRAB CAKES AND SALAD:

¼ cup (60 ml) mayonnaise

¼ cup (60 ml) crème fraîche

2 large eggs, beaten

1 tablespoon Dijon mustard

1 tablespoon Worcestershire sauce

½ teaspoon hot sauce

1 mango, finely diced

1 Granny Smith apple, peeled and cored, diced small

1 tablespoon finely chopped fresh dill

1 teaspoon minced jalapeño

2 tablespoons finely diced red bell pepper

25 saltine crackers, finely crushed

1 pound (455 g) jumbo lump crabmeat

¼ cup (60 ml) canola oil

1 head frisée lettuce

3 bunches watercress

Petals of 3 pansies, for garnish (optional)

Prepare the mustard vinaigrette by whisking together the walnut oil, vinegar, whole-grain mustard, maple syrup, salt, and pepper in a medium bowl. (The dressing can be refrigerated for up to 5 days.)

Prepare the crab cakes. In a medium mixing bowl, lightly whisk together the mayonnaise, crème fraîche, eggs, Dijon mustard, Worcestershire sauce, and hot sauce.

Add the mango, apple, dill, jalapeño, bell pepper, and crushed saltines. When the mixture is combined, add the crabmeat. Gently toss the ingredients together, keeping the crabmeat in lump form. Cover the bowl with plastic wrap and refrigerate it for 2 hours.

Preheat the oven to 350°F (175°C).

Portion the mixture into 12 equal-size crab cake patties.

Place a large sauté pan over medium-high heat; when the pan is hot, pour in the canola oil and heat. Place the patties in the pan and sear them until they are golden brown on both sides, about 5 minutes on each side. Transfer the patties to a nonstick baking sheet.

Bake the patties for 15 minutes.

While the crab cakes are cooking, assemble the salad by tossing the frisée and watercress with just enough vinaigrette to coat the leaves. Plate the salad.

When the crab cakes are ready, place them over the salad and garnish with the pansies, if using. Serve hot.

RABBIT TERRINE WITH GUACAMOLE, GREEN ONIONS, AND SMOKED PAPRIKA

MAKES 60 PIECES

Served in a classic French style, sliced and presented with cornichons and a good sourdough bread, this terrine is a fabulous starter. Chef Pacir's presentation, cubing the terrine and topping it with guacamole, green onions, and smoked paprika, creates a very special hors d'oeuvre that will delight your guests. This recipe is quite large; if your event is smaller, consider using half your terrine and freezing the rest. It will keep well for up to one month. Note that the meat mixture must be prepared a day ahead of serving.

6 tablespoons (85 g) unsalted butter

¾ cup (90 g) finely chopped red onion

½ cup (50 g) finely chopped celery

½ cup (75 g) finely chopped green bell pepper

½ cup (55 g) pistachio nuts, finely crushed

2 pounds (910 g) mushrooms (shiitake work best)

3 teaspoons table salt

2 teaspoons freshly ground black pepper

¼ cup (60 ml) brandy or cognac

1½ cups (270 g) diced turkey bacon or classic bacon

½ cup (115 g) diced fresh unsmoked and unsalted fatback

½ cup (120 ml) demi-glace or good-quality chicken base (such as Better than Bouillon brand)

2 pounds (910 g) rabbit, skin removed, deboned, and cut into small pieces

2 tablespoons minced garlic

2 teaspoons ground cumin

2 teaspoons chili powder

1 teaspoon kosher salt

2 tablespoons chopped fresh basil

2 tablespoons chopped fresh oregano

2 tablespoons chopped fresh thyme

2 tablespoons chopped fresh rosemary

1 large egg

¼ cup (60 ml) heavy cream

2 slices good-quality rye bread, crust removed and torn into small pieces

FOR THE GUACAMOLE AND GARNISHES:

MAKES 1 CUP (240 ML)

2 avocados, pitted, peeled, and roughly chopped

1 heirloom plum tomato, roughly chopped

1 shallot, roughly chopped

1 bunch cilantro

¼ teaspoon salt

⅛ teaspoon freshly ground black pepper

4 green onions, cut into thin slices, for garnish

Smoked paprika, for garnish

In a large sauté pan, melt the butter over medium-high heat. Add the onion, celery, bell pepper, and pistachios and cook until soft, 4 to 5 minutes. Add the mushrooms, salt, and 1 teaspoon of the pepper. Cook the mushrooms, stirring constantly, until they are soft and have released liquid, about 6 minutes. Add the brandy to deglaze the pan. Add the bacon and fatback; cook for 6 minutes. Add the demi-glace and cook until the mixture thickens, 2 to 3 minutes. Let it cool completely.

In a bowl, combine the rabbit meat, cooled mushroom mixture, garlic, cumin, chili powder, kosher salt, the remaining 1 teaspoon of pepper, and the basil, oregano, thyme, and rosemary. Stir well to combine all the ingredients, then cover the bowl tightly with plastic wrap and refrigerate it overnight.

Preheat the oven to 325°F (165°C) and set the rack in the middle position. Bring a kettle of water to boil.

In a small bowl, beat the egg with the cream. Add the rye bread and soak it until the pieces absorb almost all the liquid. Combine this with the rabbit mixture.

In a food processor, grind the mixture to a coarse texture and transfer it to a 14-by-9½-inch (35.5-by-24-cm) baking dish and cover with aluminum foil. Place the baking dish inside a roasting pan and transfer to the oven. Pour boiling water into the roasting pan so that it reaches halfway up the sides of the terrine. Bake until the juices run clear and the terrine pulls away from the sides of the pan, 1 hour and 40 minutes.

Remove the baking dish from its water bath, pour off the juices, and then carefully lift the terrine out of the baking dish with a large spatula. Set it on a platter and let it cool to room temperature. Cover and refrigerate the terrine until you are ready to serve, at least 2 hours; the terrine must be cold and solid before slicing.

Prepare the guacamole. Using a food processor, combine the avocados, tomato, shallot, cilantro, salt and pepper. Pulse until the guacamole is creamy.

Cut the terrine into 1-inch (2.5-cm) cubes. Spoon ¼ teaspoon guacamole over each cube, then garnish it with green onion slices and smoked paprika. Serve the hors d'oeuvre cold or at room temperature, with cocktail forks.

Opposite, clockwise from top left: Rabbit Terrine with Guacamole, Green Onions, and Smoked Paprika; Endive Spoons with Sweet and Spicy Walnut Crumble and Herb-Infused Goat Cheese; Pan-Seared Crab Cakes with Whole-Grain Mustard Vinaigrette over Frisée and Watercress Salad (both, page 119).

PAN-SEARED SALMON WITH CREAMY MUSTARD AND PISTACHIO CRUST TOPPING

MAKES 10 SERVINGS

This recipe is easy, delivers gourmet flavors, and looks beautiful on the plate. The cooking time will depend upon how you like your salmon: barely pink in the middle or done all the way through. Serve it over a lovely salad, as the Roberts chose to, or try it with your favorite vegetables or starch and reserve some crushed pistachio nuts for garnish.

¼ cup (60 ml) heavy cream
½ cup (120 ml) Dijon mustard
½ cup (120 ml) whole-grain mustard
¼ cup (25 g) finely chopped fresh thyme

6 tablespoons (35 g) finely chopped fresh dill
1 clove garlic, minced
¼ cup (60 ml) grapeseed oil

3 pounds (1.4 kg) wild Atlantic salmon, cut into 10 (4-ounce/115-g) pieces or 8 larger pieces
Salt and ground black pepper
1½ cups (170 g) crushed pistachio nuts, both fine and coarse pieces

Preheat the oven to 350°F (175°C). Line a baking tray with parchment paper.

In a small saucepan over medium heat, combine the cream, Dijon and whole-grain mustards, thyme, dill, and garlic. Heat until the ingredients are incorporated, but do not allow them to boil, about 5 minutes.

Place a large sauté pan over medium-high heat; when the pan is hot, pour in the grapeseed oil. Season the salmon with salt and pepper and, working in batches, place it in the pan, skin side down; sear

until an opaque color appears halfway up the fish and the edges are golden brown, about 2 minutes. Remove the salmon from the pan and place it on the prepared baking tray, skin side down.

Coat the top of each salmon piece with creamy mustard sauce and sprinkle it with the pistachio crumble, taking care to cover the sauce completely.

Bake until the salmon is slightly pink in the middle, 10 to 15 minutes. Serve immediately.

Opposite, bottom: Chef Brian Pancir.

Farewell to Summer

WITH CYNTHIA SULZBERGER AND STEVEN GREEN

When a fun-filled Hamptons summer has come to a close, sandals rinsed of sand and pool toys stowed away for the winter, Cindy Sulzberger and her husband, Steven Green, invite friends and family over for a Sunday afternoon farewell.

Guests know it's a stop-on-by, come-as-you-are kind of formula. Substantial hors d'oeuvres are passed for guests mingling on the patio after a pause at the bar, conversation is easy at the kitchen island, and children gather around the pool for one last splash with Sunshine, the Labradoodle.

Prior to building a winter residence in Palm Beach, the couple lived year-round in the Hamptons for nearly fifteen years with their children, Dylan and Miranda. Cindy is a private learning specialist, and Steven is a money manager.

"Our idea of entertaining is we'll get together with three other families and their kids," says Cindy. "In the summer, we grill, and everything is close together so the kids can be in the pool while parents are at the kitchen island." She recalls, "We went to Connecticut on the weekends when I was growing up, and this is very similar to the kind of entertaining that my parents did. A lot of buffets, very casual families and kids. No place cards."

Local produce drives the menu: "In the summer we eat as much corn as we can!" Steven says with a smile. The tables are decorated with bouquets of local farm stand sunflowers, and the waterfront location sets the tone for cherished memories to come.

"We enjoy the water by taking the kids tubing and water skiing," says Steven. "Or going out on the boat, finding a secluded spot, and having dinner and drinks with friends."

Their fondness for the East End state of mind is evident in their relaxed yet elegantly appointed shingled cottage on Upper Sag Harbor Cove. Here, Patricia McGrath of Coastal Home Store in Bridgehampton combined family-friendly print fabrics with stylish yet durable furnishings to support the family's well-lived-in lifestyle.

A painting procured from Robert Deyber's "Rock Paper Scissors" collection is a nod to Cindy's family heritage. Her great-grandfather Adolph S. Ochs bought the *New York Times* in 1896. Her late father was chairman emeritus of the New York Times Company and was succeeded by her brother, Arthur Ochs Sulzberger Jr., as chairman and publisher.

As the sun sets on another Hamptons summer, twilight lingers over the cove. Fishing and sporting boats motor in and out of neighboring docks, guests kiss and part ways . . . until next time.

Page 125: Steven's Three-Layer Dip (page 129) and chips; above: Cindy Sulzberger, Steven Green, Connie and Keith Lippert.

TIPS AND IDEAS
from Cindy Sulzberger

Keep it fresh. When choosing produce, always go for what is in season, abundant, and freshly picked. It tastes best and is most healthful.

Keep it local. Locally sourced items—from seafood to flowers—give a sense of place and help the local economy thrive.

Keep it simple. A party is about bonding with friends, so the menu and décor need not be overly complicated. This is especially true when entertaining families with young children.

Menu

POOLSIDE HORS D'OEUVRES FOR EIGHT

Domaines Ott Rosé

·

Steven's Three-Layer Dip
Mini Crab Cakes
Filet of Beef on Crostini with Horseradish Cream
Minnie's Chicken

Chef Brent Newsom Caterer

STEVEN'S THREE-LAYER DIP

MAKES ABOUT 20 SERVINGS

"Why not just put everything that tastes good in a pan and eat it with chips?" says Steven. "It's not fancy, and people are always surprised what is in it, but it is always gone."

2 (8-ounce/225-g) packages cream cheese, at room temperature

2 (15-ounce/425-g) cans Hormel No Beans Chili

1 (6-ounce/170-g) bag shredded Mexican cheese

2 to 3 fresh jalapeño peppers, sliced

Tortilla chips

Guacamole (optional)

Preheat the oven to 375°F (190°C).

In an 8-inch (20-cm) square baking dish, smooth the cream cheese to fill the bottom of the dish. Layer on the chili and shredded cheese.

Bake for 30 minutes or until the cheese has melted and becomes slightly golden brown.

Toss the jalapeños in the center and serve it with a spoon and tortilla chips; serve guacamole on the side, if you like.

MINI CRAB CAKES

MAKES 25 TO 30 PIECES

Always a crowd-pleaser, these bite-size crab cakes are excellent as an appetizer with your favorite sauce on the side, and they are especially great for cocktail parties. Use fresh crabmeat and serve them with spicy Dijon mustard, rémoulade, or tartar sauce. They look so appetizing sitting atop a slice of lemon or lime! Small and delicious, your guests won't be able to eat just one.

1½ tablespoons olive oil

1 red bell pepper, minced

1 red onion, minced

4 celery stalks, minced

1 teaspoon Old Bay seasoning

2 to 3 slices good-quality white bread, lightly toasted

3 large eggs

1 tablespoon Dijon mustard

¼ cup (60 ml) mayonnaise

1 tablespoon Worcestershire sauce

Zest and juice of 1 lemon

1 teaspoon salt

½ teaspoon freshly ground black pepper

8 ounces (225 g) fresh crabmeat

3 to 4 cups (720 to 960 ml) canola oil

Tartar sauce, rémoulade sauce, or Dijon mustard for dipping

Heat the olive oil in a small pan over medium-high heat. When the oil is shimmering, add the bell pepper, onion, celery, and Old Bay seasoning. Sauté until the vegetables are wilted, about 5 minutes, and set them aside to cool.

In a food processor, reduce the bread to crumbs.

In a small bowl, whisk the eggs, mustard, mayonnaise, and Worcestershire sauce with the lemon zest and juice. Add the salt and black pepper and mix well.

Gently fold the cooled vegetables and crabmeat into the egg mixture; then fold in ½ cup (55 g) of the bread crumbs. Keep adding

additional crumbs until the mixture takes on the texture of mashed potatoes.

Refrigerate the mixture for at least 2 hours to firm.

When you're ready to fry, heat the oil to 350°F (175°C) in a deep sauté pan. Form cakes using a small ice cream scoop or melon baller, place the dome-shaped cakes in the hot oil, and fry until golden brown, 2 to 3 minutes. Using a slotted spoon, transfer them to paper towels to drain until they are cool enough to serve.

Provide tartar or rémoulade sauce, or Dijon mustard for dipping.

Opposite: Mini Crab Cakes (in back) and Filet of Beef on Crostini with Horseradish Cream (page 130).

FILET OF BEEF ON CROSTINI WITH HORSERADISH CREAM

MAKES ABOUT 30 APPETIZERS

Deliciously creamy horseradish is the perfect complement to the tender, lean, and subtle flavors of filet mignon. Your guests will feel pampered and well fed when you serve this at your next gathering.

2 tablespoons Dijon mustard
½ teaspoon kosher salt
2 tablespoons balsamic vinegar

1½ pounds (680 g) filet of beef, trimmed of all fat
2 tablespoons coarsely ground black pepper

Crostini (recipe follows)
Horseradish Cream (recipe follows)
1 bunch fresh chives, finely chopped, for garnish

Preheat the oven to 500°F (260°C) and line a baking sheet with parchment paper.

In a small bowl, mix the mustard, salt, and vinegar together, then rub the mixture onto the surface of the filet. Sprinkle the pepper generously onto the meat and pat it gently to keep it in place.

Roast the seasoned filet on the prepared baking sheet until an instant-read thermometer inserted in the thickest part of the roast reads 130°F for rare (about 20 minutes) or 140°F for medium-rare (about 25 minutes), depending on your preference. Cooking time will

depend on the thickness of the beef, and the meat will continue to cook while resting.

Allow the beef to cool to room temperature, then slice the filet in half down the length of the roast. Turn each piece cut surface down on the board and slice it thinly, about ⅛ inch (3 mm) thick.

To assemble the crostini, place one slice of beef on the crostini and pipe ¼ teaspoon of horseradish cream on top. Sprinkle with chives. Serve at room temperature.

CROSTINI MAKES ABOUT 60 CROSTINI

2 cloves garlic, finely minced
½ cup (120 ml) extra-virgin olive oil

1 fresh baguette
⅛ teaspoon salt

⅛ teaspoon freshly ground black pepper

In a small bowl, add the garlic to the olive oil and let it stand for 2 hours.

Preheat the oven to 300°F (150°C) and line a baking sheet with parchment paper.

Slice the baguette slightly on the diagonal to increase the surface area, about ¼ inch (6 mm) thick, and arrange the pieces flat on the prepared baking sheet. Paint the tops with the garlic-infused oil and sprinkle them with salt and pepper.

Bake until the crostini are crisp, 10 to 15 minutes.

HORSERADISH CREAM MAKES 1 CUP (240 ML)

½ cup (120 ml) heavy cream, cold
¼ teaspoon salt

½ teaspoon sugar
¼ teaspoon Tabasco sauce

3 to 4 tablespoons (45 to 60 ml) drained fresh prepared horseradish

Place the cream in a medium mixing bowl and whisk until it forms soft peaks. Add the salt, sugar, and Tabasco and whisk until the mixture is smooth and creamy. Fold in 3 tablespoons of the horseradish; taste

and add an additional tablespoon, if desired. Use immediately or refrigerate for up to 5 days.

MINNIE'S CHICKEN
MAKES 8 SERVINGS

Steven's Grandma Minnie made this dish whenever the family visited her in Boston. She loved everything sweet, and that was how she made her chicken. Sometimes Minnie used her favorite brand of Russian dressing and onion soup mix, then added chopped fresh vegetables: onions, red and green bell peppers, and celery. This recipe works best with a whole chicken cut into eight parts, but it still turns out well when made with all legs or breasts.

8 teaspoons dried minced onion

2 teaspoons dried parsley

1¼ teaspoons onion powder

1 teaspoon ground turmeric

½ teaspoon celery seed

½ teaspoon sugar

½ teaspoon salt

¼ teaspoon freshly ground black pepper

1 (2-pound/910-kg) chicken, skin removed, cut into 8 pieces

¾ cup (180 ml) apricot jam

1 cup (240 ml) Russian Dressing (recipe follows)

2 tablespoons finely chopped onion, for garnish

2 tablespoons finely chopped red bell pepper, for garnish

Preheat the oven to 350°F (175°C).

In a small bowl, stir together the dried onion, parsley, onion powder, turmeric, celery seed, sugar, salt, and pepper. Set this onion mixture aside.

Arrange the chicken pieces in an oven-to-table baking dish, with the largest pieces (breasts) in the center of the pan. Don't crowd the pieces; allow room between them.

In a mixing bowl, combine the apricot jam, Russian dressing, and onion mixture. When it is well combined, pour the sauce over the chicken. Turn the chicken parts, making sure all the pieces are thor-oughly coated. Cover the baking dish loosely with aluminum foil and bake for 45 minutes.

Remove the foil and flip the chicken pieces over, spooning sauce over each piece. Continue to bake, uncovered, turning and basting the chicken every 5 minutes, until the sauce is slightly caramel in color and thick, about 20 minutes.

Carefully remove the chicken pieces from the baking dish, remove the bones, and slice the meat on the diagonal, then return it to the hot baking dish and spoon sauce over the slices to coat the pieces evenly. Garnish with a sprinkling of fresh onion and bell pepper, and serve immediately.

RUSSIAN DRESSING MAKES 1¼ CUPS (300 ML)

1 cup (240 ml) mayonnaise

¼ cup (60 ml) ketchup

1 teaspoon Worcestershire sauce

1 tablespoon minced fresh parsley

1 teaspoon freshly grated onion

1 teaspoon prepared horseradish

1 teaspoon salt

½ teaspoon ground black pepper

Prepare the dressing by stirring together all the ingredients in a small bowl until well blended. Cover and refrigerate until ready to use.

The dressing will keep, refrigerated, for up to a week.

An Autumn Feast

WITH VICTORIA AND MINOT AMORY

To be entertained by Victoria Amory on any occasion is a study in grace and hospitality. A food writer, blogger, and cookbook author, she has a collection of VA & Co. gourmet soups, sauces, and condiments that are available in specialty food shops from Southampton to San Francisco. Her mantra in work and at play: Elevate the everyday.

So whether she's serving late-night Pinot Grigio by the fire or a seated luncheon on the terrace at home, every detail is cared for with ease. Dishes are homemade with fresh, local ingredients; glasses are consistently and unfussily refreshed; and guests share with Victoria the kind of laughter that confirms there's nowhere else on earth they'd rather be.

When the hydrangeas give way to amber leaves south of Montauk Highway, Victoria celebrates the start of the off-season with friends and neighbors. "After the tourists leave Southampton, I always love giving a fall dinner," she says. "I love the fireplace and the idea that it's still balmy enough that you can sit outside for drinks and have dinner inside, and it's that wonderful time of year when everything is changing."

Designed by architect Jaquelin T. Robertson and Minot's late sister-in-law, 1970s "it" girl Chessy Rayner, the neoclassical clapboard house the couple shares is the very essence of warmth. Butter yellow walls set off the vibrancy of antique textiles collected on trips to France, Spain, Turkey, and Venezuela. Breezes from open doors and windows whisper the scent and crackle of a roaring fire, and sons Minot Jr., Henry, and William are at the ready with toasty beverages and wry wit.

"It's not a grand house, but it's a great entertaining house. We've had cocktail parties for two hundred people and we've had dinners for three, and it all works," she says. "There's no dining room, and Chessy's theory was that you don't need a dining room because the beautiful room is the living room, so why not set up a series of tables in the living room?"

Amory's Spanish heritage—she grew up the daughter of a count and countess with homes in Madrid and Seville before moving to New York—informs the range of her products as well as her lifestyle. "My parents entertained a lot, so that was second nature. We were brought up having people over all the time, so we learned how to be gracious and how to serve drinks and how to pass hors d'oeuvres, and that's sort of what I do now," she says (as if just anyone can whip up dinner from scratch for forty and still manage to light the candles, arrange the flowers, put on mascara, and write a blog post all about it).

"I like the thrill of giving a dinner. It's great fun, I just love doing it," she says. "But entertaining takes time.

Above, right: William Amory.

TIPS AND IDEAS
from Victoria Amory

To cook for a large group, Victoria uses a pressure cooker, a great tool to make all sorts of recipes and a sure way to shorten cooking time, leaving her freer to mingle with guests.

Victoria likes her creamy soups to be the consistency of vichyssoise, and just before serving always adds a delicious and decorative garnish; croutons, bacon bits, toast slivers, and sage leaves all make a wonderful presentation.

You have to enjoy having people in your house. It has to be something that gives you pleasure."

As guests trickle in this autumn evening, canapés of foie gras on toast points dotted with pear and apple sauce double as garnishes for a first course of local butternut squash soup (with homemade vegetable stock, of course). A buffet table is set in the eat-in kitchen, ripe with the vestiges of a fall shoot: pheasant feathers and sage adorn Long Island duck and artisan sausages, and comfort foods like mashed potato en croûte and roasted Brussels sprouts are scooped up en masse. Fresh local peaches drizzled in maple syrup round out the menu.

The sun has long set, but company lingers and the fire roars on. Outside, a family of deer rustles through the nearby woods, nosing their way toward the vegetable garden. And it feels like home.

Menu

ELEGANT DINNER FOR SIX TO EIGHT

Butternut Squash Soup Garnished with Foie Gras Slivers
on Toast Topped with Pear & Apple Sauce
Magret of Duck with Plum & Cranberry Sauce
Mashed Potatoes en Croûte
Gourmet Sausages in Wine
Roasted Brussels Sprouts with Bacon
Oven-Roasted Peaches
Tate's Blondies & Brownies

BUTTERNUT SQUASH SOUP

MAKES 8 TO 10 SERVINGS

This soup, elegant both in texture and flavor, has an unexpected taste of orange. Victoria likes to serve it piping hot in large, white bowls garnished with croutons or bacon bits (or both!). For this dinner she garnished it with foie gras slivers on toast—just a great way to start her "game" dinner!

1 yellow onion, diced, skin reserved

2 large leeks, white parts sliced, green parts reserved

1 large sweet potato, diced, peel reserved

2 pounds (910 g) butternut squash, seeded and diced, skins reserved

1 tablespoon black peppercorns

1 bay leaf

2 tablespoons olive oil

1 clove garlic, diced

Salt and ground black pepper

Juice of 1 orange

½ cup (120 ml) heavy cream

½ tablespoon freshly grated orange zest

In a large stockpot filled with at least 10 cups of water, add the onion skins, green part of the leeks, sweet potato peels, butternut squash skin, peppercorns, and bay leaf. Bring the broth to a boil and simmer, covered, for 20 minutes. Strain, discard the solids, and reserve the liquid.

Meanwhile, heat the olive oil in a large stockpot. Sauté the onion, leeks, and garlic until just soft, about 10 minutes. Add the sweet potato and the butternut squash and stir to coat the vegetables with the onion mixture. Season with salt and pepper. Cook for 20 minutes over medium heat.

Add 8 cups of the broth, the orange juice, and season again with salt and pepper. Bring the soup to a boil, cover and cook until the squash and potatoes are soft, about 12 minutes. Let cool.

When the soup has cooled, working in batches, puree the soup in a blender, adding, the cream, orange zest, and any remaining broth. Return the soup to the stockpot and heat just before serving.

MASHED POTATOES EN CROÛTE

MAKES 8 TO 10 SERVINGS

This is truly an elegant way of serving mashed potatoes—a bit of a carbo-load, but for a special occasion, it is worth every rich bite. What could be better than piping-hot mashed potatoes packaged inside flaky puff pastry? Consider mashing the potatoes a little ahead of time, then assemble the dish and cook it just before serving, so you have more time with your guests.

6 to 8 large Idaho potatoes

½ cup (120 ml) whole milk

1 bay leaf

½ cup (120 ml) heavy cream

4 tablespoons (55 g) butter, at room

temperature

6 tablespoons (45 g) grated Parmesan cheese

⅛ teaspoon freshly grated nutmeg

½ teaspoon sea salt

¼ teaspoon ground white pepper

1 large egg yolk

2 sheets frozen store-bought puff pastry, at room temperature

Preheat the oven to 350°F (175°C).

Peel and dice the potatoes and transfer them to a large bowl of cold water to prevent them from discoloring. Bring a large pot of salted water to a boil. Add the potatoes, milk, and bay leaf. Cook until the potatoes are soft and very tender, about 25 minutes. Remove the bay leaf, drain the potatoes in a colander and return them to the pot. Using a potato masher, mash the potatoes until they are soft and fluffy. Using a heavy-duty wire whisk, beat in the cream, butter, and 2 tablespoons of the Parmesan cheese. Season with nutmeg, salt, and white pepper. Whisk in the egg yolk and set the potatoes aside.

Line an 8-inch (20-cm) soufflé dish with one of the pastry sheets, allowing the edges to hang over the sides. Bake until the pastry is golden brown. Let the pastry cool.

Spoon the mashed potatoes into the dish and sprinkle 2 tablespoons of Parmesan cheese over them. Top with the remaining sheet of puff pastry and crimp the edges with a fork. Trim away the excess pastry. Make a few decorative slits using a sharp knife and sprinkle the remaining 2 tablespoons Parmesan cheese on top of the pastry. Bake until the pastry has risen slightly and is golden, about 20 minutes. Serve hot.

GOURMET SAUSAGES IN WINE

MAKES 6 TO 8 SERVINGS

A wonderful assortment of sausages add flavor, texture, and color to Victoria's buffet table. Her selection included blood sausage and merguez, a spicy lamb sausage from Morocco, plus chorizo and butifarra sausages from Spain, chicken with truffle, and duck. Cooking sausage in various types of wine brings out their flavor and adds a wonderful glaze.

3 merguez sausages
3 blood sausages (morcilla)
1 cup (240 ml) red wine

3 chorizo sausages
3 butifarra sausages
1 cup (240 ml) sherry
3 chicken with truffle sausages

3 duck with Armagnac sausages
1 cup (240 ml) white wine
3 tablespoons olive oil

Preheat the oven to 350°F (175°C).

Pierce the sausages with a fork three or four times. Over medium heat, in a sauté pan, heat the olive oil and cook all the sausages until their casings are slightly brown. Set aside on a platter.

Working in batches, you will cook the merguez and blood sausages together with red wine; the chorizo and butifarra with the sherry; and the chicken and duck sausages with the white wine.

Begin by adding 1 cup (240 ml) of the wine to the sauté pan, adjust the heat to maintain a simmer and cover. Cook the sausages until the wine is evaporated and the sausages are nicely glazed. Repeat with each type of wine and the other sausages. Transfer the sausages to an oven dish to keep warm until you are ready to eat.

OVEN-ROASTED PEACHES

MAKES 6 TO 8 SERVINGS

Fall brings all the stone fruits to perfect ripeness, and this easy dessert brings them all home. Simply roasted fruit is a treat to make and to eat with a dollop of light and fluffy lemon-scented yogurt. While Victoria featured fresh, local Hamptons peaches at her party, you can use apricots, peaches, plums, nectarines, or a combination of stone fruits. Choose what is fresh and in season for maximum flavor.

4 pounds (1.8 kg) peaches, split in half, pits removed
¼ cup (60 ml) grade-B maple syrup

2 cups (480 ml) Greek yogurt
1 teaspoon finely grated lemon zest

1 tablespoon confectioners' sugar
1 teaspoon almond extract

Preheat the oven to 400°F (205°C).

Arrange the fruit cut side up in a single layer on a cookie sheet and drizzle the maple syrup on top.

Roast the fruit until it is slightly caramelized and some of the juices are released, 10 to 15 minutes.

Arrange the peaches on a decorative platter and pour the juices over them.

In a bowl, mix together the yogurt, lemon zest, sugar, and almond extract.

Serve the warm fruit with a dollop of the yogurt on top.

Opposite, top, clockwise from far left: Mashed Potatoes en Croûte (page 139), Gourmet Sausages in Wine, Magret of Duck with Plum and Cranberry Sauce, and Roasted Brussels Sprouts with Bacon; center left: Butternut Squash Soup garnished with foie gras slivers on toast topped with pear and apple sauce (page 139).

Dinner and a Movie

WITH JOAN AND GEORGE HORNIG

Philanthropy: the love of one's fellow man. It is a concept so simple and so basic, but it sometimes becomes lost in a fast-paced and increasingly cacophonous world.

Not so for Joan and George Hornig. Philanthropy is at the heart of every one of their endeavors. "Everything we do revolves around philanthropy," Joan says. "It's a lifestyle choice."

The notion of supporting others—whether friends or charities—also informs the Hornigs' entertaining. On one lovely autumn evening, as the apples released their fragrance into the crisp air, the couple decided to host a group of friends, old and new, for the first press of the season. For most, home-pressed cider would have been excuse enough for a gathering, but the Hornigs needed an even greater purpose.

Enter Laura Moore. A friend of the Hornigs for years (she even held her wedding on their property), Laura reached out with an opportunity to screen an Australian film, *Tackling Romeo*, that was being scripted for Broadway. After the screening, guests would have the opportunity to meet the director, Lynda Heys, and discuss the message of the film in an intimate setting.

An enthusiastic supporter of the arts with a history of patronage, Joan loved the idea and began to shape it into an exciting, thought-provoking event. "The Hamp-tons have an amazing tradition of the arts, intellect, and interesting people," she says. "The whole idea is to bring all that together."

And what better platform than the arts to do it? Aside from the film screening, Joan wanted to showcase the work of local and emerging artists during the party. "I keep the work of different artists in my garage gallery," she says, "with the idea of offering them for purchase, with thirty percent [of the proceeds] going to the charity of the buyer's choice."

As guests arrived, they toured the gardens and the art gallery—with freshly pressed cider in hand—before moving into the media room for the screening. Afterward, they transitioned into the barn for dinner.

The historic barn, which was original to the property but was renovated by the Hornigs as a dynamic enter-taining space, is an idyllic spot to gather. "Nothing is too perfect in here; nothing is intimidating," Joan says. "It puts people at ease. When everyone is comfortable and feeling good, that's the key to entertaining."

A long table with bench seating was decorated with flowers and apples from the garden and small sculptures in metal and wood by artist Joey Vaiasuso—a brilliant way to reintroduce art into the conversation. Guests were seated strategically, based on interests and personalities,

Opposite, top left: Chef Gabriel Kennedy. Opposite, bottom right: Joan and George Hornig. Page 146, bottom left: Fred Tanne, Joan Hornig, Laura Moore, and George Hornig.

TIPS AND IDEAS
from Joan Hornig

"It is important to have place cards for seating. There are no fast nor hard rules for seating other than arranging a lively discussion at the table."

Joan builds her seating around the middle of the tables and keeps those who speak or laugh the loudest in different zones. It adds to the lively ambiance.

Take pictures at every dinner party of both the food and the seating to ensure you don't always put the same people together or serve them the same menus.

To keep the conversation going, Joan asks each guest the same questions to share. Some of her favorites: What are you passionate about outside your family and work? And what nonprofit are you working with now that could use the advice of those at the table?

Always have contiguous seating so as not to separate people. Joan designed many of the tables in her home for entertaining.

and because not everyone knew each other, Joan asked each to say a few words of introduction. Both tactics put guests at ease and facilitated a thoughtful exchange throughout the evening.

At the end of the night, everyone left richer than when they came. "For me, entertaining is about the guests and making them feel special," Joan says. "When people come to your home, they give you a present of their time. In return, you have to give them something that is interesting and memorable."

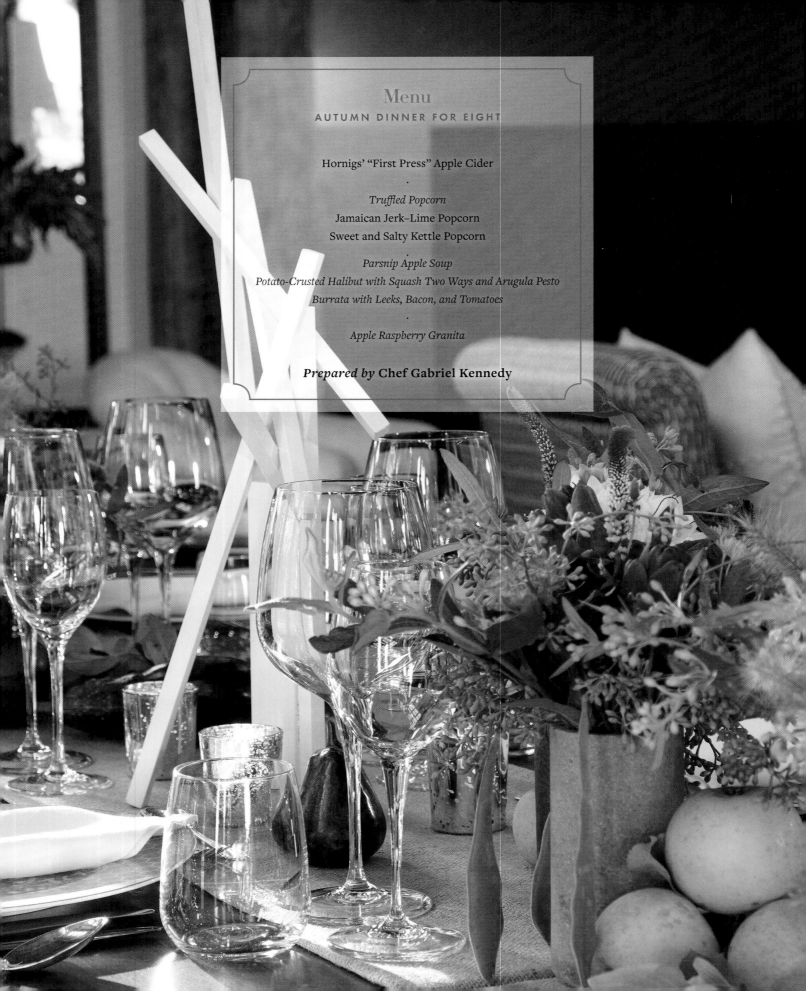

Menu
AUTUMN DINNER FOR EIGHT

Hornigs' "First Press" Apple Cider

·

Truffled Popcorn

Jamaican Jerk–Lime Popcorn

Sweet and Salty Kettle Popcorn

·

Parsnip Apple Soup

Potato-Crusted Halibut with Squash Two Ways and Arugula Pesto

Burrata with Leeks, Bacon, and Tomatoes

·

Apple Raspberry Granita

Prepared by Chef Gabriel Kennedy

TRUFFLED POPCORN

MAKES 14 CUPS

This gourmet popcorn is so delicious you won't want to save it for the movies. Perfect as an hors d'oeuvre and a special treat when inviting friends over for drinks.

3 tablespoons extra-virgin olive oil
½ cup (100 g) organic, non-GMO popping kernels

2 tablespoons nutritional yeast
Coarse sea salt

1 tablespoon butter, melted
Truffle-infused extra-virgin olive oil

Heat the olive oil in a large pot over medium-high heat. When the oil shimmers, add the popcorn kernels and stir to coat all kernels. Place the lid on the pot slightly ajar to allow steam to release.

Once the popping starts, gently shake the pot by moving it back and forth over the burner. Keep the lid slightly ajar, just enough to let the steam, but not the kernels, escape.

Once the popping slows to several seconds between pops, remove the pan from the heat, remove the lid slowly, and pour the popcorn into a large bowl.

Season with the nutritional yeast and toss to coat. Add ½ teaspoon salt and the melted butter and toss. Add about 1 teaspoon of the truffle oil, toss to evenly distribute the seasoning, then taste and add more salt or truffle oil as desired. Serve immediately.

PARSNIP APPLE SOUP

MAKES 8 SERVINGS

With the weather turning cool, we all welcome cozy, warm-you-to-the-core kind of food. This soup is deliciously comforting and pleasantly easy to make. It's a great-tasting seasonal soup that works as well for a dinner party starter as it does for a light, casual lunch in autumn, when both star players, apples and parsnips, are at their best.

FOR THE SOUP:
2 tablespoons olive oil
9 parsnips, peeled and cut into cubes (about 6 cups/810 g)
2 apples, peeled, cored, and cut into cubes (about 2 cups/220 g)
1 teaspoon salt

3½ cups (840 ml) chicken stock
1½ to 2 cups (360 to 480 ml) local apple cider
Ground white pepper
3 tablespoons butter, at room temperature
FOR THE GARNISH:
1 small parsnip, peeled and cut into ⅛-inch (3-mm) dice

½ apple, peeled and cut into ⅛-inch (3-mm) dice
1 tablespoon butter, at room temperature
3 to 4 sprigs thyme
2 tablespoons good-quality extra-virgin olive oil
4 to 5 sprigs dill

Make the soup. Heat the olive oil in a large pot over medium-high heat. When the oil is shimmering, add the cubed parsnips and apples, and season with 1 teaspoon salt.

Reduce the heat to medium and cover, occasionally stirring to make sure that the parsnips and apples don't burn, about 5 minutes.

Once the parsnips and apples are softened, add the chicken stock and 1½ cups (360 ml) of the apple cider and continue to cook until the parsnips and apples are tender, about 5 minutes. Add as much of the remaining apple cider as desired for taste.

Pour the mixture into a food processor and process on low speed, progressing to high, until the soup is smooth; add the butter, 1 table-spoon at a time, and season with additional salt and white pepper.

Strain the soup into a saucepan through a chinois and return it to medium-low heat. Reduce it to the desired consistency and keep it warm until you're ready to serve.

Make the garnish. In a small saucepan, sauté the diced parsnips and apples in the butter and thyme; allow them to brown slightly.

Just before serving, ladle the soup into bowls, sprinkle the sautéed parsnips and apple in the center, drizzle with a good, fruity olive oil, and top with a sprig of dill. The Hornigs' chef, Gabriel Kennedy, also likes to add some of the sautéed parsnips and apple to the bottom of the bowl too, for an added surprise, pouring the soup over it and then garnishing the top.

POTATO-CRUSTED HALIBUT
WITH SQUASH TWO WAYS AND ARUGULA PESTO

MAKES 8 SERVINGS

Although halibut is not local to the waters off Long Island, it is a popular, mild-flavored fish. Cod or haddock would be good substitutes here. You may consult Seafood Watch before choosing which halibut to buy or avoid (www.seafoodwatch.org).

FOR THE FISH:

2 large eggs

1 (10-ounce/280-g) bag kettle-cooked potato chips

2½ pounds (1.2 kg) halibut, cut into 8 equal portions

Salt and freshly ground black pepper

2 tablespoons olive oil

FOR SERVING:

Squash Puree (recipe follows)

Roasted Squash (recipe follows)

Arugula Pesto (recipe follows)

Chive Oil (recipe follows)

2 breakfast radishes, shaved, for garnish

Micro herbs, for garnish

Prepare the fish. Whisk the eggs in a small, shallow bowl, adding 2 tablespoons water to thin them out.

In a food processor, crush the potato chips into small flakes then pour them into another small, shallow bowl.

Dry the fish well, then dip it flesh side down into the egg wash and then into the potato chips, pressing to make sure the chips adhere. Set the fish aside, crust side down, and continue coating the remaining pieces. Season the skin side of the fish with salt and pepper.

In a large sauté pan over medium-high heat, add the olive oil and then place the fish crust side down. Cook the fish until the potato crust is a deep golden color, about 3 minutes. Flip the fish and cook for about 30 seconds longer. Remove the pan from the heat and let the fish rest in the pan for about 1 additional minute.

When you are ready to serve, make a thick swoosh of squash puree on the side of the plate. Toss the roasted squash with a little bit of the arugula pesto, lightly coating the squash, and then place a couple of wedges at the center of the plate. Place the fish on top of the roasted squash and pesto. Garnish with the shaved radish and micro herbs and top with the chive oil, drizzling a bit more on the side of the plate for dipping.

SQUASH PUREE MAKES 2 CUPS (480 ML)

Kabocha is a delicious Japanese winter squash that looks very similar to a small green-skinned pumpkin. Its flesh is a brilliant orange. Acorn or butternut squash could be substituted here, as could pumpkin or sweet potato.

3 tablespoons olive oil

2 kabocha squash, seeded, peeled, and cut into cubes (about 4 cups/600 g)

2 teaspoons sherry vinegar

Salt and ground black pepper

Heat 1 tablespoon of the olive oil in a medium-sized pan over medium-high heat and add the squash. Reduce the heat to medium and cover, occasionally stirring to make sure the squash doesn't burn, about 10 minutes.

When the squash is tender, place it in a food processor and puree it with the remaining 2 tablespoon olive oil.

Pass the puree into a bowl through a fine-mesh sieve, add the sherry vinegar, stir, and season to taste with salt and pepper.

ROASTED SQUASH MAKES 2 CUPS (480 ML)

2 kabocha squash, seeded and sliced into wedges

2 tablespoons olive oil

⅛ teaspoon salt

⅛ teaspoon ground black pepper

Preheat the oven to 375°F (190°C).

On a rimmed baking sheet, toss the squash with the olive oil, salt, and pepper.

Spread the squash into a single layer and roast until it is fork-tender and lightly browned, about 10 minutes.

ARUGULA PESTO MAKES 2 CUPS (480 ML)

3 tablespoons pine nuts

2 bunches arugula (about 4 cups/80 g leaves)

1 shallot, minced

1 cup (240 ml) olive oil

½ cup (60 g) freshly grated Parmesan cheese

2 teaspoons honey

2½ tablespoons freshly squeezed lemon juice

⅛ teaspoon salt

⅛ teaspoon ground black pepper

Preheat the oven to 400°F (205°C).

Spread the pine nuts on a baking sheet and toast them in the oven until lightly browned, about 5 minutes, tossing them halfway through. Set aside.

Place the arugula and shallot in a blender and add half of the olive oil. Once smooth, add the pine nuts and cheese. Finish by stirring the remaining oil and the honey into the mixture, then add the lemon juice, salt, and pepper.

Keep cold until ready to use.

CHIVE OIL SERVES 8 TO 10

This lemony delight is so easy to make most chefs feel it is hardly worth a mention. We all expect a wedge of lemon alongside our seafood, and this simple pairing with fresh chives elevates the lemon to an entirely new level while satisfying that citrus taste we crave with our fish. You can store it in the refrigerator for two to three days; there will be some solidification, so bring it to room temperature an hour or so before using and stir.

1 bunch fresh chives (about ¾ ounce/ 21 g), roughly chopped

½ cup (120 ml) olive oil

3 ice cubes

2 tablespoons freshly squeezed lemon juice

Combine the chives, olive oil, ice cubes, and lemon juice in a blender or food processor and blend until green and smooth. Strain if needed.

BURRATA WITH LEEKS, BACON, AND TOMATOES

MAKES 8 SERVINGS

Leeks pair fabulously with butter, cheese, and ham—so burrata, which means "buttered" in Italian, is the perfect cheese for this amazing appetizer. Bursting with flavor, this dish is best served with warm crusty bread, because your guests will want to soak up every bit.

FOR THE LEEKS:

3 to 4 slices bacon, finely diced

3 medium leeks, trimmed, cut in half, and sliced

⅛ teaspoon salt

2 tablespoons crème fraîche

FOR THE TOMATOES:

1½ cups (225 g) cherry tomatoes of mixed color, cut in half

2 tablespoons minced shallot

½ tablespoon sherry vinegar

1 tablespoon olive oil

1 teaspoon honey

⅛ teaspoon salt

⅛ teaspoon ground black pepper

FOR SERVING:

4 medium rounds burrata cheese

Micro greens

Good-quality extra-virgin olive oil

Good-quality balsamic vinegar

1 baguette, sliced and grilled

Make the leeks. In a small pan, sauté the bacon on medium-low heat until it is slightly browned. Add the sliced leeks and salt; stir and cover, reducing the heat to low. Continue cooking the leeks, stirring occasionally to make sure they don't burn, until they are tender, 20 to 30 minutes. Strain out any bacon fat, stir in the crème fraîche, and season, if necessary.

Make the tomatoes. While the leeks are cooking, place the cherry tomatoes in a medium-sized mixing bowl. Add the shallot, sherry vinegar, olive oil, honey, salt, and pepper. Toss well.

Assemble and serve. Slice each burrata in half to create half moon shapes. Divide the leeks and bacon among the plates, mounding the mixture in the center. Place a freshly cut burrata half on top of each serving, surround it with tomatoes, and gently sprinkle micro greens on top. Drizzle the top of the burrata with olive oil and balsamic vinegar. Serve immediately with warm grilled bread.

APPLE RASPBERRY GRANITA

MAKES 10 CUPS

The intoxicating aroma of fresh apples seems to be everywhere in the fall, and this refreshing dessert is the perfect way to finish a lovely autumn dinner. It can also serve as an amuse-bouche or palate cleanser during a sumptuous, multicourse dinner.

6 cups (1.4 L) fresh, local apple cider

2 cups (340 g) fresh raspberries

2 tablespoons honey

2 teaspoons sugar, plus more to taste

Combine the apple cider, raspberries, honey, and sugar in a food processor and blend until smooth. Pour the mixture into a bowl through a fine-mesh strainer, pressing with a wooden spoon to separate the puree from the raspberry seeds. Taste and add more sugar, if needed.

Pour the strained puree into a shallow glass baking dish or metal pan suitable for freezing. The puree should only be about ⅜ inch (1 cm) deep in the dish, so you will need more than one dish.

Place the dish, uncovered, in the freezer until the mixture barely begins to freeze around the edges, about 45 minutes (it will be slushy in the center). Using a fork, scrape the crystals from the edge of the granita mixture into the center. Mix thoroughly and continue freezing it. Repeat the scraping and stirring process once an hour until the granita is evenly frozen and icy, about 4 hours.

When you are ready to serve, scrape to fluff and lighten the ice crystals and spoon the granita into chilled glasses. Serve immediately.

Opposite, clockwise from top left: Parsnip Apple Soup (page 149), Apple Raspberry Granita, Truffled Popcorn (page 149), and Burrata with Leeks, Bacon, and Tomatoes.

FOUR

Perfect Celebrations

HOLIDAY FEASTS AND FÊTES

Father's Day with a Hungarian Accent

WITH NOREEN AND PETER THOMAS ROTH

In exploring the world's cultures, few means are as powerful and unfailingly unifying as food. The act of sharing a meal breaks down barriers, and the food itself—particularly when prepared with love—has a language of its own, one that resonates across nations and generations.

Hungarian-American skin-care guru Peter Thomas Roth has long embraced this concept. He and his wife, Noreen, expose their sons, Ryan and Brendan, to the Hungarian culture at every turn. Aside from making regular visits to Hungary, they also employ a Hungarian cook so the boys can practice the language and connect with their heritage through good home cooking.

"Food is an amazing tool for understanding a culture," Peter says. "When children have this understanding, they begin to have a global outlook and not be centered in their own world."

These cultural traditions are woven into the Roths' parties, as well. Rarely do guests visit without tasting *uborkasaláta* (chilled cucumber salad) or nibbling on *keksztekercs* (custard-filled pinwheels) or enjoying a meal served on Hungarian Herend china. "We are proud of our heritage," Peter says. "We make a big effort to keep it alive."

Father's Day brunch, typically a family gathering, is always a good excuse to stage a full-on Hungarian experience. When faced with this exciting prospect, such trivialities as having just moved into a new house are taken in stride.

For this Father's Day celebration, the Roths had settled into their Southampton home only three weeks prior and were still getting to know all the nooks and crannies. Unfazed, Noreen took to the challenge with characteristic aplomb. "We were still exploring all the different areas, so I thought it would be a great idea to decorate tables in various parts of the house," she says.

That gave her an opportunity to show off her own collection of beautiful objects, particularly the blue-and-white vessels she has collected over the years, and also to play with some of the items left behind by the previous owners. She set two tables, one in the dining room and one on the terrace, each with its own distinct look.

In the dining room, she mixed and matched blue-and-white china, pottery, and glassware from a variety of sources, from antique shops to eBay. An old water pitcher she's had "forever" became a vase for blue and white hydrangeas. Mismatched teacups filled with wildflowers from the garden and tied with place cards were positioned at each setting.

The table outside was more casual, set with Villeroy & Boch French Garden china, green glasses, and lace

Opposite, far left: Ryan and Brendan Roth;
center left: Cook Henrietta Laskai; above:
Brendan, Peter, Noreen, Ryan, and Carole Roth.

TIPS AND IDEAS
from Noreen Roth

I will often pick up things for parties
when I see them and not necessarily
need them. Sometimes the things I like
best are not for the table at all. I use
sunflower hair ties as napkin rings. They
always make me smile!

I like to buy one or two types of flowers
in abundance and then combine them
with flowers, greens, and branches
from my garden. I also have a fridge
in the basement, and when I am leav-
ing the house after the weekend and
the flowers look good, I will put the
arrangements in the fridge with fresh
water so we can use them again.

We are typically less formal in the
Hamptons, so I like to mix and match
when it comes to linens and tableware.
I often pick up some fun additions at
Pier 1. It is reasonably priced, so I do
not feel like I am making a huge com-
mitment. I also like the Hamptons insti-
tution Hildreth's. It has beautiful things
and a huge selection.

doilies atop place mats. "Lace is a very Hungarian touch," Noreen says.
"Even though it's traditional, it never looks old fashioned. We like a fresh
take on beautiful old things."

The food, of course, was the star of the show. The Roths' chef, Henrietta
"Heni" Laskai, prepared an all-Hungarian menu with traditional dishes such
as *Hortobágyi palacsinta* (a crepe filled with ground chicken with paprika
sauce and sour cream) and the aforementioned summer cucumber salad,
made the night before and left to marinate in the refrigerator. The starter
was a cold peach soup—a very intentional choice, according to Noreen.
"Hungarians are funny in that their appetizers are fruit soups served with a
scoop of ice cream," she explains. "And desserts aren't super sweet."

For this brunch, dessert consisted of the beloved pinwheel cookies,
as well as *fánk* (jelly doughnuts with raspberries, grapes, and mint), and
everyone's favorite, *szilvás gombóc* (potato dumplings filled with plums).

The gathering was a wonderful way to bring together the generations.
Some spoke Hungarian, some spoke English, but everyone bonded—over
good food, of course.

Menu
FATHER'S DAY BRUNCH FOR EIGHT

PTR's Peach Punch Cocktail

·

Endive Stuffed with Crab Salad, garnished
with Shredded Carrot and Chopped Chives
French Bread, Crudités

·

Cold Peach Soup (Hideg Barackleves)

Chicken Paprikás in a Crepe Pouch (Hortobágyi Palacsinta)
Noreen's Tomato Salad
Hungarian Cucumber Salad (Uborkasaláta)

·

Hungarian Jelly Doughnuts (Fánk)
Plum-Filled Potato Dumplings (Szilvás Gombóc)
Hungarian Pinwheel Cookies (Keksztekercs)

Prepared by Cook Henrietta Laskai

PTR'S PEACH PUNCH COCKTAIL

MAKES 1 COCKTAIL

This sweet-tart cocktail is the perfect way to welcome guests.

3 fresh raspberries
5 basil leaves
2 ounces (60 ml) Absolut Peach vodka

¼ ounce fresh apple juice
½ ounce fresh peach juice
½ ounce simple syrup

1½ tablespoons freshly squeezed lime juice
1½ tablespoons freshly squeezed lemon juice

Muddle the raspberries and 4 of the basil leaves in a rocks glass. In a shaker, place the vodka, apple juice, peach juice, simple syrup, lime juice, and lemon juice. Shake vigorously. Pour into the glass and top off with ice. Garnish with a basil leaf.

COLD PEACH SOUP (HIDEG BARACKLEVES)

MAKES 8 SERVINGS

Peaches are abundant in the Hamptons from August to mid-September, and this luscious fruit makes appearances in drinks, pies, and cakes and, of course, on its own, eaten out of hand. This recipe is easy and one you will want to add to your repertoire when peaches are plentiful and at their peak. While the French serve a sweet version of this soup as a dessert, the Hungarian version is typically presented as a cold appetizer.

6 very ripe, large peaches, peeled and pitted
1 teaspoon ground cinnamon
2 cinnamon sticks

6 tablespoons (75 g) sugar, more if peaches are not at their peak
10 to 12 cloves
2 tablespoons flour
3 tablespoons sour cream

½ cup (120 ml) heavy cream
¼ cup (60 ml) peach brandy (optional)
Whipped cream, for garnish
8 to 10 sprigs fresh mint, for garnish

Dice 4 of the peaches and place them in a medium saucepan over medium-high heat along with the cinnamon, cinnamon sticks, sugar, and 8 cups (2 L) water. Place the cloves in a cheesecloth bag for easy removal later; crush the cloves slightly to release their oils, and drop the bag in the soup. Bring the soup to a low boil and simmer for 10 to 15 minutes. Be sure not to overcook the peaches.

Remove the cinnamon sticks and cloves from the soup. In a blender, puree the flour, sour cream, heavy cream, and peach brandy (if using) with half of the soup. Add the puree back to the pot and cook for 2 to 3 minutes longer, until combined.

Transfer the soup to a container with a tight-fitting lid and refrigerate it for at least 1 hour. Slice the remaining 2 peaches into wedges.

When you're ready to serve, divide the soup among the bowls and garnish it with peach wedges, whipped cream, and mint. Serve cold.

CHICKEN PAPRIKÁS IN A CREPE POUCH (HORTOBÁGYI PALACSINTA)

MAKES 8 TO 10 SERVINGS

Hortobágyi palacsinta are savory, meat-filled crepes. The meat is prepared as a stew then strained, creating both a delicious filling for the crepe and a beautiful, flavorful sauce. Noreen discovered this dish in the town of Hortobágyi, where, according to local lore, the recipe originated. You can substitute veal or pork for the chicken.

1 tablespoon olive oil
1 medium onion, finely chopped
2 pounds (910 g) ground chicken
1½ tablespoons salt
1 tablespoon freshly ground black pepper

1 to 2 tablespoons Hungarian paprika
4 cups (960 ml) chicken broth
5 to 7 tablespoons (75 to 105 ml) sour cream
5 to 7 tablespoons (37 to 45 g) flour
1 tablespoon chopped fresh flat-leaf parsley

8 to 10 Crepes (*palacsinta*; recipe follows)
2 or 3 leaves from a leek, green part only

FOR GARNISH:
2 tablespoons sour cream
2 to 3 tablespoons whole milk

Heat the olive oil in a large saucepan over medium heat. Add the onion and sauté until soft and translucent, about 5 minutes. Increase the heat to medium-high and add the ground chicken. As the chicken cooks, use a wooden spoon to break the meat into very small clumps; cook until it is no longer pink, about 5 minutes.

Add the salt, pepper, and 1 tablespoon of the Hungarian paprika and mix well. Add more paprika if needed; the mixture should take on a nice red color. Add the chicken broth and bring to a simmer. Stir occasionally and simmer, partially covered, until the liquid is reduced by a third, about 30 minutes.

In a small bowl, stir together 5 tablespoons each of the sour cream and the flour; add some broth from the stew to mix it more evenly. Slowly pour the mixture back into the stew, stirring constantly so it doesn't get lumpy. Continue to cook the stew until it boils.

Using a strainer, drain the sauce from the meat and reserve both. Mix the chopped parsley into the meat and set it aside, keeping it warm.

The sauce should have a creamy texture; if it is not thick enough, whisk in more sour cream and flour. Keep it warm until you are ready to assemble the crepes.

Make the crepes as directed. Blanch the leek greens and slice them into 8 to 10 long strands. Make the garnish. In a squeeze bottle, combine the sour cream and 2 tablespoons of the milk. The mixture should be thin; add the remaining tablespoon of milk, if needed.

To assemble the dish, place about ½ cup (64 g) chicken at the center of a crepe. Pull the sides up and gather them together, creating a pouch. Tie it closed with one strand of leek. Keep the assembled pouches warm while you finish the remainder.

When you are ready to serve, pour a ladleful of sauce into a rimmed plate. Using the squeeze bottle prepared earlier, swirl some of the sour cream and milk mixture into the sauce in a decorative pattern. Place a crepe pouch in the center of the plate. Serve hot.

CREPES (PALACSINTA) MAKES 8 TO 10 CREPES

3 large eggs
1½ cups (360 ml) whole milk

1 cup (240 ml) sparkling mineral water (such as San Pellegrino)

2 cups (255 g) flour
Grapeseed or vegetable oil

In a medium-sized mixing bowl, combine the eggs, milk, sparkling water, and flour. Mix until smooth.

Heat a crepe pan or a nonstick frying pan on high heat. Lower the heat to medium-high and lightly brush the pan with oil. Pour one ladle of batter into the pan, about ⅓ cup (75 ml). Pick up the pan and tilt it in a circle so the batter covers the bottom of the pan. Cook until the edges of the crepe start to lift from the pan. Use a spatula to lift

the crepe and flip it over in the pan. Cook about 30 seconds; crepes should be soft and have a light golden color. Transfer the crepe to a warm plate.

Repeat with the remaining batter. If the batter starts to thicken, you can add a few drops of mineral water; add more oil to the pan as needed. Keep the crepes warm until you are ready to serve them.

Opposite, top: Chicken Paprikás in a Crepe Pouch with Noreen's Tomato Salad and Hungarian Cucumber Salad (both, page 165); bottom: Cold Peach Soup (page 161).

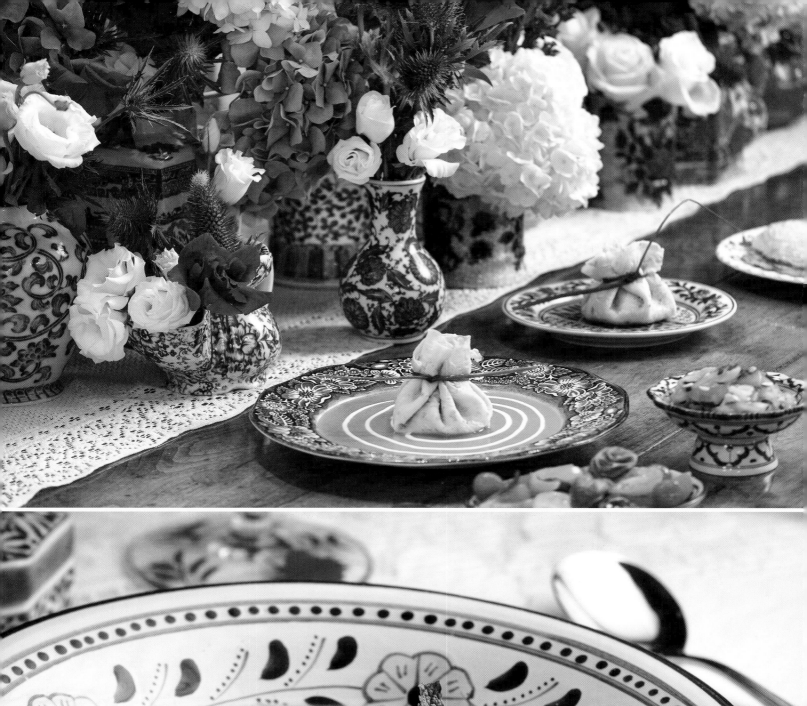

HUNGARIAN CUCUMBER SALAD (UBORKASALÁTA)

MAKES 8 SERVINGS

This salad traditionally accompanies heavy meat courses and is enjoyed as a side dish to balance the flavors and textures of a Hungarian meal. There are variations of this salad that include minced raw garlic, a little sugar to balance the vinegar, and the most popular: a dollop of sour cream over the top. You can experiment a bit as long as you slice the cucumbers thinly and salt them generously—a must!

4 medium English (seedless) cucumbers, very thinly sliced

2 tablespoons salt
2½ tablespoons white vinegar

1 teaspoon Hungarian paprika

Gently toss the cucumber with the salt until the slices are evenly coated and very salty. Put them in a container with a tight-fitting lid and refrigerate for at least 1 hour to draw out the water. Strain out almost all the liquid from the cucumbers.

Toss the cucumbers with the vinegar, adding ½ tablespoon at a time.

Mix well and refrigerate for at least 1 hour (you can also prepare this the night before and allow it to marinate overnight).

When you are ready to serve, sprinkle the salad with Hungarian paprika. Serve chilled.

NOREEN'S TOMATO SALAD

MAKES 6 TO 8 SERVINGS

Inspired by the Hungarian cucumber salad and the Greenwich Village restaurant Il Mulino's bruschetta, Noreen created this fast and easy salad to serve as an additional side for their Hungarian meals and, she says, "for the family to snack on anytime during the summer, when tomatoes are fabulous."

5 vine-ripe tomatoes (about 1 pound/455 g, in a variety of colors and sizes), sliced into bite-size pieces

½ cup (20 g) fresh basil, chopped, plus more for garnish
¼ teaspoon sea salt

¼ teaspoon onion powder
2 tablespoons olive oil
2 tablespoons balsamic vinegar

Toss the tomatoes, chopped basil, salt, onion powder, oil, and vinegar together to evenly coat the tomatoes.

Garnish with fresh basil. Serve at room temperature.

HUNGARIAN JELLY DOUGHNUTS (FÁNK)

MAKES ABOUT 15 DOUGHNUTS

Summer in the Hamptons means lots of carnivals where the fried dough treats called *zeppole* are a well-known favorite. These Hungarian doughnuts, also called carnival doughnuts, bear a striking resemblance to their Italian cousin, and like the zeppole should be enjoyed hot, just out of the fryer. The Roths serve theirs with fresh fruit to complement the jam and recommend raspberries, champagne grapes, and mint. Do not substitute butter for the margarine called for in the recipe; you will be disappointed in the result.

1 package (2¼ teaspoons/7 g) dry yeast
1 cup (240 ml) milk, warmed
2 egg yolks

½ cup (1 stick/115 g) margarine, at room temperature
3 tablespoons sugar
2 cups (255 g) flour, sifted

Vegetable oil
½ cup (120 ml) raspberry jam (or other sweet jam)
¼ cup (25 g) confectioners' sugar

In a large mixing bowl, dissolve the yeast in the warm milk. Mix in the egg yolks, margarine, and sugar. Slowly add the sifted flour and mix the dough with a wooden spoon. Put a towel over the bowl and let it stand in a warm place for about 1 hour, allowing the dough to rise and double in size.

Place the dough on a floured surface and pat it with your hands until it is ½ inch (12 mm) thick. Cut out even circles using a floured 4-inch (10-cm) biscuit cutter (a teacup works well too).

In a deep pan, pour oil to a depth of about ¾ inch (2 cm) and heat it to 350°F (175°C). As you place the doughnuts in the oil, slightly press down on the centers to create an indentation. Fry several doughnuts at a time, turning them as they rise to the surface, until they are golden brown, 2 to 3 minutes. Remove them from the oil with a slotted spoon and place them on paper towels to drain.

Spoon jam into the center indentation, sprinkle the tops with confectioners' sugar, and serve the doughnuts freshly made and still warm.

PLUM-FILLED POTATO DUMPLINGS (SZILVÁS GOMBÓC)

MAKES 10 DUMPLINGS

Potato dumplings stuffed with sweet plums and rolled in toasted bread crumbs are a traditional Eastern European preparation that is served as both a main course and a savory dessert. These dumplings are best made with the small, dark plums known as Italian prune plums, and served warm, sprinkled with cinnamon and sugar. For an American twist, try them alongside a scoop of homemade vanilla bean gelato (see page 80).

10 ripe Italian prune plums
10 cubes brown sugar
2 teaspoons ground cinnamon
2 tablespoons salt

5 medium-size russet potatoes (about 1¼ pounds/570 g)
1½ cups (170 g) dry, unseasoned bread crumbs

4 tablespoons (55 g) butter
¼ cup (25 g) confectioners' sugar
2 egg yolks
1 cup (125 g) flour

Cut the plums down the middle but do not cut them all the way through. Remove the pits and place a sugar cube in the center of each plum where the pit was. Sprinkle 1 teaspoon of the cinnamon over the plums and set them aside.

Fill a pot with water, add 1 tablespoon of the salt, and boil the potatoes with the skins on. When they are cooked through, drain them and wait until they are cool enough to handle. Peel them and push them through a ricer (if you don't have a ricer, use a potato masher, then push them through a strainer). Set them aside to cool completely.

In a medium-sized frying pan, mix the bread crumbs with the butter and cook on low-medium heat until the crumbs are golden brown, about 3 minutes. Stir constantly to prevent burning. Set them aside to cool, then stir in 2 tablespoons of the confectioners' sugar and the remaining 1 teaspoon cinnamon.

When the potatoes are cooled, add the egg yolks and flour and knead to form a dough. It will be sticky, so sprinkle generous amounts of flour on your work surface, then roll the dough to about a ¼-inch (6-mm) thickness. Cut dough into squares big enough to wrap around the plums. Set a plum in the middle of each square and wrap the dough around it, covering it completely.

In a large pot, bring water to a boil with the remaining 1 tablespoon salt. Add the filled dumplings. When they rise to the top, let them cook 2 minutes longer. Remove the dumplings with a slotted spoon and roll them in the bread crumb mixture.

Arrange the dumplings on a serving platter and sprinkle them with the remaining bread crumb mixture. Then, using a sifter or fine sieve, sprinkle the remaining 2 tablespoons confectioners' sugar over the top. Serve hot.

HUNGARIAN PINWHEEL COOKIES (KEKSZTEKERCS)

MAKES 35 TO 40 COOKIES

When the Roth family travels to Hungary, the boys, Ryan and Brendan, visit Heni's mom, and look forward to her Hungarian cookies. Typically these cookies are made with a cracker produced only in Hungary and difficult to find in the States. Heni discovered that animal crackers are the perfect substitute, and now the boys can enjoy their favorite treat at home too. Because they're not baked, these are a great cookie for warm summer days, when you don't want to turn on the oven.

6 cups ground animal crackers (about 18 ounces/510 g)
3 tablespoons cocoa powder

1½ cups (360 ml) milk
1 cup (2 sticks/225 g) unsalted butter, at room temperature

3 tablespoons confectioners' sugar
¾ cup (65 g) sweetened shredded coconut

Mix the ground animal crackers and cocoa in a bowl. Add the milk slowly, combining it until you have a moist, doughy consistency. Shape the dough into a disk about 4 inches (10 cm) thick, wrap it in plastic, and chill it for at least 30 minutes.

In a separate bowl, whisk together the butter and confectioners' sugar, creating a soft and creamy texture.

Sprinkle a generous amount of coconut on your work surface; this will prevent the dough from sticking and coat it evenly throughout. When the dough is chilled, remove it from the plastic, cut it in half,

and roll out the first half on top of the coconut, creating a rectangle ⅛ inch (3 mm) thick. With a spatula, spread half of the butter mixture over the dough. Then, starting at the long end, roll the dough into a log. Roll the log in coconut and wrap it in plastic.

Repeat with the remaining coconut, dough, and butter. Refrigerate the logs for at least 1 hour (the dough will keep, wrapped, for about 1 week in the refrigerator).

To serve, slice the logs into cookies ¼ inch (6 mm) thick. Serve immediately.

Fourth of July on the Green

WITH JOCELYN AND MICHAEL PASCUCCI

Before establishing the Chase School, later Parsons The New School for Design, American impressionist William Merritt Chase captured on his canvases the very sunsets that now preside over Sebonack Golf Club in Southampton each evening.

"The sunlight is unique for artists to paint," says Michael Pascucci, a consummate entrepreneur, the club's owner, and one of ten founding members. "And every night, it draws people out of the clubhouse and onto the deck. It's a great place to entertain."

Particularly on the Fourth of July, when a spectacular display of fireworks and festively laid tables set the tone for summer fun. As the sun dipped toward the horizon, Sebonack's executive chef Anthony Giacoponello and his team presented a meal featuring Michael and Jo Pascucci's own recipes, a combination of healthful selections from the sea as well as some delectable family favorites.

"Jo got a lot of recipes from my father, who was a great cook," says Michael, noting that his family crest from Sturno, Italy, decorates the fireplace mantel in the club's private dining room. "Dad's mother from Italy was beyond. There is such a thing as being too good a cook. The fork would go in your mouth automatically, you couldn't stop it; you had to fight the fork."

Celebrating America's Independence Day as well as their Italian heritage, generations of Pascuccis gathered around the table to break bread together—quite literally.

"There's always plenty of room for the bread on the table," says Michael, a father of four with eleven grandchildren. "Italians don't think they've eaten until they've had bread."

Enhancing the festivities was one of the best views in Southampton: the sprawling fairways of the celebrated golf course. On 300 acres with views of Long Island's Great Peconic Bay and Cold Spring Pond, Sebonack's undulating greens and expansive bunkers seem to have been carved over centuries by Mother Nature herself. The design of the course, a collaboration between Jack Nicklaus (the Pascuccis' neighbor in Florida) and Tom Doak, placed a top-rated eighteen-hole course within the original contours of the land's windswept dunes.

As an homage to the property's previous owner, banker Charles H. Sabin, an original pair of shutters from the Sabin estate is hung in the clubhouse foyer. They were the inspiration for the Sebonack logo, which features two crescent moons to form the letter *S*.

Sebonack debuted as one of *Golf Digest*'s Top 100 Courses in 2006 and went on to host the sixty-eighth U.S. Women's Open in 2013.

But for Michael and Jo Pascucci, Sebonack is a retreat from the glitz and glamour of the Hamptons, built solely for the love of the game. Whether they are at home in Locust Valley or in one of Sebonack's 3,000-square-foot guest cottages, time spent together here is priceless.

Opposite page, bottom right: Teb, Dawn, and
Lily Barnard. This page: Lisa, Alana, Michael,
Morgan, Maclain, and Ralph Pascucci.

from Jo Pascucci

While the Pascucci family prefers round
tables for ease of conversation, often
the club will set an extended royal
table for large groups. To preserve
intimacy, consider serving your dinner
family style, with platters at the center
that guests may pass to share.

Many of Sebonack's members own
wineries, and several of their special
vintages were served with the meal fea-
tured here. To showcase them properly,
they were set in a rustic wine caddy
amidst the table's centerpieces.

Menu
SIT-DOWN DINNER FOR EIGHT TO TEN

Amisfield Pinot Noir,
Episode Cabernet Sauvignon Blend,
and Portea Chenin Blanc

·

Watermelon Gazpacho
Sliced Heirloom Tomato and Mozzarella Salad
Gemelli à la Creole
Steamed Long Island Lobsters

·

Jo's Carrot Cake with Cream Cheese Frosting
The Pascuccis' Classic Cheesecake

Prepared by
Executive Chef Anthony Giacoponello

WATERMELON GAZPACHO

MAKES 8 TO 10 SERVINGS

This no-cook recipe is perfect for summertime meals, and your guests will appreciate the slightly spicy, refreshingly cool flavors. Showcase the soup's rich red color by serving it in a white bowl. Scattering micro greens over the gazpacho adds flavor and color, but feel free to experiment with the garnish to suit your style and taste. A simple strategy would be to set aside some of the diced watermelon and diced cucumber to finish off the soup or to reserve the cucumber peel, chop it finely, and sprinkle it over the soup before serving. This recipe yields a generous amount of soup and will allow for second helpings.

1 (3½-pound/1.6 kg) seedless watermelon, diced (about 8 cups)

4 English (seedless) cucumbers, peeled and roughly chopped (about 8 cups)

½ bunch cilantro

2 teaspoons Tabasco sauce

2 red bell peppers, diced

3 cups (555 g) roughly chopped tomatoes

2 tablespoons raspberry vinegar

1 teaspoon sea salt

¼ teaspoon ground black pepper

Micro greens, for garnish

Combine the watermelon, cucumbers, cilantro, Tabasco, bell peppers, tomatoes, vinegar, salt, and pepper in a large bowl. Working in batches, puree three-quarters of the ingredients in a blender and pulse the remaining one-quarter ingredients until well combined, but still slightly chunky. Transfer the gazpacho to a large bowl, cover it, and refrigerate until it is cold, at least 1 hour and up to 4 hours.

When you are ready to serve, stir the gazpacho and ladle it into bowls; top with micro greens or your favorite garnish.

GEMELLI À LA CREOLE

MAKES 15 SERVINGS

Created by Jo Pascucci and Executive Chef Anthony Giacoponello, this unique recipe blends the traditional cooking styles and flavors of Italy with those of New Orleans. The result is a slightly spicy dish, fully matured in flavor. You will have enough sauce so guests can enjoy seconds, and if you are lucky, you will have some left over. Yes, this is one of those sauces that tastes even better the next day! Gemelli is made by twisting two strands of pasta into a spiral (its name comes from the Italian word for twins), but any ridged pasta shape can be used.

2 tablespoons olive oil

2½ pounds (1.2 kg) sweet Italian sausage meat

2½ pounds (1.2 kg) hot Italian sausage meat

3 cups (504 g) medium-diced prosciutto

3 medium onions, diced

1 pound (448 kg) whole button mushrooms

1 (750-ml) bottle cream sherry

1 (28-ounce/794-g) can whole Italian peeled tomatoes, strained

1 quart (960 ml) heavy cream

Salt and ground black pepper

2 (16-ounce/455-g) boxes gemelli pasta

1 bunch fresh basil, for garnish

Heat the oil in a large stockpot over medium-high heat. Remove the sausage meat from its casings, if necessary, and add the meat to the pan. Stir and break up the meat as it cooks, until it is golden brown, about 8 minutes. Pour the meat into a strainer and let most of the grease drain out. Meanwhile, add the prosciutto to the hot pot and start to render the fat. When the prosciutto begins to brown, add the onions and cook until tender and translucent. Immediately add the mushrooms. At first, they will express liquid; continue to cook them until the liquid is evaporated and the mushrooms are tender and golden. Deglaze the pot with the whole bottle of sherry, then add the strained sausage to the pot. Simmer to reduce the alcohol, about 8 minutes. Add the tomatoes and continue to simmer for 10 minutes.

Add the cream, stir, and taste for seasoning; add salt and pepper as needed and simmer for an additional 20 minutes.

Just before the sauce finishes, bring a large pot of salted water to a boil over high heat. Add the pasta and cook until al dente, following the package instructions.

When you are ready to serve, ladle some sauce into a medium bowl and add the cooked gemelli. Toss to coat the pasta and transfer the mixture to a decorative serving platter. Top it with two or three large ladlefuls of sauce, garnish with fresh basil, and serve immediately. Serve the additional sauce in a separate bowl so guests can add as much as they like.

JO'S CARROT CAKE WITH CREAM CHEESE FROSTING

MAKES 1 LAYER CAKE TO SERVE 12 TO 16

This family favorite is occasionally served at the club, where Chef Giacoponello likes to create individual mini cakes (see Note). The Pascuccis like walnuts, but you can use your favorite nut or a combination. Be sure to chop them so they are slightly bigger than the raisins (which will plump during cooking) to assure a prettier presentation and balanced flavors with every bite.

FOR THE CAKE:
2 cups (255 g) flour
1 teaspoon baking soda
1 teaspoon baking powder
1 teaspoon ground cinnamon
¼ teaspoon salt
4 large eggs

2 cups (400 g) granulated sugar
1½ cups (360 ml) grapeseed oil
2 cups (180 g) grated carrots
1 cup (170 g) raisins
1 cup (115 g) chopped walnuts
FOR THE FROSTING:
½ cup (1 stick/115 g) butter, at room temperature

1 (8-ounce/225-g) package cream cheese, at room temperature
1 (16-ounce/455-g) package confectioners' sugar, sifted
1 teaspoon vanilla extract
½ cup (45 g) grated carrots, for garnish
½ cup (55 g) candied walnuts, for garnish

Preheat the oven to 350°F (175°C). Line the bottoms of two 9-inch (23-cm) round cake pans with parchment; lightly grease and flour the parchment.

Sift the flour, baking soda, and baking powder into a large mixing bowl. Add the cinnamon and salt and whisk together.

In a separate bowl, with a hand mixer, beat the eggs until frothy. Add

the sugar gradually and continue to beat until the mixture thickens and takes on a pale yellow color. Add the oil and beat until combined. Then gradually add the flour mixture, beating until combined. Fold the carrots, raisins, and walnuts into the batter.

Evenly divide the batter between the two prepared pans. Bake until a toothpick inserted into the center comes out clean and the cake begins to pull away slightly from the sides of the pan, 30 to 35 minutes. Let the cakes cool for about 10 minutes, remove them from the pan, peel off the parchment, and place them on a cooling rack.

To make the frosting, combine the butter, cream cheese, confectioners' sugar, and vanilla in a food processor or stand mixer until well blended and creamy.

To assemble the cake, place one layer on a serving dish or cake plate. Spread half of the frosting over the top surface of the cake. Stack the second layer on top and spread the remaining frosting on top. Decorate with the grated carrot and candied walnuts.

Note: If you'd like to create individual cakes as shown here, double the recipe for the cake and frosting. When the cakes are cooled, using a 3¾-inch (9.5-cm) round cookie cutter, cut each cake into round disks to yield approximately 5 pieces per pan. Frost, layer, and decorate as you would the larger cake. You should have 10 mini cakes and some cake pieces leftover; the pieces can be crumbled over the tops of your individual cakes along with the grated carrot and candied walnuts.

Opposite: Watermelon Gazpacho; Gemelli à la Creole (both, page 175).

THE PASCUCCIS' CLASSIC CHEESECAKE

MAKES 1 CHEESECAKE TO SERVE 12 TO 16

This is another family favorite that the Sebonack Club serves to members on occasion. The original recipe included crushed zwei-back toast, but any digestive biscuit will work just as well. Garnish the cheesecake with fresh, seasonal fruit and homemade whipped cream for maximum flavor and a beautiful presentation.

FOR THE CRUST:

8 ounces (225 g) digestive biscuits, finely crushed

6 tablespoons (85 g) melted butter

3 tablespoons sugar

1½ teaspoons ground cinnamon

FOR THE FILLING:

2 (8-ounce/225-g) packages cream cheese

1½ pints (720 ml) sour cream

6 large eggs, separated, at room temperature

3 tablespoons flour

1½ cups (300 g) suaar

Pinch of salt

1 tablespoon freshly squeezed lemon juice

Whipped cream, for garnish

8 ounces (225 g) fresh strawberries, cut in half, for garnish

6 ounces (170 g) fresh raspberries, for garnish

Preheat the oven to 300°F (150°C). Butter the sides and bottom of a 9-inch (23-cm) springform pan and line it on the outside with a single piece of foil, covering the bottom and about halfway up the sides. Set a kettle of water on the stove to boil.

To make the crust, in a medium mixing bowl, combine the crushed biscuits, butter, sugar, and cinnamon, and stir until the crumbs are moistened. Press the crumbs evenly over the bottom and about 1 inch (2.5 cm) up the sides of the prepared pan. Place the pan inside a deep baking dish and set it aside.

Make the filling. In the bowl of a stand mixer fitted with the paddle attachment, combine the cream cheese and sour cream on low speed, and beat until they are blended well and smooth. Beat in the egg yolks, adding them one at a time.

In a separate bowl, combine the flour, sugar, and salt, then add this to the cream cheese mixture and beat until combined.

In a separate bowl, with a handheld mixer, whip the egg whites until they form stiff peaks. Then fold the egg whites into the cheese mixture; add the lemon juice and fold to combine.

Pour the filling into the springform pan; the mixture will cover the crust completely. Pour boiling water into the baking dish so that it is about 2 inches (5 cm) deep. Bake the cheesecake, in its water bath, for 1 hour. Turn off the oven and let the cheesecake stand for about 1 hour. This will allow it to finish baking and to cool gradually, reducing the chance of cracking.

Remove the cheesecake from the oven and from the baking dish of water, loosely cover the cake, and allow it to cool to room temperature.

Once cooled, place the cake in the refrigerator for at least 8 hours or overnight. Remove the cake from the refrigerator, remove the foil from the sides of the pan, and run a paring knife between the edge of the cake and the pan. Release the springform latch to gently open the pan and lift it off the cake.

Just before serving, garnish the cake with whipped cream, strawberries, and raspberries.

Family Fun-Day Birthday Celebration

WITH CARRON SHERRY AND RICH HOGAN

On a crisp, sunny afternoon, Rich Hogan has just taken *Lucky*, his gleaming Hood sailboat, out on the Peconic Bay for a romp. His three daughters and their mother, Carron Sherry, trail down the dock for a peek into the oyster cages, the bounty of which will soon be served up for lunch, accompanied by a few of Carron's favorite homemade mignonette sauces.

On a bluff overlooking Wards Point, one of Shelter Island's southern peninsulas, the historic home this family shares in the summertime has unobstructed 270-degree views of Peconic Bay and Shelter Island Sound. Bike paths weave through the storied grounds on this island between the North and South Forks at the tip of Long Island, where cousins will soon join in celebration of little Eloise's seventh birthday.

Back in the kitchen, Carron joins her sister, Maureen Sherry Klinsky, and friend Tracy Marshall to prepare a buffet of family-friendly salads, roasted corn on the cob, chicken tenders, and watermelon punch for lunch on the back porch overlooking the bay. Colorful polka-dot balloons, fresh popcorn in hot pink paper cups, and mason jar drinking glasses add a sense of whimsy to the table setting. "I use great local ingredients and set everything on beautiful platters so guests can serve themselves," says Carron. "Eating outdoors, whether it's a daytime or evening event, is also key, because of the sprawling property and long views."

There are no cell phones, no media rooms, no televisions on—simply family coming together to share a beautiful day in the sun. "Our summer life on Ward's Point is all about enjoying the property, its rich history, and what we have created," says Carron. "A typical day includes rock climbing on the water tower, which was built in the 1800s, sailing from the dock on *Lucky*, and singing songs around the bonfire at night."

Entertaining friends often becomes a daylong affair, given how much there is to do. "It is not uncommon that someone arrives by boat for a climb in the morning and is still there for the bonfire making s'mores at sunset."

Built in 1873, the home was originally owned by advertising executive and philanthropist Artemas Ward, the great-grandson of Major General Artemas Ward, who served with George Washington and was a delegate to the Continental Congress. Since subdivided, the property once encompassed 220 acres of farmland, on which Ward raised pigs and pheasants and ran a dairy. Many historic details have been preserved, such as the central banister and original farm sink in the guesthouse kitchen.

"Having many friends and family in the Hamptons and being fortunate to have a destination-type property means we entertain all the time," says Carron. "It's all about enjoying long summer days outside and eating local produce. Given the number of farms, wineries, and fisheries in the area, we entertain accordingly."

Opposite: Rich Hogan and Carron Sherry.
This page: Maureen Sherry Klinsky and
Carron Sherry.

TIPS AND IDEAS
from Carron Sherry

"Rosé wine is a must for a summer
lunch," says Carron. "We love the Do-
maine de l'Abbaye Clos Beylesse from
Provence. It is light, goes with anything,
and the bottle is so gorgeous it adds a
subtle yet beautiful accent to the table."

"Tomatoes are so plentiful in the sum-
mertime in the Hamptons. Finding a
flavorful, colorful variety is simple, and
we especially love Sang Lee Farms. Be-
ing on the farms inspires us to make our
Heirloom Tomato Salad."

Menu
BUFFET BIRTHDAY PARTY FOR EIGHT TO TEN

Wine: Rosé, Domaine de l'Abbaye Clos Beylesse
Watermelon Lemonade

·

Oysters on the Half Shell with Champagne
and Apple Cider Mignonette Sauces
Heirloom Tomato Salad
Shrimp Salad with Fresh Zucchini Blossoms and Zesty Vinaigrette
Roasted Corn on the Cob with Parmesan Butter
Panko-Parmesan Chicken Tenders with Two Dipping Sauces

·

Fresh Fruit and Crudités
Air-Popped Organic Popcorn
Homemade Birthday Cake

WATERMELON LEMONADE

MAKES 25 TO 30 SERVINGS

This deliciously fresh and tangy lemonade is truly a crowd-pleaser. You can adjust the level of sweetness by experimenting with the amount of simple syrup you add. The sweeter the fruit, the less syrup needed. For the cocktail hour, you might add one more ingredient for the adults—vodka. "I make this mostly for the kids," says Carron. "And my children don't like bubbly water, so I add more spring water and less bubbly."

½ cup (100 g) cane sugar

1 (4 ½-pound/2-kg) seedless watermelon, cut into cubes (8 cups)

Juice of 12 lemons

½ cup (120 ml) freshly squeezed orange juice

1 liter sparkling mineral water (such as San Pellegrino)

1 lime, sliced into thin rounds (optional)

6 to 8 large strawberries, hulled and cut in half (optional)

Crushed ice or cubes

1 bunch fresh mint sprigs

Make a simple syrup by combining the sugar and ½ cup (120 ml) water in a medium saucepan over medium-high heat, stirring until the sugar dissolves. Let the syrup cool.

Meanwhile, puree the watermelon, lemon juice, and orange juice in a food processor or blender until smooth, working in batches, if necessary. Transfer the mixture to a large drink dispenser. Add the

sparkling water and 1½ cups (360 ml) water, then add enough of the simple syrup to reach your preferred sweetness. Stir well and refrigerate until cold, about 2 hours.

If you are setting your dispenser out on the buffet, put in the lime slices and strawberries (if using) for added color just before serving. Fill tall glasses with ice and mint sprigs to set alongside your dispenser and invite guests to pour the lemonade over the ice.

OYSTERS ON THE HALF SHELL
WITH CHAMPAGNE AND APPLE CIDER MIGNONETTE SAUCES

MAKES 12 OYSTERS

The classic piquant mignonette sauce, made with vinegar and shallots, is sprinkled on top of oysters to balance the briny, somewhat creamy bivalve. How delightful to offer your guests a pair of delicious variations. You can make the mignonette sauces up to 4 hours ahead of time, which allows the flavors to blend and the shallots to mellow. "We have our own oysters just off our dock," says Carron. "The fresher the better, so we always wait until the morning to harvest for lunch or dinner. They are best served over crushed ice." Each recipe makes about ¼ cup of sauce, easily enough for a half-dozen oysters.

FOR THE CHAMPAGNE MIGNONETTE SAUCE:

1 tablespoon minced shallot

¼ cup (60 ml) Champagne or red wine vinegar

½ teaspoon coarsely ground black pepper

⅛ teaspoon sugar

2 teaspoons finely chopped fresh flat-leaf parsley

FOR THE APPLE CIDER MIGNONETTE SAUCE:

2 tablespoons minced shallot

¼ cup (60 ml) farm-fresh apple juice

1 tablespoon apple cider vinegar

1½ teaspoons freshly squeezed lemon juice

Salt and freshly ground black pepper

1 dozen oysters

To make the Champagne mignonette sauce, place the minced shallot and any liquid released in a glass bowl. Add the vinegar, pepper, and sugar. Stir and chill in the refrigerator until ready to serve. Stir in the parsley just before serving.

To make the apple mignonette sauce, place the minced shallot and any liquid released in a glass bowl. Stir in the apple juice, vinegar, and lemon juice. Season with salt and pepper to taste. Chill in the refrigerator until ready to serve.

To serve, shuck a dozen oysters, making sure each oyster is loose in the shell. Pour crushed ice onto a serving platter and place the shucked oysters on the ice, leaving space for the dipping sauces.

Place the sauces in small glass bowls or in the top half of an oyster shell and set them alongside the oysters on the platter. Serve with small spoons so guests can sprinkle their choice of mignonette onto the oyster before eating it.

HEIRLOOM TOMATO SALAD

MAKES 8 TO 10 SERVINGS

Simple, colorful, and delicious, this tomato salad is inspired by the bounty of heirloom varieties available during summer. After slicing, Carron likes to soak the red onion in ice water for 15 minutes to soften its bite, letting the flavor of the tomatoes take center stage.

6 large heirloom tomatoes, assorted variet-
ies and colors, cut into wedges

¼ red onion, thinly sliced
¼ cup (60 ml) extra-virgin olive oil

Fleur de sel salt
Leaves of ½ bunch fresh basil, chopped

SHRIMP SALAD WITH FRESH ZUCCHINI BLOSSOMS
AND ZESTY VINAIGRETTE

MAKES 10 SERVINGS

Zesty lemon juice vinaigrette and apples are the key ingredients in this light and refreshing salad, with no heavy mayonnaise to weigh it down. Carron likes to add zucchini blossoms fresh from the garden for a pop of color and texture, creating a beautiful presentation. Cooking the shrimp in chicken broth gives them a tender, deliciously surprising flavor—you may want to adopt the method for other shrimp salad recipes as well.

6 cups (1.4 L) chicken broth
½ lemon
2 pounds (910 g) fresh jumbo (16/24)
shrimp

3 Granny Smith apples, cored and diced
into bite-size cubes
1 red bell pepper, cored, seeded, and
diced into small cubes

1 large head iceberg lettuce, shredded
Zesty Vinaigrette (recipe follows)
8 to 10 zucchini blossoms or 2 ounces
(55 g) edible flowers (optional)

Bring the chicken broth to a boil in a large pot. Squeeze the juice from the lemon half into the broth and toss the rind in for extra flavor. Reduce the heat to medium-low and add the shrimp. Simmer, uncovered, until the shrimp are bright pink and firm, about 5 minutes. Using a slotted spoon, remove them from the poaching liquid and chill them thoroughly before peeling; devein them and remove the tails as well.

When the shrimp are completely chilled, toss them with the apples, bell pepper, and lettuce. Just before serving, toss again with the dressing. Transfer the salad to a decorative serving bowl and arrange zucchini blossoms on top.

ZESTY VINAIGRETTE MAKES 1 ½ CUPS (360 ML)

"I like to shake up all the ingredients in a mason jar and season as I go, adjusting for taste," says Carron. "Then you can leave extra dressing in the jar and set it on the buffet."

2 tablespoons freshly grated lemon zest
¼ cup (60 ml) freshly squeezed lemon juice
1 cup (240 ml) olive oil

¼ cup (60 ml) Champagne vinegar
¼ teaspoon salt
¼ teaspoon freshly ground black pepper

1 tablespoon fresh thyme
1 shallot, minced

Combine the lemon zest, lemon juice, olive oil, vinegar, salt, pepper, thyme, and shallot in a medium bowl or mason jar. Whisk or shake until the mixture is combined. Chill the dressing until you are ready to assemble the salad.

Opposite, top left: Watermelon Lemonade
(page 185).

ROASTED CORN ON THE COB WITH PARMESAN BUTTER

MAKES 10 SERVINGS

For this casually chic presentation, the pulled-back cornhusks create a still-life on the buffet and great no-mess handles on the plate.

10 ears fresh corn, husks and small length of stalk intact
8 tablespoons (110 g) butter, softened

Juice of 2 limes
2 teaspoons salt
1 teaspoon dried oregano

1 teaspoon chopped fresh basil
2 tablespoons freshly grated Parmesan cheese

Peel off and discard only the first few layers of the corn husks. Clean each cob of any silk protruding from the top of the ear; remove and discard the silk.

Soak the whole cobs in a pot of cold water for 15 minutes. Be sure the ears are completely covered with water. This will provide extra moisture for cooking and will steam the corn kernels inside the husks.

While the corn is soaking, preheat the barbecue grill to medium (350°F) and prepare the corn butter by combining the butter, lime juice, salt, oregano, basil, and Parmesan in a small saucepan. Warm the mixture until the butter is completely melted and the ingredients are combined. Set aside half the corn butter for dipping.

Remove the corn from the water and shake off any excess liquid. Pull all the corn husks back, but leave them attached to the base of the stem. Use a pastry brush to coat the kernels with the butter mixture. Pull a few husks back over the kernels and wrap aluminum foil around the husks gathered at the base so they don't burn.

Place the corn on the grill and close the cover. Grill until the husks are slightly charred and the corn is tender, 10 to 15 minutes. Be sure to rotate the cobs as needed, every 5 minutes or so, to ensure they don't get too charred. Remove the corn from the grill and when it is cool enough to handle, remove aluminum foil from the husks and pull back husks from the kernels; leave them attached to form a handle. Remove any corn silk, which should fall away easily from the roasted corn. Pile the corn on a decorative platter. Place a bowl with extra corn butter on the buffet for dipping.

PANKO-PARMESAN CHICKEN TENDERS WITH TWO DIPPING SAUCES

MAKES 12 TENDERS OR 24 "FINGERS"

The crispy, crunchy panko breadcrumbs lend incredible texture to these no-fry tenders. They are easy to make and kid friendly, but the adults will enjoy them too. The dipping sauces are so tasty we recommend cutting the tenders in half, creating "fingers," so there is more to dip! If you like a thicker breading, dip the tenders in flour, then egg, then the panko mixture.

Olive oil or canola oil cooking spray
1¼ cups (140 g) panko bread crumbs
½ cup (60 g) freshly grated Parmesan cheese

2 tablespoons dried parsley flakes
1 teaspoon salt
½ teaspoon freshly ground black pepper
2 large eggs

1½ pounds (680 g) chicken tenders (about 12 tenders), or sliced skinless boneless breasts
Hogan's Tomato Ketchup and Honey Mustard Dipping Sauce (recipes follow)

Preheat the oven to 400°F (205°C). Coat a large rimmed baking sheet with cooking spray.

Combine the bread crumbs, cheese, parsley, salt, and pepper in a shallow bowl. Lightly beat the eggs in another shallow bowl.

Cut thick chicken tenders in half lengthwise or cut them all to make 24 "fingers." Dip the tenders in the egg and let any excess drip off,

then roll them in the bread crumb mixture, shaking off any excess. Place the tenders on the prepared baking sheet. Generously coat both sides of each tender with cooking spray.

Bake for 20 to 30 minutes. Turn each tender over halfway through and continue baking until the outside is crisp and the tenders are cooked through. Serve the chicken pieces on a platter with the sauces alongside for dipping.

HOGAN'S TOMATO KETCHUP MAKES 2 CUPS (480 ML)

1 pound (455 g) local green tomatoes, chopped
1 local large red tomato, chopped
1 large onion, chopped

1 chile pepper, seeds removed, chopped
2 tablespoons coarse sea salt
1 teaspoon black peppercorns

2 teaspoons pickling spice
1 cup (200 g) sugar
¼ cup (60 ml) white vinegar

Combine the tomatoes, onion, chile pepper, and salt in a large saucepan over medium-high heat and bring the mixture to a boil.

In the meantime, place the peppercorns and pickling spices in a cheesecloth bag. (To make your own, cut a square of cheesecloth and place the mixed spices in the middle. Tie it shut with kitchen twine.) Crush the spices slightly to release their flavors.

Add the cheesecloth bag to the boiling tomato mixture. Stir in the sugar and vinegar and simmer for 30 to 45 minutes or until the sauce is thick.

Remove the cheesecloth bag, let the ketchup cool, and transfer it to a mason or other airtight jar. Serve it slightly chilled. The ketchup will keep in the refrigerator for 3 to 4 weeks.

HONEY MUSTARD DIPPING SAUCE MAKES ⅔ CUP (165 ML)

½ cup (120 ml) safflower mayonnaise

1 tablespoon Dijon mustard
2 tablespoons honey

1½ teaspoons freshly squeezed lemon juice

Combine the mayonnaise, mustard, honey, and lemon juice in a small bowl. Whisk until combined. Chill until ready to serve.

Opposite, top right: Oysters on the Half Shell with Champagne and Apple Cider Mignonette Sauces (page 185).

Halloween Merriment

Autumn in the Hamptons may be quiet—most summer residents leave by Labor Day—but for the cognoscenti, it's the most glorious time of the year. Winter's first breath chills the air, the leaves turn myriad shades of russet and gold, and apple orchards are bursting with ripe fruit.

For Rudy Giuliani, the former mayor of New York City who's affectionately known as "America's mayor," and his wife, Judith, the simplicity and slower pace of the fall season are compelling reasons to stay in Southampton until Halloween. But the best reason of all revolves around a little white ball.

"We are absolute golf addicts," Judith says. Rudy adds, "Golfing through October without the crowds is a wonderful way to stretch the pleasures of summer."

So are parties. Judith is always giddy when Halloween comes around, not only because she loves to spend time at the corn mazes and pumpkin patches, but because it marks an entertaining tradition. "I do a Halloween party every year," she says. "It brings out the kid in everybody." It isn't what one might expect. No one is asked to come in costume, and no ghouls are lurking behind the hydrangeas—just a group of ladies gathering for lunch and a little childlike fun.

A self-proclaimed "theme party giver," Judith plans this event months in advance, purchasing the various components along the way. Even Rudy gets in on the hunt. "When we are traveling, he helps me find things," she says. "If we are in Vienna, for example, he'll know exactly where to find masks."

The masks the Giulianis gathered in Vienna, Venice, and elsewhere were stored in the "party closet" in the basement, awaiting their debut at the Halloween lunch. These individual works of art marked each place setting along with generous gift bags containing spiderweb cuffs, spider rings, candy, and a pumpkin-decorating kit featuring Mr. Potato Head push-ins.

"There is always something for guests to make," Judith says. "Everyone gets into it."

The decorations were equally festive. Pumpkins, bats, trick-or-treat candy, and baskets full of Halloween-themed crackers were tucked here and there to pay tribute to the occasion. The most intriguing element was Judith's collection of witches, perched on rockers, Chippendale chairs, centerpieces, and even in the loo. "I buy these all over the world," she says. "I have antique ones, crafty ones, fashionable ones . . . I have only one rule: They can't be scary."

After a fall-themed lunch that featured roasted butternut squash and porcini bisque in pumpkin bowls, mulled hot apple cider, roasted root vegetables, and

Opposite: Judith and the Honorable
Rudolph Giuliani.

TIPS AND IDEAS
from Judith Giuliani

For the best theme parties, shop weeks
or months in advance. "I start shopping
for my parties a year earlier. I always
pick up interesting treasures at arts-
and-crafts shows and on our travels.
Some people collect things for their
house; I collect for my parties."

Be organized. Place items in bins, la-
bel them, and, if possible, dedicate an
area to party storage. "I'm the only per-
son I know with two cedar closets full of
decorations for every occasion."

To maximize the fun quotient, plan an
interactive component. "The point is
to have everyone do something. I like
to incorporate a crafting element, be-
cause everyone has fun with it."

pumpkin-spiced crème brûlée, the ladies were eager to don their masks and
decorate their pumpkins. Pushing pirate eyes and silly lips into the gourds
resulted in rollicking laughter, and the party ended on an exuberant note.

Who needs spooks and costumes when you can have Mr. Potato Head?
As Judith says, "The fun of the party is being a kid."

Menu

HALLOWEEN LUNCH FOR SIX

Hot Mulled Apple Cider

·

Roasted Butternut Squash and Porcini Bisque
Poached Lobster or Grilled Sliced New York Strip Steak
Served over Arugula, Corn, Peppers, Pecans, and
Tomatoes with Poached Garlic Vinaigrette
Roasted Root Vegetables

·

Pumpkin-Spiced Crème Brûlée
Apple Crisp with Caramel Drizzle

Prepared by **Tim Burke Productions**
presents **230 Elm Caterers**

ROASTED BUTTERNUT SQUASH AND PORCINI BISQUE

MAKES 6 TO 8 SERVINGS

Peeling and dicing an oddly shaped, tough-skinned butternut squash for soup can be a daunting task, so simply cut it in half, remove the seeds, and roast it first. This concentrates the flavors without hours of simmering, and the roasted flesh is easily scraped out of the skin. Earthy yet elegant, this is the kind of soup to warm body and soul all through fall and winter—it's filling and flavorful enough for a light dinner. The Giulianis served the soup in small, scooped-out pumpkins—a lovely presentation.

1 large butternut squash, halved lengthwise, seeds removed

¾ cup (180 ml) olive oil

Salt and freshly ground black pepper

1 cup (70 g) sliced shiitake mushrooms

1 cup (105 g) sliced oyster mushrooms

1½ cups (240 g) sliced shallots

1½ cups (360 ml) cream sherry

3 cups (720 ml) heavy cream

2 cups (480 ml) chicken stock

2 ounces (55 g) dried porcini mushrooms

2 tablespoons minced fresh thyme

1 baguette (optional)

Fig jam (optional)

Preheat the oven to 350°F (175°C).

Line a baking sheet with aluminum foil. Place the squash halves cut side up on the baking sheet. Rub with ¼ cup (60 ml) of the olive oil and season generously with salt and pepper. Roast until knife-tender, about 30 minutes. Set the baking sheet on a wire rack and allow the squash to cool enough to be handled.

Meanwhile, in a bowl, toss the sliced mushrooms with ¼ cup (60 ml) of the olive oil; season with salt and pepper. Roast them in the oven, along with the squash, about 15 minutes.

Using a large spoon, scoop the flesh out of the squash and set it aside; discard the skins.

Heat the remaining ¼ cup (60 ml) olive oil in a stainless-steel pot over medium heat. Add the shallots and cook until tender, about 3 minutes. Add the sherry and simmer for 2 minutes. Add the cream, chicken stock, butternut squash, and dried porcini; taste and season as needed with salt and pepper. Simmer for 20 minutes, stirring occasionally.

Pour the bisque into a blender and puree until it's smooth. You may need to work in batches.

Return the pureed bisque to the pot and stir in the thyme and roasted mushrooms.

Serve the soup hot, with sliced baguette and fig jam, if desired.

ROASTED ROOT VEGETABLES

MAKES 8 TO 10 SERVINGS

The Hamptons inspires thoughts of sun and sand, so the abundance of root vegetables in early fall comes as a bit of a surprise to some. The crops are varied and plentiful and seem to arrive just as the days get shorter, the weather gets cooler, and the leaves fall from the trees. This easy recipe highlights the Giulianis' favorite autumn arrivals, but it works for any medley of root vegetable. Slice or cube all the vegetables to an even size to assure even cooking times and a prettier presentation.

3 parsnips, peeled, trimmed, and cut

1 large rutabaga, peeled, trimmed, and sliced

3 turnips, peeled, trimmed, and sliced

2 carrots, peeled, trimmed, and cut

4 yellow pattypan squash

3 small Yukon gold potatoes, scrubbed and sliced

2 green onions, sliced

2 tablespoons minced thyme

½ teaspoon salt

⅛ teaspoon freshly ground black pepper

4 to 5 tablespoons (60 to 75 ml) olive oil

Leaves of 1 bunch fresh parsley, roughly chopped

Preheat the oven to 400°F (205°C).

Put all the vegetables and the thyme in a large baking dish. Season well with salt and pepper, drizzle generously with olive oil, and toss them with your hands to coat them evenly.

Roast, stirring occasionally, until the vegetables are tender and golden brown, 30 to 45 minutes.

Transfer the vegetables to a decorative platter, sprinkle fresh parsley on top, and serve.

PUMPKIN-SPICED CRÈME BRÛLÉE

MAKES 6 SERVINGS

True vanilla adds a rich complexity to this seasonal crème brûlée. Those delicious dark flecks, straight from the pod, let you know this is a special dessert and well worth the calories. Removing the seeds from the pod might seem tricky because of their tiny size, but scraping the bean will remove almost all the seeds in just a few minutes, and it is time well spent.

4 cups (960 ml) heavy cream
1 large bourbon vanilla bean, split length-
 wise
¼ teaspoon ground cinnamon

¼ teaspoon ground allspice
¼ teaspoon ground ginger
¼ teaspoon ground nutmeg
8 egg yolks

1 cup (200 g) sugar
½ cup (120 ml) pumpkin puree (do not use
 pumpkin pie filling)
Whipped cream, for garnish (optional)

Preheat the oven to 350°F (175°C). Bring a kettle of water to a boil.

Pour the cream into a small saucepan. Scrape the vanilla seeds into the cream and drop in the pod as well; whisk in the cinnamon, allspice, ginger, and nutmeg. Set the mixture over medium-low heat and warm it until bubbles form around the edges, about 5 minutes. Remove the pan from the heat and let it stand for 20 minutes. Remove and discard the vanilla bean.

In a mixing bowl, whisk the egg yolks and ½ cup (100 g) of the sugar together until pale in color. Slowly pour in the cream mixture, stirring until blended. Add the pumpkin puree, stirring until blended.

Pour the mixture through a fine-mesh sieve set over a bowl. Divide it evenly among six 6-ounce (180-ml) ramekins. Place the ramekins in a large baking pan and set the pan in the oven. Before pushing in the

rack and closing the oven door, add enough boiling water to fill the pan halfway up the sides of the ramekins. Bake until the custards are just set around the edges, 20 to 30 minutes.

Transfer the ramekins to a wire rack and let them cool, then refrigerate them for at least 4 hours.

Remove the ramekins from the refrigerator 10 minutes before serving. Sprinkle each with enough of the remaining sugar to evenly cover the top of each custard. Using a kitchen torch and continuously moving the flame over the surface of the sugar, melt the topping so that it is light brown with a few darker spots. If you don't have a kitchen torch, set your oven to broil at the highest setting. Place the ramekins on the top rack to caramelize the sugar, about 2 minutes.

Serve the custards immediately in the ramekins, garnished with a dollop of whipped cream, if desired.

Opposite, top left: Roasted Root Vegetables; top right: Roasted Butternut Squash and Porcini Bisque (both, page 197).

APPLE CRISP WITH CARAMEL DRIZZLE

MAKES 8 SERVINGS

This recipe is a great addition to your apple dessert collection. It is easy (no pie crusts!), and if you prepare it ahead of time and put it in the oven just before guests arrive, the house will smell wonderful all evening. The Giulianis served their crisp over a short-crust pastry—really delicious! It can be served on its own too, and of course pairs beautifully with ice cream or fresh whipped cream.

Short-Crust Pastry (optional; recipe follows)

FOR THE STREUSEL TOPPING:
½ cup (55 g) flour
¼ cup packed (55 g) light brown sugar
4 tablespoons (55 g) unsalted butter, at room temperature

½ teaspoon ground cinnamon

FOR THE FILLING AND FINISH:
¼ cup (40 g) golden raisins, macerated for 15 minutes in ¼ cup brandy
3 Granny Smith apples, cored and thinly sliced

½ cup packed (110 g) light brown sugar
½ tablespoon ground cinnamon
4 tablespoons (55 g) unsalted butter
⅛ teaspoon ground nutmeg
Caramel sauce (store-bought)
¼ cup (25 g) confectioners' sugar

Preheat the oven to 350°F (175°C). If you're using the short-crust pastry, press the dough into the bottom of a 7-by-11-inch (17-by-28-cm) baking dish, in one even layer. If you're not using the pastry, grease the baking dish.

Make the streusel topping. Combine the flour, brown sugar, butter, and cinnamon in a food processor and pulse until crumbly.

To make the filling, strain the raisins and combine them in a bowl with the apples, sugar, cinnamon, butter, and nutmeg. Toss well to combine and transfer to the prepared baking dish. Crumble the streusel topping over the apple mixture.

Bake until the top is brown and the filling is bubbly, about 30 minutes.

Using a large spatula, carefully transfer to a decorative plate (it will crumble a bit). Drizzle with caramel sauce and, using a sifter, sprinkle confectioners' sugar over the top. Serve warm.

SHORT-CRUST PASTRY MAKES 2 CUPS (480 ML)

1½ cups (170 g) flour, sifted
½ cup (100 g) sugar

2 egg yolks
1 tablespoon vanilla extract

1½ tablespoons sour cream
½ teaspoon baking powder

In a mixing bowl, using your hands, combine all the ingredients until you have a dough-like consistency. Set aside until ready to use.

Opposite, top left: Catharine Grimes.

Summer Sips

A SELECTION OF FAVORITE HAMPTONS LIBATIONS

SUMMER SIPS

———

Summertime and libations go hand in hand. Whether welcoming guests with a cocktail, cooling off from the heat with a vitamin-packed juice, or refueling after a fierce workout with an energy drink, refreshments are *de rigueur* in the Hamptons. From time-honored cocktails like Cyril's Bloody Mary to powerhouse drinks like Juice Press's Rocket Fuel, here are recipes inspired by some of the local favorites.

———

MANDARIN PUNCH
MAKES 1 COCKTAIL

For Timothy G. Davis, luxury market leader for the Corcoran Group, breakfast on the porch of the American Hotel in Sag Harbor is a summertime ritual. And, after long days of showing some of the Hamptons' most coveted properties, some evenings the power broker unwinds at the hotel's bar with this refreshing, citrusy cocktail.

2 ounces (30 ml) Hangar 1 Mandarin Blossom vodka

4 ounces (120 ml) seltzer water
Lemon, lime, and orange wedges

Fill a tall glass with ice. Pour the vodka over the ice and fill the rest of the glass with seltzer. Garnish with the citrus wedges.

The American Hotel
49 Main Street, Sag Harbor, NY 11963
631-725-3535, www.theamericanhotel.com

———

TUTTO SPRITZ
MAKES 1 COCKTAIL

Tabletop accessory designer Kim Seybert has an eye for detail and the elements that define the good life. Not least among these is a refined cocktail. She prefers the Italian accent of a Tutto Spritz, one of the specialties of Tutto il Giorno in Southampton and Sag Harbor.

4½ ounces (133 ml) Aperol liqueur
Splash of lemon-lime soda

4 ounces (118 ml) Prosecco
Orange wedge, for garnish

Fill a water goblet with ice. Pour the Aperol and soda over ice and top with Prosecco. Garnish with an orange wedge.

Tutto il Giorno
56 Nugent Street, Southampton, NY 11968, 631-377-3611,
6 Bay Street, Sag Harbor, NY 11963, 631-725-7009
www.tuttoilgiorno.com

PAMA LEMONADE
MAKES 1 COCKTAIL

For Lucia Hwong Gordon, the Hampton Classic is a quintessential summer rite. After summer travels, she finds gathering in an intimate setting to watch friends and children show horses—her twin girls both ride—simply magical. Post show, mother and daughters lunch at the Wölffer Estate Stables table in the main tent. Lucia enjoys sipping a festive, elegant Pama Lemonade, which she calls "the perfect Hampton cocktail."

1½ ounces (45 ml) Pama pomegranate liqueur
1 ounce (30 ml) citrus vodka

1 ounce (30 ml) rosemary-infused simple syrup
3 ounces (90 ml) lemonade
Lemon wheel

Fill a tall glass with ice. In a cocktail shaker with ice, combine the pomegranate liqueur, vodka, simple syrup, and lemonade; shake and strain into the glass. Garnish with a lemon wheel.

CYRIL'S BLOODY MARY
MAKES 1 COCKTAIL

In the Hamptons, Cyril's Fish House is an institution. Its owner, Cyril Fitzsimons, can often be found sitting in the back of his restaurant holding court. Visitors love it here for the top-notch cocktails and the boisterous vibe. True Hamptonites come for the Buffalo wings or Buffalo squid—and Cyril's famous Bloody Mary. The recipe is secret, but we've imbibed enough of these spicy numbers to concoct our own version. Like Cyril, we serve ours with a celery stick, which balances the heat.

2 dashes Worcestershire sauce
2 dashes Tabasco sauce
2 teaspoons prepared horseradish
1 splash fresh lemon juice
1 pinch celery salt

1 pinch freshly ground black pepper
2 ounces (60 ml) vodka
4 ounces (120 ml) tomato juice, preferably Sacramento brand
Celery stick

In a small pitcher, combine the Worcestershire sauce, Tabasco, horseradish, lemon juice, celery salt, and pepper. Stir and let the flavors meld overnight in the refrigerator.

When ready to serve, pour the chilled spice mixture into a tall glass. Add the vodka and tomato juice and stir. Add enough ice to top off the glass. Garnish with a celery stick.

Cyril's Fish House
2167 Montauk Highway, Amangasett, NY 11930
631-267-7993, www.cyrilsfishhouse.webs.com

SEBONACK SOUTHSIDE
MAKES 1 COCKTAIL

The Southside, a variation of the mojito that was invented at the Southside Sportsmen's Club in Long Island, has been a Hampton favorite for generations. At the Sebonack Golf Club, a new version of the classic has emerged: the Sebonack Southside, which may be served with or without a floater of the sky-blue liqueur Hpnotiq. Pictured sans floater, as it was served at the Falk party (page 36), is equally apropos for sunset imbibing.

6 to 8 mint leaves
½ teaspoon sugar
1 lime wedge
1 splash sour mix

2 ounces (60 ml) vodka
4 ounces (120 ml) lemonade
1 splash club soda
Hpnotiq liqueur

In a pint glass, combine the mint leaves, sugar, lime wedge, and sour mix and mash together with a muddler. Fill the glass to the top with ice. Add the vodka and lemonade, pour into a cocktail shaker and

shake. Pour back into the pint glass, top with club soda. Wave the bottle of Hpnotiq over glass for the floater, just enough to give the cocktail a blue tint.

Sebonack Golf Club
405 Sebonac Road, Southampton, NY 11968
631-287-4444, www.sebonack.com

ROCKET FUEL

MAKES 1 SERVING

Stacey Griffith, the much-celebrated senior master instructor at SoulCycle, is hailed by many as the ultimate fitness guru. Her disciples—a devoted band of indoor cyclists—swear by her coaching style, referring to her as a "miracle worker." Between classes at the Barn and her own workouts, Stacey stops by Juice Press for a shot of Rocket Fuel. As the name suggests, the juice packs a punch, due largely to guayusa concentrate, an extract from an Amazonian tree leaf that delivers clear, focused energy.

2.6 ounces (75 grams) Runa Amazon guayusa loose leaf tea

Hot water

2 ounces (59 ml) freshly squeezed pear juice

2 ounces (59 ml) guayusa concentrate

1/2 ounce (15 ml) freshly squeezed lemon juice

1/4 ounce (7 ml) feshly squeezed ginger juice

5 drops maca extract

Make the concentrate. Pack loose leaf tea into a small bowl. Bring water to a boil and slowly pour enough hot water over the tea leaves to cover them completely. Steep for 15 to 20 minutes, then strain the tea. Refrigerate concentrate in a tightly covered container until ready to use.

In a tall glass, combine pear juice, guayusa concentrate, lemon juice, ginger juice and maca extract. Cover and chill. Serve cold. Can remain in the refrigerator for up to two days.

Juice Press,
2486 Montauk Highway, Bridgehampton,
NY 11932, 212-777-0034,
93 Main Street, Southampton,
NY 11968, 631-488-4688,
www.juicepress.com

LEMON CLEANSE

MAKES 1 SERVING

Pierre's French bistro is a Bridgehampton staple, and locals love it for its beautiful pastries, organic smoothies and juices, and a petit déjeuner without equal. Kendell Cronstrom, editor in chief of Hamptons Cottages & Gardens magazine, frequently stops in for a late-morning breakfast and his favorite juice, the Lemon Cleanse.

2 organic carrots, trimmed

1 organic Granny Smith apple, halved

1 ounce (30 g) organic ginger (about 2 inches/5 cm)

1 organic lemon, halved

One at a time, place the carrots, apple, ginger, and lemon in a professional-grade juicer until all the juice has been extracted. Enjoy immediately.

Pierre's
2468 Main Street, Bridgehampton, NY 11932
631-537-5110, www.pierresbridgehampton.com

THE TORQUAY

MAKES 1 COCKTAIL

Pronounced "tor-key," this drink was named after a very well known beautiful beachside town outside Melbourne, Australia, where the owner of Race Lane was raised. It was created to welcome patrons with something cool and refreshing after a long, hot day at the beach. Both actress Julie Bowen and author and businessman Joe Plumeri are fans of this invigorating cocktail.

2 quarter-inch slices lemon
5 quarter-inch slices seedless cucumber

2½ ounces (74 ml) Hendrick's Gin
1½ ounces (44 ml) St. Germain Elderflower Liqueur

In a cocktail shaker, muddle the lemon and 4 slices of the cucumber then add the gin and St. Germain. Shake and strain into a chilled martini glass. Garnish with the remaining cucumber slice and serve.

Host Selections

ALLINSON RESOURCES

GARDEN
Nievera Williams Design
223 Sunset Avenue, Suite 150
Palm Beach, FL 33480
(561) 659-2820
www.nieverawilliams.com

TABLETOP
Hôtel European Hotel Silver
Ginger Kilbane
www.hotelsilver.net

Paule Marrot Editions
(336) 847 2630
www.paulemarrot.com

Lynn Chase Designs
63A South Sandisfield Road
New Marlborough, MA 01230
(413) 229-5900
www.lynnchase.com

FLOWERS
Topiaire Flower Shop
51 Jobs Lane
Southampton, NY 11968
(631) 287-3800
www.topiaireflowershop.us

SPECIALITY ITEMS
Michael's Crafts
1440 Old Country Road
Suite 400
Riverhead, NY 11901
(631) 284-2201
www.michaels.com

AMORY RESOURCES

SAUCES
Victoria Amory
www.victoriaamory.com

SAUSAGES
La Tienda
www.latienda.com

D'Artagnan
www.dartagnan.com

CHINA
Juliska
www.juliska.com

BLOOMBERG RESOURCES

RIDING CLOTHES
Ariat International, Inc.
www.ariat.com

Brennan's Bit & Bridle
42 Snake Hollow Road
Bridgehampton, NY 11932
(631) 537-0635
www.brennansbitandbridle.com

SADDLES
CWD
1000 W. Oak Street
Burbank, CA 91506
(818) 859-7708
www.cwdsellier.com

EVENT RENTALS
Party Rental, Ltd.
7 Tradesman Path
Bridgehampton, NY 11932
(631) 537-4477
www.partyrentalltd.com

FLOWERS
The Bridgehampton Florist
2400 Main Street
Bridgehampton, NY 11932
(631) 537-7766
www.thebridgehamptonflorist.com

CATERING
Robbins Wolfe Eventeurs
Official caterer of the Hampton Classic
521 West Street
New York, NY 10014
(631) 537-1926
www.robbinswolfe.com

TABLETOP
Artfully Equestrian
www.artfullyequestrian.com

Villeroy & Boch
www.villeroy-boch.com

BURCH RESOURCES

STAFFING
Staffing 911
251 East 110th Street
New York, NY 10029
(646) 964-6472, ext. 708
www.mintstaffing911.com

EVENT PLANNING
Mint Management
251 East 110th Street, 2nd Floor
New York, NY 10029
(646) 964-6472, ext.701
www.mintmanagement.us

COHEN RESOURCES

TABLETOP
Gracious Home
1992 Broadway
New York, NY 10023
(212) 231-7800
www.gracioushome.com

General Home Store
100 Park Place
East Hampton, NY 11937
(631) 324-9400
www.generalhomestore.com

Ralph Lauren Women's and Home
888 Madison Avenue
New York, NY 10021
(212) 434-8000
www.ralphlauren.com

La Capannina
Via Le Botteghe, 12 bis
80073 Capri, Italy
+39 081-837-07-32
www.capanninacapri.com

ELENOWITZ RESOURCES

GOURMET
The Perfect Purée of Napa Valley
www.perfectpuree.com

TABLETOP
Bespoke Global
www.bespokeglobal.com

WINE
Bergström Wines
www.bergstromwines.com

Ramey Wine Cellars
www.rameywine.com

FALK RESOURCES

CATERING
Seasons of Southampton
15 Prospect Street
Southampton, New York 11968
(631) 283-3354
www.seasonsofsouthampton.com

TABLETOP
Blue Provence
300 South County Road
Palm Beach, FL 33480
(561) 651-1491
www.blueprovence.com

Asprey New York
853 Madison Avenue
New York, NY 10021
(212) 688-1811
www.asprey.com

PRODUCE
Schmidt's Market
120 North Sea Road
Southampton, NY 11968
(631) 283-5777
www.schmidtsmarket.com

POULTRY
Iacono Farms
106 Long Lane
East Hampton, NY 11937
(631) 324-1107

PASTRIES
Tate's Bake Shop
43 North Sea Road
Southampton, NY 11968
(631) 780-6511
www.tatesbakeshop.com

Pierre's
2468 Main Street
Bridgehampton, NY 11932
(561) 537-5110
www.pierresbridgehampton.com

Sant Ambroeus
30 Main Street
Southampton, NY 11968
(631) 283-1233
www.santambroeus.com

WINES & LIQUORS
Herbert & Rist
63 Jobs Lane
Southampton NY 11968
(631) 283-2030

Southampton Publick House
40 Bowden Square
Southampton NY 11968
(631) 283-2800
www.southamptonbrewery.com

BAKING SUPPLIES
Williams-Sonoma
2044 Montauk HIghway
Bridgehampton, NY 11932
(631) 537-3040
www.williams-sonoma.com

FANJUL RESOURCES

FLOWERS
Sag Harbor Florist
3 Bay Street
Sag Harbor, NY 11963
(631) 725-1400
www.sagharborflorist.net

LOCAL SEAFOOD
The Seafood Shop
356 Montauk Highway
Wainscott, NY 11975
(631) 537-0633
www.theseafoodshop.com

PRODUCE
The Green Thumb Organic Farm
829 Montauk Highway
Water Mill, NY 11976
www.greenthumborganicfarm.com

Bette and Dale's Farm located on the Sag
 Harbor–Bridgehampton Turnpike
 and Carroll Street
Sag Harbor, NY

CHEESE
Cavaniola's Gourmet Cheese Shop
89B Division Street
Sag Harbor, NY 11963
(631) 725-0095
www.cavaniola.com

GOURMET
Arlotta Olive Oil
www.arlottafood.com
Found at farmer's markets throughout Long
 Island.

GIULIANI RESOURCES

LOCAL PRODUCE
North Sea Farms
1060 Noyac Road
Southampton, NY 11968
(631) 283-0735

COOKIES
Pottery Barn Kids
1 Hampton Road
Southampton, NY 11968
(631) 283-0934
www.potterybarnkids.com

SPECIALTY ITEMS
Mr. Potato Head pumpkin push-ins
 available at Amazon.com

CATERING
Tim Burke Productions Presents 230 Elm
See Salm Resources, opposite.

HOGAN RESOURCES

PRODUCE
Sang Lee Farms, Inc.
25180 Country Road 48
Peconic, NY 11958
(631) 734-7001
www.sangleefarms.com

Sep's Farms
7395 Main Road
East Marion, NY 11939
(631) 477-1583

BALLOONS
Amazing Parties
20 Hampton Road
Southampton, NY 11968
(631) 287-9040
www.amazingparties.com

OYSTER SUPPLIES
Cornell University Cooperative Extension
www.cce.cornell.edu

WINES
McCall Wines
22600 Main Road
Cutchogue, NY 11935
(631) 734-5764
www.mccallwines.com

HORNIG RESOURCES

PRODUCE
The Green Thumb Organic Farm
See Fanjul Resources, at left.

Schmidt's Market
See Falk Resources, page 215.

Citarella
See Roberts Resources, at right.

Round Swamp Farm
184 Three Mile Harbor Road
East Hampton, NY 11937
(631) 324-4438
roundswampfarm.com

PASCUSSI RESOURCES

TABLETOP
Pottery Barn Outlet
1770 W Main Street #1603
Riverhead, NY 11901
(631) 369-7699
www.potterybarn.com

FLOWERS
Lilee Fell Flowers LLC
367 Butter Lane
Bridgehampton, NY 11932
(631) 537-0413
www.lileefellflowers.com

WINE
Terlato Family Vineyards
(888) 241-0259
terlatovineyards.com

Protea Wines
www.proteawinesusa.com

Amisfield Wines
www.amisfield.co.nz

ROBERTS RESOURCES

MEATS AND PRODUCE
Citarella
20 Hampton Road
Southampton, NY 11968
(631) 283-6600
www.citarella.com

KITCHEN SUPPLIES
Loaves & Fishes Cookshop
2422 Montauk Highway
Bridgehampton, NY 11932
(631) 537-6066
www.landfcookshop.com

ROSS RESOURCES

TABLETOP
Kim Seybert
www.kimseybert.com

TABLETOP/FABRIC
Mac Fabrics
426 Clematis Street
West Palm Beach, FL 33401
(561) 223-1393
www.macfabrics.biz

SALM RESOURCES

CATERING
Tim Burke Productions Presents 230 Elm
230 Elm Street
Southampton, NY 11968
(631) 377-3900
www.230elm.com

LOCAL PRODUCE
Babinski's Farm Stand
160 Newlight Lane
Watermill, New York 11976
(631) 875-0262
www.facebook.com/babinskifarmstand

LOCAL WINE
Wölffer Estate Vineyards
139 Sagg Road
Sagaponack, NY 11962
(631) 537-5106
www.wolffer.com/winery

SAMUELS RESOURCES

CHEESE
The Village Gourmet Cheese Shoppe
11 Main Street
Southampton, NY 11968
(631) 283-6949
www.villagecheeseshoppe.com

PRODUCE
Catena's Market
143 Main Street
Southampton, NY 11968
(631) 283-3456

SEAFOOD
Cor-J Seafood Corp.
36 Lighthouse Road
Hampton Bays, NY 11946
(631) 728-5186
www.corjseafood.com

Clamman Seafood Market
235A North Sea Road
Southampton, NY 11968
(631) 283-6669
www.clamman.com

SAUCES
Old School Favorites
Found at farmers' markets on the East End
 of Long Island
www.oldschoolfavorites.com

TABLETOP
Yvonne Parker
www.yvonneparkerartfulliving.com

STAFFING
Hamptons Employment Agency
149 Hampton Road
Southampton, NY 11968
(631) 204-1100
www.hamptonsemployment.com

EVENT PLANNING
Studio3
349 Fifth Avenue
New York, NY 10016
(212) 367-7950
studio3nyc.com

SULZBERGER RESOURCES

CATERING
Brent Newsom Caterer
PO Box 369
Wainscott, NY 11975
(631) 324-9860
brentnewsomcaterer.com

FLOWERS
Serene Green Farm Stand
3980 Noyac Road
Sag Harbor, NY 11963
(631) 334-6311
serenegreeninc.com

LOCAL PRODUCE
Babinski's Farm Stand
See Salm Resources, at left.

LOCAL SEAFOOD
The Seafood Shop
See Fanjul Resources, opposite.

Index

Acknowledgments

Creating *Hamptons Entertaining* has been both a labor of love and a culinary romp through one of my favorite places on the planet, the Hamptons, but it has not been a solitary undertaking. It was my friend Maureen Sherry Klinsky who first encouraged me to write this, my second book on entertaining and lifestyle, and to her I am very grateful.

My family, dedicated to the environment and eager to participate in all I do: thank you for inspiring me and being by my side throughout this project. Michael, Kayla, and Gigi: I love you—with your support and encouragement anything is possible. Kayla and Gigi, my green-market buddies and kitchen partners: you made procuring ingredients, testing, and tasting a celebration. Thank you for all the Instagram love!

I am so grateful to renowned chef Eric Ripert for providing the foreword to this book. Eric, thank you for your thoughtful contribution and for helping to highlight the work of the Peconic Baykeeper in an effort to help preserve our little slice of paradise.

My heartfelt thanks to each and every gracious host and hostess who appears on these pages. You all have generously shared your beautiful homes, yachts, barns, creative ideas, and hospitality in the spirit of giving. Your willingness to share food, wine, and your treasured recipes is so greatly appreciated. Thank you for agreeing to appear on these pages in support of the Peconic Baykeeper. You are the epitome of Hamptons entertaining.

It was truly an honor and pleasure to work with the many talented chefs, cooks, culinary aficionados, and mixologists who invited me into their kitchens and behind their bars to shape menus and perfect recipes. Many thanks to Angel Burbano, Tim Burke, Anthony Giacoponello, Gabriel Kennedy, Henrietta Laskai, Brian Pancir, Rowaida Plumeri, Doug Reiss, Tim Robbins, Luke

Schlafer, Taryn Schubert, and Karen Sheer.

Special thanks to Marta Aleksiejuk and Elisa Pelaez for your assistance and enthusiasm in the kitchen. It was a joy testing, tasting, and re-testing recipes. Thanks to Marta for hunting down the best, freshest, hard-to-get, and out-of-season ingredients. Whatever I needed somehow showed up on my kitchen counter. And thank you Lukas Aleksiejuk for agreeing to be our taster.

Many thanks to my co-authors and treasured friends Aime Dunstan and Daphne Nikolopoulos, whose generosity and spirit of volunteerism knows no bounds. They have each given generously of their time, energy, and talent and volunteered countless hours for which I am eternally grateful. Much gratitude to Katherine Shenaman and Will Ehrenreich, both of whom volunteered on countless photo shoots. And thanks to my photographer, Jerry Rabinowitz, who so beautifully captured the spirit of the Hamptons.

Deep appreciation to my agent, Carla Glasser, and my extraordinary editor, Marisa Bulzone, who helped ensure all elements of this book accurately reflect the grace and generosity of the party-givers featured on these pages.

Thank you to my editors at Abrams, including Leslie Stoker, Dervla Kelly, and Rebecca Levine; and Jennifer Brunn and Erin Hotchkiss in marketing and publicity.

Special gratitude to the many friends who have helped along the way with ideas, introductions, encouragement, and hands-on volunteering: Troy Albert, Annharriet Buck, Laura Canale, Bill Finneran, Julie Goodfriend, Steven Harnik, Kathy M. Higgins, Yue Sai kan, Katherine Lande, Clara Lessin, Paul Page, Yvonne Parker, Mark D. Passler, Christine M. Pesce, Paola Bacchini-Rosenshein, and Carl Roston.

About the Contributors

ANNIE FALK
AUTHOR

A Palm Beach resident by way of New York, philanthropist and author Annie Falk consistently finds new ways to contribute to both communities. With a background in corporate event planning and a passion for the culinary arts, Annie has created numerous events to support humanitarian projects alongside the world's most recognized names in entertainment, fashion, and society. She learned to cook from the legendary chef Roger Vergé at Le Moulin de Mougins in Provence.

The proceeds of her first book, *Palm Beach Entertaining: Creating Occasions to Remember*, were donated to one of her favorite charities, the Children's Home Society of Florida.

The private foundation she began with her husband is dedicated to improving the lives of children, protecting and preserving our natural environment, and responding to environmental emergencies that adversely affect families. Annie serves on the board of directors for the Norton Museum of Art and the Palm Beach Police Foundation and on the board of visitors for Duke, Nicholas School of the Environment.

Gloria Estefan, Usher, former Governor Charlie Christ, and others have presented Falk with awards acknowledging her many contributions. She is a recipient of the Ellis Island Medal of Honor, and her name was read into the Congressional Record. Annie is the R. David and I. Lorraine Thomas 2012 Child Advocate of the year.

DAPHNE NIKOLOPOULOS
CONTRIBUTING AUTHOR

Daphne Nikolopoulos is an award-winning author and journalist. She is editor in chief of *Palm Beach Illustrated* magazine and editorial director of Palm Beach Media Group, overseeing eleven magazines and three websites.

Daphne also writes fiction under the pseudonym D. J. Niko. Her debut novel, titled *The Tenth Saint*, was released in 2012 to rave reviews by both readers and the trade. It was awarded the Gold Medal for popular fiction in the prestigious, juried Florida Book Awards. An archaeological thriller embroidered with historical motifs, *The Tenth Saint* is the first book in the Sarah Weston Chronicles series. The second, titled *The Riddle of Solomon*, was released in 2013. Daphne is now at work on a historical novel set in tenth century B.C.E. Israel. The epic story details the collapse of the United Monarchy and the glory and fall of the empire built by King Solomon.

Her works of nonfiction include *The Storm Gourmet: A Guide to Creating Extraordinary Meals Without Electricity* and her work as a contributing author in *Palm Beach Entertaining*.

Daphne is the mother of twin toddlers and, in her spare time, volunteers for causes she believes in—literacy, education, child advocacy, and the advancement of traditional and tribal arts around the world. Born in Athens, Greece, she now lives with her family in West Palm Beach, Florida.

AIME DUNSTAN
CONTRIBUTING AUTHOR

A former fashion and society columnist for the *Palm Beach Post* and a contributing editor for *Hamptons Cottages & Gardens* magazine, Aime Dunstan combines a decade of media production with her personal passion for entertaining, creating picture-perfect events that leave a lasting impression.

While serving as special projects editor for Cottages & Gardens Publications in New York, Aime oversaw special events at its designers' show house in Sagaponack and honed her event production skills under celebrity chef Daniel Boulud at his eponymous Café Boulud. She produced countless events and weddings before launching her company IT! EVENTS + MEDIA.

Aime is an active community volunteer and in 2014 celebrated cancer survival by heading up publicity for the American Cancer Society's annual Palm Beach gala committee. Together with Annie Falk, Daphne Nikolopoulos, and acclaimed chef and food writer Victoria Amory, Aime coauthored *Palm Beach Entertaining*.

Aime lives in historic downtown West Palm Beach with her husband, son, and loveable pooch.

JERRY RABINOWITZ
PHOTOGRAPHER

Jerry Rabinowitz, a leading South Florida–based commercial and fine art photographer, specializes in lifestyle and architectural themes. Exploring images through design, color, and light, Jerry has attracted clients from many national and regional publications as well as corporate and advertising clientele. He was the sole photographer of *Palm Beach Entertaining* and has served as principal contributor to several books about the Southwest. He also travels through Central America documenting the Maya world with the Archaeological Conservancy.

WILL EHRENREICH
PHOTOGRAPHER'S ASSISTANT

Will Ehrenreich received a BFA in Studio Art from the College of Wooster in 2012 and currently spends his time as a working artist in both New York City and eastern Long Island.

KATHERINE SHENAMAN
STYLIST

Katherine Shenaman, owner of Katherine Shenaman Interiors, specializes in high-end interior design, with an emphasis on the fine and decorative arts. With a design philosophy rooted in classicism, Ms. Shenaman often offers a contemporary twist on the traditional. She holds an MA from the University of Buckingham, through the Wallace Collection in London, and a BA from Palm Beach Atlantic University. One of her projects was recognized by the Preservation Foundation of Palm Beach with the Ballinger Award (2010). Ms. Shenaman contributes her services to nonprofit organizations such as the Boys & Girls Clubs of Palm Beach County, American Red Cross of the Greater Palm Beach County, and Church of the Harvest in Pahokee, Florida.

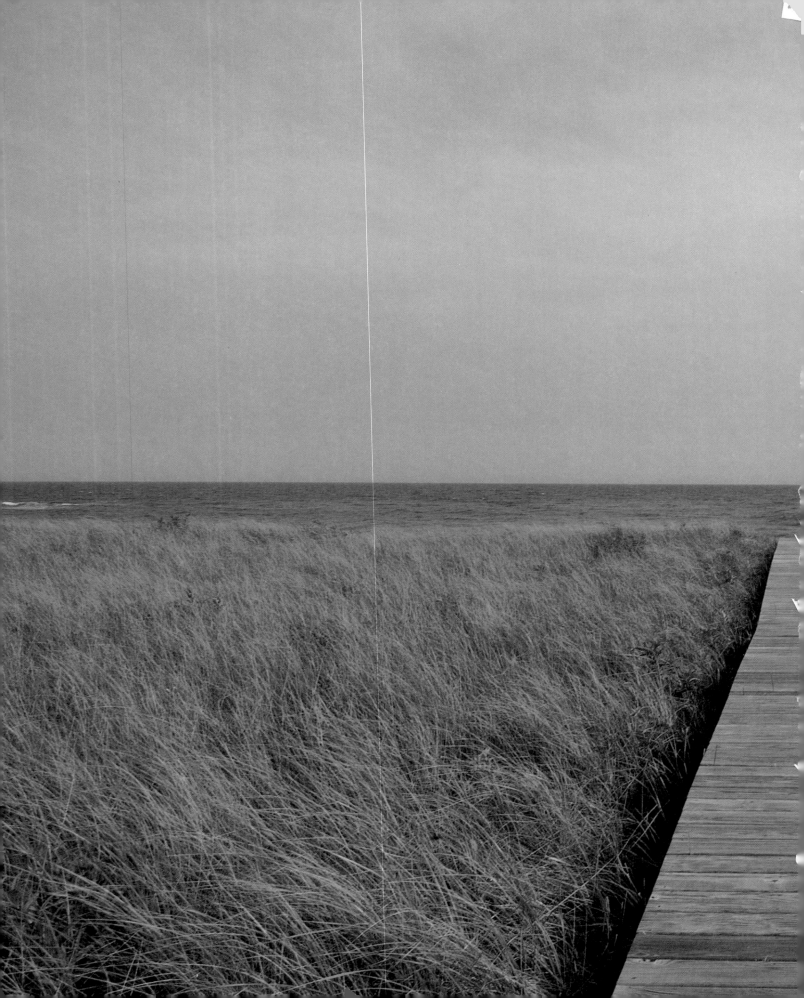